Praise for *From the Land of Green Ghosts*

DP

"A page-turner . . . deeply moving, beautifully written, and most inspiring. When I reached the last page, my heart was filled with joy and gratitude."
—Nien Cheng, author of *Life and Death in Shanghai*

"[A] writer of uncommon elegance and sensitivity."
—*New York Times Book Review*

"A distinguished accomplishment that radiates both intelligence and spiritual awareness. . . . [This is an] incisively told, remarkable story of a long journey from the hills of Burma to Cambridge University, from a young Burmese man now living in Britain." —*Kirkus Reviews* (starred review)

"*From the Land of Green Ghosts* is probably the best memoir you will read this year. The Padaung believe that those who die violent deaths return as terrifying 'green ghosts,' and they refer to Burma as the land of green ghosts. Pascal Khoo Thwe couldn't be further from that land, but the memories of his life there continue to haunt him and make exceptionally haunting reading." —*San Francisco Chronicle*

"Pascal Khoo Thwe's extraordinary memoir is unique as much for the riveting story it tells—a young man from a semiliterate Burmese hill tribe flees a bloody civil war to attend Cambridge University—as for the sublime way it is told. It's as if the very purpose of the author's arduous study of English literature was to enable him to tell this tale with requisite power and dignity. In fact, the narrative often reads like good fiction, with its memorable characters, indelible images, and an unwavering moral compass." —*Seattle Times*

"*From the Land of Green Ghosts* is a requiem written in exile for a once-rich country destroyed by a corrupt regime. It honours the ideals of fellow students in their dream of a free and multiethnic Burma. And while it bears the wry and unmistakable imprint of Pascal's literary education, it has an immediacy and lyrical candour all its own. A political statement as well as a poetic lament, the book is a true work of art."
—*Financial Times*

P9-DGQ-581

"A perceptive, moving, elegant, earthy, ironic book about the innocence of tribal life, the absurdity of the Burmese 'Road to Socialism,' the perils of rebellion, and the painful benefits of exile. Pascal Khoo Thwe has written an extraordinary, tragic memoir in luminous English, with no self-pity, but with a powerful self-knowledge." —Patrick French

"*From the Land of Green Ghosts* is a moving story that travels from a remote hill village to modern Cambridge by way of a brutal regime and the struggle of decent, ordinary people to counter it. In places, it is a thrilling and fascinating page-turner. In others, it fills one with respectful awe at the resilience and determination of a young man to fight despair and never lose hope." —*Sunday Times* (London)

"What gives [this story] particular resonance is the beauty of its prose: rich, vivid, and never cloying. He never loses his sense of humanity, always seeing through the barbarism to the frailty—and folly—beneath. The result is a marvelous book, full of pity, yearning, and wisdom."
—*Sunday Telegraph*

"*From the Land of Green Ghosts* is a magical story, full of richness and subtlety, told with the instinctive touch of a true writer. An extraordinary tale."
—*Mail on Sunday*

"I shall not reveal how Pascal became a student agitator in the movement for democracy, learnt of the order for his arrest and was forced to flee into the jungle to join the guerrilla fighters against the regime; or the terrible details of the ragged fighting in which he saw the death of many of his friends; or the stages by which, in his extraordinary 'Burmese Odyssey,' he reached the doors of Caius College: for by now, any reader who has bought this book will be utterly gripped, and will need no incentives from a critic to read on. *From the Land of Green Ghosts* deserves to become the *Wild Swans* of this new century. You should buy it for the vividness of its firsthand reporting—this is what guerrilla warfare is like, this is what jungles are like to live in—but you will actually read it for Pascal himself: he is wonderfully witty, tender, self-aware, and wise about his own youthful vanities, yet still deeply vulnerable. One finds oneself waiting, quite desperately, to discover how he will cope with what, if any, degree he will get from Cambridge. And I was left wondering, with a degree of interest rarely raised by any other memoir, how happy he is now. For in the end one realizes just how those apparently simple memories have been sharpened by the complex—and Yaula-destroying—griefs of exile."
—*The Spectator*

About the Author

PASCAL KHOO THWE was born in 1967 in a remote part of the Shan States, in southeast Burma. He was born as a member of the tiny Kayan Padaung tribe, famous for its "giraffe-necked" women. How he developed a passion for English literature (specifically, James Joyce), became involved in the student resistance to savage military repression, escaped to Thailand, and won an English degree at Cambridge University is the story told in *From the Land of Green Ghosts*, his first book. Pascal Khoo Thwe lives in London.

FROM THE LAND
OF GREEN GHOSTS

FROM THE LAND OF GREEN GHOSTS

A Burmese Odyssey

PASCAL KHOO THWE

Perennial

An Imprint of HarperCollinsPublishers

In describing certain events which he did not personally witness, the author made use of the excellent account in Bertil Lintner's book *Outrage* (1990).

Photographs courtesy of the author.

First published in the United Kingdom in 2002 by HarperCollins Publishers.

A hardcover edition of this book was published in 2002 by HarperCollins Publishers.

HarperCollins books may be purchased for educational, business, or sales promotional use. For information please write: Special Markets Department, HarperCollins Publishers Inc., 10 East 53rd Street, New York, NY 10022.

First Perennial edition published 2003.

Line illustrations by Pascal Khoo Thwe

Maps by Richard Geiger

Library of Congress Cataloging-in-Publication Data is available.

ISBN 0-06-050523-0

03 04 05 06 07 RRD 10 9 8 7 6 5 4 3 2 1

In Memoriam

Moe Kyaw Naing, 1988
Aung Than Lay, 1989
Chit Hlaing, 1992
Ko Ko Naing, 1993
Valentino Day Pho, 1993
Maung Si, 1993
Aung Soe Lwin, 1994
Edward Bo Byan, 1995
Gabriel Bo Byan, 1995

. . . pueri innuptaeque puellae
impositique rogis iuvenes ante ora parentum
(. . . boys and unwedded girls
placed young on funeral pyres before the eyes of their parents)
VIRGIL, *AENEID*, BOOK VI

Contents

Illustrations

Foreword
by John Casey

Early in 1988 I was on my way to Japan to spend six months teaching at a university in Kyoto. I decided to visit Burma *en route*. It was a place I had long wanted to see, my interest being compounded out of the Kipling associations attaching to the name 'Mandalay' and from Burma's having been closed to the outside world since General Ne Win seized power in 1962. It was only very recently that restrictions on tourists had been a little eased.

A friend of mine at Caius College, Cambridge, had taught a Burmese student. This man was now a minister in the Ne Win government, and my friend sent him a telegram to introduce me. The result was that an astonishing tour, in which I was escorted by up to a dozen officials, was arranged for me in Upper Burma, concentrating on the historic sites around Mandalay. Finally, on a Sunday morning, I was taken to Maymyo, accompanied by a convoy of Land Rovers and (as I realised later) several agents of the military intelligence. There I found, to my intense embarrassment, that the entire staff of the Maymyo bank (which was, of course, closed) had been assembled in their best shirts and *longyis* to entertain me to lunch and escort me around the town. The wishes of the masters in Rangoon had to be obeyed. The bank employees obviously had not the faintest idea why this inconvenience was being forced upon them, but they treated their unknown guest with exquisite courtesy, and even with humour. Still, I felt as though I was taking part in a Marx Brothers hoax.

At the end of the day in Maymyo my hosts urged that I have dinner with them. Luckily I had the sense to realise that it was time they got back to their families. Besides, there was something I recollected. The

night before I left Bangkok for Rangoon, I had met at dinner a couple from the British Embassy who had just come back from Burma. They recommended a good antique shop in Rangoon, owned by Madame Thain, which I had duly visited. To entertain favoured visitors Madame Thain, a voluptuous Chinese lady in her seventies, would absent herself for a few minutes, and reappear in her best silks, cheeks rouged, diamond and ruby necklace sparkling, to read one's palm, dance and sing 'You are my Sunshine'. Only after these preliminaries would she grudgingly consent to sell a few pieces of old Burmese lacquer. They also mentioned two excellent Chinese restaurants in Mandalay. At one of these restaurants, they said, I should ask for a waiter who loved James Joyce. I thought I might as well seek out the Joyce-lover, and insisted to my hosts that we separate for the evening.

In the restaurant I did not meet (as I expected) an aged Chinese, but the author of this book. Pascal Khoo Thwe was an English literature student at Mandalay University, working at the restaurant to support himself after the demonetisations of the Burmese currency by General Ne Win. He was a hill tribesman – of the tiny Padaung tribe, famous for their 'giraffe-necked' women – a Catholic, with animist undertones. He had stumbled on a couple of works by Joyce – an author of whom he had not previously heard – by chance, for he was unusual among Burmese students in being keen to read outside the narrow curriculum prescribed by the university. He had not heard of Jane Austen, George Eliot or T.S. Eliot, but knew plenty of verse from *Palgrave's Golden Treasury*, and really did seem to understand the humour and irony of Joyce's *A Portrait of the Artist as a Young Man*.

Pascal took me to his campus to meet his friends studying English literature. They epitomised the ethnic diversity of Burma – Padaungs, Chinese, Shan and Burmans. They told me that they mostly studied novels, and had to make do with a single copy among (sometimes) a hundred students. One student brought out, with great care, his chief treasure – a fragile object wrapped in a silk cloth. It was a battered, much annotated photocopy of Hemingway's *The Old Man and the Sea*. It was enough to bring tears to the eyes. My meeting with these students, passionate in their desire to discuss literature, and with hardly any prospects, made an unforgettable impression on me. In the next few weeks I wrote a couple of letters and sent some books for Pascal and his friends. But now the great insurrection of 1988 was under way, and I had no reply.

In this extraordinary book Pascal describes that chance meeting in Mandalay, and the very surprising consequences that in the end flowed from it. It was a strange and unpredictable intervention in the course of a life that in a few weeks was to reach a crisis. He describes his life, from his tribal childhood, immersed in a ghost and dream culture, where ancient animist and Buddhist practices were mixed up with the religion newly brought to the tribe by Italian Catholic missionaries, his time in a Catholic seminary, his days in Mandalay. Then follows his experience of – and role in – the uprising of 1988, his months as a fugitive in the jungle after it was so ruthlessly crushed, and his eventual escape to England and to Caius College, Cambridge.

It is an astonishing, thrilling and true story. There is a pattern of remarkable coincidences that you could see as luck or as something providential. There is much in the book about the horrors – and absurdities – of modern Burma. There is a good measure of humour both in his observation of his tribe and its customs and (which is more surprising) even at some of the most dangerous moments in the jungle fighting. But this is less a book about politics or history than a spiritual autobiography in which, uniquely, he writes with the point of view both of a member of a bronze-age, newly literate tribe and of someone who in the end managed to receive a Western education at a famous English university.

Pascal left Burma without any papers or records, for they had all been seized during the fighting in the jungle. Gradually, as his English improved, and memories came back to him, he assembled an enormous manuscript. He showed a genius for remembering. He also mastered an objective style that communicates intense feeling in a way that can properly be described as poetic.

When the publishers suggested that I might help revise and cut the manuscript for publication, I was at first diffident. I had never read anything quite like it, and there was an obvious danger of flattening it, making it more conventional. Yet our discussions as the final version was produced were fruitful. He had, for instance, mentioned that in his family chapel in Phekhon a picture of St Joseph with the Child Jesus hung on a pair of buffalo horns. Why buffalo horns? 'Because the buffalo is a hardy but violent creature, because a buffalo killed a king of Burma who was an enemy of our tribe, because the Lord Buddha is often portrayed riding on dangerous animals to show the triumph of good over evil.' Or again, he wrote of the 'illusive' meteors

that in childhood he would watch shooting over the village. Why 'illusive'? Because meteors are emanations from the spirit world. At every point such explanations were forthcoming, for Pascal's mind, like that of his people, understands the world in symbolic terms.

This mixture of points of view, allied to a rich imagination and sense of fact, has produced, I believe, a powerful and original work of literature. My friend and colleague at Caius, Colin Burrow, wrote this at the end of Pascal's time at Cambridge: 'It is I think quite wonderful that one can even imagine that someone from a tiny hill tribe in Burma, who could have been rotting in a jungle for the past few years, might go on to become an English writer of quality. But he could.'

He has.

Cambridge, July 2001

1
IDYLL OF THE TRIBE

Phekon from the Lake

Prologue

Imagined Journeys

When I was young I used to watch the rising sun with amazement. There is a long lake on the east side of my home town which cuts through the blue range of mountains that skirts the lake, and seems to disappear over the south-east horizon. I used to watch the sun emerging from the blue misty mountain, and saw it as a boy climbing out of bed. Then I would gaze at the lake below the mountain where fishing boats were crossing water golden in the first light. The bells of the pagoda could be heard from the top of the hill as the Buddhist monks chanted their sutras. Immediately afterwards the angelus bell rang from the belfry of the Christian side of town.

My mind kept wandering to places I imagined were beyond the blue mountains, on the south-west side of my view, where the frame of the lake disappeared. I asked my teacher at school what lay beyond the apparently borderless lake. He pointed on a map to a famous scenic waterfall, called Lawpita, which was also a hydro-electric installation supplying electricity for half of Burma, and, at the bottom of the waterfall, the legendary River Salween, which starts in China, meanders across Shan State, Kayah State and Karen State, and finally joins the sea at Moulmein.

He told me that the jungles towards Salween were full of bandits and rebels – what he called 'destructive elements' – whose aim was to undermine Burma and the government. Their speciality was kidnapping young girls and keeping them in some dark lair in the middle of the jungle. This gave me a vague sense of fear and foreboding, although I had as yet no idea who these bandits and rebels might be, what they were trying to do, or what the government was. I had

fantasies of protecting, or rescuing, my schoolmates who were at risk from these malefactors. At the same time I found myself constantly drawn to imagine what it would be to cross the thick jungles towards unimaginable places and the great Salween.

I always woke up to the songs of Jim Reeves, Paul Anka, Elvis Presley and the Beatles, before I had learnt the names of any of them. My father used to listen to these songs on the government radio. The English programmes were broadcast only three times a day – 8.30 to 9 a.m., 1.30 to 2 p.m. and 9 to 10 p.m. – after the main Burmese programmes, and were introduced with a piece of Burmese music, hectic and unintelligible to me to this day. For reasons I could not understand, every adult in the room sighed with a sort of disappointment when they heard it. Then followed an announcement in English: 'This is the Burma Broadcasting Service. The news, read by Marie Conway.' It was not until I was about ten that I could understand those two English sentences.

Radio and our family life were inseparable. My grandmother used to get up early to go to Mass. She had been converted to Catholicism from Buddhism more than thirty years before, but had become devout only recently. By six o'clock she had finished cooking breakfast and strolled to the church which was about a hundred yards away. Either my mother or I cooked breakfast and lunch for the family. Sometimes we had to pound husked rice-grains in a big wooden mortar with a heavy wooden pestle to get white rice – a backbreaking job. For breakfast we normally ate boiled rice, meat, fish and vegetable curries, and fresh seasonal fruits with rice-wine. We offered the choicest bits of food to God and our ancestors at the family shrine.

My father usually switched on the radio to announce that he had woken up. This was also a signal for us to boil the water for his tea and rice-wine, for he rarely ate breakfast. He liked his tea very strong and his rice-wine very dry. My mother could predict his mood from the volume at which the radio was played. All my younger brothers and sisters would then wake up with their cries for breast milk and, later, rice-wine. Sometimes there were fights for possession of the rice-wine pot. Eventually this was solved when more pots were supplied.

It was many years before I began to understand the significance of the radio in my father's life. He was a believer in the Burmese regime – the Burma Socialist Programme Party of the ruler, General U Ne

Win. He listened to the state radio with intense concentration as though he was looking for a revelation from above, something that would confirm his faith. When he finally lost that faith, then it was that he switched to the BBC.

My mother couldn't speak my father's language, Padaung, when she married him, only Karen. I myself ended up speaking Burmese, which is neither my father's nor my mother's tongue. Curiously enough, I started to speak Padaung about the same time as my mother. I felt special because I could speak one language more than my cousins. I used to see people in a different light depending on which language I spoke to them in.

As soon as the sun was up, the whole family basked in the sunlight to absorb heat and energy like a flock of swallows on a branch, and discussed the ensuing day's business.

CHAPTER 1

The Goddess of Creation

'Beautiful goddess of creation, help me find the source of spring.'
MY GRANDMOTHER'S MANTRA BEFORE
STARTING HER STORIES

Genesis According to my Grandmothers

'My ancestors told me it was after the beginning,' said my grandmother, Mu Tha, adjusting her head on the log she was using as a pillow. Her brass neck-rings gleamed in the candlelight. The rings were fourteen inches high and rose to her head as though they were supporting a pagoda stupa. Hanging from her ears and neck were several silver chains holding coins and charms. The holes in her earlobes were big enough to put a bottle cork in. We sat at her feet massaging her legs and shoulders as we listened to the story.

'The male and female winds were blowing through space, but the female wind was pregnant and could not keep up with the male. The male wind circled her until she gave birth to a golden egg, from which emerged the goddess of creation with her children. Sitting on the empty shell of the egg, the goddess watched the faraway stars coming into existence. They appeared in the deep blue-black sky like tiny but brilliantly luminous red, white and yellow flowers, their petals falling to the ground in a gale, filling the firmament.

'The goddess ordered the clouds to produce another world. They formed a sphere which turned into the earth. She created a monkey and ordered it down to the earth to test whether it was solid. The creature descended to earth but was too cowardly to tread on it. Returning to the goddess he lied, and said that he had tested the earth

7

and that it was firm enough for her children to live on. She cursed him and decreed that monkeys would never sleep on the ground – and to this day they never do.

'The goddess then created a warbler, and gave it the same orders. The warbler descended and hopped on every quarter of the earth to test its strength. It returned to the goddess and reported that the surface was indeed strong enough to support her children. The warbler was rewarded with a six-month sojourn in heaven every year. That is why we see warblers only six months in each year.

'After many years living on lower earth, human beings became discontented. They wanted to enter middle earth. A huge boulder which they could neither move nor destroy separated middle from lower earth. The goddess piled charcoals that burned with a heavenly intensity around the boulder, causing it to disintegrate. Horses and elephants came to help men clear away the resulting debris, and as they laboured in their task, they broke their horns. The elephants transferred their broken horns to each side of their mouths, creating tusks. The horses grafted theirs onto a tree, where they became mangoes. So the horses lost their horns for ever.

'So human beings and animals got to middle earth together and in amity. But the humans, overcome with hubris, began to forget the language of the animals who had been their helpers and killed them for food. The humans then forgot even their own common language, so they split into disparate peoples and were scattered throughout the world.

'That is how human beings lost paradise and were condemned to be wanderers over the face of the earth.'

All the time she was speaking, Grandma chewed betel nuts, and at every opportune pause in the story she spat out an old nut and began chewing a new one. Our grandmothers, Mu Wye, Mu Kya, Mu Tha and Mu Shant, were oracles and educators of our family in the traditions and way of life of the tribe. (We thought of them all as 'grandmothers' according to our traditions. Mu Wye was the wife of my paternal grandfather, La Pen, head of the tribe – or of our clan, which was the largest of the Padaung clans. Mu Kya was married to 'grandpa' Nauk, La Pen's brother; Mu Tha was Mu Wye's sister; and Mu Shant was Mu Wye's cousin. They all had the status of grandmothers.) To us children they were by far the most powerful goddesses of the clan. Even their husbands consented to their absolute rule in domestic

affairs. Mu Kya and Mu Tha had worn the neck-rings most of their lives, but gave them up in old age. They looked to us like mythical creatures, half-human and half-bird – and yet it never occurred to us that the Padaung were different from other people. That we were descended from a 'zawgyi' – a male creature, half human and half angel – and a beautiful female dragon did not seem odd, merely a source of pride. Our supernatural origins were also revealed in the klong, or 'drums of desire' (which we also called 'frog-drums') that were beaten on solemn and auspicious occasions. These had been bequeathed to the tribe by a supernatural being, called 'Big Ball' from his most obvious feature. He was a mischievous creature who delighted in destroying our trees. One of our farmers captured him by seizing him by the testicle with a pair of bamboo tongs. He obtained his release by promising to leave our trees alone in future, and endowing the Padaung and our cousin tribes with the drums of desire. These became the most precious of all our possessions.

Nor did it seem strange that the myths of creation our grandmothers taught us hardly coincided with the doctrines of the other institution that governed our lives – the Catholic Church. For we were indeed Catholics. Italian missionary priests had given us an alphabet only in the twentieth century, and our spiritual and secular education was in their hands. Perhaps Grandma Mu Tha's story of the creation had elements of Noah and the Tower of Babel – but we never bothered ourselves to wonder whether our ancient traditions of the Padaung and the teachings of the Church exactly matched.

Our other cousins are the Pa-O, the Kayah who are the majority in the Karenni State, the Geba, the Karen and the Lahta or short-necked Padaung. To a child, living amongst them all was like being in a garden full of highly coloured and sharply differentiated blooms. I wanted to know whether we all had common ancestors, what they did and where they came from. Some of these questions were answered by my grandmothers – as long, that is, as we entered into the mythic world of the stories they told over ten years in the evenings after dinner.

And why should we not enter it? It was a world in which our own tribe was important, and our group of related peoples also important. It explained and justified our way of life. It was very different from another sort of history in which we were marginalised, eccentric and even an embarrassment – a history which contained plenty of mythology of its own.

Burma: A Very Short History

Phekhon was my birthplace. It was situated between the Shan and Karenni (Kayah) States on the south-east of the Socialist Republic of the Union of Burma. The nearest town was Loikaw, about twenty-five miles away. The capital of Shan State is Taunggyi, some 150 miles distant. Strictly speaking, Phekhon was neither town nor village. It was more like a large settlement, with a population of around thirty thousand. The Italian parish priest, Padre Lesioni, baptised me 'Pasquale' because I was born around Easter, and my parents believed that in the spirit of Easter I would overcome life's difficulties. (Padre Lesioni had no hesitation in proposing Italian names for the infants he baptised: my sisters were Pia, Piarina, Sophia, Patricia, Remonda and Paula.)

I was the first child, and the portents surrounding my birth in 1967 suggested I was fortunate. 'It was the year when the harvest was very good and the animals were very fat,' said my grandma. As soon as I could understand, they taught me that I was a Catholic, that my tribe was Kayan (Padaung) – known for what outsiders call our 'giraffe women' because of their necks artificially elongated by rings – and that we were a sub-tribe of the Karenni (red-Karen). Our spiritual leader is the Pope, who lives somewhere far away called Rome. Karenni (Kayah) is our state. Burma is our country. We live in Shan State and we are Burmese, but not Burmans. The Burmans are the majority, ruling people of Burma and we were one of the smallest of the minority tribes and peoples. This was in the late sixties, when Burma had not long entered the era of military socialism.

Burma lies on the edge of the peninsula known as mainland South-East Asia – what used to be called Indo-China – and is bordered by India, Bangladesh, China, Laos, Thailand and the Indian Ocean. It is the size of England and France combined, or of Texas. The country is divided into seven states and seven divisions. In each of the states one or more of the ethnic minorities of Burma predominates – such as the Shan, the Kachin, the Karen or the Karenni. The area of Burma where the Burmans predominate is divided into seven divisions – e.g. Rangoon Division, Pegu Division, Mandalay Division. The main rivers, Irrawaddy, Chindwin, Sittaung and Salween, flow from the highlands of Asia to their deltas, supplying water and means of transportation. The northern tip of the country enjoys an alpine climate, while the

central flatlands are semi-arid most of the year. The borders are mountainous and have, historically, provided natural barriers against invaders – although over the centuries the Irrawaddy valley was invaded four times overland from present-day Yunan in China. There are three seasons in Burma: hot, from mid-February to May; rainy, from June to late September; and cold, from October to January. The climate is determined by the monsoon rains, which blow from land to sea for half the year, and then change their direction and blow from sea to land.

Since Burma is essentially the valley of a river system shut off from the outer world by mountains and sea, one would expect it to be the home of a unified people. However, this is not the case. There are at least ten major ethnic groups and a hundred sub-tribes, with Burmans making up nearly two-thirds of the population. Others include the Shan (the largest minority), Karen, Karenni, Mon, Arakhan, Kachin and Chin, who live mostly in the hills that encircle Central Burma. Chinese and Indians are also numerous, and are mostly concentrated in the big cities. Burmese is the official language, but non-Burmans speak their own tongue as their first language. English is spoken mainly by people with higher education. The chief religion is Tharavada Buddhism, which is practised by about 90 per cent of Burmans, Mons and Shans. Many of the Chin, Kachin, Karenni, Karen and a number of other minority peoples are Christians. Traces of animist belief persist in the religion of all these people. Burmese Buddhism makes place for the pre-Buddhist *Nats* (*Nas* in Padaung), or nature spirits, thirty-seven of whom are in a sort of official pantheon. Hinduism and Islam also have followers, mainly in cities and in the Arakhan State, which touches Bangladesh to the West. Burma is richly blessed with natural resources, including rubies, jade, fertile soil, virgin hardwood forests – especially teak – fish and a great variety of wildlife. The total population of Burma is forty-eight million.

Historically, the goal of Burma as a unified nation has remained elusive. There was a period of around two hundred years, up to about 1300, during which the Shan dominated the country, but they fell under Burmese suzerainty in the mid-sixteenth century. Burman kings, Anawrahta, Bayintnaung and Alaungpaya – the founder of the last Burmese dynasty in the mid-eighteenth century – established unified kingdoms with different capitals. The capitals have included Ava, Amarapura,

Mandalay and Rangoon, the present capital. The most illustrious kingdom, famous for art and architecture, was that of Pagan (1044–1325). But all these kingdoms collapsed eventually in rebellions, civil strife and general mismanagement as successive dynasties lost their original vigour. At times China achieved ascendancy over Burma – for instance, during the reign of Kubla Khan, who invaded Burma in the 1270s – and even demanded tribute from native kings. But for nearly all its history until the nineteenth century Burma retained its independence.

The Portuguese established trading posts in Burma in the sixteenth century. From the beginning of the seventeenth century both the Dutch and English East India Companies had representatives in Burma. It was in the latter part of the eighteenth century and the early nineteenth that Western influence began to grow, until eventually the country became absorbed within the British Empire. The British interest in Burma arose from the worldwide conflict between England and France at the end of the eighteenth century. The British developed anxieties about French designs on Upper Burma from their position in Indo-China, which they feared might affect British power in India, especially in Assam and East Bengal. In the reign of Bodwpaya (1782–1819) the Burmese themselves actually provoked British power. Members of Bodwpaya's court had talked wildly of annexing China and India. In 1818 Bodwpaya's viceroy in Pegu had addressed a letter to the Governor-General of India laying claim on the king's behalf to 'Ramoo, Chittagong, Moorshedabad and Dacca' as territories that originally belonged to Arakhan and were hence rightfully Burmese. Under the next king, Burmese armies actually crossed the border into British India. They posed no conceivable threat, but they gave the British an excuse they had long needed. In 1824 the British occupied Rangoon and the whole of Lower Burma.

The penultimate king of the Alaungpaya (Konbaung) dynasty, Mindon, established a new capital at Mandalay and attempted to co-exist with British power. He rejected advances from the French, including an offer of a military alliance, and hoped that one day Lower Burma might be returned to him. When he died without an obvious heir in 1878, one of his queens intrigued to raise to the throne one Thibaw, an insignificant son of the king's who had spent most of his life in a Buddhist monastery. She and her supporters hoped to rule the country with Thibaw as a puppet. However, Thibaw's queen, Supayalat, soon

became dominant, and the pair pursued a more dangerously national-ist, and hence anti-British, policy than Mindon had allowed.

Thibaw suffered a great propaganda defeat in his very rise to the throne. It had been an immemorial tradition when a new king suc-ceeded for there to be a 'purging of the realm according to custom' – i.e. a massacre of the previous ruler's kinsmen. Since Thibaw was distant from the throne, he had to kill eighty-three members of the royal family. The killings were spread over two days and were carried out by members of the Royal Guard. As was customary, the princesses were strangled while the princes were sewn into red velvet sacks and gently beaten to death with paddles – it being taboo to shed royal blood. Unfortunately for Thibaw, this took place in an age when worldwide communications brought such goings-on to international attention. The details – including the fact that the mass of corpses buried in a palace courtyard created a gas which caused the soil to erupt, so that it had to be trodden down by elephants – were all reported in the West, especially in England, where they excited very unfavourable comment. Eventually the British, claiming to fear secret negotiations between Thibaw and the French, annexed Upper Burma in 1885, sent Thibaw and his queen into exile, and abolished the kingdom. From then on until shortly before independence, Burma was ruled as a part of the Indian Raj.

The British occupation of Burma, swift as it had been, later met with resistance. There were numerous uprisings in the early years, and many executions. In those years the British had to maintain in Burma army and police forces proportionately much greater than those they needed to control India. Whereas Indian nationalism was a late devel-opment in British rule, the Burmese as a whole never accepted the conquest, and a nationalist spirit existed throughout the whole of the British period. The exception was the minority peoples, many of whom were enthusiastically pro-British, for they regarded the British as pro-tectors from their ancient Burman enemies.

But the last years of the nineteenth and the first decades of the twentieth century were undeniably a period of peace and prosperity in Burma. The British transformed the country's infrastructure with railways, state and mission schools, and the development of agriculture, especially in the Irawaddy delta. Burma became the greatest exporter of rice in the world. A major complaint amongst farmers, however, was that they were increasingly in the hands of *Chettias*, or Indian

money-lenders. Rangoon was a major world port, a prosperous and fairly cosmopolitan – in fact, substantially Indian – city. English law was introduced, and law and medicine became the most popular professions in Burma.

Nationalism resurfaced, led by lawyers and then by students. In 1920 there was a university strike in Rangoon immediately after the university first opened. From then on, students were always foremost in the struggle for Burmese independence. The British had made some progress in establishing representative institutions – and there was already a free and very lively press – when the war with Japan broke out in 1942. Not long before, there had been another university strike, led by a clique of students who called themselves 'Thakins' ('Masters' – a word the British used to describe themselves in Burma). A group of Thakins – the 'Thirty Comrades' – had made secret contact with the Japanese, and eventually made their way to Japan. They included Maung Nu, who eventually (as U Nu) became the first and last democratically elected prime minister of independent Burma, and Ko Aung San, now universally regarded as the hero of Burmese independence. One of the less prominent Thakins was Boh Ne Win, who had left college in Rangoon without a degree and who worked as a clerk in a suburban post office.

When the Japanese invaded Burma in 1942, the British forces, overstretched in the world war, soon retreated to India. The Japanese brought with them the Thirty Comrades, who organised a 'Burma Independence Army' which, under Japanese rule, became the 'Burmese Defence Army' under the nominal control of Aung San. It soon became clear that the Japanese promise that Burma would be independent was an illusion. Japanese atrocities against the Burmese – and against the non-Burman population, many of whom fought on the side of the British – soon changed popular sentiment. Late in the war, Aung San changed sides and joined the fight against the Japanese. In 1947 he became prime minister of a Burma that was promised independence in 1948. But in July 1947 a political rival organised the assassination of Aung San and most of his ministers as they sat at a cabinet meeting in Rangoon. Aung San was succeeded by U Nu, who won elections, usually with massive majorities, until 1962.

The independence constitution of Burma stipulated that after ten years the minority states that existed at the time of independence – the Shan and Karenni States – would have the legal right to secede

from the Union of Burma. (States that were created at or after independence – the Kachin, Karen, Mon, Chin and Arakan States – did not have that right. But many of them – especially those which had not been ruled directly from Rangoon during the British period – desired autonomy, if not full independence.) From the beginning of independence, Burma was plagued by ethnic insurgencies and a powerful, Chinese-backed, Communist rebellion. There were periods early on when the writ of the government scarcely ran beyond Rangoon. In 1958 political and ethnic conflicts persuaded U Nu to hand power temporarily to a 'caretaker government' headed by the commander of the army, General U Ne Win. Ne Win handed power back to the civilians in 1960, after U Nu had won another election with a huge majority.

U Nu set himself to negotiate with the ethnic leaders, offering a large amount of autonomy, hoping to persuade them not to exercise their right of secession. In February 1962 Ne Win, claiming that the unity of the country was in danger, seized power in an almost bloodless coup. In July of that year soldiers massacred hundreds of students who were protesting against the new regime on the campus of Rangoon University, and later dynamited the student union building. The soldiers were commanded by one Sein Lwin. Over the next few years Ne Win overthrew the parliamentary system and established a military government, gradually concentrating all power in his own hands.

U Nu had always claimed to be a 'socialist nationalist'. Ne Win banned all political parties and set up a one-party system called 'The Burma Socialist Programme Party'. Independent newspapers were shut down and student organisations outlawed. Peasants were compelled to sell their produce to the state at government-controlled prices. All private industry was nationalised; even shops, hotels and restaurants were largely owned by the state. Ne Win closed Burma to the outside world, and for many years foreigners were refused permission to visit the country as tourists. The boards of nationalised companies were dominated by retired army officers, and the army became a super-privileged ruling caste. The economy gradually disintegrated, and by 1988 Burma was one of the ten poorest countries in the world.

General Ne Win's proclaimed policy was to combine socialism with nationalism and Buddhism. The moral ideal was to end 'the exploitation of man by man'. It was a sort of voodoo socialism, composed of little more than slogans. In fact the Burmese army – or at least its

higher officers – had embarked on a campaign of national plunder. They made money from the jade mines and from opium. They could buy imported whisky and cigarettes at ridiculously low prices, and were provided with cars and houses beyond the dreams of the vast majority of Burmese. It has been calculated that nearly half the national budget went on maintaining the armed forces.

Ne Win regarded himself as the Father of the Country, and made no distinction between his own and the national wealth. Stories abound of his export of vast sums of money and of gems to his various overseas bank accounts. He considered himself the inheritor of the old Burmese kings, and one of his wives was actually a member of the former royal family. He oversaw even the smallest details of national life, decreeing, for instance, that the Burmese ought to wear national dress (trousers were supposed to be confined to members of the armed forces, the *Tatmadaw*). If spelling mistakes occurred in newspapers, the editors were fined.

Ne Win's regime was marked by hostility to educated people. He seems to have been especially jealous of U Thant, Secretary General of the United Nations and the most famous Burmese since Aung San. When U Thant died abroad in 1974 and his body was brought back to Rangoon for burial, the Ne Win government decided that it should be interred in an obscure graveyard, with no public ceremony. The students of Rangoon University, determined to accord U Thant the honour he deserved, seized the coffin and held a splendid Buddhist funeral on the university campus, finally burying him at the site of the old student union building that had been blown up in 1962. Soldiers of the *Tatmadaw* and the *Lon Htein* (a heavily armed paramilitary police force) stormed the campus, killing several hundred students. Schools and universities were closed throughout the country and martial law was declared.

The government regained control and kept it through the army, the *Lon Htein* and 'MI', or military intelligence, its chief secret police force. The regime intensified its drive against the ethnic insurgents. In the late eighties foreigners began to be allowed in for short visits, although those large parts of the country still affected by the insurgencies – including my own home town – remained closed to them. But by that time Burma seemed under control, quiescent and thoroughly cowed.

* * *

16

Burma proper, its history and politics, had not yet intruded into my tribal world, where our own legends preoccupied me. Each time I listened to my grandmothers' stories I could almost hear the voices of the ancestors and feel their presence. To the Padaung, truth and myth are not the same thing, but nor are the myths simply stories. The myths do not just remind us of the ancestors, or teach us about them – they make our lives and those of our ancestors contemporaneous. Through our daily activities and ceremonies, and in the telling of these stories, our past is alive to us and we can talk to those who went before. Yet I was between two worlds – the beginnings of my Western, or at any rate Christian, education by the priests, and the mythical history of the Padaung. So I also felt like an exile, or a traveller lost between two unfamiliar shores. As they told the stories, my grandmas were not as I knew them day to day. They had disappeared – there was no trace of complicity between their daily selves and their selves as story-tellers. They may even have made up some of the stories, or parts of them – but in being told in this way the stories entered the world of our myths. The grandmothers' words, their pauses to spit, their meanderings as the narrative developed, their hums and ululatings, frightened me. They were talking about things that had a deeper meaning for all of us than the grandmas could fully understand. So the grandmas were like vessels through which the traditions passed. This was in the shamanistic traditions of our people.

Another world had begun to fascinate me even before I was properly equipped to enter it – the world of books. I saw it as a forbidden land. I was especially drawn to books which – surprisingly often – had a warning note on their covers: 'Not to be read by those under the age of 16.' One of these had the title *Democracy*. I had no idea what that was, but the fact that it was in some way dangerous or forbidden naturally attracted me.

I was brought up not only among my ancestors, but among ghosts and fairies as well. Ours is a ghost and spirit culture, and for us the presence of ghosts is as natural as reincarnation is to the Buddhists. In childhood I was always trying to interpret signs which were at once familiar through their repetition, and barely intelligible. I felt that the grandmas' stories meant more than they said, and tried to get reality out of the mouths of the grandmas and from the many faces of books. The two worlds were always intertwined. Words, indeed, became flesh. Ghosts and spirits of the past were introduced into our daily lives with

prayers and mantras, and they lived and ate with us like members of our families. We knew they were there; we felt their presence, we heard their voices in ourselves and in the forests and farms around us. We neither exaggerated their presence nor underestimated their potential. We took their existence for granted. Someone who saw a ghost would not expect to shock anyone whom he told of his experience – it would be a plain matter of fact. They were part of us, and we part of them.

When I asked my grandmothers why they wore rings on their necks, they gave me different answers – a mixture of pure myth and mythical history. One reason they gave was that they wanted to keep alive the memory of our Dragon Mother. Another was that in the 'dark' days of anarchy before the British came, foreign tribes, including the Burmans, used to raid the villages and carry off our women. To preserve the identity of the tribe, our women ancestors wore rings around their necks so that they could be identified whenever they were reunited with their tribe. Another reason was even more inventive – to protect themselves from the attacks of wild animals such as tigers, which tended to seize the necks of their victims.

As far as I could tell, the wearing of neck-rings dated back many hundreds of years. The rings are of one long coil made from an alloy of silver, brass and gold. Only girls born on auspicious days of the week and while the moon is waxing are entitled to wear them. These girls start wearing rings from the age of five, when the neck is circled only a few times. As they get older more rings are added. The rings are changed when they marry, and longer coils are added – one above and one below the main coil. Outside observers claim that the necks of the women are not genuinely elongated – rather the rings depress the shoulders and give the impression that the neck has been enormously lengthened. But our women were proud of their necks. They also wore rings around their calves and silver bangles on their wrists.

Our grandmothers would allow us to touch their 'armour' when we were ill. One should touch them only to draw on their magic – to cure illness, to bless a journey. They were portable family shrines. This was a practice older than Buddhism, but which was absorbed into the later religion. The women also tucked money into the rings. For us children they were like walking Christmas trees, full of family treasures and miraculous powers. They wore white tunics and black skirts with red linings, and wrapped their heads in pink sashes. They wove their

own blankets, clothes, skirts, towels and the like on a traditional loom. My mother, though, was influenced by modern ways and sewed our clothes on a Singer sewing machine. I was always delighted when my grandmas gave me traditional tunics and trousers on special occasions. When I was older I also wore Burmese dress, including *longyis*, or sarongs. But, proud of our own traditions and resentful of Burman domination, we deemed Burmese dress 'impractical'.

Grandma Mu Kya's neck was fourteen inches long. It took her a couple of days before she could support her head after she decided to take off her rings for good. Special shirts with very tall collars had to be made for her. We used to tease – and flatter – her by saying that Elvis Presley had obviously copied her style. I have a vivid memory of her as she came to visit our house, when the first thing we saw was her long neck and head floating above the hedges, for all the world like a walking wild goose.

The Goddess of Creation
as I saw her
in my childhood dreams

She is dancing; she is creating; by dancing she is in control like a goddess.

Grandfather's Domain

Some weeks after my birth, my father applied powdered spider to my fontanelle to make me intelligent and industrious (my Padaung name, Thwe, means 'spider', and implies intelligence), and my grandmother chanted magic words over my head to ward off evil. When I was older I asked her what exactly she did to me. 'I spat on your head three times and uttered magic words to preserve you from evil spirits, evil people and from all misfortune.' The relatives came to give me their blessings, which involved tying cotton threads on my wrists. A gold wedding ring studded with a ruby was hung around my neck with a cotton string to keep me healthy, and tiny round metal bells were tied to my ankles, both to ward off evil spirits and to help the family keep track of my movements. When I was able to sit up my parents rubbed my feet with a large dried mushroom to make me walk early. The tinkling of the bells inspired me to energetic movements – too energetic for my parents, for I could never stay still and in one place.

I hated to be left alone in the house while my parents were working. Sometimes they tied me to a post with a long string to watch over the rice grains that were drying in the sun on a bamboo mat in front of the house. I loved the rich fragrance of fresh rice grains, and would crawl up piles of rice in order to roll down from the top. I didn't cry as long as I could see or hear my mother, except when I was hungry. I was used as a scarecrow. At first the birds and fowls were nervous of foraging the grains in my presence, but soon they sensed that I was harmless and would swarm to the mat and eat the rice. I was thrilled – but my mother was not.

I began to explore the compound of the house and further afield. A great variety of trees grew around our house – jack-fruits, cotton trees, flames-of-the-forest, paw paws, oranges, Asian pears, peaches,

pomegranates. Vegetables – chillies, lettuce, pumpkins, mustards, red and white maize – and herbs such as turmeric, basil, lemongrass, onions and garlic, and shrubs of jasmine bordered the house and invaded the hedges. On a hot breezy day it was like swimming in a sea of herbs. I liked to stand on the bases of trees and gaze up at their amazing branches and the blue sky beyond. I had an urgent desire to get among and touch the beautiful flowers, fruits, leaves, birds and animals that thronged the trees. The branches were to me like amazing and welcoming human arms, or rooms and corridors. Each tree was uniquely exciting, and I passionately wanted to climb and explore them. My mother tried to discourage me, telling me that I could climb them when I grew up, but I couldn't wait. She warned me of snakes, ants and spiders in the trees, but I was not convinced. She told me that they could hurt or even kill me, but my curiosity was insatiable.

I began being given rice-wine at the age of one, to wean me off breast milk. In my drunken sleep I always had sweet, slow dreams of swimming. My mother chewed cooked rice and mouth-fed me. 'Drink a lot of rice-wine and be strong like a teak, and fiery as a dragon,' was the constant advice of my grandmothers before they gave me a drink. I drank until I fell asleep, and when I woke I cried to drink again. My mother was not sure that so much rice-wine was good for me at so tender an age.

It was years before I understood some of the jokes my birth had inspired among my relatives. Why, I wondered, did my father's friends say, 'Mr Louis has overfulfilled his quota – he is a Model Worker.' These were apparently jokes against socialism, but I did not know what that meant. 'Ha! Ha!' said Grandpa Loi. 'Work hard in the farms, work hard in the factories, and the socialist revolution will win. But you have to work hard in bed to *defeat* socialism!'

'Hush! Don't say that in front of the boy,' said my father.

But Grandpa Loi was not to be silenced. 'What does it matter? One day he will learn about it. I have produced seven and I am still producing. So you really will have to overfulfil your quota to catch up with me.'

I knew there was something serious under this badinage, and also something that made them nervous – whether the sexual or the political innuendo, I am still not sure. Grandpa Loi was one of our Buddhist cousins on my grandmother's side. His eldest daughter was married to Uncle Yew, the oldest son of Grandpa Nauk. I was closer to my

grandparents, uncles and aunts than to my father. All my grandparents chewed betel nuts, and their lips and teeth were stained deep red. So when they shouted, even in jest, they presented to me a fearsome spectacle.

My first solid meal was roast chicken with rice. My mother picked the bones for me. We all shared our dinner on one big round bamboo plate, coated in shiny black lacquer, that my father had woven himself. Portions of rice were piled along the rim of the plate, with curry dishes in the middle. We ate with our fingers, while with our spare hand we drank soup using a wooden spoon. My father always kept especially choice dishes for himself – even my mother never touched them. We children certainly had to avoid the part of the plate where they lay enticingly. 'You will be allowed to eat them when you grow up,' my parents told me. I was filled with impatience, and tried the forbidden dishes. They turned out to be baby wasps, baby beetles, offal and other exotic delicacies. My father simply did not like ordinary meat. We ate bear, deer, wild boar, tortoise, ant-eater, snake and bat, but not unusual animals like elephants or tigers. In general I ate and drank insatiably. I thought life was about eating, drinking, playing and sleeping in this best of all possible worlds.

I became a little closer to my father by the age of three. He would let me sleep by his side, and used to squeeze me between his legs to keep me warm. I felt cosy and secure on stormy nights listening to the rain and the wind. I was especially frightened of thunder and lightning, and of the fruit and branches of the mango tree as they thudded onto the corrugated iron roof during the storms. As I grew older, I preferred to sleep on the floor on a traditional straw mattress with a bamboo frame, for I was always falling out of the big bed in which the family slept.

The family bedroom was filled with the odours of urine, mothballs and rice-wine that accumulated during the night. Even mosquitoes seemed to avoid the room. My mother had to wash all the dirty nappies every morning, and the windows had to be opened the whole day to get rid of the smells.

When I was a little older, I was told what lands belonged to our family, and how many animals we owned. That was how we measured our substance, rather than in terms of money, of which we had little. I gradually became aware that my grandfather had been a '*Hane*', a chief. He used to rule the Phekhon area – about twenty-four by thirty

miles, with a population of thirty thousand – until all the traditional rulers were abolished by the Ne Win regime. Not only did the government abrogate his chiefly authority, they also nationalised much of his land, and what was left was then mostly submerged under the waters of a new dam. Yet I felt I had the freedom to roam over most of his old lands that had not been submerged, to play there and pick the fruits. I felt protected as the grandson of a *Hane*, and I soon realised that most of the population still regarded him as their chief whatever the government might say.

But with my father it was plain that the chieftancy had come to an end. No one saw him – and he did not see himself – as inheriting the old order. He was a vet. Since I had been brought up to regard animals as virtually part of the household, I could never understand why he treated only animals, and drew the line at ministering to people. Quite a lot of his income was payment in kind, with people giving him animals as presents. He would hand them on to me to look after, and I was delighted to count them as they multiplied day by day. 'Look after them well,' he would tell me. 'One day you will have to look after your people.' I picked up the idea that even if my father himself was not cut out to be a *Hane*, and although the office had been abolished, he nourished the secret hope that I would somehow one day occupy the position of my grandfather. I wondered when that wonderful 'one day' might be, and lived with the hope of its arrival.

My awe was reserved for my grandfather, La Pen. If my grandmas were jointly the oracles and educators of the tribe, he was the quiet god who was not to be trifled with. We seemed to feel his presence before we heard or saw him. He was about five feet ten inches tall – a very good height for a Padaung – with a brown, beardless face (like our Mongolian and Tibetan relatives we are not hirsute). He always wore a black-and-white-striped turban, a pair of baggy trousers, a *hwanseng* – a shirt without lapels, rather like an Indian jacket – and a black Burmese tunic. Although he was a benevolent presence, I felt his power also as something feral, even tiger-like, as he prowled quietly around his domain. He never raised his voice to any member of the family, but when he spoke everyone listened. No one was allowed to sleep on his bed – which made a strong impression on us children, accustomed as we were to sleeping from time to time with all our other grandparents. He never entered his bedroom through the main doors, but instead would climb in at one of the windows along the

corridor. When Grandma told us her stories, he would be lying quietly on his bed in the dark, listening. Occasionally, as she developed the myths about the creation of our tribe, or the Great Flood, he might add authoritatively: 'Yes, it was like that.' He didn't much like the light, and especially he hated electric light when finally it arrived in our township.

La Pen was born in one of the oldest Padaung villages towards the end of the nineteenth century, son of the village chief. He showed signs of independence from an early age: 'I thought, I want to rule my own village,' he told us. Sure enough, as soon as he was fifteen – well in advance of the usual age for leaving home, which was eighteen – he left his own village and his father's jurisdiction, and went east to a small village called Phekhon. There he established his own fiefdom. The Padaung tradition is that someone from a chiefly family may turn up in a village, and if he proves popular and gives the impression of strength and practical intelligence, people will start gathering around him for protection and advice. This happened with my grandfather, even though he was only fifteen. He started with two or three households made up of his relatives. As his prestige grew, the local villagers would make him presents of cattle, with which he purchased about a hundred acres of land. His brother, Grandpa Nauk, joined him later on, and his domain grew steadily. He attracted not only Padaung as subjects, but Shan, Pa-O and Intha as well. At that time the British were extending their rule towards the remoter parts of Burma from Rangoon. They let my grandfather be, so long as his men did not engage in any hostile acts against them and he paid his homage and taxes. He came to regard the British as his friends, and as excellent people to trade with.

The fissiparous tendency demonstrated by my grandfather existed not only among the Padaung but in several of the neighbouring tribes. It was the same tradition that split the Karenni State in half shortly before the arrival of the British. The ruler of the Karenni had formed a high impression of the abilities of a Mon he had got to know, decided he would make an excellent ruler, and handed over the eastern part of the Karenni State to him.

Although my grandfather had to establish his rule and prestige through his personal qualities rather than by a divine right of inheritance, his subjects nevertheless regarded him as a sort of minor god. Accordingly they would from time to time present him with chickens

in ceremonial woven baskets, which were raspberry-shaped, and once a year they came to perform their kowtows.

At the age of eighteen, Grandfather met a girl called Mu Wye and married her. She came from the village of Khwa-ee, about ten miles from Phekhon. She told us that they met on a market day. She was a great beauty, sixteen years old, proud and independent. So two powerful personalities came together. Her sister Mu Tha and her husband came to live with them.

My tribe were mostly animists, although some were Buddhists, who worshipped the *Nats*. These nature spirits are not peculiar to the Burmans, who had received them into Burmese Buddhism, but are part of popular religion in most of South-East Asia. We worshipped the ancestors as well, and practised the shamanism that in one form or other is to be found all over east and central Asia, from Japan through Korea to Tibet and Mongolia. But my grandfather, and later his wife, were converted to Catholicism.

It was an unusual conversion, brought about involuntarily by an Italian missionary, Padre Carlo, who was on his way to China. He had no intention of winning Phekhon for the Church, and was simply passing through. My grandfather was out on a hunting trip, and came upon this strange being, who he decided was either a wild beast or a *khimakha* (an ogre in the style of the Tibetan yeti, that looks like a cross between a bear and an ape and is as tall as a tree). So he captured him and brought him home. Padre Carlo was chained in a pigsty for the night, where his wailings and lamentations could be heard throughout the village. He made signs that he wished to eat, and accepted some cooked rice. This made the villagers suspect that he might, after all, be a human being, and that therefore he had rights, including traditional hospitality. (Some doubts about his humanity lingered, due to the fact that he had no toes. The Padaung had never before seen shoes.) He was persuaded to stay in the village for the rest of his life, and in due course converted the whole village to Catholicism, except for my grandfather. He finally consented to join the new religion only after he lost a wrestling match with the priest, whom he had challenged about the power of his god. It was agreed that whoever lost would convert to the other's religion. The Christian God was obviously potent, because my grandfather was taller and more powerfully built than the priest, who was anyway suffering from malaria at the time.

Eventually Phekhon became a town – the only Catholic town in Burma. My grandfather and Padre Carlo grew to be firm friends, and together built the town's church. The priest fitted into our culture because he was a great believer in *Nats*. That, at any rate, was how the tribe interpreted his frequent contests with the devil, which he used to describe almost casually. The devil would pull him out of bed at night, or blow out his candle and pour ink over his papers as he wrote up his journal in the evening. None of this surprised us, for we saw the devil as behaving in the usual way of a malicious *Nat*. Padre Carlo's power certainly extended to the *Nats*, for he managed to confine one to a hole in the ground in a corner of the church compound, forcing it to become his genie. He sprinkled holy water on it from time to time to keep it under control. We also kept bottles of holy water, candles that had been blessed by the priest, and charcoals around our strips and paddy fields as a superior way of controlling the local spirits, and perhaps the devil himself as well. We sprinkled holy water around the house to keep out soldiers and policemen, although it was not always efficacious.

So Padre Carlo fitted in very well to our traditions and Padaung culture – except for one thing: he did not know what dreams were. He told us in all honesty that he never dreamed.

Life with the Parish Priest

Sometimes I spent nights in one of the boarding houses of the mission with the priest's adopted children. There were about 150 children, some of them orphans, in the mission and its boarding houses, ranging in age from five to twenty. The boys were looked after by the priests and their catechists, and the girls were under the care of the nuns in the convent. The parish priest and the mother superior of the convent were Italians – the other priests and nuns were Padaung. Everyone spoke both Padaung and Burmese. The nuns also looked after the priest, the children, the dispensary, the cattle and the faithful. In a word they ran the Catholic church. They did the shopping in the market, cooked, washed the clothes, drove the bullock carts, ploughed the fields, taught the children, cared for the sick. They lived and died in obscurity, and no one ever heard them complain in the way my mother complained.

The boys were supervised by 'monitors' who were known for their

severity. The heads and the bodies of the boys were usually infested with lice, and they shared their beds on long wooden platforms in a wooden house, which gave the lice a good opportunity to spread. Each boy was given two acrylic blankets neatly folded around a bundle of clothes, which was used as a pillow. The beds were infested with floor bugs, and the dormitories were overpowered with the smell of urine and soiled clothing because of a lack of soap. Yet these conditions – along with the monotonous food – were greatly enjoyed by the children, so superior were they to the harshness of daily life in their villages. They prayed, worked, studied and were punished regularly, and accepted the discipline (which eliminated bullying) as being for their own good.

The smallest children were afraid of the humid darkness and the sounds of the wild animals that ruled the nights. The church compound was also known to be haunted, as it was built on the 'harsh' land near the cemetery rejected by the natives. As a result, at night the children answered the calls of nature near the dormitories, rather than in the lavatories in the 'haunted' area. In the morning a regular ritual took place. The children were called upon to name the culprits, and if none did they all had to circle the faeces in a regular procession until someone owned up or pointed the finger.

There was a general feeling, shared by the children as well as by the priest, that a day in which no one was punished had somehow gone wrong. Someone might be punished for getting to his bed first after night prayers, or for being the last. Or the priest might prod his cane into the middle of the crowd and punish the one in the middle just for being in the middle. He had a collection of fine Italian leather belts on the walls of his rectory, and would invite the children who were to be punished to the room for some biscuits. When they got inside he would lock the door and ask them which belt they liked best. Then he would lash them with the belt of their choice. They would cry out with the pain, and the priest would give them their biscuits, tell them not to be naughty again, and let them go. It was a little ritual that seemed to satisfy everyone who took part in it. Indeed, the children loved him. He clothed them, fed them and taught them until his death. He never returned to Italy. He became accustomed to be a quasi-ruler, and so far had he gone in adopting our customs, taking on even a tinge of our animism, that he ended as a benign version of Mr Kurtz in Conrad's novel *Heart of Darkness*. Like the

ghosts of our ancestors he and the other Italian priests became, after death, part of our society, pleasantly haunting and guarding our village.

In 1936 another white man turned up in Phekhon, in the company of some Indians from Loikaw. He invited two of the grandmothers and some of their friends from the village who wore neck-rings, along with their husbands, to come to England. They had no idea what the purpose of the invitation was, and the Italian priest was vehemently against their going away. Nevertheless, they were all excited and eager for the journey. They were to be taken around Europe by a circus called Bertram Mills and exhibited as freaks. Since we did not have the concept of a 'freak', and since, anyway, we took our tradition of women wearing the rings for granted, they and their relatives were unlikely to be offended by the idea.

They were flown to Rangoon from Loikaw, and shipped to France to be shown to the French public as a test of their popularity before they eventually arrived in England. Not long before the Second World War broke out they returned to Phekhon, richer with English money. They showed us photographs of places they had visited, but could never remember the names. To them the whole of Europe was inhabited by the English. After all, they were the great power who ruled the Burmans who had so long wished to rule over us, and who ruled India – so why should not all Europe belong to them as well?

The grandmothers told me that one of the photographs was taken in front of the English chief's house, in a big village called London. They said that in this big village they didn't have to climb the stairs, but the stairs carried them up and down. They liked the moving stairs, because they hated walking in the shoes that had been provided for them – since all their lives they had gone barefoot.

They suffered from the cold of England. Nor did they understand what spirits the English were appeasing in always having to drink tea at a certain time, although they loved the cakes that went with this ceremony. 'The English are a very strange tribe,' said Grandma Mu Tha. 'They paid money just to look at us – they paid us for not working. They are very rich, but they cannot afford to drink rice-wine. Their trees are unable to grow leaves during the rainy season. They say "Hello," "How are you" and "Goodbye" all the time to one another. They never ask, "Have you eaten your meal?" or "When will you take your bath?" when they see you.' Grandma Mu Tha gave up trying to account for these strange habits, which afforded her great

amusement. If we had had the notion of 'freaks', I suppose she would have put the whole English race into that category.

When the Japanese Imperial Army invaded Burma in 1942 with the help of the Burmese nationalists, and welcomed by much of the Burman population, most of the hill peoples (with some exceptions, such as a section of the Shans) fought on the side of the British. The minority peoples had always regarded the British as their protectors, and the loyalty of the Padaung, the Karenni and Karens was intense. When the 'Chindits' of General Orde Wingate – essentially British guerrilla troops sent from India to harass the Japanese occupiers – began their operations, the Nagas, the Kachins and the Karens gave them invaluable help, acting as guides and fighting for them. My grandfather and his brothers and friends all fought alongside the British using home-made guns and other weapons, while our grandmothers and their families spent many months hiding in the jungles. They had to survive on the roots and vegetables of the jungle, which they used both for food and for medicines. During the concluding part of the war the Japanese tried to kill Padre Carlo, but the people hid him in the remotest depths of the jungle where no Japanese soldier dared enter. When the Japanese were finally defeated in Central Burma in 1945 they burnt the houses of Phekhon and tortured some of the villagers to death. But as their power waned the villagers got the upper hand, and chased them all the way to the Thai border, killing them in scores as they fled. To my grandfather, ever the hunter, this had all the pleasure of the chase – and the wounded animals that were to be hunted to the death were shown no mercy.

By the end of the war my grandfather had lost half his children to disease as they hid in the jungle. All my father's brothers perished. After the war they built a new house bigger than the one the Japanese had burnt, constructed of teak and corrugated iron. Grandma was certain that it was the Virgin Mary who had protected her, her sister-in-law Mu Kya and her family from the Japanese soldiers.

The crowning insult was yet to come. The post-war Japanese government decided to compensate Burma for the atrocities inflicted during the conflict. They built a dam at a place called Mobye, about ten miles south-east of Phekhon. This dam feeds water to the hydro-electric plant connected with the very Lawpita waterfall that occupied my childhood imagination and which supplies electricity to half of Burma. Phekhon was granted the status of a township – and got no electricity.

Almost all my grandfather's and the villagers' wetland paddy fields and forests were immersed under the waters of a lake fifteen miles long and seven miles wide (what he had left were wet paddy fields and cultivated strips which, along with some forest land, came to nearly a hundred acres). The regime hoped (so we believed), by flooding his lands, to diminish my grandfather's influence with his people, for he fed them with grains (rice, millet, maize) from his strips of land. The traditional hunting grounds and sources of food were destroyed. The sum of two hundred kyats (about $10) was given to each family in compensation. My grandfather's rage at this new collusion between those who had colluded during the war itself was titanic, and never left him: 'The Burmans and Japanese bring nothing to us but war and destruction. It would be in the interests of humanity if they were eliminated.' His hatred is, I fear, best expressed in the words of the King of Brobdingnag on mankind in *Gulliver's Travels*: 'the most pernicious race of little odious vermin that Nature ever suffered to crawl upon the surface of the earth'. As Plato expelled the poets from his Republic, so Grandpa drove socialists from his household.

My grandfather had no real belief in education, although he quite liked the fact that school got his family out of his way for long periods, leaving him to the solitary way of life he found most congenial. He suspected that the education insisted on by the state was merely a plot to enslave the tribes and take away from them their traditional way of life and culture. I think that for him, knowing the legends of the tribe and mastering our traditional skills was all a man or a woman needed in life. He himself could carry out the most essential tasks entirely on his own, and preferred to do so. For instance, he would quietly set to and build a bullock cart, or virtually anything else we needed about the house or farm.

Someone suggested to me many years later that the Padaung are essentially a bronze-age people, like the people described by Homer and the Greek tragic dramatists. I read in the *Odyssey* how Odysseus himself makes the bed-chamber for himself and his wife Penelope, setting the bed firmly into the trunk of the tree that forms the supporting pole of the house, and I realised that this was indeed close to the customs taken for granted by my grandfather.

I always saw my father as overshadowed by my grandfather. Unlike his father, he was not a born leader and did not aspire to be one. The contrast between the two went deep. Where my grandfather was open

and even arrogantly fearless in expressing his loathing for the regime, his son was vehemently opposed to any confrontation, and hated political argument. He convinced himself that obedience was the chief and safest civic virtue, seeming to take a satisfaction in obeying orders; he preserved his own self-respect by giving them and expecting to be obeyed unquestioningly. You could say that my father penetrated to the heart of Burmese socialism – that it was a system for procuring obedience and eliminating any questioning.

He had entered Rangoon University in the late 1950s to study veterinary medicine. In 1962, during his time as a student, the first military coup was mounted by Ne Win. My father witnessed his friends being arrested and killed *en masse* on the university campus. Ne Win's determination to repress those minority peoples who wished to exercise their right to independence gave impetus to the ethnic insurgencies. Some of my father's friends fled to the jungle and joined the Karenni rebels, who had been waging war for a separate state ever since Burmese independence. The new regime banned all political parties, closed down independent newspapers, and nationalised schools, factories and hospitals except leper colonies. (The reason for that exception was that leper hospitals were unprofitable, and it was only the missionary charities that were prepared to care for the lepers.)

When he qualified as a vet, my father was sent to a small town near the Chinese border for several years. Despite the blanket repression by the new regime, he welcomed the restoration of order and was determined to keep his faith in the Burma Socialist Programme Party. He believed that once order had finally been imposed, prosperity would return. In all this he showed a certain strength, or stubbornness, for he was setting himself against the ethos of our whole family, and especially against his own father.

My mother was of the Geba tribe, cousins of the Padaung, who live mostly near the ancient town of Taungoo, about a hundred miles west of Phekhon. Her father was a schoolmaster and her mother a nurse, which meant that she was seen by my father's family as suspiciously over-educated. My grandmother was not pleased with the bride my father had brought home: 'She doesn't know how to make rice-wine, and she is soft-hearted. I told you to marry a peasant girl who would know how to look after the farms and the house. But now you marry this educated girl who can't even pound chillies. Education will not put rice in your bowl.'

My mother's parents were much more polite, and said nothing about their son-in-law. In fact they regarded their cousins the Padaung as barbarians scarcely touched by civilisation. The Geba are an artistic and musical people, whereas the Padaung know only war, hunting and football.

My father's father paid ten silver coins, and several buffaloes and cows as dowry to my mother's parents (among the Padaung dowries are usually paid by the groom's family, not the bride's). My father could not carry his bride on his back to his home as her tradition required, for he was about five feet tall and weighed less than nine stone. She was about the same height but a stone heavier. He had to pay a fine to the elders of her tribe for his failure – which seemed a bit hard, considering that her home was a hundred miles from his, which would have taxed the strength of a Samson.

My father settled down in his parents' house to work as a vet and produce a better Burma. My mother settled down to her task – to produce babies. At first she suffered, caught between the silence of my grandfather and the scolding of my grandmother. But the ease and confidence with which in due course she produced her eleven babies established her unassailable prestige and silenced all criticism.

I was introduced by my parents to the Christian God at an early age. I liked the smell of the house of God. He was a heavily bearded man, yet He was clothed in a red sari, which was fascinatingly incongruous in so masculine a figure. He stood on top of the altar in a niche, bathed in a fragrance of lilies and incense. On His left was His father, Joseph, holding Him when He was small, and on His right His mother, Mary, in heaven in a blue dress. The family of God was a subject that fascinated and puzzled me. My parents told me that they lived in heaven, but at the same time were everywhere.

One day Padre Carlo's successor, the bearded Padre Lesioni, appeared and offered me some sweets. My mother ordered me to take the sweets and kiss the priest. I thought God himself had come down from the altar, and was terrified. Why could He not remain stiff and motionless in His niche, gleaming in mystery like the Lord Buddha? My mother lifted me up and put my face near that of the hairy God. I howled in terror. I preferred the hairless face of the Baby Jesus of Christmas to the bearded Crucified One of Good Friday. When I went to Mass I thought I was attending God's breakfast.

I was fascinated by a picture in our house that showed a boy being

led by his guardian angel safely across a rickety bridge, from which some planks were missing, over an abyss. I identified with the little boy, and had great faith in my own guardian angel. Strangely enough, the picture remained with me when I was in the greatest peril of my life, and gave me a sort of confidence.

By 1971 I began to sense that my father was becoming unhappy with how things were going in Burma. He was now sure that we were ruled by an oligarchy who were concentrating the wealth of the country into their own hands. This showed itself in the petty officialdom with which he had to deal. When he ran short of medicines for his veterinary practice, he had to write a detailed report requesting what he needed. He then had to pay 'tea money' – i.e. bribes – to get the medicines. The one thing that all officials, from high to low, had in common was a delight in bullying. I began hearing my father sigh deeply in bed, and discussing with my mother subjects that I did not understand but which I knew were connected with this unhappiness. I could not understand why he argued aggressively with my mother each evening after work. He did not give me as much pocket money as he had done before. My mother tried to assuage his griefs and understand him, but they ended up quarrelling bitterly. Our grandparents couldn't bear the disputes, and moved out of the main house into a new one they built at a corner of the compound.

Our House and Neighbours

So our family now lived in the old teak building which had been my grandfather's main house. The cooking, eating and brewing of rice-wine went on in a different house called 'the kitchen'. Both buildings were roofed with corrugated iron, which made them very hot during the day and cold at night. Grandpa knew that corrugated iron was impractical in our climate, but he thought that this newfangled material added to his prestige. The main house was a two-storey building with ten rooms divided equally by two hallways, one downstairs and one upstairs, with two stairways from the two sides of the building. At the top of each staircase was a small gate to keep the animals out and the children from falling.

The house was built according to mathematical and astrological calculations, and with the advice of a shaman. In order to decide

whether the ground in which the foundations were to be laid was propitious, my grandfather arranged for a hole to be dug, in which were buried some eggs, rice and rice-wine. After three or four days they were taken up again and examined. The rice-wine was tasted and the eggs were cracked open. If the wine tasted good and the eggs were still fresh, this meant that the ground was sweet, that there was no poison or acidity in the soil.

Those beliefs, by the way, were not confined to the Padaung or the other hill tribes. They were shared by the Burmans as well. Soon after Thibaw became king of Burma, jars of oil that had been buried in the foundations of the royal palace in Mandalay were examined and found to have gone sour. Thibaw's soothsayers took this as an ill omen, and recommended that he abandon the palace. This would have been an immensely expensive thing to do, since the palace had been built only recently by Thibaw's father, King Mindon, so instead the soothsayers suggested that Thibaw sacrifice a few hundred people, of whom a number were to be Europeans. This led to a great panic, with thousands of people, including the whole population of Europeans, fleeing Mandalay, giving the British a further excuse to intervene and annex Upper Burma in 1885. The throne room of the great palace of Mandalay became a club for British officers.

The site and position of the house was chosen partly for astrological reasons, and partly for security. It was propitious that we could see the North Star. It was also important that the moon would rise in the right place, partly so that we would come under the beneficent influence of the moon-spirit, and partly so that the moonlight would reveal enemies approaching the house by night.

At the centre of the house was the family chapel. This was the setting not only for religious ceremonies, but for all important occasions. We would gather there for family discussions, and my grandfather used it as an office. The truth was that unconsciously we treated it as a pagan domestic shrine just as much as a Christian chapel. We would even drink rice-wine there on special occasions – but we drew the line at eating there.

A picture of St Joseph holding the Christ Child hung on the horns of a wild-buffalo skull opposite the shrine. This also had connections with our pre-Christian past. The buffalo is the hardiest and among the strongest of animals, but is also a destroyer. We believed that a buffalo had killed the famous Burmese king Alaungpaya. According

to Karen myth, Alaungpaya was conducting a war against the Siamese at the time, and whenever he invaded Siam Burmese troops would always, on their way, destroy Karen and Karenni villages. Therefore the buffalo is a hero to the Padaung, and we would often hang the Padaung flag on the horns of a buffalo. (Historically, the great king Anawrahta was actually gored to death by a buffalo on a military campaign, but nowhere near Siam.) Furthermore, the Buddha is often seen seated on a dangerous animal – such as a hamadryad (or king cobra) – symbolising his conquest over dangerous brute strength or evil, a conquest by meek goodness. So St Joseph and the innocent Christ Child showed their superior power over the buffalo, cancelling its power of destruction, just as the Buddha does.

On the outside wall of the chapel in the hallway hung portraits of Grandfather and Grandma on the horns of deer. On the east of the hallway flanking the balcony were the two rooms for Grandpa's children and one for his twelve adopted children. The custom of adopting children originated in feudal vassalage or slavery, which had been abolished in the later nineteenth century. Vassals might leave their children with the chief to pay debts, or as sureties for their good behaviour. Later, poor parents grasped the chance of leaving their children with chiefs as the best means of getting them an education. My grandfather's adopted children came from poor families in the village. Their parents were eager to send them to live in the chief's house, where they would be brought up exactly as his natural children, would be fed, and would work with the rest of the family on the farm-strips.

The corners of the balcony were adorned with pots of geraniums. On the central building-post hung a weatherbeaten and faded coat of arms of my grandfather. It had been granted to him by the Sabwa of Sakoi, then our paramount prince. It was traditional in inspiration, for it included beasts of prey and destruction – buffalo horns and a leopard – but at the insistence of the Italian priest these were arranged around a cross. At both ends of the corridors that girded the house were wild orchids hanging on the eaves with birds' nests above them.

On the ground floor directly beneath the balcony was the main silo, with wooden mortars and pestles for pounding the rice. To the south-west of the house in the compound were a pigsty and the family toilet. They stank comparably, and we took the smells from both of them for granted.

To the north-west of the main house was a one-storey wooden building called 'the kitchen', where the family cooked and made their rice-wine. There were two rooms, one for cooking, the other for storage. The floor of the kitchen was raised three feet above the ground, and the cool space underneath was occupied by the domestic animals. When the cooking and eating was finished all the scraps of food were swept onto the ground beneath through a square hole in the floor so that the animals could finish them up. Above the fireplace was a teak shelf where meat and herbs were dried and smoked, and where traditional medicines in the form of roots and the leaves of herbs were kept, along with some animal parts and organs. This room smelled of the infusion of herbs, soot and rice-wine, while the other exuded the fragrances of ripening bananas, papaya and other fruits.

To the north was the thatched house built for the grandparents to escape their extended family and live in peace – for although my grandfather lived surrounded by children and grandchildren, he remained curiously detached and solitary, and there was no doubt that he preferred talking to adults. The two of them cooked their meals and slept there, perhaps reliving their companionship as it was before their huge family, natural and adopted, arrived. The kitchen and the grandparents' house were shaded by a massive 'danyin' tree which produces brown pods containing white nuts and gives off a foul smell like pickled fish. On the south-east corner was the family well, surrounded by an orange tree, an Asian pear tree and herbal shrubs.

Mr Kalwe had the loudest voice in the township and was, accordingly, the town crier. He would recite from memory all the notices put up by the authorities. Although he was drunk most of the time, he was the semi-official singer at our wakes and funerals and he knew by heart all the old poems of the tribe. He also took on himself the responsibility of digging graves and tending them ever afterwards – all for the price of a bottle of Padaung rice-whisky. Mr Patrick (a Padaung, despite his name), our catechist, and his family lived adjacent to our house on the south-east, next to a man who ran a government-owned fish shop, but whose real income was from illegal gambling on the premises. (The Ne Win government had banned gambling, although it was well known that the General himself had a passion for it which he satisfied at Newmarket and other racecourses on his regular visits to England. On one occasion Ne Win was prevented

from getting to the races. The English wife of the paramount prince of the Shan States, who had been imprisoned by the regime, parked herself in front of the house in which the General was staying, demanding an interview. The English police refused to intervene. Ne Win cowered inside peeping out of the curtains, and never came out at all.) Most families in the village were farmers who cultivated tiny arable strips of wet and dry lands. The different tribes and religions lived harmoniously together, except when it came to politics and football.

The streets of Phekhon did not have names. There were three Buddhist monasteries, two government offices, a police station with its jail, a Catholic church, a post office, a marketplace and a government school. There was a barber shop in the centre of the village, run by a Burman who also happened to be working for the military intelligence.

In the first half of the 1970s the political situation was still stable in Phekhon, which was largely insulated from the policies of the Burma Socialist Programme Party. The lives of the inhabitants mostly went on in the old way. Food was abundant, the weather was predictable and harvests were good. We were Padaung, we were Catholics and we seemed to live in a world of our own, with our own ceremonies and traditions. We had no feeling that anything alien could intrude into this. The sense of security showed me that we lived in paradise. At the same time, government radio constantly warned of the 'destructive elements' that menaced this idyll. Sometimes we were told that they lived in China, and were controlled by the Communists. But we were also warned that they lurked in the jungles within fifty miles of our town.

There was the idea of another paradise at the back of my mind; but this was of a paradise lost. My grandparents would tell me of a golden age, the age of the rule by the British in Burma. I had no real idea of who the British were or what their rule had been – just the feeling that their departure was regretted. 'The British have all gone home now,' said my grandmother with fond longing, as though she were talking of long-lost relatives. 'We were prosperous under the British, but when they went they took the prosperity with them.' I felt the genuine sadness with which she spoke.

I had the idea that the past was a matter of fond memories, and of the keeping of precious relics. Grandma showed me some old

photographs she kept hidden in her bamboo trunks. They were pictures of our tribesmen taken during the 1900 great exhibition in Mandalay, including a line of long-necked women standing before the walls of the Mandalay royal palace. The trunks exuded the scent of camphor and perfume, luxuriously overpowering. Grandma loved perfumes, and always stored them in small bottles among her clothes in the bamboo boxes along with her jewels. So the past took on in my imagination the character of something exotic, valued but somehow not to be too openly spoken about. At the bottom of one trunk was a flag that I did not recognise at all. It was the flag of democratic Burma. I wondered why Grandma hid it away.

Mother looked after the house. In particular she was responsible for the rice-wine-making, one of the most important activities in a Padaung family. My grandmother told me that when I came to marry I should choose the girl who made the best rice-wine in town.

The Padaung take pride in their rice-wine-making skills. Every house had its own rice-wine brewery, with clay pots and distillery. After each harvest great care was taken in choosing the special sorts of rice that were used for the different rice-wines. Our local spring water was prized for its suitability for wine-making. Each time my mother prepared to make the rice-wine, she would offer food and libations to the guardian spirit of wine. The wine-making area was cleared of salt and acidic fruits. Rice was cooked in a huge bronze pot, then spread on a clean new bamboo mat to be cooled. Powdered yeast was then sprinkled on the bed of rice and mixed with rice husks for hot rice-wine; the mixture was then stored in large clay pots and sealed with ashes.

When it was ready to be consumed, the pulp of rice-wine was scooped from the big pot and stuffed into a smaller one. Hot water was poured into it, and it simmered for at least ten minutes before it was ready for the drinkers to suck it through a communal bamboo pipe. Hot rice-wine has about a 10 per cent alcohol content.

We made another sort of rice-wine, which we called 'Padaung whisky'. This was a notoriously fiery brew, made from white rice without the husks, and had a 60 per cent alcohol content. We also believed in its curative powers and its efficacy as a disinfectant.

Sometimes big pots of rice-wine were buried underground for two or three years and brought out for special occasions. They tasted

stronger than the usual wine, and the texture was as thick as honey.

Weddings

In my earliest memories, weddings are surprisingly prominent. They seem to have been celebrated all the time. This may not be an illusion, for there was in those years a succession of excellent harvests in what is anyway normally fertile land, and people got married as soon as they could afford to. In our tradition, love-making – mostly in the sense of serious courting, although it could include sex – began at an early age, and weddings came not much later. The Padaung took great pains to find a 'clean' partner. Ideally, cleanness included virginity, but the tribe had never insisted upon that before it came under the influence of the Church. We were strict about consanguinity, avoiding marriage even with third cousins. With religious assiduity we also traced the family history of potential partners. We wanted to avoid 'bad blood', which we interpreted in the broadest sense. So laziness, swearing, leprosy, mental illness, dishonesty and wizardry were regarded as impediments of almost equal seriousness. Being from an enemy clan did not help either. The potential spouses most hotly competed for were those from the families of artists, those generally acknowledged as leaders, mighty hunters, and those who had the best seedlings.

Despite all this, boys were in general allowed to woo their loves without hindrance from their elders. They were expected to meet at festivities, after which more intimate courtships were tolerated. Indeed, the elders and the parents of the girls were obliged to provide a place where the youngsters could meet regularly and in privacy. This was preferably a comfortable hut with fire, food and rice-wine, where they could indulge in such leisure activities as weaving and choosing seedlings.

The role of seedlings in our courtship rituals may seem strange – and perhaps it is unique to the Padaung. It has both a symbolic and a practical role. If you are good at choosing the seedlings, this means that you will be canny at producing a good crop for next year. Through our symbolic or analogical ways of thinking, it also suggests that the young couples will produce good families. So for them to sit discussing and choosing seedlings at leisure strikes us as powerfully sexy.

In earlier days the real obstacle to young people's love-making was not moral or religious, but tribal. If you fell in love with a girl or boy from an enemy clan, you simply had to flee the village – or else you would be killed. (When, years later, I came to read *Romeo and Juliet*, I felt quite at home.)

The young men had to compose ditties to discover the intentions of their lovers. We Padaung are not a very subtle or indirect people, and so the ditties were not especially hard to decode, e.g. 'I want to enter the golden door to worship the two pagodas. Will you kindly let me in?' That was one of the acceptable forms of the genre. Our neighbours the Shan went further, and allowed their girls full sexual liberty before marriage. Although that liberty rarely took the form of promiscuity, a Shan girl could take several lovers and still preserve her good name. The only absolute taboo for all of us was having an illegitimate child – and the only contraception we knew consisted in drinking a horrible herbal mixture which was supposed to work after sex. Elopements by couples who had been forbidden to marry by their families because of tribal or religious differences were common among all the tribes.

On the eve of the wedding ceremony the groom, accompanied by his friends, would go to the bride and invite her to leave her parents and come to his house. She was then expected to resist, to cling to her mother, to weep and sing songs in praise of motherly love. Although this was the ritual that was expected, it was also true to what we all felt – that this was a solemn rite of passage, sad and joyful at the same time. To a great extent our rituals shaped our emotions and taught us what to feel. The father would then drag his daughter the length of the house and out to the groom's bullock cart. Meanwhile the blood of a chicken would have been smeared on the front gate of the house and banana plants strapped on the gates around it to ward off evil spirits.

The friends of the bride then had to follow the couple, singing songs of happiness and in praise of marriage, ringing bells and striking drums and gongs to keep the evil spirits at bay. Having been taken to the groom's house, the bride would be offered a cup of rice-wine, which she shared with the groom. She would then be ritually whipped with a honey-stick to make her fertile. After this, while the food for the wedding feast was being prepared, someone would recite the legends and myths of the tribe and the family histories of both bride

and groom. Here is one of the stories that I heard regularly at weddings.

'Once upon a time, on his way back from the fields, a young farmer called Khoo Lachrist found an egg inside the hollow of a tree-stump. He put it into his bag and set off for the farm. When he got home, he tried to fit the egg into a pot to be boiled for his supper – but the egg was too big for the pot. He took a bigger pot, but it was still too small for the egg. Even his biggest pot proved too small. Not knowing what to do, he found the largest basket in the house, put the egg in it and left it.

'Next day, he went to the fields as usual. When he got home, he found that someone had already prepared his dinner and rice-wine. His puzzlement increased. On the second day, the same thing happened. But on the third day, he caught a glimpse of a beautiful woman just as she ran out of the kitchen. She was about to get away, but he caught her by the hand and asked her who she was. "I came out of the egg," she replied. "I beg you to let me go – I will not try to escape." But he gripped her ever more tightly, and knew that he could never bear to let her go. "Trust me," she said, "I could only disappear if you found a way of putting the egg back into the chicken." So he let go of her hand. They ate the supper she had prepared, and made love.

'Next morning, Khoo Lachrist went to his uncle and told him everything that had happened. His uncle understood the mystery, and they named the girl Mu Lachran because she was heaven-born and not of human making. They celebrated their union with a wedding, and lived together for two years in perfect happiness.

'One day, when he came home, Khoo Lachrist found that his beloved wife was gone. Next morning, he went to the village shaman and consulted the bone-oracle. The shaman was able to tell him that his wife had been stolen by a stranger from the east, but that he would be able to find her with the help of his dog. However, the shaman warned him that the return journey would be fraught with difficulty and danger. Khoo Lachrist did not despair, but resolved that he would follow his wife to hell if that was required. He killed a chicken, offered its blood to the *Nats* for guidance, and cooked the meat. After the meal, he and his faithful dog set off from the village together.

'After days of journeying under a blazing sun, man and dog were weak and exhausted. "If you hold on to one of the forks of my tail and follow me, all will be well," said the dog. "But you must not say

'I'm tired' every time you have climbed a hill, for if you do the forks of my tail will drop off." Khoo Lachrist promised to abide by the dog's instruction, but he forgot the warning and exclaimed "I'm tired" seven times as he climbed seven hills. Soon it was clear that the dog was dying, but before it died the faithful animal told its master to keep one of the flies that would be buzzing around its dead body. "Release the fly when you reach your destination. The creature will fly straight into the nostril of your wife and she will sneeze. That is how you will know where she is." Thus instructed, he buried the dog and resumed his journey.

'He reached his destination on the borders of Thailand [the Thai Shans being the hereditary enemies of the Padaung] and released the fly as the dog had told him. A moment later he heard someone sneeze. And there he found his beloved wife, surrounded and menaced by strangers – the men who had seized her. The kidnappers took him prisoner as well, locked them in a house, and set it on fire. But as the house burned, both the lovers flew out of the blazing building and into heaven. Then Mu Lachran flew to the east and became the Morning Star. Khoo Lachrist flew to the west and became the Evening Star. Since then they meet only once every seven years, but their love is eternal.'

At the wedding ceremony metal frog-drums – our precious 'drums of desire' – would be beaten in the special way that invokes the spirits of the ancestors so that they too would shower prosperity and fertility on the couple. The frog-drums, which were decorated around their tops with figures of frogs, were powerfully magical and are another example of our analogical thinking. Frogs are one of our guardian spirits. The drums are made of an alloy of gold and silver which gives out, when struck, what to our ears is a croaking sound. A certain type of croaking by frogs means that there will soon be rain – hence the croaking brings the rain. So when rain is needed the Padaung imitate the croaking sounds with their drums, which persuades the rain spirits to send the downpour. The drums are powerful in warfare and in scaring away evil spirits. All this helps explain their ancient and more formal name, 'drums of desire'.

The Padaung and our cousin tribes treat the precious frog-drums as though they are human beings. They give them individual names, for they see them as mediums and messengers between the past, the present and the future, between the living and the dead, between the

physical and spiritual worlds. Each drum is believed to have particular powers according to the composition of the metal alloy, and to the hour of the day it was made. Different drums have different roles – some are beaten on the occasions of birth, some of marriage, of death, of war.

After these solemnities, everyone would fall to eating and drinking. I ate and drank like a small monster or ogre that had been released into these festivities from the spirit world. Sometimes I would drink myself into a stupor and fall asleep still embracing the pot of rice-wine. When I woke up, I would resume eating and drinking just as I had been doing before. My father never stopped me. As a result I began to look like a gigantic maturing beetle grub with legs and arms. When my mother found out she was horrified and furious. But my father and his relatives actually encouraged me: 'Let him eat his heart out so he can grow up like a giant. Let him eat while he is blessed with an appetite,' they would say.

Always I came home drunk and comatose, with my stomach protruding like a balloon. My father would carry me home on his shoulder: 'Now I carry you home when you are drunk. But when you grow up you will have to carry me home when I am a drunken old man.' He laughed as he said that, but he told me seriously never to fall in love with rice-whisky. I never did, because – fortunately – it always gave me a terrible hangover.

I particularly liked Christmas, because every house threw open its doors and entertained guests with rice-wine. I went round as many houses as I could manage, getting more and more drunk. I loved going to the church to look down on the Christmas crib from the shoulders of my father. A pagoda on the top of a hill always featured in the crib, so I felt that Jesus was born near our village. I always checked the cowsheds around the town, hoping to find a naked Baby Jesus so that I could look after Him. I very much wanted Him not to be cold and neglected of men, for they told me that Christ loved us so much that He came from heaven to be with us on earth. I loved Him in return. What I most wanted was to give Him rice-wine to keep Him warm, fat and contented.

Learning to Love the General

At the age of five I was sent to the government school. My mother had to drag me there weeping and howling in protest against being separated from my uncles and aunts. It was an epic struggle, with my mother sometimes hitting me to urge me on, and sometimes coaxing me with sweets. I hated her wiles. In the end she tricked me by slipping quietly away when my back was turned. I was furious, and cried in the hope that that would bring her back – but it didn't. I thought I had lost her for ever, but I dared not try to go home because I didn't know the way. I was in despair. By the evening I had forgotten all my anger and started to enjoy school. I was committed to the care of a teacher who represented the less severe side of my mother. I liked to share lunches with her, and she made me her pet.

Paper was in short supply, so we could not afford exercise books. Instead we wrote on black slates most of the time. When I received my first pencil and exercise book I was so happy that I just smelled them, and found the scent magical. Our kindergarten classroom was built of wood and roofed with leaves, half of which leaked in the steady monsoon downpour. So we attended class with plastic sheets on our heads. There were about fifty children in my class.

The school was on the outskirts of the town, bordered by bushes, ponds and barbed-wire fences. Just behind the barbed wire the jungle stretched into the far distance. The headmaster was a Karen Baptist called Mr Joseph. He was a short, bulky man with red lips and red eyes who chewed betel leaves and nuts and spat out sprays of red liquid as though he were a fat, squat lizard. He was dangerous and unpredictable, especially when he was drunk – which he was most of the time, for we could smell alcohol whenever he walked past our classroom. He carried a cane in his hand and tapped it on the walls

and floor, humming and coughing just to remind us of his presence. Both teachers and pupils were afraid of him, for he spared no one.

Before the start of classes, pupils and teachers assembled in front of the flagpole facing the school. There we sang the national anthem, saluted the flag and our national martyrs, and recited our duties to the nation. There also I heard for the first time, from the mouth of Mr Joseph, about the greatness of the leader, General U Ne Win, the beneficent, far-seeing ruler of Burma. In the classroom we also bowed every day to the portrait of the General, so that I began to feel he must be some sort of god or religious figure. I was puzzled, because at home Grandpa never referred to Ne Win as 'His Excellency' but always as 'the dictator' – a word of which I did not know the meaning, but which I was certain was unfriendly. I also learned from my teacher that the world was round. When I went home, my grandpa insisted it was flat. 'My teacher will not give me any marks if I say it is flat,' I replied, 'so he must be right.'

'What does *he* know? He's a socialist, isn't he? All socialists are liars. Look how we live. They said socialism would make us rich – and look at us! I don't know whether the world is round or not, but I do know you must never believe anything they say!' Grandpa spat copiously and contemptuously.

I was troubled. For the first time there was conflict between two authorities. There was another conflict. Mr Joseph talked of the benevolence of the ruler, but I could see that he himself was a bully, and that everything in the school depended on fear and bullying. We lived in dread of punishment all the time. I was punished for wetting myself, because I still hadn't managed to control the calls of nature. We knew punishment before we learned anything. I had the sense that there was something wrong. What made things worse was that my parents urged precisely the teachers who had a liking for corporal punishment to beat me if I misbehaved. They did this with a will, and never troubled to distinguish between ebullience and rebelliousness.

The bullying spread to the pupils, who became like pack-animals seeking out the weakness of newcomers. They carried catapults, flint pellets, knives and other ingeniously painful home-made weapons. I was a new target, and it seemed impossible not to be part of the system of bullying. Not only did they bully you, they also forced you to join them in bullying others, to cheat in exams and even to ambush unsuspecting teachers on the way home. To hurt me they would call

me by my father's name, because for some reason we Padaung found it insulting when someone uttered the names of our parents. Once I complained to my parents, and the bullies were briefly punished. But then the teachers punished me instead.

This went on for three years, to my increasing despair. I was on the brink of giving up my education when Uncle Yew came to the rescue. Uncle Yew was a superman to me, tall, strong and handsome. He was popular and influential among young people and the elders alike. That such a god-like figure could suddenly intervene in the cruel, self-enclosed childhood world that the bullies dominated was to me a sort of miracle. By sheer force of personality he became the inspiration of the young. He organised them into an excellent football team; he took them on daring hunting expeditions lasting for days; he gave them a sense of pride in the arts and skills which, as Padaung tribesmen, they ought to inherit. To my astonishment he actually succeeded in changing the hearts of even the most determined bullies.

I had a sense, even at that age, of how the majority can submit to the bullying of a few determined individuals, and how a single man can restore to others a sense of the dignity of individuals and the power of a community. I had an obscure feeling that it was not just my school but the larger society around me that was afflicted by bullies. In my heart I knew that my own father was a victim of this. To be sure, I did not then have the language or understanding to express such ideas, but I knew what Uncle Yew had done, and I revered him for it. The memory has remained with me ever since.

Mr Joseph was untouched by all this, and continued in my childish eyes to embody the contradiction that I sensed between the pretence of benevolence and a quite different reality. He it was who told me of the dangerous world of the jungle just beyond the barbed-wire fence, a world controlled by General U Ne Win's enemies that stretched all the way from school to the Lawpita waterfall and the great River Salween.

The chief spring of the town was about half a mile from our house. As well as providing us with most of our water, which we all, men and women, fetched in clay pots, it was a social centre to which all flocked to bathe, meet and gossip. The water flowed from a cave system, largely hidden by bushes, into two ponds. One of these was traditionally reserved for male bathers and the other for females. The

ponds were surrounded by old, very large pyinkado trees that grow up to seventy feet, and are as sacred as banyans, by teak, and by big boulders on which we used to bask in the sunshine, lizard-like, after our swims. We boys would compare our genitals, and whoever had the largest was made to feel embarrassed. Although we were in the male pond, there were always two or three girls with us. When we told them that they were not allowed to join us in basking because they had no penises, they replied: 'But we have them too, only they are inside us and you cannot see them.' We accepted this, and made them honorary members of our gang. We made them undergo initiation rites: they had to climb tall trees, stay under water for one 'minute' – which in fact consisted of a hundred seconds counted slowly – and chew ten red chillies raw without drinking water for at least fifteen minutes. They passed all the tests.

The spring was near an important Buddhist monastery and its adjoining pagoda. These were surrounded by immense, ancient trees where lived, according to my grandmother, the *Nats* who presided over the spring. She warned us that if the trees were cut down the spring would die out and the town would run short of water, because the guardian spirits would have nowhere to live. Every month, food and candles were offered in spirit houses beneath the trees. Grandma also warned of other misdeeds that would cause the spring to dry up: 'Women in their periods and young mothers who have not yet been purified would pollute the spring and displease the spirits. They have to avoid it.'

At the foot of the monastery hill where the stream of the spring met the lake was a '*zayat*', a meditation house and resting place for travellers, resembling a gazebo. Buddhists assembled there to hear sermons by the monks and to meditate. The mood for meditating was assisted by the view of the lake to the east and the monastery and pagodas on the hill to the west.

Behind the monastery, on a hillock dotted with tamarind trees and bushes, was an army post that commanded the whole town. There were fifty to seventy soldiers guarding the post against the Karen and Karenni rebels who since 1948 had been fighting for an independent state, but they spent much of their time wooing the local girls both in their homes and in the fields. In earlier years the soldiers had stationed themselves right in the middle of the town so that if they were attacked by the rebels they could make use of human shields.

But the villagers, in one of their few successful attempts to assert themselves against the army, had managed to force them to the out-skirts. Surrounding the army post were our arable strips. To the west of them was the Calvary Hill, with a wooden cross about fifty feet tall sandwiched between two boulders. Beneath the Calvary Hill were two limestone caves hidden in subtropical jungle, where we used to play and collect bat-droppings to be used as manure.

From the Calvary Hill we had a panoramic view of the whole town and its mix of faiths and tribes. There were the Christian quarters with the church spire, the convent, the boarding school to the immedi-ate east, and the market by the lake. To the north of the market were the Shan and Intha Buddhists with their monasteries, wooden houses with thatched roofs, and paddy fields. To the south-west were the Shan quarters near the spring, overshadowed by the army post, and the pagodā. The whole town was richly dotted with fruit-bearing trees, banana and bamboo groves (we had no coconut or palm trees). The lake dominated the town like a big plastic sheet, sometimes silvery, sometimes golden, and sometimes shimmeringly blue. The surface of the lake made the blue and normally crystal-clear sky look bigger and deeper, as if it was divided only by the blue range of mountains.

The jungles to the west of the town and the lake to the east were our playgrounds. We used to pick seasonal wild fruits and play hide-and-seek. But our special pleasure was war games. Inspired by all the government warnings about the rebels lurking in the jungles around the town, we enacted guerrilla raids and attacks, abductions and killings.

The war games became reality later, when we witnessed real fights between government troops and rebels very near the town. We were intensely excited, because each fight seemed ridiculously like a game, except that real people got wounded and killed. Perched on tree branches on the tops of hills, we watched the clashes as if they were football matches. We cheered and shouted while people were slaugh-tering each other in earnest in the valley.

We organised dangerous games for ourselves. We built small carts with wooden wheels for downhill racing. The carts were like modern go-karts, but with no steering wheel or cover. Of course we wore no protective clothing. To make the carts run faster, we greased the axles with a slimy liquid chewed from the bark of a gum tree. The steeply descending track was strewn with tree-stumps, barbed wire, cacti and

bamboo. Worst of all, the track skirted an electricity pylon mush-roomed with landmines at its base. No one managed to finish the track without getting hurt. Two boys were killed. Another of our games was to use long poles to prod and explode the landmines around pylons.

We picked most of the vegetables we needed from our farm-strips and from the jungle. Seasonal vegetables ranged from mushrooms, bamboo shoots and beans to wild herbs and edible flowers. These last grew on the *stinto homphao* tree only during the summer. The leaves of the tree are also edible; they drop off in March and are replaced by the white flowers. These have a soothing flavour, like that of rose petals, fragrant but not as strong as a rose scent, and are rich in iron. We planted pumpkins, maize, cucumbers, aubergines, beans, yams, sweet potatoes, mustard seeds and lettuce according to the season.

When we tired of the jungle we would go swimming and fishing. We learned to catch fish and snakes from our fathers. The excitement of the chase was greater than the haul, which was usually meagre. I wanted to bring home enough fish to cheer my mother up when she was sad. A strange competition developed between my father and me, because he also wanted to make a good impression on my mother to make up for the trouble he knew he caused her through his excessive drinking and outbursts of rage. If I caught more fish than he did, he would surreptitiously buy some that others had caught. I knew I really ought to keep quiet about this, but then I felt honour bound to reveal the secret to my mother.

When we arrived home from the jungle or the lake we always washed our hair with a home-made shampoo of soap fruits, slimy barks and roasted herbal beans. This was a ritual cleansing that we carried out before we re-entered our houses. We recalled our ancestral spirits, who watch over our welfare, and enticed them to enter the house with us by making offerings to them of aromatic flowers and the choicest food.

Modernity did intrude in fits and starts. Traffic lights were intro-duced in Loikaw in the early 1980s, and the first-ever traffic accident occurred on the day they became operational. A car ploughed into a police post that stood next to the lights, and a traffic policeman was killed. The driver had simply panicked when he saw the lights, even though his was the only car on the road. The traffic lights were scrapped.

It was surprising that they had been thought of at all, since there were only five vehicles in the whole of Phekhon. They were pre-war General Motors trucks, and were used to carry passengers to Loikaw, twenty-five miles away to the south-west, in the morning and bring them back in the evening. The owners of the trucks were considered to be the richest men in Phekhon, with the result that they and their passengers were often the victims of bandits or policemen (we usually called bandits '*dacoits*', and considered that policemen came into the same category). There was no public or private passenger transport to take people more than thirty miles beyond the town, so anyone who wanted to travel to the capital of the Shan State, Taunggyi, 150 miles away via the road which passed through Loikaw, had to hitch-hike on government lorries. This meant that you had to sit on top of piles of logs, marble slabs and other heavy goods carried by the lorries as they snaked around the tortuous roads of the Shan hills.

Nor were the difficulties of movement simply physical. Anyone who wanted to travel more than thirty miles from the town had to apply for a permit from local government officials. Sometimes it took days, even weeks to get one. Then there was always the fear of landmines, which the government claimed were laid by ethnic insurgents. In fact the poorly maintained and potholed roads claimed more lives than mines ever did. You could travel to Lake Inle by boat, but no one, except merchants, used them. Boating accidents were also common. The result was that people used modern, powered transport only when absolutely necessary, because it was an exceptionally stressful experience. Otherwise they used bullock carts. In general they preferred not to venture beyond their home town. Patience, flexibility and stamina were essential if one wanted to travel any distance in Burma.

Few of us in Phekhon had seen an aeroplane except in the distance, when one might fly past the lake on its way to Heho near Taunggyi. Aeroplanes crashed frequently during the rainy seasons, often because they were badly maintained. Burma Airways used old Dakotas and Fokkers left by the British. The state of the aeroplanes was so bad that passengers had to use umbrellas when they flew on a rainy day.

A Portrait of the Artist as a Young Padaung

By the early 1970s every commodity in Burma began to have two prices – the official, government-controlled price, and the black-market one. The regime had introduced government stores and had forbidden any private buying and selling. The result was that all goods became scarce and often unobtainable, while outside the government shops there was a flourishing black market. So the great majority of people could barely afford even the necessities of life, while the rich provided amply for themselves.

The poor became ever worse off, as did government employees such as my father. Contrary to the official philosophy of the Burma Socialist Programme Party, with its claim to end (in General Ne Win's own words) 'the exploitation of man by man', being poor meant that you were exploited by many – by corrupt officials, black marketeers and all who themselves exploited the system they had set up – and casually despised by your rulers. Because the system's greatest claim was that poverty was being eliminated, those whose experience was the contrary directed all their anger at the system itself and the false hope it offered.

My father had remained devoted to the regime and dedicated to his work. Then he learned that his employer, the government, would not be paying his salary for three months (in fact, unknown to the public, the government was bankrupt). At first he persuaded himself that it was his patriotic duty not to complain, but then the food allowance he received for his family – payment in kind from the government that formed an important part of his income – was ended. He had to borrow from our relatives in order to buy food for his

family at black-market rates from the private shops run by the relatives of government officials. At last it dawned on him that all essential goods controlled by the government were being siphoned off by local bureaucrats and sold on the black market. His life had been devoted to his work, and now he found that he could not get even a bag of rice at the official rate. He started to drink heavily.

He would explode with sudden rage at my mother, and then spend the night, while everyone was asleep, ceaselessly tuning the radio from station to station, as though still in the hope of getting the message from above. The next morning, full of remorse for his behaviour, he would plunge into frenetic work until his body could take no more. As well as working in his office, he laboured on the farm-strips. When he was physically exhausted he drank rice-whisky until he could drink no more, and was again filled with rage. My mother could not endure all this and fled to Loikaw, where she stayed with her sister. She filed for divorce even though she knew that this was against the teachings of the Church. After a couple of months, in response to my father's pleas and contrition, she returned. Things went back to normal.

Moonlight

In the evenings after dinner the whole family liked to bask in the flood of moonlight on the balcony of the house. The young night was pollinated with stars, and the full moon looked to me like a huge lollipop as it rose in the east over the purple hills and shed light on our unlit town. The nights of the full moon were magical for us, and filled us with excitement, for we were not brought up with electricity. The moonlight seemed to give a sort of warmth on a cold night and coolness on a hot night. It even seemed to heal sorrows and spiritual wounds.

The Padaung think of the moon as a beneficent spirit, one who heals discords within families and in general brings peace. That the scenery looks completely different under the shimmering glow of moonlight was not just an experience of a special beauty for us, it also had a particular spiritual meaning.

We would run frenziedly about the house while the adults were chatting over a pot of rice-wine: 'Stop rushing around like monkeys while your elders are talking. Go and play with your friends in the street.' Standing on the veranda, I would call my friends to come and

play in the moonlit square outside. When the nuns at the convent nearby started their night prayer, we knew it was time for us to go to bed. We washed ourselves at the well and went home whistling.

I had a tree-house, and would sleep in it, lying on straw on the hottest nights as I watched the stars until the cool breezes that came at midnight sent me to sleep. Then I would have fantastic dreams. I would tell my parents of my dreams when I woke up. They took them seriously, and we would interpret them together and do what was necessary to prevent the predictions in them from coming true. If I had dreamed of a plane crash in the village, this meant that someone was going to die at the place where the plane crashed in my dream. Sometimes as they listened to my dark sayings, the adults wore a common smile of conspiratorial relish. Whenever my predictions came true they took my talent for prophecy as a simple matter of fact, because they assumed that truth speaks through the mouths of children – so I became the unofficial family oracle. But however powerful my dreams seemed to me, I never confused them with real life. I divided my dreams into categories, each with its own methods of interpretation. Although my interpretations were partly my own invention, they did overlap with Padaung traditions of dream symbolism. To dream of a fish meant trouble or danger ahead; human excrement stood for money; a dream of flying meant that one's spirit was being refreshed; caves stood for one's soul, one's inner self. My family thought that my prophetic dreams were a gift I had been vouchsafed. Yet at the same time they took them for granted, for we assumed that all dreams were prophetic messages from the spirit world.

On summer nights we watched the burning of the mountain slopes by the slash-and-burn farmers on the other side of the lake. The red trails of the fires seemed to devour the water of the lake and the stars of the sky like some mythical monster. The fires were reflected in the lake, so that the whole scene had a special quality of terror and mystery. It seemed to me as though half the world was burning. The fires burned for many nights in succession, and I often woke during the night to watch the changing pattern of the flames. The fragrance of blossoms from the orange tree often swept past the house on the evening breeze as we slept in the open on the balcony or in the tree-house. We also washed and ate in the open – there were not many mosquitoes in our town. Wild grouse, cuckoos and summer

birds called their mates from bushes and treetops, while the sounds of the cicadas and bees were unbearably loud.

Why do I have such vivid memories of a burning world? As usual, these were not just my personal response, but were shot through with the beliefs I had inherited. The Padaung are haunted both by the Christian idea that the world might come to an end, and by their own ancient beliefs about fire: 'When the forest burns, the wild cats rejoice.' This is a vision of civil disorder and of those who would exploit it. Fire is one of the 'five enemies of man' in Buddhist tradition – but it is also a power we revere, a power to cleanse and renew.

During the rainy season, I would watch the lightning as it filled the sky with fantastic patterns, and the meteors shooting past the mountains. We saw meteors as the work of ghosts – illusions to puzzle us, for no one knew where they came from or where they landed. They were another emanation of the spirit world. Different types of clouds gathered on the horizon and we guessed which one would bring which sort of rain. The first monsoon of the year, which brought the most refreshing rain to the land, always brought a light storm as well. This first rain was sacred to the *Nats*, as were the first crops to be harvested. The stormy rain washed away all dirt, unhealthy fruits and flowers from the trees. We were not allowed to play in that rain because although it was sacred it was also believed to be unclean.

The monsoon finally rewarded the farmers who had been labouring in the first quarter of the farming year to prepare the ground. They would have been ploughing and raking the soil during the summer months. Nevertheless, they were cautious about the inconstancy of the weather. They prayed to the spirits of rain, sacrificed animals and made food offerings to them at holy places so that they would bring the rains at the right time. Grandma used to predict the weather from bird-songs and the behaviour of animals and birds, especially grouse and cuckoos.

The Padaung were mostly slash-and-burn farmers. Trees and bushes in the jungle were cleared at the end of the cold season and left to dry. Then in the early summer the farmers burnt the dry vegetation, filling the air with smoke. Seedlings were planted on the charred surface of the patches of dead forest before the monsoon arrived. The land was hoed to mix in the ashes, the sower breaking the ground as he dropped the seed. The same land would be cultivated for two years in a row, but in a third year the strips would barely repay the cost of

seed or the labour, so a new plot would be prepared and the old land left to the jungle. The Padaung began to cultivate permanent plots and became wetland farmers only after they came into contact with the Shans. With us, one of the small rectangular wet fields surrounded by dikes is chosen by the farmer for a seedbed, and the selected rice seeds from the previous year's harvest are broadcast in the field at the onset of the monsoon. Once the monsoon rains become steady, the ploughing, weeding and repair of the dikes begins. When the rice plants in the seedbed are about a foot and a half tall, they are transplanted by hand one foot apart in the flooded fields which have already been ploughed and manured. As the rice grains mature in November and December, the water is drained from the diked field and the grains are allowed to mature in dry soil.

According to immemorial tradition it was from the Shans that we first learned the art of irrigation. The Shans, like their Thai cousins, had developed excellent irrigation systems while they still lived in southern China (from which the Thais migrated in the thirteenth century AD) before the coming of the Han Chinese.

We grew maize, sorghum for the domestic animals, groundnuts for oil, beans, yams, potatoes, cucumbers, pumpkins, melons, gourds, watermelons, chillies and other vegetables in the paddy fields. But the most important crop was rice, which was not only a staple food, but was used to make the rice-wine that we drank every day of our lives.

I loved the cold season best. It brought the rich fragrance of the rice and other crops as they ripened after the heavy rotting smell of the monsoon. Each season had its own distinctive smell but the cold season was the best, when the air became cool and crisp every morning. The migrating swallows, parrots and scarlet minivets returned in convoys, one after another, and congregated on the tops of flowering trees.

The monsoon had its own special character of sound – the combination of the bird-sounds, the rain, thunder and wind. We thought of this as a 'busy' noise that replaced the staleness and stasis of summer. The cacophony of the monsoon gone, the music of the cold season worked up to a climax in the songs of birds both native and migratory, especially the scarlet minivets and the swallows. I loved going for an early swim in the lake each cold morning, when the water gave back the heat of the previous day. It was warmer in the water than out of it. Any ailments in our bodies seemed soothed by the warm water.

The harvests would start in late December with groundnuts, maize, beans and other crops. As it was the most important, the rice harvest was attended with much ceremony. Friends and relatives came to help with the reaping, threshing, winnowing and storing of the grain.

The farmer began reaping with a sickle, accompanying this with a prayer and some magic incantations. The rice plants were bound into sheaves with straps of straw or bamboo and later shifted to the thresh-ing floor. Threshing was usually done when the moon was waxing, preferably before full moon, because it was believed that the influence of the moon as it waxed would increase the yield of the harvest. We held the sheaves at the bottom and beat the grains onto the threshing table with much singing and chanting that was designed both to relieve the labours of the threshers and to soothe the spirit of the rice.

We winnowed by fanning away the chaff with square trays made of bamboo. You had to observe certain rules during harvests to avoid calamity. Swearing and quarrels had to be avoided so as not to drive away the spirits of prosperity. Singing and conversation, on the other hand, were supposed to please the good spirits and persuade them to stay with us. When the grains had been collected, the harvest was stored in the silo of the house and topped with the shells of tortoises, which were believed to slow down the consumption of rice. This was yet another example of the our symbolic way of thinking. The tortoise is a slow-moving creature; therefore, we reasoned, to cover our grain stocks with its shells would induce us to measure out our use of the grain.

Ten per cent of the harvest was stored in the village silo to be used in an emergency. If dormice ate the grains during the harvest, we thought this was a good omen, and the creatures were killed and consumed. The dormice had eaten the spirits whose magic suffused and protected the grain, so in eating the dormice we regained the spirits and took their magic back into ourselves.

With the coming of socialism to our town, farmers were compelled to sell quotas of grain to the government buyers at a very low price. All the good-quality rice produced in Burma was reserved for export or (just as often) sold to the black-market rice merchants. What was left – rice of the poorest quality – was then sold to the people. If farmers wanted to eat their own good-quality rice, they had to buy it from merchants at roughly ten times the price that they had been paid for it. As a result, farmers were reluctant to grow surplus rice for sale,

preferring to grow only enough for their own families. When there was a bad harvest, they didn't even have enough to feed themselves. Burma, which was the world's biggest exporter of rice before the Second World War, became a net importer. Even leaving aside the flaws in the regime's agricultural policy, sheer mismanagement and rampant corruption began to undermine the economy as early as the mid-seventies. The price of food and domestic goods rose steadily, until inflation ran out of control. Even basic food needs were no longer met. Rice was unavailable at the official rate, and sky-high on the black market.

Some farmers illegally grew poppies in the jungle to support their families in bad years. When they discovered that opium made them much more money, with less effort, than normal crops, they grew more and more – and eventually poppies outstripped rice and other grains. At first the government tried to eradicate the poppy fields, making use of helicopters, machine-guns, flame-throwers and other technical assistance provided by Western governments. But government officials soon realised that they could enrich themselves by becoming unofficial agents for opium warlords, and so would destroy only a few token fields. The weapons supplied by the West were turned instead on internal enemies of the regime. The alleged fight against drugs became an excuse to attack ethnic rebels and even villagers who showed any opposition towards the government. As a result, the opium trade boomed as never before.

After the harvest there would be a harvest festival in each village lasting three or four days. Silver swords were sent to surrounding villages to invite the inhabitants to the festivities. These swords were precious heirlooms for the village – like our frog-drums – so sending them was an act of friendship and hospitality. The neighbouring villagers had to bring the swords back when they came for the festival. Auspicious days for the celebrations were chosen by the elders with the help of bone oracles. A chicken was killed, and the village shaman would rip the leg bones from the flesh and read the signs. If they were auspicious the festival would go ahead as planned. If they were unfavourable the festival would be postponed, and the villagers would sacrifice a pig to appease the *Nats* before the next reading of the bone oracles. They would go on doing this until the signs were auspicious, and if that did not happen the festival would be abandoned altogether. Instead the villagers would attend the festivals of other villages.

Preparations for the festival started as soon as the harvest was in. A tall, straight pyinkado tree was chosen from the jungle by a shaman as the festival totem. The shaman, with offerings and prayers, then invited the favourable spirits to enter into him. When he was deemed to have become possessed by the spirits, the villagers would cut down the totem, all the time beating drums and gongs, and carry it to the village with the shaman riding on it. The totem was then decorated with bamboo threads woven into beehive patterns to attract the *Nats* and erected in the sacred field just outside the village. The villagers slaughtered animals and offered their heads, trotters and tails, along with other gifts, to the guardian spirits of the village and the farms. They gave thanks to the spirits, dancing around the totem with the drums and gongs. They wrapped rice with leaves of elephant grass into small parcels which they steamed. The steamed parcels were then eaten with curry and washed down with rice-wine by the villagers and their guests. The festival over, the villagers returned to their farms contented with the knowledge that they had appeased the spirits.

My grandmother Mu Wye was the first woman who influenced my way of thinking. Her influence was as strong as the teachings of the Church. She was illiterate, but her memory was immense, even better than her husband's. She was proud of being a strong woman with prestige in our tribe, but she wanted to become a man in her next life. She was also proud of her household skills, especially in rice-wine-making. From her I got the idea that the lot of a woman is constant work, for she never ceased. She could not even return home from the farm without at least a bundle of firewood on her back. Even while she was chatting with her family she would be doing something useful at the same time – whether it was choosing seedlings for her fields or telling the beads of her rosary. She swept and garnished the house, and stocked it constantly with all the food, drink and tools necessary for the daily survival of the household. She sharpened all the knives and hoes herself.

Our households were each like an *oikos* of the ancient Greeks. Not only did we live in extended families, every household was an economic unit, virtually self-sufficient, a hive of activity. My grandmother ruled the household as a wise and practical woman – exactly as is described in the Bible:

She seeketh wool and flax, and worketh willingly with her hands . . .
She considereth a field, and buyeth it: with the fruit of her hands she
planteth a vineyard . . .
She perceiveth her merchandise is good: her candle goeth not out by
night.
She layeth her hands to the spindle, and her hands hold the distaff . . .

The Book of Proverbs did not seem remote and strange to us –
rather it described our daily life. If only it had mentioned my grand-
mother's skill in rice-wine-making, the picture would have been com-
plete. Grandma competed in the art with her sister-in-law Mu Kya,
the 'ex-copper angel' – the term with which we oddly teased women
who had given up wearing the rings around their necks. (Although
foreigners always talk of 'giraffe women', this was a term we had hardly
heard of. An uncle who picked it up so infuriated my grandmother
by using it of her that she would throw firewood at him.)

Above the fireplace in Grandma's kitchen, beneath the sooty shelf
(our houses lacked chimneys, and the smoke had to find its own way
out through holes cut in the gables) hung a huge amount of dried
meat – beef, wild boar, rats, fish, game birds, moles, snake – and above
that were herbs of all kinds. In the corners of the store-room were
huge bags of pounded rice, while big pots of rice-wine were being
brewed, swamped with clouds of rice-wine gnats. We had no trouble
from mosquitoes there, for they hate the yeast that rises from the
rice-wine as it brews. Beneath the roof, sheaves of maize and millet
hung from the beams on bamboo poles. Grandma's cat always roamed
above the beams protecting the grain from rodents. Geckos and wall-
lizards were constant visitors to the walls – propitious and sacred
creatures that preyed on small insects. The floor of the house had to
be swept every day with elephant-grass brushes.

After my two younger brothers were born, my parents decided that
I should sleep in my grandparents' room. The younger ones were not
allowed to sleep there until they learned to control the calls of nature.
They all slept in the bed between my mother and father, until a new
brother or sister came along, when one of the older ones would gradu-
ate to the grandparents' room.

To sleep with the grandparents was an immense privilege, because
it meant we had the joy of hearing folklore and fantastical stories.
Except for a few school textbooks and my father's veterinary reports,

there were no books at all in the house. Nor was there television. Radio was a source of merely alien legends, and so my grandmother's role as oracle and story-teller came into its own. As with the myths of the tribe, so with my grandmother's stories – Grandpa would lie quietly in the darkness, occasionally confirming her stories, extraordinary as they were, with grave remarks such as, 'That is what my mother used to tell me.' We had to massage her before she consented to begin her stories. It sometimes seemed to take hours of massaging before the story came, almost as though we were getting the spirits to come to a shaman. If we stopped massaging her she would stop telling the story. Often she would fall asleep in mid-flow, and we would have to wait for the next night. It was a bit like the *Arabian Nights*.

Grandma's stories usually lacked happy endings. The heroes or heroines would end up being killed or eaten by *khimakhas* or punished by the gods. There were two stories that took her two or three years to finish, so skilled was she in the techniques of postponement and elaboration. Naturally we would beg her to resume, and she would do so provided we were on our best behaviour and she was in a good mood. We would ask her to repeat our favourite bits again and again. She varied the theme and didactic purpose of the story according to her mood of the moment. This is a greatly condensed version of a favourite story entitled 'The Seven Beautiful Sisters', with the subtitle 'Why Peacock Feathers are Beautiful and Owls are Ugly':

'There once lived seven sisters who were vain and idle. They spent their time preening themselves and singing. So they attracted the attentions of a carnivorous *khimakha*, who was prowling in search of flesh. He was as tall as a tree and ugly as a buffalo. He understood neither music nor singing. All he knew was eating, especially the flesh of young girls. The sisters sought to protect themselves by building seven walls. Nevertheless the *khimakha*-yeti destroyed their walls, and they had to flee and fall silent.

'The birds wished to hear their singing, and to protect them surrounded them with seven mountains. They sang sweetly and happily for the birds until the *khimakha* caught up with them. They promised to do anything he demanded, provided only that he would spare their lives. In the end he gave them this challenge: they were to scatter seven barrels of sesame seed on sandy ground, and collect it all into baskets again within a day.

'They tried and failed, and were about to despair when the fowls

and birds came to their rescue, and gathered up all the seeds. The *khimakha* still ravenously desired to eat the sisters, so again they fled. The birds helped them by wiping away their footprints. But a fly who hoped to eat the *khimakha*'s leftovers led him after the sisters.

'They climbed up dangling creepers to a rocky promontory, and took their rest by a small pond. The *khimakha* saw their images in the pond, and thinking they were in the water, drank it all up. Then his stomach exploded, and vipers and other snakes came out of it. The seven sisters prayed, and God metamorphosed them into peacocks – all except the youngest. Because she did not become a peacock, she wept more and more copiously, until her tears were transformed into jewels on the feathers of her sisters. On the seventh day her eyes became rounder and rounder, and she turned into an owl. Seeing her own image in a glass, she became ashamed at her own ugliness, and flew away. That is why owls come out only at night.'

The story had a strange effect on us. It made us sympathetic to birds for a while, and we actually stopped shooting them for a few weeks. Grandma did not only think that owls were ugly – she also believed that eating the meat of an owl brings bad luck. Once I caught an owl and prepared to cook it. Grandma told me not to do so, but instead to talk to it thus: 'Now, I spare your life. When in the future my life is in danger, help me to escape the peril. Now I release you. You go your way, and I mine. Fly away!' And I released it. Years later, when I was in the greatest danger, that memory became charged with significance for me.

My grandmother's attitude to animals was entirely without senti-ment. It was more a matter of knowing the rules of mutual dependence, which produced respect. You were not to kill animals in the mating season or when they were producing young, otherwise you would one day be cursed with the same harm you were inflicting on them. You could say that she respected animals the way she understood her own family.

She would often give food to wild animals, expecting this to influ-ence their behaviour. She talked to them as she talked to her own grandchildren, nagging them the way she nagged us. At her farm-strips she would talk to the ants and instruct them not to take her lunch before she ate it. 'I will give you some lunch, all in good time,' she would say. She then went to work in the fields. Lunchtime came and we went back to the hut, where, to my surprise, no ant had eaten her

food. They circled round it but made no attempt to invade. Before settling down to her lunch, she would give them a scoop of rice. She also left some for the crows and foxes who regularly visited her before she went home each evening.

After a day's work in the farm or jungle, we had to call back our guardian spirits – called '*Yaula*' – before returning home. '*Yaula*' literally means 'the shadow beneath', and in our minds it normally takes the shape of a butterfly. When someone dies his *Yaula* turns into a ghost. And our *Yaula* can leave us if we are terrified or injured. The *Yaula* presides over all our daily activities. Health, humour and success all depend on it. Someone with a satiric or bitter disposition is regarded as not having good *Yaula*, and their prospects for a happy life are poor.

If someone falls ill, it is vital to call back his or her *Yaula* if they are to recover from the illness. The shamans or the elders have the task of enticing the *Yaula* back into the sick person. Food, libations and other offerings are prepared, and then the shaman or elder enquires of the spirit where it was lost. They then go to the place where the *Yaula* is thought to be caught or entangled. This is usually on trees near a cemetery or some other ill-omened place or, in the case of someone who has been injured, the place where he suffered his accident.

Having arrived at the scene, the shaman pleads with the *Yaula*, very courteously, to come home, and when he senses it is inclined to return, he drops a trail of rice grains on the ground to guide it back. Sometimes he will tie a cotton thread to the tree and suggest to the spirit that it follow that, just in case birds eat the grains, creating the danger that the *Yaula* might get lost.

Everyone celebrates the return of the spirit with a feast. The elders tie cotton threads around the wrists of the person whose *Yaula* has been restored, all the while pouring out blessings and thanksgiving. Before he may join in the feast, the patient ritually washes the hands of the elders.

Similar ceremonies are performed for people who are about to travel to faraway places, in order to invoke the blessing and protection of the ancestors for the journey. For us, faraway places might mean anywhere out of our own state, such as Rangoon or Mandalay. When my grandmother and grandfather were taken by the circus to the inconceivably far-off country of England, the ceremonies were performed with the fullest solemnity. We have a deep fear that if we are

long exiled from our land and our people, our *Yaula* might be irretrievably lost, and with it all our happiness and good fortune.

Our *Yaula* ceremonies might sometimes be performed to remember our dead, and to cherish the lives of the living. When that happened a thanksgiving Mass would very likely be celebrated as well. The Church did not ban the animist ceremony, but we had to perform it discreetly and with mutual respect. We reconciled the two approaches by believing that while the traditional ceremony worked more quickly, the Christian ritual was an excellent guarantee for the long term.

My grandmother had her own way of reconciling the two faiths. She would kill a chicken, slitting its throat and offering its blood as a libation to the spirits of the farm after each Mass of thanksgiving. The priest told her that it was unnecessary to do that because the Mass had already pleased the highest God. But Grandma had her own reasons: 'The gods are like government officials. If you want things done quickly, you have to bribe the small ones.'

I was taught that our Christian God dwelt in the tabernacle above the high altar of the church. At the same time I shared my grandmother's sense that there were also smaller gods. I explored the caves beneath the Calvary Hill hoping to find them. The caves were overgrown with bamboo groves, trees and undergrowth. To reach the entrances you had to follow the trails of animals. When you got to the mouths of the caves the first thing you noticed was the smell of bat droppings. The entrance of the largest cave seemed like the mouth of some huge living creature, with its hanging stalactites and jutting stalagmites. The bats hanging from the roof of the cave seemed to me like drops of blood on the skin of an animal, for I saw the interior of the cave as like the massively rough skin of a buffalo, and the clusters of hanging bats like lesions on the skin caused by leeches and flies. Behind the ithyphallic pillars I could see a dark tunnel going down, and could hear water dropping in the dark onto stones and into a subterranean stream.

Each stone pillar was an individual being to me. I came to see them as my actual ancestors, some tall and thin, others short and fat. They changed their hues, and perhaps their humours, according to the weather. I sensed that I was connected with the world of the dead, and with spirits of the tribe who had been half forgotten because of the new religion. So I felt both thrilled and guilty. I wondered whether the spirits of the dead would go out from here into the world again,

or whether they remained here for ever, resenting their semi-oblivion. It was like standing between life and death, the living and the dead, the real world and the world of dreams.

Padaung girl

CHAPTER 5

Death of a Footballer

My grandfather never reconciled himself to the regime, and was recklessly fearless towards its local representatives. He believed absolutely in his role as a traditional ruler, and regarded with contempt the efforts of the government to interpose their local representatives between himself and his people. His confidence came in large part from the traditions not only of the Padaung and the other hill tribes, but also of the Burmans. There are five tiers of authority in a traditional Burmese community which command the respect of the people: God holds the highest position, followed by the teachings or *dhamma* of the Buddha, the whole community of the monks – the *sangha* – parents and teachers respectively. Rooted in these traditions, people revere and are ready to listen to their monks and priests. This leaves hardly any place for deference to representatives of the government, especially now that the old, sacred monarchy of Burma is no more. Our loyalty is to our religion and our community. There is no room for any ideology that claims to compete with these, let alone to transcend them. The only thing that might make headway with the people would be a system that actually provided for their physical needs, leaving aside their spiritual aspirations, better than their religion does. The regime could not do even that.

The Burmese Road to Socialism claimed to be a blend of nationalism, Buddhism and socialist economic and political theory. It claimed that it would produce prosperity and 'end the exploitation of man by man'. But of all Third World despotic regimes it was one of the least intelligent, and one whose promises rang extraordinarily hollow. One American ambassador to Burma, Burt Levin, was later to say that the Burmese army had no political instincts whatsoever. And the army ran the regime. Army officers retired to run the boards of the nationalised industries with exemplary ignorance and inefficiency.

The result was that the gap between promises and what was delivered, slogans and reality, was comically wide. Apart from repression, the main effort of the regime went into slogans and gestures. Farmers who could not afford to buy grain for their families had to attend rallies at crucial moments in the harvest to shout slogans glorifying the regime's agricultural policy. The rulers seemed satisfied with such compliance, as though all they really believed in was word-magic. They tirelessly covered the countryside with giant billboards glorifying the *Tatmadaw* as the mother and father of the country, the guarantee of the integrity of the Socialist Union of Burma, defender of the country from the American-Soviet-colonialist conspiracy against Burma and their 'treacherous minions' within the country. They knew, and we knew – and they knew that we knew – that it was all fantasy, that living conditions were getting worse and worse as a once prosperous, rice-exporting country slid towards a subsistence economy. They simply held on to the magic of repetitious propaganda. They were therefore liable to be discomfited when anyone pointed out that the emperor had no clothes.

This my grandfather did without regard for the consequences. He shattered taboos without subtlety, but also without fear. When officials came to demand that he organise his tribe in political rallies, he would respond with astonishing aggression. He would denounce General U Ne Win, before whose portrait every child bowed every school day throughout the land, as a half-Chinese impostor who had conned the Burmans into submitting to him. Having started on that track he would denounce the Chinese as one of the cruellest peoples on earth, capable of killing their fellow countrymen in the millions. The Burmese regime were mere plagiarists of the genocidal polices of Mao Tse Tung, pedants and ignoramuses: 'I am the chief of my people and will always be the chief whatever you do to me.'

The officials were unsure at first how to react to this, how to cope with a man who carried on his own private warfare against the government. He even refused to fill out the official forms for the national census, which he was supposed to do on behalf of the tribe. They tried to humiliate him by demanding his educational qualifications, knowing he had left school at an early age. His reply to that was: 'Not to be underestimated.' He was fighting against impossible odds, but he fought like a man.

The civilian militia of our town was under the control of a distant

nephew of my grandfather, a man called Eugene. He had been trained by the Burma Socialist Programme Party in Rangoon in the early sixties. They had promised him power in Phekhon overshadowing that of my grandfather if he could drum up the support of the Padaung for the ruling party. He was never able to do that but, with the help of the regime, he assembled an arsenal of German automatic rifles and Enfield rifles from the First World War, with which he hoped to intimidate the locals into supporting the army and the regime. He held morale-raising rallies for his few collaborators every week at the township football ground and in front of government offices. My grandfather openly ridiculed Eugene, and made it plain that he regarded him as a mere puppet with no claim to rule at all.

The situation could not be allowed to go on. They arrested my grandfather, cajoled, coaxed and threatened him. They beat him up, and arrested and brutalised some of his followers. In reply he uttered a traditional curse, the imprecations of which included condemning them to be eaten by maggots. He ended with an emphatic spit on the ground, turned away from his tormentors and walked off with his followers while the officials jeered nervously. Grandpa then went to the cemetery with some shamans to inform his ancestors of the curse and invoke their support. With the shamans he held a ghost-raising ceremony. It was bizarre and frightening.

The punishment was not long in coming. One night there were heavy footsteps on the stairs and hallway of our house and the soldiers burst in. When my father and grandfather opened the upstairs doors we saw armed men in army uniform pointing their machine-guns at them. They were taken away into the darkness along with our bullock cart and our two bulls.

We felt defenceless without the two grown men, and fearful because we knew that they had been taken to the front lines, where the army was fighting the ethnic rebels, to act as porters for ammunition and as landmine sweepers. News from the front lines was sporadic, and all the family could do was assemble in front of the shrine and pray to the Virgin Mary that they would return unharmed.

Several times my father and grandfather were taken away by the soldiers, but each time they did return. Sometimes they would come home with only one bull. The army had eaten the other as a patriotic 'contribution' on the part of my family. It would take my father a month to find another bull fit for work, and it cost him dear. The

cart was like our family car and the bulls were its twin engines. The cart could only be used with two bulls, and it took a long time to train them to work together.

By the mid-1970s, the army was becoming desperate. They were being comprehensively defeated by the rebels on the Chinese and Thai borders. Their convoys were attacked and soldiers killed *en masse*. Their camps were regularly raided and the troops massacred. The rebels even attacked the Kayah State capital, Loikaw, on more than one occasion. It was then that the army, especially the officers, began to use civilians as human shields in their battles against the rebels. Soldiers were infiltrated among civilian travellers, and the civilians would be seized and forced to carry supplies and ammunition to the fronts. Since they were seized while on a journey rather than from near their homes, no one could know what had happened to them. Women, children and old people were conscripted and compelled to work on road construction without wages. The government called this 'volunteer labour'.

For a time this use of civilian forced labour began to turn the tide for the government, and there was a period in the late seventies when they started to win battles. Yet still the numbers of the rebels grew steadily. The Burma Communist Party guerrillas in the north-east of the country were growing more powerful and more daring, helped by supplies of arms from the Chinese Communists. The Karens consolidated their fighting power by building up their income from taxing traders and loggers as they passed back and forth across the Thai–Burma border.

The rebels attacked the pylons which carried electricity to Central Burma from the Lawpita hydro-electric plant. Government soldiers responded by planting landmines around the pylons rather as though they were planting bulbs. Animals got blown up – we lost several working bulls and buffaloes. Some children were killed. Then the army ordered us to build fences around the minefields. We did so. The rebels defused the mines and blew up the pylons again. The army replanted the mines and insisted that the villagers guard them day and night. Then the rebels blasted the hydro-electric plant itself.

We children (I was about eight at the time) made our own contribution. We would trigger off the government mines by shooting at them with catapults and prodding them with long bamboo poles, running away before we could be caught. We were not sure whether

the rebels were criminals, headhunting Indians, baby-eating Chinese, or Communist and British stooges, but we very much wanted to play this serious game.

My grandfather, though, was sure what he thought. The worst regime he could remember was that of the Japanese – and they turned out to be the old friends of the present regime. He felt vindicated.

Football and the Padaung

The Padaung have a talent for football, and they play it with all their hearts. The highest Padaung ambition was to become a member of Phekhon Township football team, which was famous for its prowess throughout the whole south-east Shan State. The players were mostly fuelled by Padaung whisky and rice-wine, which had to be supplied in gallons for each game. Over many years they lifted a large number of trophies. My uncles were always in the team.

The relatives of the players – in fact, virtually the whole town – travelled to Taunggyi to cheer the team on, even though hardly any of them could afford the journey. Wives and mothers would let their sons and husbands off work for a while if they won the finals. There was no radio or television coverage of the games, and the news of the results only reached our town days after the matches had been played, usually in the middle of the night when the fans got back from Taunggyi in trucks. If the team lost in the early rounds of the tournament, they would not dare show their faces for days, but lay low, licking their wounds in shame. But they never blamed any individual player for the failure.

The football season lasted only a month at the top level. Although the Padaung players were mostly farmers, and therefore amateurs (there were no professional players in the whole of Burma), they were very fit from the heavy work on the farms and from climbing mountains. They trained whenever they could take a few hours off from work. Those who made it to the final rounds were allowed a free trip to Taunggyi by truck. The town council managed to squeeze out minute funds for their accommodation and food, but it was never enough. Food was so short that on one occasion the team ate a dead dog that they found knocked down on the road by a car. An old woman who lived nearby gave them some money to take the dog away and clear up the mess. She assumed they were going to bury it, having

no idea that the Padaung regard dogs as perfectly edible. If the players were lucky they would be allowed to sleep under the stands along with the cockroaches, ants and rats. Taunggyi was the nearest thing to the big, wide world, but they would often not have enough money even to get out and see the limited sights of the town.

One player always went to the town centre every morning after training, leaving the others to go to the cinema. If there was no game he would spend the whole day drinking a single pot of tea in the café. We asked him what he did, and he said that he had been watching the most powerful man in town. It turned out that he loved watching a traffic policeman at work. He had never seen one before. He said: 'You see, when he raises his hand, all the cars stop. And when he says "Go," the cars have to go. Isn't he the most powerful man in town?' He was certainly not joking. Every year he came back to watch the traffic police.

One of our schoolmasters was captain of the squad, so every year in which the football team won the trophy in Taunggyi there was a school holiday. The whole town would turn out to welcome the triumphant players, and the Phekhon brass band would play 'See, the Conquering Hero Comes' from Handel's *Judas Maccabaeus*, which the Italian priests had taught us. For every player this was the greatest moment in his life.

Football games were also great social events, and were accompanied by an enormous amount of drinking, and by dancing. The winning teams were rewarded with a dozen barrels of soap, and a barrel of rice-wine for the celebrations. The town council once made the mistake of handing out only boxes of matches as the prize. In their rage the players burnt the goalposts and nets.

Sometimes the games led to violence and outbreaks of serious fighting. Anything could set it off, from a bad referee's decision to poor management of the crowd. Here the traditional authority of the chiefs and tribal elders came into play, for they alone could control the people and be listened to with respect. The government were anxious to break their authority, and would often insist on sending in the police. Since the local tribes detested the police – whom they regarded as aliens, corrupt and treacherous, with their Enfield rifles and uniforms that were completely unlike our Padaung styles of dress – this led to pitched battles. The fans forgot their differences and united against the police. There were even gun battles.

Uncle Yew

Uncle Yew, the hero of my childhood, was now a tall, handsome man in his mid-twenties, captain and goalkeeper of the township football team. He had been selected to be the keeper of the Burma national squad, but turned it down because he could not bear being away from his wife and children.

One cool evening, as he sat drinking and talking with his friends, Uncle Yew was approached from behind and stabbed by a drunken Shan who was infatuated with Yew's wife. The sword blade entered his ribcage on the left, passed through his stomach and came out on the other side, missing his heart by an inch. He forgave his attacker, but his friends threatened to kill the relatives and friends of the culprit and burn their houses if they did not hand him over to them. The police were powerless to keep order, and it was only the parish priest who was able to restrain them at the very last moment.

In the middle of the night his friends and relatives took Yew to Loikaw General Hospital, twenty-five miles away on a bumpy and dusty road that was hardly more than a dirt track. There was no ambulance or any significant medical care in Phekhon. He was bleeding badly, but there was no means of giving him a blood transfusion. They covered his wounds with iodised cotton wool. There were tears in his eyes from the intense pain he was enduring, but still he smiled. His wife, his parents and sisters wept with grief and anger all the way to the hospital. 'Don't cry, I will survive, I will not leave you,' he said to comfort them. They talked to him all the way to the hospital, so that he would not give up and leave them. With every bump of the car it seemed we were about to lose him. The bumps made him cough up blood, and his eyes turned white. After three hours the car reached the hospital, just in time. His wife fainted with exhaustion – she was pregnant with their third child, so both of them ended up in hospital together. For me this was the expulsion from my childhood paradise where suffering did not exist.

A month later they came back home together. Yew was still smiling, and walked with his wife, proud of her protruding belly. We would often visit them, helping them and keeping them entertained until their child was born. It was a girl, and they were comforted. Uncle Yew's health also improved greatly. Life became normal again for a while. I often spent nights with them – gloomy nights that always

gleamed with their smiles above the candlelight. Yet I knew that our happiness was just as frail as the candlelight in the dark, flickering with every wind that blew. Yew did not play football with the confidence he used to have, and he, more than anyone else, seemed to have a sense of his fate. But he played with the same success as before, and his younger brothers followed in his footsteps.

While Uncle Yew was recuperating, his best friend, a schoolteacher, was shot dead by rebels who mistook the party he was travelling with for a group of army officers. In fact they were social workers who were trying to teach the hill tribes about anti-malarial medicines. Uncle Yew felt guilty, because he was supposed to have been with the group rather than his friend. The overall leader of the rebels was a great friend of the man they killed, so he executed the rebel who had shot his and Uncle Yew's friend. A further complication arose when the dead man's wife threatened to kill herself in despair at the death of her husband. Luckily, the brother of the dead man, who was a bachelor, promised to take care of her and her children – and eventually married her.

The death of his best friend seemed to affect Uncle Yew's health and morale. Two or three years later he died from his wounds, which had never completely healed. He asked his father to cook him an especially delicious meal the day before he died, but never managed to touch it. My tribe say that a dying man always asks for the things he most loves before he dies. Nobody else had any idea that Yew was going to die. The curry he had asked for was packed neatly and put into his coffin for him to eat on his nearer journey to another world.

I spent three nights in a row singing in his wake until the morning of the funeral. I watched his corpse right up to the point of burial in case he might wake up like Lazarus. Since then I have not feared the dead. Yew's mother sang a traditional dirge to guide him to the underworld. We wrapped him in a home-woven xilinous blanket and put him in the coffin, with his food and drink and a coin in his mouth for payment in another world, and carried him to the church.

After the Requiem Mass the priest blessed the coffin. A pungent and putrid smell came out as the morning heat increased. Despair touched my heart. My hero was really decaying and was about to be buried. At the cemetery, the priest blessed the grave and the coffin again. My youthful hope sank as they lowered Yew's coffin into the grave to the faltering sounds of 'Nearer, my God, to Thee' played by

the Phekhon band. I was asked to be the first to throw clay into the grave. When 'Auld Lang Syne' was played and he was buried and gone, I looked at the wooden cross, marked 'RIP, PETER YEW', with the dates of his birth and death. His eternal youth was commemorated in a pile of dust under an auspicious rising sun.

Last thing of all, his father bade him farewell in front of us all: 'Well done, my boy. Well done, Peter Yew, for you have made us proud. You have finished your hunting. Enjoy being with our ancestors for ever; enjoy the banquet with them. They await you, and we will join you when the time comes. Meanwhile tell our ancestors about us, tell them to help us, and to protect us from the evil powers. Ask them to make our land fertile, to bring good weather and rains for us, to make our women fertile. Go my son, go, back to our ancestors. May your journey be gentle and your soul bright as the stars.'

I was thrilled. It was like the end of a football match which our team had won.

Death of a Sister

Another uneventful summer arrived. The monotonous song of the lonely cuckoo terrorised the horizon. Cicadas joined the cuckoo in the maddening chorus that was the hot season. I missed the migrating birds, the scarlet minivets who stayed with us during the cold season and liked to perch on the tops of trees in small groups, feeding on the nectar of flowers. During the summer months they vanished to cooler climes. Summer was a time for us to sing about their beauty and their songs, in memory of missing friends and lovers.

In the summer, all the old leaves dropped from the trees, except from some pine trees; the forests were naked. It was time to catch cicadas. Some edible cicadas swarmed on the bark of barren trees. We caught them with sticks smeared with sticky birdlime. Fried cicadas could be eaten as snacks or enjoyed as an accompaniment to meals. Boiled cicadas with rice soup could cure eye rashes, it was said. Roasted cicadas and crickets with a pinch of salt tasted like salted crisps. The sounds of the cicadas varied greatly, the small ones producing a horribly monotonous sound that almost drove us mad. Then there was one that only sounded out at four o'clock in the afternoon, and the pattern of whose noises told us what the weather was going to be. The pink and white lilies blossomed in abundance around the church

at Easter. But during summer everything seemed dead and lethargic.

When the sounds of the cicadas and the lonely calls of the cuckoos died down, it was the eve of the monsoon. During the rainy season wild mushrooms and truffles sprang up – the best of the seasonal fungi. The middle of the monsoon was the time to pick the young shoots from the bamboo groves.

Late summer brought the young leaves and flowers of wild vegetables. The tender leaves of tamarind trees were sour, but could be eaten as salad or boiled for soup. The sourness quenches thirst and whets one's appetite. It also cools the stomach. The task of picking the leaves of the tamarind gave me an excuse to play with friends in the tamarind tree. We chased each other, jumping from branch to branch like monkeys. Some children would fall off and seriously hurt themselves. We played until we were exhausted, but still came home with our bags of tamarind leaves. Young banyan leaves were also eaten as vegetables.

I spent the summers with my friends hunting, swimming, singing, working in the fields and fishing. Occasionally we would spend the whole day swimming in the lake and basking like snakes on boulders in the sunshine, dreaming of the future. One hot evening as I returned from the jungle I found my mother sitting at the foot of the stairs weeping. She looked to me like a cross between a *Pietà* and a girl who had lost her doll. I learned that my oldest sister, Paula, had died from typhoid. Paula was only four years old. She escaped like a butterfly under my hands. She seemed hardly to have lived – but for that very reason I felt that she did not really die. She remained with us, a diffuse and sacred presence. My father was inconsolable. He loved Paula and pampered her as a special gift from God. She was his first daughter after three sons, and the first death in the family. He found her death impossible to accept. My mother could not comfort him, and they ended up quarrelling. He began to drink heavily again. Nights of vigil and anxiety exhausted my mother and her milk dried up.

My father reverted to his old, hopeless behaviour. He drank tea and rice-whisky, and rarely ate. When he was drunk he would sit tuning his transistor radio from station to station like a man possessed. Eventually my mother's patience snapped. She snatched the radio from him and smashed it to pieces. At last the evil spell of the radio was broken, and with it, strangely, vanished my father's faith in the promises of the Burma Socialist Programme Party and the government.

He stopped listening to the radio and found solace in religion. He began to go to church and took pleasure in prayer and in listening to sermons. He became more affectionate to my mother (although I never saw them kiss one another in my life) and to us children.

At the age of ten I passed my primary examinations and began in the fifth standard. This was one of the most exciting periods of my life as I reached puberty and began to learn the English alphabet and some words. What made it even more exciting was that the English teacher was notoriously harsh – her reputation had spread throughout the school. She had many forms of punishment in her repertoire, from knocking our knuckles with pieces of wood, to making us kneel on splintered pebbles in the sun for hours in front of the school. These were punishments for mistakes in English spelling or for not doing homework. But the real reason for them was that she was passionately anxious for us to learn English. The government had officially abolished the teaching of English in schools, and found ways of discouraging us from learning it. All the essential texts were translated – usually very badly – into Burmese. Any text that seemed too difficult to translate, which included many scientific texts, was simply discarded.

By the middle of the academic year I could show off my knowledge of English by reciting nursery rhymes, including 'Black-Eyed Susan', 'Hickory Dickory Dock' and 'Baa Baa Black Sheep'. But young as I was, I began to notice that something was changing in our lessons. We seemed to hear more and more about obedience and good citizenship, at the expense of traditional teaching. Instead of our own, or even Burman, stories and legends, for instance, we were told about the heroic deeds of the Thirty Comrades – the Thakins who had combined with the Japanese against the British – amongst which those attributed to Ne Win figured prominently. I found myself rebelling against this, even though I could not have formulated the thought that education was being invaded by political brainwashing. But at about this time, English language was reintroduced as a subject at elementary-school level. The reason was that Ne Win's daughter and favourite child, Sanda Win, had applied to study medicine in London, but had been rejected because her English was not up to standard.

Hunters and Hunted

In 1977 we were finally told that the Americans had landed on the moon. We watched the full moon from the balcony at nights in case we saw their spaceships and they waved to us. We also heard that Elvis Presley was dead. Uncle Eugene and his friends were all distraught. Elvis Presley represented everything that all of us – in the face of incessant government anti-American propaganda – loved about the United States. Indeed, he was just about all we knew about America. They stopped playing any music except the songs of the King. Elvis Presley songs dominated our town for several weeks. I had wondered who Elvis was, because I had not heard of him before, but then I realised he was one of the singers whose music I had heard every day on my father's radio. The government felt obliged to issue guidance to the effect that Presley was a decadent and depraved man whom young people should certainly not emulate. They went so far as to discourage youngsters from learning the guitar and denounced guitar-players as 'street ghosts' who wore their hair long and dressed in decadent tight trousers instead of the traditional *longyi*.

About this time a group of Japanese Second World War veterans came back with members of their families to dig up the bones of their dead. When the tide of war turned in 1944, my grandfather and his friends killed very many of the Japanese occupiers. Some were buried around the edges of the churchyard so that they could serve as guardian spirits. Others – the ones who were believed to have committed the worst crimes, in the form of murders and rapes – were left hanging alive from poles over deep natural pits until they perished.

The Japanese sobbed when they found the bones of their comrades and loved ones – and my grandfather and his friends wept along

with them. They had a meal together, drank rice-wine and exchanged memories. It was amazing and moving to see these old men becoming reconciled to each other before they died.

As for the Japanese who had been hung over pits, and whose remains could not be recovered, their spirits were exorcised by priests and shamans and ordered to make their way back to Japan. Before they left, the Japanese urged us to visit their country in cherry-blossom-viewing time, so that we would get a sense of them as different from the occupiers who had brutalised and murdered our people. Not only would it have been impossible for us to afford that, the government would never have granted the necessary travel permits. They wanted to keep the new relationship with Japan to themselves. So this surprising and unexpected friendship was never allowed to blossom.

Year after year the rainy season passed and the cold season brought its beautiful dews, only for us to be robbed of them as the scorching summer advanced. In these years we noticed that the weather had become less predictable, and crops failed every now and then. Weddings became rare events and funerals were frequent. Some of my own friends died in accidents or from stepping on landmines, and their deaths, following the death of Uncle Yew, began to give me for the first time a realisation that the things I valued were not eternal. As I began to sense the uncertainties of human life I sought more and more the companionship of animals.

I began hunting animals when I was very young, and it was through hunting them that I began to love them – for the hunter does indeed love his prey. Or rather, it was through hunting that I came to know and therefore to respect every sort of animal. For instance, I began by hating crows because I found their scavenging repulsive. I tried persistently to kill them, but they were always able to fly away before I had time to take proper aim with my catapult. Through this obsessive interest in the crows I began to observe how delicate their movements were, and how acute was their sensitivity. They seemed able to smell, see and hear dangers from afar with extraordinary sharpness, and were always on the alert and ready to warn their comrades. In the end I lost any relish in hunting them and left them alone. I began to see why the Buddhists regarded crows as sacred birds, symbols of transience and decay. Their sacredness comes from their exceptional sense

of danger, especially danger of death, and because they will eat corpses. In Buddhist tradition they are messengers of death.

At weekends sons and fathers went fishing. We had four traditional ways of catching fish: angling with bamboo sticks, diving, netting and scooping with baskets. My own speciality was diving. To become adept at catching fish by diving we practised staying underwater, holding our breath for as long as two or three minutes, for we had neither goggles nor breathing apparatus. Agility of hands and fingers and sensitive palms were essential if we were to distinguish fish from water-snakes. Although the bite of water-snakes was not lethal it was almost paralysingly painful. You also needed nerve and skill to catch hold of catfish, for they have fins of razor sharpness.

The creatures I hated most were water-leeches, which lived wherever there was plenty of fish, and especially in muddy ponds. They climbed onto the most sensitive part of your body and sucked the blood until they became plump and ball-shaped. Only then did you feel the irritation between your legs. They would not drop off easily but stuck obstinately to the flesh like a second, unerect but engorged penis. The only way to get rid of them was by rubbing them with salt and tobacco. Sometimes we would lure leeches to the verge of the pond by making squelching noises on the water – which somehow attracted them – then pick them out and throw them to the ground. Having rendered them helpless we turned them inside out and dried them in the sun.

The jungles offered us boys an abundance of animals to hunt and therefore an abundance of pleasure. We forgot the outside world as soon as we entered the jungle, so absorbed were we in the chase. We brought with us catapults and clay pellets, bows and arrows, machetes and hoes. We would have spent some of the day before rolling and drying the clay pellets, trimming bamboo arrows and collecting bird-lime from banyan trees to snare cicadas and birds. Once in a while we made guns for ourselves, using umbrella handles for the barrels and pounding gunpowder from saltpetre, charcoal and bats' droppings. As might have been expected, our recklessness and ignorance led to frequent accidents. The guns often blew up in our faces when we tried to fire them, and the gunpowder mixture often exploded as we pounded it. In the end we gave up making our own gunpowder, except when we were building home-made rockets for competitions and celebrations that we held to honour the *Nats*.

The rocket celebrations always followed prayers and sermons by

the Buddhist monks. The rockets are supposed to encourage the spirits of the sky to pour down rain on the earth at the time when we were awaiting the monsoon. Rockets and their bamboo tails were carried around the fields with dancing and the beat of gongs and drums. Then we released them with rocket-praising chants: 'Linlo, linlo. Ryauk! Our rocket! It can fly. Ryauk! Into the sky! Ryauk!' I still have no idea what 'linlo' or 'ryauk' mean.

Every evening we practised shooting with our bows and catapults. Our targets were my grandfather's orange and mango trees. We were only allowed to shoot at ripe fruit, and had to bring it down by hitting the stem so that the fruit could still be eaten. The rampaging house rats were also good for shooting practice. I became a useful goalkeeper by learning to catch rats with my bare hands without getting bitten.

Before every hunt we consulted a spirit-medium to discover what the spirits of the jungle required of us and how successful we were likely to be that day. We perpetually strove to keep in with the *Nats* and secure their good will, believing that they would help us if we propitiated them. Before entering the jungle we offered them food and libations, candles and incense. We made sacrifices of rice, rice-wine and incense in the spirit house situated at the entrance of the village surrounded by immense trees and dense foliage. We also paid attention to omens. If a snake crossed our path, that meant bad luck, and we avoided the path. If a stag strayed into the village, it had to be hunted down and killed, for it was believed to bring bad luck on the entire village. The only way to exorcise the bad luck was by eating the animal. Observing the host of taboos, even when we had no idea what they meant, became second nature.

As soon as we entered the jungle we had to be quiet and on the alert for our prey and for the animals which preyed on us. The most savage were the soldier bees and the poisonous snakes, especially hamadryads (king cobras). The soldier bees attacked without warning, swooping at our heads as soon as we entered their territory. If there were territorial disputes between two swarms of bees, they would fight until one side lost all its soldiers, and the rest had surrendered to the conquerors. First there would be ever-increasing buzzing noises as the tension built up. Each side would take up position on adjacent trees. Then the soldiers from both sides rushed into the space between them for a desperate clash. Popping sounds ensued as the dead soldiers

dropped to the ground, piling up in heaps in no time. The battle done, the conquerors rushed to the defeated hive, bit the wings off their remaining victims and carried them to their own hive, where they were forced to build cells for the victors – becoming, in effect, slaves.

Whoever among us saw a hive first could claim it for his own by marking the tree. He could then come back to it when the honey was ready for harvesting, which was once a year (no one ever purloined the honey from a hive that had been claimed by someone else). We used the branches on which the bees built their hives as fertility rods, beating the buttocks of animals and people to make them fertile. One difference between the Padaungs and Burmans is that for us a wild-bee nest near one's house portends prosperity, but for the Burmans, disaster.

There are three edible kinds of hornet. One, the biggest, nests underground. The second nests on tree-trunks, cliffs and anywhere high, even electricity pylons. The third nests near houses. We used to harvest the baby hornets when they were well-developed and tender, by smoking their nests at night. The ground hornets are the easiest to hunt, the art lying in the technique of smoking their nests. Too much smoke can kill the queen, and too little can put the hunter's own life at risk. After you take the cells of the babies you have to leave the nest quickly to allow the queen to recover without being too much disturbed.

The meat of the baby wasps is tender, and the taste is somewhere between scrambled egg and roasted prawn, depending on how mature they are. They taste most delicious when they are about to turn into adult wasps. Then they are rich in protein and their texture is like milk chocolate. (Many years later, I was to read Lewis Carroll. My descriptions of these tastes sound quite like him, but are literally true.) They are best grilled and garnished with herbs and spices. We regarded wasps as a delicacy, which is why we tried to be so precise in describing their taste – rather like wine-lovers in Europe. The hollow wasp-cells were hung on the door of the house to drive away evil spirits, which we believed became confused by the configuration of the cells and avoided them. The Padaung think that ghosts can only understand and deal with straight lines, so the hexagons of bee-cells are beyond them. Evil spirits are not noted for their understanding of maths.

Bats were abundant in the cold season, when a certain sort of sweet berry proliferated. They were normally skinned and smoked above the

fireplace, and tasted more or less like rat: gamy in taste and crunchy in texture, more delicate than the flesh of cats and dogs. (The meat of wild cat had the texture of jungle fowl, but tasted like hare.)

In the summer we especially enjoyed dung-beetle hunting. First we searched for the beetle hills, which resembled molehills. The difference was that a beetle hill had on it traces of dry cow-dung with grass fibres. The age of the baby beetles inside could be predicted from the colour of the hill. Beneath each hill, about three feet down in a cavern hollowed out by the beetles, were the young, cocooned in round earthen balls about the size of tennis balls. The outer layers of the cocoons were of clay, and there was an inner layer of recycled dung. A baby beetle looks like an enormous maggot, about the size of an egg when young, and turns a golden colour when it matures and starts to look like a beetle. Baby beetles were delicacies prized as highly as young wasps by the Padaung. We eviscerated them, grilled and cooked them with ginger, garlic and wild herbs.

Green caterpillars from avocado and Sichuan pepper trees were also sought as food, as were the yellow ants which built their nests on trees by sewing up the leaves. We would harvest these nests and soak them in hot water. Yellow ants, which are sour in flavour, are eaten as medicinal food. We regard them as good for the stomach, their sourness being (according to our medical ideas) good for excessive heat if you have been poisoned by too hot a diet.

My parents and grandparents told me that I had the hands of 'life, healing, bounty and fire' – the power to heal and the power to kill. They told me gravely that I was not to use the power to kill unless I also used the power to heal and multiply. To exercise and develop my power to heal I was given many jobs. I would take part in ceremonies in which I had to hit sick or infertile people with rods. When rice or other seedlings were to be planted, I was expected to sacrifice chickens to the spirits of the farm, and to perform a ritual planting, making the hole for the first seeds. I was also supposed to have a beneficent influence over the livestock, and was given the task of making nests for the hens and hanging them on trees whenever my grandmother thought they were coming into laying in the next two or three days. After the chicks hatched, I had to 'release' them in another ritual and burn the old nests to ward off evil. When I asked my grandmother how she could tell that a hen was going to lay, she said: 'It always

makes desperate cries that only a woman can understand.' I could ask no more.

Whenever I visited my relatives, they would press upon me all sorts of gifts from their farms – puppies, kittens, chickens, birds, piglets and the like. The idea was that they would be bred under the protection of my name and my healing and multiplying powers, deceiving the spirits into thinking that they belonged to me rather than to the whole family.

So I grew up imbued with a sense of shamanistic, therapeutic power, with darker powers, as it were, in reserve. My father, practical and utilitarian as always, wanted me to become a vet like him, or else a medical doctor. But the sense of myself that had been bred into me had already given me a different idea, one related to the magical world I inhabited. I wanted to become a priest, a healer of souls, commander of greater spirits than the *Nats*. I would present myself with all my gifts to the Church, my people and my country. I wanted to become a saint and martyr.

The Shaking of the Dead

The breeze came, like a harbinger from our relatives in my mother's part of the country, sending their good will to us under a blazing sun. When the wind blew from the north-east, it brought the memory of our friends who were studying in Taunggyi. There were breezes and gusts coming from all directions. My grandmother Mu Wye told me to watch and see what they would bring to our town.

The twisting dust devils whirled and danced in the dry paddy fields. They usually herald a hot summer followed by earthquakes. Earthquakes tended to strike around noon or midnight. I watched as the wooden windows of our house flapped to and fro in a regular rhythm like the ears of bulls, sometimes in the dead of night, sometimes in the middle of a scorched day. It was as though our house was alive. When the quake stopped, the town became alive with agitated discussions of what it portended. The word 'earthquake' in Padaung literally means 'the shaking of the dead' – one of the two things we believe cause the tremors of the earth, the other being the stirrings of the big fish that guards 'the drum of desire'. I was more frightened by the idea that the dead were shaking our house than by the movements of the fish. I used to have arguments with my friends and my brother Peter about whether earthquakes were caused by the dead or the fish.

Births and Deaths

My mother was always in a desperate mood when she was about to give birth to a new baby. Her sense of the hopelessness of life in Burma, the feeling that we would always go on getting poorer, had taken its toll. 'Don't think I can't chase you now if you are naughty.

Wait until I have my baby, then I will catch you with a big stick.' She was a fast runner, as were all her family. An aunt of mine, her sister, once won a five-hundred-metre race when she was six months pregnant.

As soon as a baby was born, the midwife had to give it a name to prevent evil spirits from naming it themselves and claiming it as their own. The baby's father had to bake stones and put them into a clay pot filled with spring water in which jungle herbs had been steeped for the mother to sit on. My mother always gave birth in the kitchen, except once when she was taken by surprise and the baby was born while she worked in the fields.

No one except the father and the midwife was allowed to enter the birth room until the baby was a week old. The strange smell of herbs overpowered the whole house. Cotton threads were tied loosely around the baby's neck while charms were muttered into its ears. My mother was given a ceremonial massage to ease her pains. When all the ceremonies were finished, everyone washed their hands and sat down to eat a celebratory meal. Nothing could be eaten before these ceremonies if we were to avoid pollution. Then, our traditional rituals finally completed, the baby was taken to church to be baptised.

Meanwhile my father had to prepare a charm to put on the baby's fontanelle. For boys, a spider for industry and a piece of a bear's, tiger's or leopard's skin for courage and strength. For girls, a singing bird for beauty and charm. Cacti and the empty cells of bees and wasps were placed near the cross in front of the house to ward off evil spirits.

For two months my mother stayed strictly in the birth room, and strangers were absolutely prohibited from entering. Anyone who blundered in unknowingly during these first months of the baby's life had to pay compensation as a penalty for the intrusion. In earlier times strangers were not even allowed to enter the village after a baby was born. The village gates would be closed until the baby was sufficiently mature to be safe. Intruders were simply killed to make sure that no wicked spirits entered.

For me, the arrival of the newcomer meant more work. I had to learn how to make a hammock out of a blanket, wrap the baby up and carry it on my back in a bamboo basket. My mother breastfed the baby until the age of eighteen months (three or four years if no other baby came), when she weaned it with chewed rice.

* * *

From an early age I wondered what death might be. I wondered what it was like not to breathe, because my mother had told me that to die is to cease to breathe. If I was sulking, I tried hard not to breathe, and whenever I was unhappy I lay on my back and pretended to be dead. My feeling was that I would enjoy life more by understanding death.

As I grew older, death began to seem undesirable and unpleasant. In the first place, I learned that dying is not easy. I started to feel the repellent presence of death in different ways. First, I heard it, in the sound of church knells or funeral guns. Then I smelled it, first in the incense at funerals, and then in the odour of decomposition in the corpse itself. It changed its appearance like a chameleon as I grew up; it prowled on the balcony and corridors of my memory. My parents told me not to be afraid, not to be preoccupied with death, but they could not keep me from seeing that they were as afraid as I was. Yet these feelings were only a presentiment. It was not for another decade that I was to see death in so many of its grotesque and violent forms.

Death was divided into several types: normal death, death at childbirth (mother or child), death by plague, death by accident ('raw' death) and mysterious death. Those who died at childbirth required different burial grounds from those who died in accidents or plague. If a woman or a baby died in childbirth, the corpse would be kept at home for either one or three nights – odd numbers keeping evil fortune at bay – and hired sextons would bury the dead before noon.

If someone was murdered or died in an accident, this was categorised as a 'raw death'. The belief was that the deceased would become a 'green ghost' – the most feared of all the spirits. If someone dies a raw death, it is necessary to summon their spirit into the coffin before burial and to chase it away from the cemetery with gunfire after the burial.

Frog-drums were beaten in a special way to ward off evil spirits during wakes. The metal alloy of the drum was believed to possess a powerful vibration, a 'voice' that could deafen the hearing organs of evil spirits. Men and women would perform the funeral dances, circling around the coffin almost unceasingly the whole night, fuelled by rice-wine and food. The dances were intricate and were accompanied by the beating of drums and gongs, and the music of pan-pipes and singing, representing the life of the dead, from hunting to harvesting.

If the mourners wanted to express the courage of the deceased, they would mime his actions when he had gone hunting a bear, then mimic the bear itself. They would stamp to drive out the evil spirits, and would prance in a war dance to show that the dead man had been a warrior.

A professional mourner or shaman would harangue the soul and exhort it to start on its great journey to the spirit world, describing the way and warning of all the dangers it would encounter. Christianity had not managed to erase any of our traditions, but it had grafted itself on to them more or less successfully. We had been persuaded to adopt the words of Christian hymns in place of some of the traditional lyrics, but the music, which so obviously expressed a different spiritual world, was more or less unchanged.

The singing from the wakes haunted my nights, so bizarre did the tunes seem to my ears. Ululations accompanied by *klongs* – drums that resemble African tom-toms – would continue for three or four nights, mingling with the usual deafening nocturnal noise of the cicadas. If there had been deaths at the same time in different parts of the village the wailing and singing sounded even more uncanny – like the amplified droning of bees in their hives – produced by the Tibetan-style throat singing, with extremely deep men's voices joining the high-pitched ululations of the women. The singing sounded very alien, even though we knew the people who sang at the wakes, for it was as if a spirit had entered into them and they were no longer themselves. This was another sign of how the shamanistic tradition ran in all of us.

Early in the morning, the coffin was carried to the church, led by a flute band with a buffalo-skin drum, each beat of which sounded like a slow explosion. We lived very near the church, so the funeral processions always went past our house. We would close all the windows, gates and doors of the house so that the dead would not leave bad luck behind as they passed. We were taught to say, 'Go your way, don't come into our house,' or – just in case it was the stronger charm – 'Eternal rest grant unto them, O Lord, let perpetual light shine upon them. May they rest in peace.'

Death of a Pope

I hated the sounds of death knells, especially at night or early in the morning. The slow and monotonous tolling seemed to have the power to suck my soul down towards my feet and out of my body. You could tell the age of the dead from the peals of the bells. A high-pitched bell (an E) was rung for a child or young person; a bell of middle pitch (D) for someone in the prime of life; the bell of lowest register (C) for those who died in old age. Once, though, the bells did not obey these rules.

On a quiet midnight in August 1978 we were awakened by the sound of knells. Something serious was happening, for all three bells were being rung at once. My mother was hysterical, the younger children cried, and my father caught the excitement. The whole town stirred and the dogs howled. Grandfather remembered that the last time the bells rang like that was when the Japanese invaded the country nearly forty years before. 'Perhaps an atom bomb has exploded and it is a world war,' he said. 'Or perhaps the rebels are attacking the town. We might have to go down to the bomb shelter.' I was frightened at the idea of going into the shelter, which in its damp airlessness seemed to me like a large grave.

Grandpa walked to the church to find out what had happened. Mother lit some candles on the family shrine. Everyone prayed. Grandfather returned half an hour later, vivid with excitement. 'The Pope is dead, in Rome. He was called Pius the Sixth. The priest told me.' I wondered where Rome was. I supposed somewhere near heaven. I heard the news of the death of Pope Paul VI as if it was the death of God, and heard the knells as ringing for God's funeral. I was anxious that we were going to be without God on earth for a while.

At that time I was always half expecting catastrophe. The government constantly warned us against enemies within and without, destructive foreign elements and their 'treasonous minions' inside Burma. Not only were the jungles almost on the edge of the town populated by rebels who, we were told, kidnapped young women, we were also (it seemed) threatened by headhunters and Communists, Chinese and Indians. There were wild rumours that both the government and the Communist rebels who controlled north-east Burma had the habit of killing people and burying their heads beneath bridges that were under construction, for good luck. We understood that there

were two different types of Chinese, one with white and the other with red skin. The reds were (of course) Communists. When we checked the Chinese who actually lived in our town, we saw that their skin was white or yellow, and concluded they could not be Communists. We accepted the local wisdom that Communists were cannibals and tortured Christians, so we decided that Chinese Communists must be even worse than Burmese Socialists. The adults caught the fever of suspicion and fear, and forbade us children from going into the jungle.

My friends and I worked out the best means to protect our town from its numerous enemies. We planned how to establish strong defences, and to ambush any intruders with bows and arrows. We found a new potential foe in the Indians. Indians in Burma had long been abused by the regime as unscrupulously avaricious money-lenders – 'Chettias' – and were officially described as bloodsuckers. We took this literally, and so did many simple people. It was rumoured that Indians were coming into Phekhon disguised as snake-charmers, hawkers, merchants and even doctors in order to steal the blood of the Padaung – which was known to be excellent – and sell it to hospitals in India. On market days, accordingly, we watched the only Indian family in Phekhon and the visiting Indian merchants for signs of the conspiracy. They seemed disappointingly normal people – simply our neighbours.

So neither Communists, nor rebels, nor bloodsuckers turned up. Some Burmese government soldiers did, though, and were caught stealing our animals. Grandfather Nauk confronted them and demanded compensation from their commander. He was beaten up by the soldiers. (In 1997, aged nearly ninety, he would be less lucky. Some Tatmadaw soldiers were caught stealing my family's chickens, and Grandpa Nauk, fearless as his late brother, protested loudly and in strong terms. The soldiers attacked him, knocked him down, and kicked him into insensibility. He died in hospital of his injuries a few days later.)

Eventually life returned to normal. We returned to the lake and the jungles. The bloodsuckers, the rebels, the red-skinned Communists and the Pope were forgotten.

Death of an Animist

One day we heard that a Padaung animist boy had died from the bite of a poisonous snake, and that a shaman was going to perform a ceremony to lure the snake back to the house so that the boy's relatives could avenge him by killing it. We saw a man squatting by the corpse in front of a decorated alms-bowl murmuring as if to himself, 'It is a powerful snake. Get your sticks and wait for it at the back of the house. I am attracting it back.' He closed his eyes and muttered again. 'Yes – it is coming. We are here. This way, this way, come. Almost there . . . Now! There it is, near the fence!' Outside the house we could hear yells of excitement, followed by noises of thumping and cracking. A cobra was smashed to pieces. 'You have to do that or else they become addicted to human blood,' said the shaman. They skinned the snake, gutted it and chopped its head off. The skin, guts and head were buried under the house. The meat was cooked, then packed neatly and placed inside the boy's coffin.

There was an animist wake. The mourners played pan-pipes, sang, danced and swayed rhythmically around the coffin according to their traditions. We called this the 'Swinging Wake'. A professional woman mourner leaned her head on the coffin and chanted from unknown epics for ten minutes, then dried her tears and smiled, drank her rice-wine and began mourning again. I was both amused and mystified. The people outside the house were making weaves of different patterns – beehives and streamers – out of bamboo threads and banana plants, designed to attract the benevolent spirits. Then they festooned the house and the coffin with the woven fabrics. They burnt foul-smelling herbs and fumigated the house with them to ward off evil spirits. They also continually beat the frog-drum, and intermittently fired off home-made guns. It was deafening and uncanny and, to me, genuinely frightening.

The wake lasted only two days, because the corpse had turned blue and was fast deteriorating. The coffin was carried off to be buried along with the personal belongings of the dead boy. A shaman led the funeral procession, followed by two men who bore a big gong on their shoulders and beat it regularly, by women who carried offerings for the spirits, and finally by the coffin itself and the rest of the mourners. The gunners kept up an intermittent fire to drive green ghosts away.

The bearers swayed, swinging the coffin back and forth as they

talked to the dead: 'He doesn't want to go yet. Let us swing him again. And toss him. Come on, boy, we can't go on carrying you like this. You have to go now.' They buried him with all his personal belongings, and built a small hut above his grave. The skulls of animals that had been ritually slaughtered, some grains of corn and cheroots left over from the wake were hung on a pole. A pig's head, trotters and tail were set in place on the grave, and bamboo spikes were planted all around it. The mourners bade farewell to the boy and to his grave, and went home laughing, never to return until the next funeral. No Requiem Mass. No commemoration. No flowers.

As I watched, I felt a sort of emptiness for the first time in my life, and I felt that a gulf separated my parents' religion, despite its pagan elements, from all this. For us Catholics, the festival of All Souls was a time to remember the dead, to refurbish the cemetery and plant flowers around their graves, light candles and pray for them. But our cousins did nothing after their burials and never visited the cemetery, for above all they went in fear of the ghosts that infested it.

Death of a Chief

My grandfather ordered a coffin from a carpenter long before he died. As befitted a chief it was elegant, made from teak and therefore waterproof. He kept it on the ground floor inside the house, but every morning he polished it and then dried it outside. We were shocked to find such an ominous new piece of 'furniture' in the house. (He also kept in the house a more traditional coffin that was simply hollowed out of teak. He did that to show respect for tradition, but explained that he preferred the sleek, elegant lines of modern coffins. He thought that coffins made hastily during a wake were horrible: 'I don't want to go into the other world with your disgusting cheap coffins. Anyway, my coffin will save you money,' he would say.)

My grandfather was confident that he would meet God in the next world, but he was not sure how soon this would be: 'There is a long queue between heaven and hell. We are not all allowed to meet Him just as soon as we like. Sometimes you have to reincarnate before you are allowed to meet Him.' A flash of his old political bitterness came back: 'I hope the queue is not as long as for the Socialist shops.'

He explained to us what his intentions were. He wanted to prepare for death according to the traditions of a chief. This meant that every-

thing had to be got ready impeccably, and with the most perfect attention to detail. At the same time he believed that keeping the coffin at home ready would also preserve his life – it was a way of appeasing death by paying tribute to it. We found the idea ridiculous, but eventually we got used to it.

My grandmother did not say anything, but I do not think she was as sceptical as we were. According to her, the dead have to ferry themselves across the river of death in their coffins, and there are many unfortunate souls who cannot get across the river because they have no lights, and so get lost in the great darkness. If a newly dead soul came along in a coffin made of pinewood, they would seize it and shred it to make torches – which would mean it would take longer for him to reincarnate. The dead also need a fifty-pya coin in their mouth to pay the toll across the river.

Despite his sense that death was near, Grandpa went on busying himself with planting trees for posterity, riding his bicycle great distances every day, talking to his adopted children and subjects. He also began selecting the animals that were to be slaughtered at his funeral. He attended Mass every Sunday – he was less pious than his wife, who went every day. She never expressed her feelings about the possible departure of her husband. Instead she thought of all the things he wanted her to do when he died. A Requiem Mass was to be celebrated, and all his and her relatives, friends, subjects and adopted children were to be invited. Three buffaloes, five bulls, seven pigs and some chickens were to be slaughtered for the feast. A fifty-pya coin was to be placed in his mouth, and hot oil and some bottles of rice-wine must be stored in his coffin as provisions for his journey. His remains were to be kept in the house for at least three days before burial.

In the event my grandfather lived longer than any of us expected, to his eightieth year, and died on a cloudy morning in 1979. The house was filled with wailing from his daughters. I wanted to run away from home or to the arms of a girl I was childishly in love with at the time. I dreamt that we flew away together in the form of two scarlet minivets with brilliant wings.

The funeral meat tasted as if it had already been eaten by the ghosts. When we made offerings of meat either to the *Nats* or to our ancestors, we never touched it ourselves. The offering once made, it has already been eaten by the spirits, and any human being who touched it would entirely lose his appetite. At my grandfather's funeral we felt that this

was true of the whole funeral feast – which was a way of experiencing our grief as insupportable.

Grandfather's corpse was laid in state in the chapel room in front of the family shrine. His Buddhist subjects paid their respects in their own way, kowtowing before his coffin and making offerings to him as though he had already been transformed into a guardian spirit. The funeral dirges were sung in different styles by the different groups. The group judged the best was awarded the heads of the slaughtered buffaloes. Wave after wave of guests flooded in. They played their traditional bamboo flutes accompanied by the massive buffalo-skin drums. All the time a government agent prowled around among the guests trying to sniff out no one knew what. Everyone knew what he was, and he knew that he was recognised. But we tolerated him, talked to him, drank with him. The presence of a regime spy was so inevitable that we could almost think of it as part of the ritual.

Meanwhile, my other grandmother, the ex-giraffe woman Mu Kya, wailed elegies in the manner of a professional mourner to ensure the dead man's smooth journey to the other world. The priest arrived, blessed the house and said a prayer in Latin. He made no comment on the extra, traditional, ceremonies. The brass band played hymns, and we all recited the Catholic prayers for the dead.

My grandmother was too busy organising the funeral to weep for her husband on that day. I watched all she did, and she showed me exactly how things were to be ordered. The wake and the singing went on for three nights. The funeral gave us an opportunity to meet all our relatives from afar whom we had never met before, animists and Buddhists, Padaung and Geba. They were all there to mourn the man whom they most respected in their generation, the last man recognised as the head of the tribe. Everyone felt that they were witnessing the end of a way of life, that there would be no successor chief, that government officials would replace the old, ceremonious way of doing things, along with its tolerance and gentleness.

After my grandfather's funeral the house seemed bereft of a quiet and powerful presence. We knew that something stately had departed. His old Raleigh bicycle was locked away like a horse without a rider. Grandma's grief was restrained in a way that surprised us. It was as if she knew that he was coming back to her. We had the feeling that he was not totally gone. Then she told us that he would be coming back on the seventh night after the burial. He had told her this when

he was alive. I thought this was impossible, because the priest had told us that the souls of the dead go straight to heaven or hell immediately after death – but at this time my grandmother was thinking in older ways.

We waited for the 'return' half with nervous amusement, half with expectant curiosity. Eventually the seventh night came. There were no signs of anything unusual. We said our evening prayer and went to bed as usual, in the grandparents' old room. We children were sleeping with Grandma, hiding our heads under the blanket. I asked her if Grandfather was really coming back. 'Keep quiet or you are not going to hear it!' she said.

The bell struck nine.

The night was lively with the hymns of nuns from the convent.

After what seemed to me a very long time, ten o'clock struck.

The owls were screeching in the trees behind the house. Some youths came back from their girlfriends' houses whistling and strumming their guitars under the starry sky. The dogs barked at them as usual.

Eleven o'clock.

The howling of wild dogs could be heard faintly from the direction of the cemetery. The howling gradually turned into hysterical or aggressive snarling and yelping. Then the dogs who lived by the church barked with a moaning or crying sound – more like wolves than dogs. The barks got nearer to our house.

'There he comes,' said Grandma.

Our own dogs barked from in front of the house. Their barks became friendly, as though with recognition, and then quietened down. I was intensely curious to know whether Grandfather would behave as he did when he was alive, always entering the bedroom from the corridor through a window. We heard footsteps climbing up the stairs through the hallway. The stairs door opened with a long creak – it sounded like the noise of a tired cicada. The steps sounded like his: steady and deliberate. The sound of footsteps continued towards the direction of the veranda of his bedroom window. 'That's him,' I thought. We were waiting apprehensively inside the room as the footsteps approached the window. We heard the window being opened, but its flaps did not open as I expected. An expectant silence ensued.

Grandma spoke: 'Is it you, La Pen? I did everything you ordered for your funeral. I hope I have been a dutiful and faithful wife to you. But this house belongs to the living, not the dead. You know that.

Please go back to the grave, to your new home. Go back to where you belong. I will meet you again when I am dead.'

There was no answer. We heard footsteps going back through the window, into the hallway, and down the stairs. The barking of the dogs accompanied him as he went away. The widowed lover sobbed quietly in her bed. I could not think of anything to say that might console her. We drank rice-wine together and went to bed content. That night she did not scold me for being noisy.

In September 1979, not long after the funeral, my parents' eighth child, Patricia, was born. She looked like a reincarnation of my grandfather. I wondered how long my mother would go on producing children. 'I'm tired of being a baby-producing machine,' she complained. Her complaint was futile – she was to give birth to three more children, one while she was out working in a paddy field. She beseeched God and the priest to let her bring the endless cycle of childbearing to an end. Neither heaven nor the Church granted her prayer, so she made the best of it. She produced healthy babies and made us older children look after them.

A Spoiled Priest

'Many are called, but few are chosen.'

After the death of our grandfather, my father officially became master of the house. But it was a role in which he did not seem happy or comfortable. He devoted himself to his work as a vet, and looked for nothing beyond that. He would inoculate cattle, castrate bulls and buffaloes. When – as often happened – thieves speared our animals when attempting to rustle them, he would operate on the beasts, take the spear out and clean the wound. My father had always been in demand when it was necessary to put down an animal, and he used to have the sedatives needed. But now these were unavailable, so the villagers would tie the creature – usually a bull or a buffalo – down with ropes. Without sedation the animals would bellow and kick their feet, tears in their eyes, then simply breathe heavily with the pain as they were slaughtered. Pigs squealed like children.

Having lived for so many years under the same roof as the most powerful man of the clan, and having always been subordinate to him, my father found it impossible to assert himself and take on the role of strong clan leader. With the ruthlessness of a child, I could see that he had never been given the chance to grow, or to venture out of the protective world he devised for himself, a world that made a virtue (called 'obedience') out of his weakness. I saw this as self-deception on my father's part, and was determined not to be like him. I wanted to be like my grandfather. I was determined to move out of the house. At the age of twelve I went to stay with the adopted children of the priests in the boarding house in the church compound. My father supplied me with bags of rice as my fee to the church. I had begun to think that one way of distinguishing myself and of acquiring

authority and prestige comparable to that of my grandfather was to become a priest. My best friend had gone to Taunggyi, 150 miles away, to study in the seminary there with the aim of entering the priesthood, and I determined to follow him.

The boarding house gave me a sense of seminary life. I would go home to see my family only once a week. Every morning, noon and evening I was expected to attend church and say my prayers. The first weeks were the hardest to endure, and gave me a first taste of the disciplines of the Catholic Church in Burma. We went to bed at nine, but were able to get to sleep only after several hours spent killing the lice and floor bugs with a burning candle. The food was only slightly better than what we fed to the pigs at home, but it was out of the question to complain. Such is the power of habit that after a few weeks I came to enjoy the food, to the point that during the two meals per day I would manage to eat three plates or more of rice which had been scooped from a bamboo basket with the bone of a cow. The curries were simply boiled leaves and lentils with a copious amount of water and salt. We were allowed to store private supplies of chillies, dried fish and meat above our beds in bamboo containers. Occasionally we had the luxury of animal bones with potato curry.

Whenever there was a wedding or a funeral, all the children in the house – two hundred of them altogether – were invited to pray with the guests or mourners. Our living in proximity to the priests and the priesthood gave our prayers just a little extra power. We were also invited to join the wedding and funeral feasts, so we naturally lived in hope of both weddings and funerals. In particular we were alert to the sound of the funeral knells, which announced the news of square meals to us, even as they brought grief to the families concerned. I regularly sneaked back to my parents' house for a good dinner when-ever the providential supplies became meagre. Sympathetic though my parents were to my hunger, they never let me enter the house without my stripping off all my clothes and having a thorough wash in spring water. My head was shaved and scoured to get rid of head lice, and my clothes were burned to destroy fleas, lice and floor bugs.

Yet the discipline of the lessons from serious teachers was good for me, and working on church farms and playing football vastly improved my health and humour. I was allowed by the priest to ring the Angelus bell. This was a thrill – I felt that a little bit of the power of the priest was already rubbing off on me. Best of all, I was invited to tour the

surrounding villages with the priests, where it was my task to teach the children prayers and hymns. The meals and rice-wine on these tours turned out to be abundant and delicious. Every exotic food regarded by the Padaung as a delicacy – baby wasps, wild boar, porcupine, wild cat, armadillo – was presented by the pious villagers to the priests. They were the princes of the tribe, and the rest of us were the paupers. That, at least, is what I felt, partly with resentment, but also with the pleasing sense that I was preparing to join a powerful and respected elite. My favourite activity was tasting the many varieties of rice-wine and priding myself on my rapidly developing connoisseurship.

Meanwhile I won all the prizes in academic and religious competitive examinations. I was unfailingly polite to my teachers, priests and elders, showed appropriate respect to my equals, and genial kindness to those placed below me, as Burmese tradition demands. Almost unconsciously I was absorbing the arts of a ruling elite, and at the same time mastering the rules that enabled one to rise effortlessly in that elite. I was not unaware that all this uncomfortably resembled the arts by which Burma itself was ruled.

At the end of the academic year, just before the examination results of the government schools came out, the priests declared that at the age of thirteen I was clever and pious enough to go to the seminary if I passed my sixth-standard exams. I was overjoyed, and exulted in my good fortune. To us Catholics of the Taunggyi diocese, the idea of going to Taunggyi seminary was as thrilling as getting into Eton or Harrow would be to English children. My mother sewed new school uniforms for me on her Singer sewing machine and my grandma, Mu Wye, wove new clothes for me on her traditional loom in expectation that I would indeed pass my exams. My father saved up his pocket money, dried some meat and collected wild honey and vintage rice-wine in bottles. I started to wash thoroughly, brush my teeth and wash my underwear every day to prepare for my new life. I gave away my old textbooks, exercise books and clothes to my younger brothers and sisters. Years later I realised that I was behaving with exactly the mixture of pride and false humility that characterises Pip in Dickens's *Great Expectations*. But at the time I was no more aware of that than Pip is. My two brothers quite resented all this, yet at the same time they were proud of me.

I did pass my sixth-standard exams. That did not surprise me. What

did surprise me was that the authorities were prepared to let me go to study in Taunggyi. Normally it was difficult for any but the children of Party members to study outside their own town. The Party Chairman of Phekhon was notoriously jealous of the fact that our relatives were more successful at school than his own children. Indeed, he did all that lay in his power to prevent other people's children receiving a good education – and he could do this by the simple means of refusing official permission for them to leave Phekhon to study. I was sure that I was allowed to go only because I would not be aiming at an official career in government service after I graduated. The Party Chairman was happy to allow Catholic children to study for the priesthood, because that diverted them from politics and public life.

My father gave a huge feast to celebrate my going away. He slaughtered several of his massive prized Gloucester pigs. This was a special honour. Our normal pigs were small, black creatures, slightly larger than the Vietnamese pot-bellied variety. My father's Gloucesters were highly prized amongst us because they grew bigger and flabbier, producing a fatty meat that we particularly relished. We invited all the villagers, including the adopted children of the priests, to eat and drink with us. They in their turn sang and prayed for my future. Grandma Wye wove a towel to celebrate my success. My relatives bestowed on me blessings and pocket money, and urged me to study hard so that I could indeed become a priest. I noticed that the priesthood was not particularly in my father's mind – only that I should get a good education. The idea of being away from home for the whole year in a place I had never seen was both exciting and shocking to me.

And it was then that I lost the habit of asking questions. It was as though, with my success and amidst these celebrations, I felt that I had already arrived at my goal, and that all I had to do now was to go on obeying the rules that had brought me so far. I believed implicitly that the priests and the Church – the organisation into which I was casting my lot – had the answers to questions I had never even begun to think of. The priests had already warned me that God does not favour those who, like Jonah, ask too many questions, or who, like Eve, are curious and inquisitive. God loves those who suffer in silence, like Job. I determined to be like Job.

My father warned me of the dangers of the journey to Taunggyi. The road was sometimes blocked by dacoits, and the police regularly deployed roadblocks. The difference between the two was that the

dacoits robbed travellers sporadically, whereas the police did so offici-
ally and systematically. Nevertheless, with three friends and an uncle
I embarked on an old GMC truck loaded with rice bags, and began
the long journey to Taunggyi over winding mountain roads that had
been severely damaged by torrential rains. As the truck left, it churned
up the red Shan State soil, covering with dust my family, who had
assembled to say farewell, so that as we moved away they had become
completely invisible.

At a small town called Pinlaung, the police stopped us, and confis-
cated our truck when the driver refused to pay them a bribe. Pinlaung,
which is two thousand feet above sea level, sandwiched between two
mountains, is cold at night throughout the year. This was the beginning
of the monsoon season, and we spent an uncomfortable night huddled
in the back of the truck, while the drizzling rain seeped through the
tarpaulin. The next morning we had to catch another truck to complete
the journey.

We approached Taunggyi from the direction of Lake Inle, which
made the town look like a garden hanging from the clouds. The
excitement of arrival helped us endure the further attentions of the
police, white helmets on their heads and Enfield rifles on their shoul-
ders, as they searched the truck as though they hoped to find drugs,
or a cache of weapons – or anything sensational that might justify
their existence. When they found nothing, they looked at us as if we
were expected to pay them for their efforts.

In the Seminary

The seminary, run by the priests of the PIME missionary order, struck
me as a mixture of military academy and palace. The main building
was constructed in the style of an Italian villa, painted in pale yellow
stucco edged with white. It was surrounded by flower and vegetable
gardens, bordered with massive hedges and overlooked by rubber trees.
I had never seen anything so magnificent, and it gave me a new sense
of the power and grandeur of the Church.

The Father Superior, Paul Harry – a very light-skinned, high-caste
Indian – started by reading us new students the rules from a black
seminary book. They were comprehensive. We were not to discuss
politics, women, pop music, food or drink, although talk of football
and other sports was allowed – even encouraged. We were permitted

to read newspapers and magazines only after one of the Fathers had scanned them first. Newspapers always came to us with square holes cut out after Father Paul had read them.

Our pocket money was confiscated by the priests, and was to be returned to us only when we needed to buy something essential. We were allowed to go into the town once a week at most. The use of perfume or any other cosmetics which could attract the attention of the opposite sex was forbidden. Friendship with girls was, of course, absolutely prohibited, and looking at them appreciatively was frowned on. We practised 'control of the eyes' when we talked to them – averting our gaze to the side or downwards. We had to avoid hailing or shouting at one another. Smoking would be forbidden until we became priests. This would take eleven years altogether – four years at the 'minor seminary' here in Taunggyi and another seven in the 'major seminary' in Rangoon, where we would study two years of philosophy and five of theology. Until then smoking was a sin almost as bad as having female friends. Most important of all was the golden rule of silence that we were to observe most of the time. We were to study regularly, but not too hard. 'God doesn't need clever priests. He loves disciplined, obedient and holy ones,' said Father Paul.

Next, we were ushered to our dormitory. The bed on my left was occupied by a student who regularly sleepwalked. On my right was a more unusual case, a boy who sleep-sang all night – almost always the Kyrie Eleison. The junior boys and the seniors were lodged in two separate dormitories, each ruled by its own monitor. The nuns and their ancillary girls who looked after the seminarians lived in a convent in the corner of the compound. They cooked for us, sewed our clothes and attended to all our needs. Women are indeed the infrastructure of the Catholic Church in Burma. They neither had, nor sought, the prestige of the clergy, and the idea that they might claim recognition for their role did not occur to any of us.

We were given a timetable for the whole year, and daily domestic duties were divided among us. We were to clean the dormitories, dining room, classrooms, toilets and chapel in turn. The gardens had to be tended every day except Sundays. When we were allowed out at weekends, we went into the woods around Taunggyi and hunted for vegetables, crabs, fish, birds, spiders and any other edible plants and creatures we could get hold of. Our motto was *Ora et Labora* ('Pray and Work'). Curiously, we were also told to keep in mind a slogan

derived from the inspirational American Protestant writer Norman Vincent Peale, and translated into Burmese as 'Better, better, every day. Better, better, every way.'

We got up at five o'clock every morning, and said our morning prayer kneeling by the bedside as soon as we awoke. Fifteen minutes was allowed for washing our face, brushing our teeth and going to the toilet. (Since we are not a hirsute people, I never had to shave, which helped.) I hated having to queue in the cold for the stinking toilets, which never worked because of a shortage of water and spare parts, and to complete the business in five minutes. At 5.15 we had meditation and mass in the chapel; 6.45, breakfast; seven o'clock, Latin class; 8.45, attendance at the government school. Lunch was served at noon after the Angelus, and then we played football until one o'clock. Then we were back to the government school until just before four. The visit to the Blessed Sacrament in the chapel followed. After that we were free to play or work until five, when we had study; six o'clock, rosary; 6.45, dinner; 7.45, night prayer, eight o'clock, study; ten o'clock, all lights out. At weekends we practised singing and playing musical instruments. I sang soprano and played all the instruments. We were taught both English and Latin in the seminary, and I found that I was especially good at learning off by heart the declensions and conjugations. The work for the government school was not nearly as arduous as what was set for us by the priests.

Father Paul drilled us in football every weekend, and also taught us to march in time to the brass band. If ever we made a mistake, he would stare at us out of his hawk-like, hooded eyes, then mimic the mistake with astonishing exactness. He was rumoured to have been a witch-doctor before he entered the priesthood, so we attributed to shamanistic powers his mysterious ability to appear like a ghost from nowhere in his white cassock whenever we were breaking the rules.

When our relatives came occasionally to visit us, we were not allowed to meet them on our own. One of the priests would sit between us and listen to our conversation, especially if the guests were females. Letters were opened and read by the priests before we received them, and our own letters had to be handed to the priests in open envelopes before they were posted.

Yet all these rules did not strike us as severe – they were merely the discipline we had to accept on the way to the prized goal of the priesthood. The restrictions on letters, especially, were not a burden

at all, for we Padaung are not a letter-writing race. My family would answer my letters about twice a year, keeping until I returned home for my annual visit the letters they had not got round to posting. I remember only one letter from my father. It informed me that I had a new baby sister, who was to be called Remonda. She was their ninth child. 'She will be our last,' he told me – wrongly, as it turned out.

We were allowed to go to football matches when our home team was playing. Father Paul wanted us to be priests who were good at football, because that would convince people that God was on our side. He often arranged matches with the local people, especially the Baptists. The pressure to beat them was greater than when we played any other team. The games were full of fouls and injuries, and when we won the celebration seemed the sweeter. The Baptists felt the same when they beat us.

When we were not playing football we played other games, including the traditional game, *chinlone*. *Chinlone* is a Burmese form of football, and is the national game. The word *chinlone* refers to a hollow ball of about six inches in diameter formed of plaited rattan, with openings around its surface between the tightly woven strands. The game is played by four to six people, who stand in a circle a few feet apart. The ball is tossed as gracefully as possible from player to player with the instep, head, shoulder, knee, or side of the foot (hands being forbidden), being kept in the air as long as possible. *Chinlone* requires great stamina and skill, and thick skin on every part of the body that the ball strikes. Boys roll up their *longyis* as they play, hoping to show off to girls their firm muscles and tattoos.

People often invited the seminarians to pray and sing with them on feast days, both in the churches and in their homes, as if our prayers were more powerful than theirs. We were regarded by the faithful as prayer machines who could ward off poverty and the other evils that they saw as emanating from the regime. Both government soldiers and rebels would ask priests and monks to bless their guns before battle – so our faithful were simply in a Burmese, indeed worldwide, tradition.

But I gradually came to realise that we were treated as people from another class. In joining the priesthood I would immediately be promoted to an admired, respected and powerful caste, and would be shielded from the rigours and struggles of life experienced by my mother and my father, and all my relatives. I would live according to

the discipline of the Church, which was demanding but at the same time would protect me from the chaos of personal choice that might overwhelm me in the secular world. The thought had begun to grow on me that it might be precisely these things that attracted me to the priesthood – that it would be a way of escaping the poverty and daily grind of my family, as well as gaining prestige among my people; that I would obtain, therefore, rewards in this life and in the next as well. I even felt that my family themselves were unconsciously moved by the same ideas, that we therefore sustained each other in an illusion.

I did cultivate a spiritual life as best I could. Yet my tribal culture lent itself more naturally to ceremonies and outward observances than to inner spiritual self-examination. This had been true also of Padaung who were converted to Buddhism, for our fundamental sense that what we had to do was appease the complicated world of the spirits was deep in us.

I realised that there was another reason, apart from the fact that obedience came easier than rebellion, why I was happy to obey the rules of the people who educated and fed me. I certainly saw it as following the will of God, but I was also desperate to shed my tribal tradition and transform myself into a civilised person and a saint. For us teenage, hill-tribe Catholics, becoming a saint meant doing beautiful and heroic deeds that would be recorded in books of hagiography. Especially heroic would be the conversion of the heathen, which merged, in my mind, with standing up for our own tribe against the dominant Burmans. It was the religious equivalent of being a football hero.

Apart from the gardens, I spent much of my time in the library. The collection of books consisted largely of antiquated natural theology, as well as some anti-Communist tracts and copies of the English children's comic the *Beano*. I paid much attention to a book published in London in 1882, entitled *Nature's Wonders*, by the Rev. Richard Newton, D.D. It explained how all the works of nature – sun, moon, stars, light, flowers – praise God. I learned that 'the Sun is like the father of a family with his children gathered round him', and that the sun also praises God by its beauty; that God has arranged that the sun should set slowly rather than in a twinkling of an eye so that the sunset is beautiful for us to behold. There was not a single book in Burmese, apart from a Burmese–English dictionary. The lives of the saints, popes and other religious heroes inspired me. I found myself wondering why

there were not more Asian and African saints – and not a single tribal one from Burma. I wanted to be the first Burmese saint. So I read as much as I could about the Western saints in the library.

Already, at the end of my first year in Taunggyi, I had begun to feel part of a sort of conspiracy of self-deception, one that necessarily involved an acceptance not just of the rightful authority of the Church, but of authority as such. Nevertheless, living for these years in the conformist world of the Catholic Church in Burma was for me a time of genuine happiness.

When I returned to Taunggyi for the second of my four years, I felt thoroughly at home there. I put my whole soul both into my studies and into obedience to the priests and to my teachers at the government school. Something I was taught in physics lingered in my mind: that Isaac Newton was such a genius that he had built a bridge without nails or screws. It was not even held together by bamboo threads. This miraculous bridge was over a river in a place called Cambridge, in England, and I felt a desire to see it.

Since all the members of my year in the seminary were enthusiastic students, we were given unusual freedom to explore the surrounding area. Taunggyi was a town of flowers – flowers everywhere, in every season. Flowers on trees, flowers in the bushes and in the gardens; the mauve-blossomed jacaranda trees, the flame-of-the-forest trees, the burnished gold of the gol-mohur, the blossoms of mangoes, the white blossom of wild apple trees, the multi-coloured roses, the claret dahlias, the white jasmine, poinsettias, frangipani and many more. Both vegetables and flowers thrived in the gardens of the seminary. I delighted in using the Latin names for plants, vegetables and flowers, some of which I made up from what I had learned of the language, mixing them with Burmese and English names. I worked incessantly in the gardens, trying to turn them in my imagination – as was my wont – into a self-enclosed Eden. I felt that I would be saved *labore*, if not *oratione*.

I was assiduous in my novenas, my meditations and other private prayer. When I look back on the power and attraction of the Church for me, I suppose some of it had to do with the sense that we had indeed been saved from the multitudinous rites and spells of animism, and that Catholicism had given us a faith with the same dignity and beauty of worship and art that Buddhism had given to the majority

Burman race. The Church had for us a sort of rational mystery, more dignified than the mysterious spirit world of animism. Confession also was a way of expelling the fear that surrounded us in animism, a conquering of anxiety. My dissatisfaction, which I could not quell, was that my religious life was immature, that it did not give me the access I craved to an inner spiritual world.

More innocent boys joined us in the seminary. The innocence of some of them extended to their not knowing the facts of life. Sometimes we sat on the lawns around the buildings during the recesses talking about our villages. Occasionally the conversations strayed to the subject of women, and the boys argued passionately whether or not women have pubic hair. Some could not believe that women, as the more delicate sex, did have hair on that part of the body. These boys were perplexed by an incident that occurred at the government school. Two girls – demure and apparently modest – had been pursuing the same boy for half the year. So passionate had their desire for him become that they decided to settle their rivalry with a duel, or trial by ordeal, the winner of which could claim the boy as hers. They took up their positions on bicycles facing each other on the tops of two knolls in front of the school. At a given signal they pedalled furiously down into the valley below, and crashed into each other head on. A loud, metallic cracking sound signalled the collision, and both girls were thrown heavily onto the tarmac road. Fortunately, neither of them was killed, and they lay there groaning by their bent and mangled bicycles. The outcome was that the boy spurned both girls and began flirting with a new one. The seminarians were shocked by the frenzy of these girls, and some of them revised their opinions about pubic hair.

Meanwhile my doubts about my vocation were growing. It was not that I had lost my faith, even in small measure. It was rather that a feeling had been growing in me, and would not let me alone, that I had a long, arduous journey to go, and that it was not a journey mapped out by the Church. I was puzzled, because what this journey might be was vague and obscure, even as my sense of it was powerful. I felt that I had to read the signs, that it was a journey I would have to decide to embark on by myself, and that it was one in which I could not be guided by authority. I was looking for someone, or for some signs that would tell me what my mission was. I could find

neither within myself the imperative mandate that would have justified my actions, nor a voice from above to deliver it to me.

At the age of seventeen I felt powerless to make such fundamental decisions on my own. I did not have the courage to renounce the certainties of a life in religion, even though I could no longer identify myself with it. It was not that I was afraid to be alone – more that I could not bear being outside the fold. All my life had been guided by authority, and I did not really have the concept of deciding for myself, which therefore struck me as being a sort of sin, and yet also a destiny. So divided was I that my own heart seemed to be far away from my body; all was confusion and I found no 'light amid the darkening gloom'.

It was then that I realised I was either not ready, or was unsuitable, for the priesthood. I decided not to join the order. Instead I began to think about going to university. There were only two universities in Burma at the time: Rangoon and Mandalay. The Shan States were in the Mandalay educational zone, so it would be that university I would attend.

I summoned the courage to talk frankly to my Bishop, a fellow Padaung. To my immense relief, he tried to understand. Unlike the other priests, who were strongly against the Church continuing to support my education if there was no guarantee that I would enter the priesthood, he assured me that he would be happy were I just to become a good Catholic, be of service to my people and a good example to others. My English teacher at the seminary, an ex-Salesian brother, encouraged me to study English at the university. Although I had achieved good enough grades at my tenth-standard exams to take a scientific or professional subject, the facilities for studying those subjects were poor.

It seemed that whatever my mission was, it would be a long, long journey full of difficulties. I could not understand why I felt such a deep sense of despair, such 'spiritual dryness', or apathy, as the Church terms it. No more could I understand why this despair in my heart co-existed with an unstoppable urge for adventure in my soul. The conviction that had been bred into me in childhood that I was a sort of shaman gave me a confidence that I would find my true vocation.

My original sense that I had a vocation for the priesthood seemed to be changing into a sense of destiny more obscure but no less strong – that God was testing me, preparing me to go somewhere new and

difficult, to do something that would break from my own way of life as decisively as had the seminary. I was strongly influenced by the prejudice most people I knew had against a 'spoiled priest', and felt that in giving up my priestly vocation I would be gravely offending God. But my conversation with the Bishop helped me. It was as though the severe aspect of God was manifested through Father Paul Harry, and the forgiving aspect through my Bishop.

Armed only with naivety and a sense of my own luck, I left the seminary with genuine sadness and headed home to prepare myself for university life. It had rained when I left for Taunggyi, and it was raining as I returned. I loved the relentless rain that tormented the red Shan hills. Despite my academic achievements I returned home crestfallen, because I knew that for many my having failed to become a priest would mark me down as a black sheep. I understood what it was like for the township footballers to come home after losing the finals in Taunggyi.

My father and uncles were quietly pleased that I didn't want to become a priest. Although they were obedient Catholics, they felt the priesthood was an unnatural and emotionally harsh way of life for anyone close to them. But to some of my friends, for whom it was the highest vocation a Padaung could aspire to, what I did was a betrayal. Catholicism had given a new identity to the Padaung, one that inevitably had political overtones. We looked up to the Pope as our leader, rather than to General Ne Win. Our religion at last placed us on terms of equality with the other peoples of Burma, and gave us a culture equal to that of Buddhism. Mother Church really does possess the soul of the Padaung, whom it had given a new and more refined sense of their own identity. I felt all this, and so I sympathised with the disappointment of my friends.

But I was determined to wipe the slate clean and begin again. The idea of a mission hung in the air, and took on a slightly different meaning. My mission in life would be to help my people succeed – by succeeding myself.

To the Land of Green Ghosts

A Subdued Celebration

As soon as I arrived home, my father told me with a rather self-satisfied smile that I had a new brother: 'He looks a bit like you. Soon we will be able to form a football team.' He called the baby Christopher, because he had become tired of the Italian names proposed by Padre Lesioni. Christopher did indeed look very like me, and clung to me tightly as soon as I picked him up. It was like holding my clone. My mother was mightily relieved after the birth, but exhausted. This, she insisted, was the last – there would be no more babies. (In fact there was to be one more, my youngest brother, Henry.)

Before I left for Mandalay in December 1984, my family celebrated a thanksgiving Mass, and also arranged a tribal ceremony in which cotton threads were tied around my wrists to empower my ancestors to confer their blessings upon me, and to bring back my *Yaula*. After the Mass the elders gave me their blessings, tying more cotton threads around my hands. Then we drank our celebratory white rice-wine, called *thibu*, that is drunk hot and has a thick, honey-like texture – so thick that it normally has to be diluted with water. Next came the feast. We ate a celebratory dish called *diansa*, which includes meat, wild vegetables, spinach, yam, sugarcane or jaggary, and fruits of the season. It all symbolised the bounty of the earth. We ended up smoking the best cheroots.

After the meal, I had a rain shower by the side of the lake with my friends from childhood. It was the last monsoon of the year, a feminine rain, dropping lazily on the surface of the lake. The rays of the late-afternoon sun made the raindrops sparkle like precious stones. Under the steady rain we wallowed in the shallows of the lake with the

abandon of water-buffaloes, lapped by the mini-waves, yelling with pleasure. At the same time there was a touch of 'melancholy not unnoticed'. I seemed to shed my seminary self, and to revert to being a wild tribesman, as though I had never left, never been subject to disciplines and austere ideals, never been a civilised man or a potential saint.

My companions caught the mood. They chanted a mock Easter plainsong in Padaung: 'This tribesman is going to the university, *alleluia*! He will study literature, *alleluia, alleluia*!' I was conscious, as we all were, that there was something forced in the merriment. However ill-suited I had been to the priesthood, my four years at Taunggyi had already begun to separate me from my innocent tribal past. Mandalay and its university were a world impossibly remote from all I had known, from what I still thought of as the childhood paradise of living securely in the midst of the tribe. Secretly I was overcome with anxiety. I felt like a messenger to the world of the dead, because to the Padaung, as to many of the hill peoples, Central Burma is an alien land, the abode of evil spirits, green ghosts and the like – not to mention the Burmans themselves, whom we regarded almost without exception as liars, cheats and Machiavellian schemers.

As the rain eased, we roasted the fish we had caught and had a picnic. Just before sunset we watched a double rainbow arch over the lake and disappear with the sun. My friends all said that this was a good omen. Then it was time to go. The church bell rang for Vespers. From the Buddhist monastery there was silence as the monks fasted, as usual, in the evening. After dinner I visited all my relatives, friends and acquaintances to say my farewells, to be plied with food and drink, to receive words of advice, blessings and monetary assistance. The advice was as heartfelt as it was various. From my drinking companions the most pondered instruction was: 'Whatever you do, don't drink that poisonous Burmese alcohol. I have heard it is so lethal that people can die after a few drinks – especially if they are used to decent rice-wine.'

And from the old folk: 'Whatever you do, don't fall under the spell of the *Natsaya* [witch-doctors or warlocks, people with the power of summoning evil spirits and ghosts]. There are a lot of dangerous ghosts down there.'

'Don't urinate under sacred trees, or else you will sicken and die. You must ask permission of the spirit of the place when you need to

answer a call of nature. If green ghosts chase you and are determined to have you, tell them to join the Burma Socialist Programme Party instead. Let them know of your special powers of cursing, that you could confine them to hell for ever with the cast-off wives of Ne Win. That should stop them.'

'Don't forget how to play football. Remember, we Padaung are the best.'

'If you meet a nice girl, write and tell us what she is like.'

My grandmother gave me her parting blessing: 'If you are in danger, say your rosary. Evil spirits are helpless against the Holy Mother. By the way, don't forget to spit three times whenever you leave an evil place.'

After an evening full of laughter and argument, I lay in bed unable to sleep the whole night from excitement.

Leaving Home

Next morning, I packed everything I needed into a wooden box and some bags. I was also supplied with dried meat and rice-wine. I waited for the truck that was to take me the twenty five miles to Loikaw, and the further 125 miles to Taunggyi, from where I would get a bus to Mandalay, another 125 miles distant. At about eight, a truck loaded with bags of rice, grains, salted fish and marble slabs from Loikaw arrived. I travelled to Taunggyi perched on the top. Although I now knew the road well, I still felt awe as the track wound among the high, wooded mountains. The driver stopped from time to time to offer candles and coins at the spirit houses, wayside altars that were situated at the most dangerous points of the road. The general belief was that all road accidents were the work of the spirits, and could not be attributed to bad driving or averted by good. We needed all the help we could get, since no work had been done on the roads since the British left Burma.

We spent the night in Pinlaung. The next day, towards sunset, we approached Taunggyi from the direction of Lake Inle. As the truck groaned up the steep, winding road, the town, perched on a hill (the name means 'big mountain'), again appeared to me as a garden hanging from heaven. There I changed to a bus. My luggage was loaded onto the roof and I squeezed myself into the crowded interior, my nostrils overpowered with the smell of sweat and dried salted fish.

Of Mandalay I knew nothing at all. I did not know a soul in the

town. I did not even know where I would stay when I arrived. All I knew was that I was supposed to study at Mandalay University, but of what that entailed I had been able to get no information at all from any source. I had no time to reflect on these uncertainties, for at that moment the bus pulled off in a storm of dust which concealed from view all those standing to see it off.

The bus wove along the Shan plateau, stopping along the way to pick up more passengers and goods. The engine laboured and groaned ever more loudly as it struggled with the excessive load. We saw mountains with pagoda-shaped tops, interspersed with tropical trees, then as we descended cherry blossom and peach blossom, with streams running through the trees. Round every corner small pagodas seemed to pop up, along with hundreds of spirit houses. Everywhere was rich in animal life – monkeys, wild peacocks, Burmese grouse, and deer that barked in the distance.

The bus broke down every six hours or so, usually because the engine overheated as we struggled up and down the steep and tortuous mountain roads. More than once tyres burst, and on one occasion the bus skidded to the edge of the road and came to rest only two or three feet from a precipice. The combination of hairpin bends, sudden lurches and general anxiety meant that at any one time some passengers would be vomiting out of the windows.

Central Burma

After three exhausting days I could see the middle of Burma from a mountain in Shan State. The landscape was immense, under a burning sun. In the face of this blank vastness I felt tiny and insignificant for the first time in my life. I felt heat of an intensity and dryness I had never experienced before. The great Irrawaddy crawled in the mist like a stupendous, shimmering python. There were no thick forests such as I was used to, none of the cool greenery of the Shan plateau – only stunted trees and, everywhere, pagodas whose golden tops sprang, always surprisingly, from the arid country. The paddy fields – a richer, more subtle gold than the pagodas – were ready to be harvested in a few weeks. They were encircled and flanked by palm trees and dotted with white pagodas and old, sometimes ruined, monasteries. The smell of ripening rice swept past my nostrils with a touch of burnt grass. The beauty of the countryside had to compete, though, with giant

billboards carrying government propaganda: 'The Socialist Revolution must win', and 'Sweat and blood – that is the *Tatmadaw*'.

I found myself thinking of the old dynasties of Pagan, Tangoo, Ava and Mandalay, of the great king Anawrahta, the superhuman Kyansi-tha, the conquerors Bayintnaung and Alaungpaya, of King Mindon, founder of Mandalay as the capital, whose wisdom had prolonged Burmese independence in the midst of British power, of the last king, Thibaw, and his manipulative wife, Supayalat. In the midst of my anxieties I felt thrilled that I was near their great works, where they built their cities and pagodas and fought their battles. Although we Padaung and Karens felt a traditional enmity towards the Burmans, we were not immune to the glamour of the imperial royal past.

On the bus were Chinese traders, Shan tea-merchants, civil servants and government officials. Each group was suspicious of every other. Near Thazi, one of the passengers gestured to me with his hand. At first I could not grasp what he meant. Then, right outside the window, I saw a prison wall with barbed wire at the top. On the wall was a notice: 'We will pay for our wrongdoings with sweat'. Someone suddenly said with a touch of anger, 'Some people paid with money.' The whole bus burst into laughter, but then fell silent. Some prisoners in chains were being led into the compound by armed police. I felt a sudden chill in my heart. Then they disappeared from my view. I drank a mouthful of rice-wine which my mother had prepared, and then another and another. I felt better, even happy.

My sense of direction was going astray. The sun seemed to set on the wrong side of the horizon, for I was used to seeing it sink behind the hills. Up to now the east had signified to me 'beyond the lake' and the west meant the hills. Before the blanket of darkness fell, the long-anticipated royal city of Mandalay came into view. The passengers became restless and checked their baggage. I was puzzled that they were doing this so long before we arrived at our destination. They murmured conspiratorially into each other's ears, readjusted their luggage and reshuffled their possessions. Some Chinese women stuffed their jewellery into unimaginable places inside their clothes and their bodies.

The reason dawned on me as we approached the city and were stopped by a policeman at a checkpoint under a large sign that read 'Welcome to Mandalay'. He climbed onto the bus and ordered all the passengers to leave their seats. Once they were off the bus, armed

police checked their identity cards and unloaded all the baggage for examination. They seized some packets of Chinese seasoning powder, salted fish and other dry goods, explaining that they were doing this because to carry such goods in any quantity caused 'inflation' and damaged the national economy. No passengers dared acknowledge ownership of this property for fear of arrest. The police took it all – for immediate resale, as everyone knew, at black-market prices. Their potential customers were already hovering by the station like vultures.

The passengers responded with scarcely audible but ferocious curses, of which 'May they die in agony in this life and be slugs in the life to come,' 'May they make ugly corpses,' 'May they choke to death on a fish-bone,' and 'May they become dogs in their next lives and eat my shit' were among the mildest. The imaginative richness of the invective revealed a general hatred of the authorities beyond anything I had imagined, despite the example of my grandfather.

I was questioned for half an hour, having aroused unwelcome curiosity because I had no valuable things and didn't look like a student. Students usually travelled in groups and liked to dress fashionably. The seminary had taught us to dress down so as to avoid attracting the attention of females. Shabby, alone and tribal, I was an object of perplexed suspicion to the police.

2

REVOLUTION AND FLIGHT

'Never, Never Argue'

The Royal City

As soon as I arrived in Mandalay, I was robbed. The bus station was crowded with drivers of horse-drawn carts ('gharries'), motorised 'tut-tut' rickshaws and trishaws, all fighting for passengers; and with lepers, aggressive beggars and pickpockets. Brought up as I was in the profound tranquillity of a tribal hill village, as I stepped off the bus I felt plunged into a world of frenzy and chaos. I had never seen such a mass of discordant humanity, and had no idea where I was supposed to go, or where the University of Mandalay was.

Amid the confusion, a young driver seized my luggage and began making off with it. As I chased him other drivers were trying to grab me. He took me to the darkest corner of a street which – like nearly all the others – had hardly any lighting, where his cart was parked. (Not only are street lights sparse in Mandalay; the few that do exist have usually had their bulbs shot away by young men practising with their catapults.) Two sinister-looking friends of his joined him, and they talked to each other in low, conspiratorial voices. I told them to take me to the Catholic Lafon church, a well-known landmark in Mandalay. Instead they circled round the same block two or three times, before stopping outside a Methodist church in quite a different part of the town. The humiliating thing was that as they circled I could see the church only a few hundred yards away, but was too paralysed with nervousness to order them to go there.

They demanded ten times the normal fare. I protested. They surrounded me menacingly, and the one who was still holding my bags insisted on yet more. I surrendered the money, and he smiled. With inward rage I thanked them for their kindness to strangers, while

taking the number of the cart in case one day I could have my revenge. So, in the most traditional way possible, a country boy arrived in the big city. After asking directions, I found my way to Lafon church, and managed to get a place in the university hostel attached to it.

Mandalay

Inspired, as he believed, by the Lord Buddha, King Mindon founded Mandalay in the nineteenth century. Traditionally the Burmese capital would change with each dynasty, even with each reign, and essentially surrounded the residence chosen by the king. Mindon intended the city to symbolise a renaissance and reinvigoration of Burmese Buddhism, yet in building it he reached back to pre-Buddhist traditions. The 'Golden City of Mandala' was designed according to a pattern that includes ancient Brahmanist symbols and rules for enlisting the aid of benevolent deities. It is from the top of Mandalay Hill in the north-east of the city that the beauty of this 'New Jerusalem' of the Buddhist faith is best appreciated. The Hill is crowded with pagodas and monasteries and attracts pilgrims from all over Burma to festivals, retreat and meditation. In my years in Mandalay, whenever I felt homesick for my green hills in the midst of the baking heat and chaos of the city, I would climb the Hill to gaze longingly in the direction of home three hundred miles away, and meditate on my future.

The canopied stairs that went to the top of the Hill were populated with palmists, astrologers, soothsayers and tattooists. The young visited the Hill as a place for lovers' trysts. The old came to meditate, on this consecrated ground, the journey to their next incarnation. It was a symbolic centre of Burmese culture, and here writers and artists came to gather inspiration. There was also a venerable tradition – much stronger in the old days of democratic Burma – of politicians who came from all over the country to climb the Hill to acquire merit and divine help. When the morning dews lifted and dispersed, you could see the blue Shan plateau to the east, and to the west the Irrawaddy, that looked to me, even more than when I first saw it, like a noble, glistening python quietly crawling from the north.

Immediately beneath the Hill were the long, rose-red walls of the old Royal City – King Mindon's palace. Within the walls none of the original teak buildings, their triple-pitched roofs magnificently carved,

remained. During the Second World War the Japanese had turned the palace into a fortress. As the British retook Burma it was besieged, and all the buildings were burned. For the Burmese the burnt-out shell, its moat overgrown with weeds, speaks eloquently of how the country has fallen on evil days. There is an army barracks inside the walls, but apart from that the most numerous inhabitants are the bats which the citizens of Mandalay like to watch from the Hill at sunset, coming out from the deserted walls in their tens of thousands as the heat becomes less intense and the light fades. I brought to the spectacle words from outside the Buddhist tradition, from the *Lamentations of Jeremiah*: *Quomodo sola sedet civitas* ... ('How doth the city sit solitary ... how is she become tributary!').

In fact the only beautiful thing about modern-day Mandalay is its name. The first thing I felt in the city was the dirty heat that permeated it, heat mixed with every sort of odour. The daytime heat in summer reached more than forty degrees Celsius, while the nights were cool and, in winter, of a bone-dry coldness. There could not have been a greater contrast with the fresh mountain air and temperate climate I was used to. I could well believe stories of hill tribesmen who sickened and died when they came to live in the plain of Central Burma.

Apart from heat and homesickness, the chief enemies of well-being in Mandalay were the mosquitoes. They too seemed to have an urban cunning and malice, conscious of how easy a victim was a simple boy from the hills. At night in the hostel it was impossible to study outside the mosquito net. My fellow students and I tried to smoke them out of our room, but only managed to choke ourselves. In the end, the only way to go to bed was to wave the mosquitoes away vigorously and then jump onto the bed and under the net in the few seconds it took them to regroup. Even so a handful of them would always have got inside the net, and would show themselves in the morning like flying grape-pips blushing with human blood.

Thirst was constant in Mandalay, and the provision of water every-one's preoccupation. Clay water-pots and coconut-shell cups were to be found everywhere in the city, in the shade under trees, even at the cemeteries. Local people provided them free out of public-spiritedness. For some reason the constant thirst seemed to produce constant hunger. Yet at first I was unable to stomach the smell or taste of the food of Central Burma. The pungency of the pickled fish was too strong for my nose and too piquant for my taste. They even added

fish paste to their curries. But hunger proved to be a good appetiser and, graduating first to cold Chinese food, I began to enjoy the local cuisine. We cooked our meals on clay stoves, using sawdust and charcoal for fuel. In truth we were so poor that we could afford hardly any food, especially meat. The students from Chin State resorted, when they became desperate for meat, to stealing dogs. Perhaps out of necessity I decided that my favourite food was a noodle dish called 'mohinga', in which rice noodles are served with fish broth, banana trunk, shallots and sometimes slices of boiled egg. It is the cheapest substantial dish you can buy in Burma. I also liked such local snacks as roast palm roots, corn on the cob, Mandalay rice cakes and tea-leaves salad.

Teashops were abundant throughout the city and were open twenty-four hours a day, serving tea, coffee, fruit juices and snacks. Mandalayans like remarkably strong tea brewed for up to seven hours and served with sugar and evaporated milk, fresh milk and, particularly, condensed milk. As for the snacks, these included goat's feet soup with palata (a sort of chapati), palata with beans or sugar, nan with beans, samosas, Chinese dumplings and sweets. If I remember all these dishes so clearly, it is because in my constant hunger I was acutely conscious of all the good things on offer and what I could and could not afford.

The shops that served these snacks also offered ordinary tea free of charge, and so, like other students, I would buy one pot of tea and then sit drinking endless cups of free tea while listening to music. Hardly any of us could afford cassettes or tapes, and the tea houses were the places where we could listen to the latest pop music, as well as exchange personal and political gossip.

To me, Mandalay (a place which, as I later learned, foreign visitors enjoyed as a sleepy backwater that time forgot) was an amazing metropolis, a town of astounding variety and sophistication, a city that never slept. In Mandalay I learned to use the telephone and the electric kettle. I was so excited with the former that I felt I had to ring someone up. Unfortunately I knew no one who possessed a phone, so I rang up the nuns in the Mandalay convent, rather to their bemusement. The electric kettle was more useful. We had no socket, so we would fill a mug with water, perch the electric coil on the rim of the mug and attach the wires to a pluck (our word for a plug). Electric shocks were frequent.

My first introduction to foreign gadgetry went with the first stories I began to hear about the wonders of the West. I was told that in the West people could cook their meals without pots and pans and stoves. I was puzzled how this could be possible. The few Burmese magazines that were not government-controlled regaled their readers with these strange stories which they gleaned – in embellished form – from the British tabloid the *Sun*, from *Newsweek*, and from the novels of Jeffrey Archer, one of the few living English writers allowed to be published in Burma.

The beliefs we absorbed about the West strangely resembled the fantastic stories early Western travellers sent back about the Mysterious East. One teacher at school had told us that in the West things were so advanced that pigs could be grown on trees, and that a type of furniture had been developed that could be eaten if ever food supplies ran low. He also explained to us that the West got so cold in winter that if you peed outdoors the urine would instantly freeze so that you had to snap it like a stick. We had a pretty good sense that these were tall tales – but they made better listening than the equally tall tales of the regime. When we learned that the Americans got to the moon, for instance, we had solemnly been informed by a fanatical socialist-nationalist teacher: 'Our ancestors got there centuries ago on the astounding flying machines that the genius of the Burmese had perfected – secrets alas now lost.' We learned something important from all this: that the Burmese, after nearly thirty years of isolation from the rest of the world, constantly subject to official propaganda urging them to detest and despise the West, were in fact fascinated by the Western way of life and ignorantly credulous about it.

In the streets of Mandalay hundreds of pariah dogs, infested with every sort of canine disease, gambolled on the tops of rubbish heaps, lurking around shops and any other place where food was thrown away. Their smell carried many yards. Occasional showers of rain would release the scent of jasmine and other fragrant flowers in sudden waves that mingled with the smell of sewage from blocked streams. Never have I lived in a place where one's sense of smell was so affronted and yet so stimulated at the same time.

There were no showers at the hostel where I was living, so we had to buy water for showers, at fifty pya for ten gallons. Showering in private was out of the question, since the wells and shower shops were always on the corner of the busiest streets. We clubbed together to

pay for our ten gallons and took our showers communally. It was not luxurious, but it encouraged our sense of comradeship.

University

One of the landmarks of Mandalay is known as the Lafon church. This church, built in the French Gothic style in 1894 by Father Lafon, a French priest, was a centre of Catholic life. But it was in a decayed state. Many of the windows were broken; the prayer-books and hymnals – by Father Faber, the famous nineteenth-century English priest and hymn-writer – had foxed and yellowed leaves; the organ was unplayable because the wind-chest was full of holes. Attached to the church was a hostel that had been nationalised by the government in the 1960s, when all Church schools were taken over. Six or seven Catholic and Baptist students lived there. Although Mandalayans still called it the 'Lafon church' the government had officially renamed it 'Ratanabummi', which means 'cluster of gems'. The students instantly renamed it 'Ratanafummi', which means 'fake gem' and which also alluded to Ratana-natme, one of the wives of the dictator. We found this humorous because Ne Win was fond of the use of the word '*ratana*' ('gem') as part of the linguistic propaganda promoting his politics of illusion.

The penchant of the regime for attaching beguiling words to a sordid reality was par for the course, an example of the fantasy world that passed for reality. We had been used to it all our lives. Much of the fantasy centred upon agriculture – one of the chief failures of the regime in a country where the majority of the population still worked on the land. Every year, Ne Win would dress up in robes reminiscent of a king of Burma and symbolically plough a furrow or two to start the season of sowing. At harvest time the newspapers were full of photographs of happy farmers, dressed unconvincingly in fine and expensive clothes, dancing and singing their way to the centres which the government had set up to receive farm produce. In fact they were forced to sell their produce at low government prices. The government-controlled media joined in the deception. This is from the English-language newspaper the *Guardian* (no relation to the famous English liberal newspaper of the same name) in February 1988: 'Tomorrow, Peasants' Day will be observed throughout the country. It is a day on which we are honouring the peasantry . . . While the State is doing its

utmost for the welfare of the peasants, we may be sure that the peasants on their part will strive further for the all-round development of the country, by growing crops as scheduled and bringing their harvests to the State as land revenues according to the prescribed rates.'

We would also be told that farmers were always prepared to 'donate' a proportion of their income from the rice sales to the pagodas, and there would be a picture of the head of whatever local monastery was under military influence receiving and blessing the 'gifts'. Another odd bit of propaganda was that fishermen would release many of the fish they caught in order to gain religious merit. This was meant to suggest that the rivers and seas of Burma so teemed with fish that such sacrifices came naturally. The regime's propaganda was a weird mixture of socialist ideas with traditional Buddhist images of paradise. So a military base might be called 'Conquering Flower Land'. Indeed, the Ne Win government virtually claimed that the land ruled by the Burma Socialist Programme Party was a Nirvana, with no poverty, political dissent, incorrect thoughts or pickpockets.

The 'cluster of gems' in which we lived was a run-down, squalid and vandalised building which was never refurbished or given even elementary cleaning except when inspectors or influential people were expected to pay a visit. The main University of Mandalay campus, about two miles away on the outskirts of the town, was no better. The original, magnificent buildings were by now surrounded by jerry-built huts to create classrooms for the ever-increasing student body. The only things that were never touched by the builders were the tamarind and other flowering trees around the campus, because they were afraid of the *Nats* that inhabited the trees.

The first few weeks in Mandalay had been shocking for me. Shaken by the robbery on my arrival, I dared not go out for three or four days. The truth was that I was terrified by this new world, this enormous and impersonal city. It was almost impossible for me to face people on my own. Eventually I ventured out to have breakfast in a teashop: a cup of tea with condensed milk and cooked beans on a piece of nan bread. I felt that everyone in the shop was staring at me because of my strange appearance and accent. In my anxiety I broke a teacup and saucer and had to pay for them – which came to more than the cost of my breakfast. People looked at me (I thought) as though I were a criminal: some were amused, some disgusted. The

embarrassment was more than I could bear. I stumbled on the doorstep on my way out and everyone laughed. I got up and shook the dust off my body, trembling and ashamed. I went straight back to my hostel and dared not go out the whole day. I missed all my classes and lectures, and dared not speak to anybody because I was afraid no one would understand me with my alien hill-tribe accent. At the hostel I kept telling myself that this was a disastrous beginning, that I would have to overcome this fear of strangers, this shame about myself, that I would be an abject failure if I gave up after having come all this way carrying the good wishes and hopes of my family and tribe. Nevertheless, it took me a week before I dared venture out to classes again.

The English Department had about four hundred students altogether. There were twenty teachers, mostly young graduates who taught grammar. There were only three or four proper lecturers. My chief disappointment was when I discovered that there were no proper textbooks for the students. Most 'textbooks' were photocopied sheets crudely stapled together. Even these were in short supply. When it came to texts of complete novels, the shortage of copies made studying almost impossible. The 150 students in each year might have to share a single copy. Sometimes a student might type out the entire text as the only way of having a chance to master it. The only alternative was to buy proper texts on the black market – at the impossible black-market prices.

I was part of a group of twenty or so students of English literature who had become close friends. We were Burmans, Shans, Kachins, Chinese from the Shan States, and two Padaungs. Our passion – for such it was – for English literature came from our sense that it was the key that unlocked the mysteries of the West. Perhaps those of us who were from the minority peoples had a special desire to take a subject that helped us escape from Burman domination. But I had been fascinated by English ever since I began to learn it, and all of us would have discussions about the works we were studying far into the night. Traditionally, medicine was the subject that attracted students with the highest qualifications from their tenth-grade, or matriculation, exams, but to us English literature was no less exciting, and students who could have studied medicine – including myself – often chose English instead. They did so even though they knew there would be few material rewards flowing from their choice. After classes we would

discuss what we were reading privately amongst ourselves, and make sense of it by relating it to our own, diverse backgrounds.

Before I had a chance to concentrate on my studies, I came under pressure to join the 'Lanzin Youth League', the youth movement of the ruling party. Members of the Lanzin Youth would assemble to greet visiting dignitaries, waving little Lanzin Youth flags. Apart from that it was a sort of bizarre boy-scout organisation, which also included elements of Red Cross training. There were hikes in the mountains mixed with basic lessons in health care and the Burma Socialist Party Programme ideology – especially the grandly entitled theory: 'The Correlation of Man and His Environment'. However, few of the Lanzin Youth had much interest in that. Many of them did learn useful organisational skills which, in a few years' time, they would use against the regime.

In Burma, apart from good and bad news, there was 'fragrant' news. The term denoted news that was good but that was given a sarcastic or hostile twist by the regime. The 'fragrant' news from the West at that time was of the new computer age, of advanced technologies and of political freedom. People reacted in different ways to the news, but always and necessarily from a position of ignorance. Our teachers could hardly enlighten us, for they both shared the general ignorance and were at the same time obliged to apply the official ideology to the scraps of puzzling information that came their way. The result was an amalgam of the regime's anti-colonialism and resolutely pre-modern superstition.

These were the words of a lecturer in political science: 'You may talk of Western freedom, but here in Burma we have a far superior and more genuine freedom – and always have had. That is why we possessed these Western technologies in ancient times when the Western countries were still in a state of primitive barbarism. If you read the ancient Burmese texts you will see that our ancestors could fly in the sky. They also possessed secret weapons still undreamed of by the colonialists. They were able to defeat the enemies of Burma simply by their use of the power of thought. Western inventions are as nothing compared with the glories of old Burma.'

We all sensed a certain vagueness in what he was saying but, schooled in Confucianist and Buddhist traditions of reverence for one's teacher (in Buddhism teachers, along with parents, are among those to whom one owes a kowtow), we listened in respectful silence to his

fantasies. But then one student broke the spell: 'Why, then, were our ancestors beaten by the British in the last century if they had such fantastic powers?'

The lecturer's face reddened visibly with embarrassment and anger. 'Well, because the British are criminals and colonial invaders – and they used a lot of Indians.' (He added the bit about the Indians because, I think, he sensed he was on weak ground and assumed that the hatred of Indians instilled in us by the regime would get him through.)

The student – astonishingly – persisted: 'But surely the real reason was that the British were fighting with machine guns and cannons, while our soldiers were tattooing themselves with magic ink that was supposed to make them invulnerable to bullets, and fought the invaders with swords. So they were mown down like grass.'

The teacher's face was now suffused with barely suppressed rage. 'You have been thinking too much, comrade – but to no purpose. All you are doing is repeating the lies spread by the colonial minions. I think you need a holiday. Meanwhile, shut up and learn your Party principles.'

The student did indeed take a holiday – which is to say that he disappeared from classes for several months. Later, I learned he had been sent to a hard labour camp. He never came back to the university, for in the camp he lost his reason, and ended up in an asylum. When the news leaked out, the teacher was not at all abashed – rather he took it as proof that dissent was rationally unthinkable: 'You see, all those colonial and capitalist minions are mad. Don't believe a word they say.'

Not only was the student neither mad nor pro-colonial – he was not even anti-socialist. He was simply arguing an historical fact, and wanted to generate a discussion. But perhaps, in the circumstances in which we studied, that was a mad thing to do.

Troubled, I went to an English teacher, whom I had come to trust, in order to learn about the argument in private. He said: 'Remember what your grandfather said about the earth's being round at school and flat at home. He was a wise man, and taught you what you need to know in Burma. It is the same in politics. Learn the arguments for socialism in the textbooks, parrot them, pass your exams. Never, never argue. But keep within your own head and heart what you and everyone really knows – that in the real world it is a system of incompetence and corruption, and a project for ruining the country. They may be

as ignorant as peasants – but they have the guns. Never, never argue with them.'

Talking to him removed a stone from my heart.

Mandalay

Moe

Studies

At university I took political science, logic, history, Pali (the ancient Buddhist liturgical language) and Burmese literature as my optional subjects and English as my major subject. We spent the whole first year studying English grammar, fifteen poems, one play and two novels. The novels were Hemingway's *The Old Man and the Sea* and *Goodbye Mr Chips* – a sentimental tale about an English schoolmaster, by James Hilton. The play was Shakespeare's *Macbeth*. The poems were taken from *Palgrave's Golden Treasury*, and included Wordsworth's 'Daffodils', Shelley's 'Ozymandias', Tennyson's 'Break, Break, Break', 'Leisure' ('What is this life if, full of care,/We have no time to stand and stare') by W.H. Davies, and selections from Longfellow's *Hiawatha*. Essays were dictated to the students to be learned by heart. Discussion was not encouraged. Any talk by the teacher about a book not on the course, and hence not explicitly approved, spelled disaster for the tutor and for his family. He would be dismissed, or worse.

I enjoyed the Burmese literature course. We read classic Burmese poems, including an epic about the heroic deeds of Nat Shin Naung, an eighteenth-century Burmese general. My favourite poems were ancient ones, written almost invariably by monks. They celebrated, above all, the beauty of women.

The subject of history had been taken over by the regime for propaganda purposes. You could say that it was the story of heroic Burman nationalists from the ancient kingdom of Pagan (1044–1287) to General Ne Win. The main period for study was the irruption of the British colonialists into Burma from the early nineteenth century, culminating in the extinction of the Burmese monarchy in 1885. The

climax was the period from the Great War to the Second World War, the creation of the Burma Independence Army under the Thirty Comrades, and the salvation of Burma by Ne Win in the *coup d'état* of 1962.

The tutors never asked themselves – or invited from us – any questions about the validity of their teaching or their methods. Many of the high-ranking professors seemed concerned with little more than their own importance and holding on to their comfortable jobs. You had to massage their egos to do well in exams. Yet there were also some tutors who genuinely loved their subject, who were not slaves of the authorities, and who sacrificed themselves in the interests of their students. Such teachers were 'more rare than rubies', and we worshipped them.

Our political science tutor was a brilliant man and a fearlessly outspoken teacher. After dictating to the class in the usual manner, he would add: 'That is what *they* say about politics – but none of these ideas has any relation to reality. But don't say that in your exams. Just write down what the authorities want you to say – which is what I have just dictated to you – and you will pass your exams with flying colours.'

What was breathtaking to us was that he would then go on to demonstrate the enormous contradictions there were between the Ne Win government's propaganda about the ideals of the Burma Socialist Programme Party – in fact the whole fantasy world promoted by the regime – and the ugly realities we all knew about: a collapsing economy and education system, corruption and the suppression of the most intelligent among the population. As a result, students packed his lectures. He was demoted, and sent to a remote part of Burma as a village schoolteacher.

The lectures of young female tutors were also packed, but for different reasons. They were filled by male students who came to admire the lecturers' beauty. After the lecture, the students would swarm into cafes and discuss a lecturer's body with great analytical passion. They were especially excited by beautiful toes. For Burmese, the toes and fingers are the most compelling signs of physical perfection in the female.

For the second term I supplied myself from home with dried meat and bottles of rice-wine. I had at last begun to get rid of some of my shyness, and started to explore the city and its surroundings.

Mandalay is famous for its '*pwes*' or festivals, and for the artists who perform in them. *Pwes* took many forms: there were 'pagoda' *pwes* and *Nat pwes* – even the funerals of monks were regarded as *pwes*. Spirit festivals – the *Nat pwes* – were notorious for chaos and deaths. Indeed, a spirit festival was never regarded as successful unless there was a fatal accident, because the spirits require human blood. Rapes were also common. Family men avoided these festivals, and locked up their daughters.

The Burmese love *pwes*, and above all they love the clowns, who played their part with ribald jests and burlesque. They also bravely expressed the feelings of their audience that never found an outlet in the government-controlled media. I once met a clown who made jokes about the misdeeds of the regime at every performance, even though a prison van was waiting for him behind the stage. He was regularly put in prison, but he went on telling his jokes in full knowledge of what was to come. He was loved by his audience, but no one could protect him from the wrath of the regime. In the end the police knocked all his teeth out to demonstrate to him who was in control. Not many months later we were to witness a new sort of *pwe* – a festival of popular rage against the regime. But as yet that was unthinkable.

New Love

One evening, on my way back to the hostel, I stopped at a street stall to have a bowl of mohinga. Three girls were sitting there having mohinga as well. As I walked in, they looked at me in a scrutinising way as though I was going to rob them. I hesitated, but then took a seat beside them. I ordered a bowl of mohinga nervously and settled down to it, trying not to look like a gauche hill tribesman. Suddenly one of them murmured: 'What an idiot to dress in those clothes at this time of year!' I looked at myself uncertainly. They were right. I was wearing an army surplus jacket, and was sweating like a pig. With my long hair I looked more like a rebel from one of the ethnic insurgencies than a student. I took my coat off and put it on the bench, and ate quickly to avoid the torture of their giggles.

On the street the wind was blowing harder and harder, as though a storm was coming up. I paid the stall-keeper and headed out towards the hostel. No sooner had I reached the door than one of the girls shouted: 'Hey guy! You forgot to take your jacket.'

Outside, the wind was blowing so hard that it was bringing trees down. There was thunder and lightning, and the sky fell in. At the hostel I had a free shower (I usually limited the number of showers I took because water was expensive) under the gargoyles of the church with my friends, including the priest. Feeling like a new man, I jumped onto the bed under my mosquito net, and began to study as usual. It was still raining outside, but less heavily. At about eleven, I heard people shouting for help from the other side of the street. I put on my jacket and ran out into the rain.

First, I thought the people were chasing a thief, or that perhaps the rain was causing some serious damage to the building. I was amused to discover that they were all in a state of panic about some creature that had got into the first floor of the house. They showed me where it was. I peered between the wooden wall and the post of the house, and through the chink I could see something stirring. They urged me not to touch it. I examined it carefully – it was a snake that had been driven by the drenching rain flooding the ground outside to take refuge in the house. Now my 'primitive' hill tribesman's upbringing came in handy. Using a technique my grandfather had taught me I seized the snake by the tail and swiftly broke the creature's back with a sharp jerk of its body. Fortunately the snake was coiled around the post, so it was easier for me to break its back without being bitten. I took it back to the hostel, where it made a delicious dinner.

Several girls came out of hiding, still petrified, and I heard one say: 'It's the man with the jacket!' I looked at her. She smiled nervously, and said in an exquisitely shrill voice (the sort of voice that we Burmese find erotically attractive): 'I didn't know there were boys around our hostel. It is handy to have boys near us. We can call on them when we need them again. By the way, my name is Moe. You can call me Moe. You can visit us.' I was overcome by her insolent way of talking, and pierced to the heart by her eyes. I hated her. I realised that she was beautiful, but I didn't tell her because I felt such rage.

Afterwards, I tried to avoid Moe and her friends. They teased me and ridiculed my accent, and I felt followed everywhere by their giggles. For a long time pride and shame made me resist them – but in the end I gave in, and Moe and I became friends.

Moe's father was an army officer from Lower Burma, and he met her mother, who was from Upper Burma, in Maymyo while he was training as a cadet there. The family had to be on the move all the

time, travelling throughout Burma, from the bottom of the country near Malaysia up to the top in Kachin State, which borders India and China. When Moe's father was promoted, he was sent to Shan State. He was killed in an ambush near Taunggyi some years later – apparently carried out by rebels from the Padaung's cousins the Pa-O. Mother and daughter moved to Upper Central Burma. Moe was only twelve at the time. The government compensation for the father's death and the widow's pension were not enough for the two of them to live on, and they led a bare hand-to-mouth existence while Moe was studying in high school, making a little extra money at weekends selling snacks – tempura and plates of rice and beans – on street corners. But Moe's mother somehow managed to save enough money for her university education.

Moe was a devout Buddhist. She had the independence and earthiness that until now I had thought typical of Padaung women, rather than of Burmese. She seemed devoted to fun and pleasure, including the pleasures of the senses. It was a long time before I realised that all this concealed a sense of purpose that was to astonish me.

For a long time I found Moe hard to understand. Her attitudes and beliefs were far more complicated and contradictory than anything I had experienced – even harder to make out than the mixture of Catholicism and animism in which I had been brought up. Religion to her was private, something that satisfied her soul at unseen depths – very different from the rules and outward observances that had governed my own religious life. It had nothing to do with morality, or with relations between men and women; nor was it emotional. She loved visiting pagodas and monasteries at weekends to meditate, strengthen her mind and acquire (so she said) a sharper sense of the world around her. She seemed to live for the world of the senses – which in Buddhist tradition are part of the veil of illusion – and said that she had no interest in renouncing what we Catholics called 'the world and the flesh' in favour of an ascetic holiness. She believed that a woman could become a Buddhist nun only out of the profoundest despair. And yet in the very strength with which she rejected conventional Buddhist other-worldliness she showed a religious belief, for to live every day intensely seemed a sacred duty for her.

Unlike other worshippers, she did not pray for a better life in another world, wanting instead to consecrate the life of this world. Instead of seeing existence as suffering in the usual Buddhist way, she

saw a life not lived to the full as a scandal, as something shocking. She wanted to live fully, and to find someone who would face the future along with her until she died. The idea of permanent happiness was to her impossible. The joy of life was to have the courage and intelligence to overcome the fears and obstacles of life, and to live absolutely in the present – which was the only way of enjoying it. I never knew anyone of such vitality.

She admitted that she was extremely impatient – again a contradiction to the Buddhist ideal – for which she blamed the 'chemicals' in her body. I asked her if she thought women were lower in the Kharmic cycle, as Buddhism has always taught. 'Yes and no. It would take too long to explain. Just use your senses and you will know.' That was the closest she ever came to an explanation. I came to trust her senses, and mine as well.

Our innocent friendship did not last long. Neither of us was a virgin, and we decided to become lovers on a night of the full moon, which we thought would be auspicious for our future. Our rendezvous was on a bench under a tree in a quiet part of the campus one evening before Moe's hostel closed. We spent most of the time fending off mosquitoes and giggling. Afterwards we went to the cinema and walked along the moats of the Mandalay royal palace. From Mandalay Hill we watched the sun set over the Sagaing Hills. A fortune-teller read our palms. He predicted that both of us would end up in a foreign country.

We decided to keep our affair a secret. We felt this was necessary because we shared the general fear that the government wished to make trouble when there were relationships between people of differing religious, social and racial backgrounds. The government relied on the maxim of divide and rule, wishing to keep the dominant Burmans suspicious of the minority ethnic groups and of non-Buddhists. Any growth of knowledge, or actual friendship between the groups ran counter to their strategy and was dangerous. People in Rangoon tended to believe the government-inspired idea that the Padaung were cannibals – even Moe's friends believed it until they met me.

In my tribe you choose a wife if she is good at making rice-wine and at other household skills. I was not used to sophistication in a woman, so Moe was an entirely new experience. When she wanted to feel Burmese, she would wear her smartest *longyi* with no underwear.

She wore pink Burmese blouses when she was in a romantic mood, blue when she felt depressed, and flowery patterns when she was in her best spirits. She tied her long hair into a severe knot and wore yellow 'padauk' flowers in her hair during the summer. I told her that only ugly women needed flowers in their hair, and she gave up wearing them. She would put on Burmese make-up – 'thanakha' powder, made from the bark of sandalwood – on hot days. She spent immense time and care choosing her thanakha and used a special round stone to pound the barks to powder, rubbing them at the same time with water and jasmine petals. She wore Burmese flip-flops on her feet and always carried a parasol.

When she felt like being 'Western' Moe still wore her *longyi*, but with brassiere and underwear, along with Western high-heeled sandals and make-up. She never wore jeans because she thought they ruined all sex appeal and were horribly uncomfortable in hot weather. Skirts did not suit her at all. She always carried two handkerchiefs, one for wiping her mouth after eating, the other, a fine silk one, for show.

During the nights, we boys would strum guitars and serenade the girls with popular Burmese songs, sitting on the fence of their hostel. Occasionally the girls encouraged us, cheering and showering us with sweets. Sometimes the police chased us, arrested us and charged us with a breach of the peace. It was thrilling for us to smuggle our girlfriends out of the hostel and take them out for the night – we called it 'stealing pork'. The porters had to be bribed for a month beforehand, and all the parties concerned had to co-ordinate their plans with great care for the enterprise to be successful.

At the same time, I studied hard in the Burmese way, taking down everything my teachers said, learning it by heart, without daring to question or debate. My friends and I all passed our first-year examinations (out of what was to be a four-year course) 'with flying colours'.

Then, just before the end of the academic year, in October 1985, the state radio announced without warning that the government had demonetised the currency. All hundred-, fifty- and ten-kyat banknotes were declared worthless, and were to be replaced by seventy-five-, thirty-five- and fifty-kyat notes some months later. There was an immediate build-up of political tension, and the universities, colleges and many schools throughout the country were closed. I had hardly any money left. I sold my bike and went home. Moe cried when it was time for us to part. She went to a pagoda to offer flowers and

candles to Lord Buddha, and I went to pray in church to the Virgin Mary. We both prayed that our relationship might last for ever. Then she went back to her home in Upper Burma, and I returned to Phekhon and Shan State. We both hoped to meet again in Mandalay at the start of the new academic year in December.

Back home, my mother had given birth to her eleventh and last baby. He was named Henry and (in Padaung) 'the Last'. My parents were far from overjoyed – they worried how they could possibly feed all ten of us. Full of my new sense of myself as a grown man, I told them they were not to worry. They had done their duty as parents, and it was now the turn of us children to look after them. They were not convinced, but gradually they became less authoritarian towards me. Imperceptibly, I was beginning to become a figure of authority in my own right. To question any of their parental decisions ceased to seem unfilial and against our traditions. The result was that I now began to have a different idea of myself, and a new desire – to be a good son, one of whom my parents could be proud.

Worth Only One Bullet

The First Demonetisation

Even in sleepy Phekhon, in the months following the demonetisation you could sense the anger building up throughout the country. Everywhere – in the tea and noodle shops, the markets, even the churches, the conversations were only about the demonetisation. Never since the military coup of 1962 had there been such bitter and general discontent, nor such a sense of the Burmese spirit being so alive. Yet people hardly spoke of their own individual situation – it was as though a deep embarrassment, even a sense of shame, deterred them from doing so. People who had no money smiled uneasily, while those who had some became subdued and secretive. Some people went mad or committed suicide. While the rampant inflation – universally blamed on the government – had been a disease, the demonetisation was a lethal injection.

Yet neither the public disquiet nor these individual catastrophes were ever mentioned in the media, all of which – newspapers, television and radio – were government-controlled. So people felt something more than a sense of material loss. They felt humiliated that a once prosperous country, with a previously high level of education, should be governed by such mendacious incompetents. Instead of admitting their failures, the Ne Win regime redoubled their efforts to blame the disaster on the hidden exterior and interior enemies of the nation – the Chinese-backed Communists, the ethnic insurgents, the capitalists, the colonialists and their 'minions'. It was officially announced that compensation would be paid to those who could establish that they had earned their money 'by honest means'. This meant that all money from any source other than working for the government was unsalvageable. Very few people were ever compensated.

Day after day the state media insisted that the government had demonetised the currency for the good of the country, to control inflation. The populace had to be patient. The black-market traders and other 'destructive elements' would be smoked out by the measure and destroyed. Inflation would all but disappear. Meanwhile, big merchants and government-related businesses were making huge profits from the general misery. Farmers might have no option but to sell their land at minimal prices to government agents. They in turn would sell it to rich Chinese (or sometimes Indian) traders. People were being forced to pawn all their possessions to buy food. So all the propaganda on state radio was greeted with shouts of rage in the teashops. Monks made their own special protest, refusing to accept alms. Through all their rage people kept a stubborn belief that the government would – must – refund their money. But that did not happen. The regime even managed to give the impression that they wanted to provoke the populace, that they were consciously spitting in their face and demanding that they take it with a smile. They did so, but not for long. Anyway, throughout south and east Asia, the smile has a different meaning from what it usually has in the West. We smile stoically, to mask embarrassment, shame, humiliation and anger. The populace had begun to feel that this time they should have a political *pwe* – a festival of political rage, a settling of scores.

When the university eventually reopened in January 1986, I didn't have enough money to get back to Mandalay. My parents' savings had been wiped out in a few days. I applied to the university for a stipend and was refused on the grounds that I was not a member of the Lanzin Youth. The Church could not help me, because some of the priests resented my being an ex-seminarian or 'spoiled priest'. They thought it was a waste of money to help someone who was not going to become a priest. By the time I managed to travel back to Mandalay, it was too late for me to enrol for the year.

Like many Burmese women, Moe was generous to her lover. She could find money enough to feed us both, so I had no need to get a job. I felt this as a humiliation, but she insisted that it was a Burmese tradition for women to support their families, and that I only had to look around me to see that that was true. But in the end I had to find work. Although Moe fed me when she could, I often fasted for days while I was searching for a job. I did not tell my parents what was

happening, because I knew they were in trouble themselves. Suddenly all the disastrous scenarios I had imagined fell upon me all at once. I had absolutely no idea what to do. Until then I had led a charmed and protected existence. I had never struggled for my own survival and I had never been without money or support from my family and relatives.

Life as a Waiter

After roaming about the streets of Mandalay and starving for several months, I got a job in a Chinese restaurant owned by a Chinese Methodist elder. He was in his late fifties, a handsome man, a pillar of the community. His own children were university students, so he understood my predicament. He took me in and treated me virtually as a member of his family. I worked seven days a week from eight in the morning to nine in the evening, but he let me have Sunday mornings off to go to church. The pay was three hundred kyats per month (about $5 at the black-market rate). I didn't mind the low pay. I was more than grateful for his kindness in taking me on at all when I had nothing to eat – a personal kindness that meant all the more in a country where no workers' organisation actually protected their interests.

In the mornings I cleaned the restaurant floor and furniture and prepared vegetables, and in the evenings I served customers. Once or twice I even had a chance to practise my English on tourists. My boss was happy for me to fraternise with tourists as long as I did not talk too much or criticise the food. He would watch me from the counter all the time over his small, oblong glasses.

The restaurant was like a theatre, a place where people liked to display their wealth and power to us waiters. Police from a neighbouring police station often came to collect the tribute of food and alcohol to which they felt entitled. Military Intelligence ('MI') agents sipped rum and sodas in a corner of the room and kept an eye on the customers – merchants with their mistresses, army and police officers doing black-market deals with my boss, the children of the rich and famous.

In contrast to that was the regular, wrenching sight of chained criminals, of whose identity I knew nothing, condemned to prison for life, taking their last meals with their families in the outside world. As

the meal ended they would perform a kowtow to their parents, begging forgiveness of them for the misfortune they had brought on the family. This had a meaning which all Burmese recognise. There are five categories to which you kowtow: the Buddha, the Buddha's teaching, monks, parents and teachers. The prisoners were not kowtowing to the police, or to the state that the police represented. Although they had received life sentences, most of them were simply petty criminals, unfortunates who had been sucked into the criminal world by abject poverty and total lack of education.

When they were in a good mood the MI agents were boisterously friendly. They were proud of their work, and would tell me about it and about themselves – for they knew what power they exercised over ordinary Burmese. An agent boasted to me one day, 'Look at my card. I am an MI.' (For some reason he wanted to avoid the word 'agent'.) 'If you are ever in trouble, let me know. I can help you. You are a good man.' I politely said I would – and I suppose I meant it, up to a point. The MI were, after all, a more impressive body of men than the police, whom everyone regarded as merely venal and detestable.

Chinese weddings and funeral receptions were the most exhausting jobs for us. Chinese customers were intensely demanding and almost impossible to please. They had the habit of humiliating waiters in front of their guests. The first non-Asians I met were Soviet diplomats. They were a uniquely repellent breed – especially their wives, who insisted that we boil the plates before meals were served on them. We dutifully did so and wiped them spotlessly clean with the newest napkins we had. When the hot, newly boiled plates were sent back to them the ladies would wipe them again with napkins doused in Johnny Walker Black Label before they ate.

I also had my first encounters with people from the West. I was so shocked by my first impressions of Western tourists that for several days I could not accept what my senses presented to me. I saw massive, sweaty bodies lumbering into our restaurant like white buffaloes who had just completed a day's ploughing in the fields. The women seemed only half-dressed and – biggest shock of all – they displayed rough body hair (I noticed that especially among Germans and Israelis). Whatever perfume they wore, foreign white tourists seemed to exude a pungent and unpleasant body smell.

Apart from Soviet diplomats, the customers that one never seemed

able to please were officers of the Burmese army. They demanded that one humiliate oneself before them. One evening I waited on an officer who had clearly been drinking heavily. He said, 'Serve me properly, boy. And remember – you are worth only one bullet.'

'Yes, sir.' Despite my shock and anger I forced myself to be impassively polite, to smile and to nod. Yet I found myself staring at him, remembering the dark powers attributed to me in childhood, and saying to myself, 'See you again, soldier.' I saw his fate.

I did see him again – on the Thai–Burma border where, after a battle between the Burmese and Thai armies, I found the body of a Burmese officer riddled with bullets. I turned it over – and it was he.

Amigos

All seemed to be well when I rejoined the university for my second year in 1987. I had spent the previous year working in the restaurant to raise funds for my studies (and to send money to my family), and looked forward to getting back to academic work. I was happy in my studies and in my job. My moustache and goatee beard started to grow faintly and I felt I was fully a man. I had a girlfriend who gave me unstinted devotion. I had even got used to the appearance of white tourists. Surely, nothing could go wrong again.

I discussed the future with Moe. Her mother wanted her to become a schoolteacher in the town where they lived, so that the two of them could remain together. But Moe's ambition was to be a university lecturer. This was not just an idle dream. Moe was never a mere dreamer; rather her imagination allowed her to open her eyes more than most of us can to the possibilities that are around us every day and that most of us are, from habit, too timid to grasp. She was determined not to be a mere housewife doing menial tasks – but she was equally determined to be a good wife. I came to see that in her idealism she was actually at the heart of reality because, unlike me, she was consciously and continuously dissatisfied with the society around us.

Moe's language was not quite prose – nor was it poetry. Her everyday talk was mixed up with the words of Burmese love songs and romantic novels. But she was not a sentimentalist. She had an extraordinarily sensual, connoisseur's way with words – lingering lovingly over a Burmese word that might be especially rare, or that she could

savour with her tongue as you might savour a delicious wine on the palate.

We planned to get married soon after graduation in three years' time, whether our parents allowed us to or not. We assumed that they would be unhappy with our union because of our differences of race and religion. My family would be horrified at my marrying someone from the land of green ghosts. Hers would think of my tribe as little better than cannibals. We decided to elope if the worst came to the worst, for we could not imagine tolerating delay. We had no thought of resisting our all-consuming and mutual passion that made the outside world a mere shadow of what burned in us. Moe was the lover I had met on a stormy night who had the daring passions of a man and the enduring affection of a woman. I lived in a permanent state of intoxication at the thought of what was to come, at my amazing luck. All my work, both in the university and in the restaurant, was directed only towards the ideal bliss I could see for us both. Amazingly, we still managed to keep our love affair to ourselves.

More students from Kayah State arrived from Taunggyi College to resume their studies at Mandalay. We formed the first Kayah State Students' Union of Mandalay University. Of course this union was not allowed to have any political purpose, but had to be purely social and religious. Most of us were Catholics, mixed in with a few Baptists and Buddhists. Our chief activities were rice-wine drinking, cooking and eating together, having picnics and lending each other money. Students from Shan State, Kachin, Chin State and some other parts of Burma also joined our group which, in its way, was unique – a non-political, purely friendly coming together of people from minority groups in a spirit of self-help. I knew of no other similarly inter-ethnic society in the university.

We gathered in a run-down hut that we called, without irony, 'Our Heaven'. This was not officially on the campus, and so we had a certain freedom from the attentions of the university authorities. Something that marked us out for sceptical comment was that we included women in our everyday activities. Many students could not understand that at all, for they assumed that if a boy and a girl lived in the same house it infallibly meant that they were lovers. Friendly companionship of this sort between the sexes was hardly thinkable to the Burman majority. We divided the hut with a curtain and slept, on our bamboo beds, in the separate sections. To share the hut in the way we did carried,

for others, an obvious sexual connotation. Even for us it was something of a conscious statement, but we did not even try to explain our point of view to the rest.

'Our Heaven' was about three hundred square feet in size, made of bamboo and roofed with palm leaves. It was situated in a dank part of the campus and surrounded by several equally run-down and shabby huts. In a corner was a kitchen. At the centre was a shrine adorned with a rosary, a bunch of flowers in a bottle, candles and pictures of the Virgin Mary, St Dominic and St John Bosco – the patron saint of the priests who had converted the Padaung. The hut could accommodate up to ten people at night and fifteen during the day.

Our Burman Buddhist neighbours, who worked for the university as cleaners, were very curious about the unusual way of life of their new Christian neighbours, and often dropped in to see what was going on. Gradually they came to see that our set-up, while odd, was not scandalous. The hut was leased to an employee of the university whose wife was a '*Nat Kadaw*', or spirit medium – the very type against whom I had been explicitly warned by my family – who hated Muslims and pigs with no sense of incongruity, yet whose daughter and son-in-law enthusiastically bred large fat porkers behind her house. The area was surrounded by bushes, tall trees, cowsheds, pigsties, stinking latrines and stagnant streams. One water-tap served twenty families for both washing and drinking water.

The families around us were devoted to swearing and cursing, and every day we woke up to the sound of the most ingenious, creative Burmese obscenities and oaths, in which the men and women strove to outdo each other. They swore between clenched teeth, and even continued to swear – if at a subdued level – in their sleep. I considered compiling a dictionary of Burman curses just from our neighbours, but in the end decided it would be too massive a task.

We cooked – both boys and girls – and ate together, and whiled away the evenings smoking, playing Scrabble and Chinese checkers, singing and endlessly talking. We did talk about politics and about the ethnic insurgents from our various peoples, but one subject we rigorously avoided was the question of political freedom in Burma as a whole. It was still almost unthinkable that our many and various discontents could actually move towards a demand for radical change. It would also have been dangerous.

We were a disparate collection. There was Cherrino from Loikaw – usually called by his Padaung name, Psychaw – orator and actor, who loved having a captive audience in the hut. Alvin, a tall, mild-mannered man destined for the priesthood, was being relentlessly pursued by a Chinese girl whose frank ambition was to get him into bed, and to whom a life of celibacy was a scandal and a waste. He kept her at bay by promising to marry her if he lost his vocation. Shan Kale, a weightlifter and lover of English literature, shared a room with Psychaw. They would get drunk every night, fight violently, and spend the next morning affectionately binding up each other's wounds. Almost inevitably there was a police informer amongst us – a friend of the *Nat Kadaw*, our landlady. He stole our food and concealed it among his clothes in a trunk. There was no difficulty in identifying him, for his father was a police commissioner who often visited us out of curiosity.

The girls included several who intended to become nuns, and who were studying natural science. They had one thing in common, stemming from their tribal backgrounds – they were all terrified of ghosts. This encouraged us to play a simple, cruel trick on them that never failed, even though we repeated it endlessly. As we walked back to 'Our Heaven' with them at night we would attach an empty condensed-milk tin cup by a long string to their handbags when they were not looking. We would then drop the cup at the corner of the darkest street, shout, 'Ghost! Ghost!' and run away. The girls would take to their heels, the tin cup clattering behind them, until they were reduced to sobs of terror. Our ghost culture is so strong that their inbred fear simply cancelled the fact that the trick had been played on them many times. It was cruel, and, I suppose, brought into question our belief that we had set up a little community where the sexes were equal. But we were not always thoughtful or consistent.

Moe was so busy, in various activities of which I knew little, that I saw much more of my friends than I did of her. Sometimes we boys went to watch pornographic videos in the local 'bio-scope' or video hall. The halls were packed with students, government officials, police and Buddhist monks. The reactions of the audience were not exactly what the makers of the videos might have expected. Whenever scenes of oral sex came up, the entire audience would spit heavily. Other explicitly erotic scenes would provoke them into throwing things at the screen. In fact the audiences were both fascinated and deeply

embarrassed. Very often at the end the police would mount a raid and fine us ten times the entrance fee. Usually, though, we managed to jump out of the windows and avoid arrest. The supreme incongruity of these video halls was that the walls were festooned with images of the Lord Buddha, and with the most venerable of religious texts: 'Impermanence: all decays, nothing remains for ever.'

Rough Justice

In a country where we associated law and order with arbitrary oppression, all of us were ready to dispense our own crude, sometimes extremely brutal forms of justice. Thieving was an epidemic, and both the thieves and those from whom they stole were desperate. We also knew that many thieves were in league with the police, and that between the two there was a mutual sharing-out of booty.

No thief was spared if the students caught him red-handed. He would be kicked and punched to death. Shan Kale, who liked to practise karate chops on the aluminium street lamps of Mandalay, liked even better to use his strength on thieves.

There was, however, one thief who escaped the justice of the mob. He was caught trying to steal bicycles – our most precious possessions – on the campus. Just as he was about to be beaten, a police car appeared. This enraged the students, who began throwing stones at the police and shouting: 'Here come more thieves! Kill them as well!' The police turned tail and fled. The Rector of the University arrived just at the moment when the frenzied mob was about to beat the life out of the thief. Luckily for him, the Rector was the only man in the university to whom the students might be prepared to listen. They all made way for him with applause. He asked them to calm down, and silence descended.

'What do you intend to do with him?'

'We are going to teach him a lesson – we are going to kill him.'

'Boys, you know "life is precious".' To make the point more solemnly, he repeated the remark in the sacred language of Pali: '"*Manusatta dullaba*. Human life is difficult to bring into existence." But easy to destroy. Don't kill him.'

He spoke with authority, expecting to be obeyed. But our usual deference towards authority was suspended at that moment, and the students rebelled against the tone with which he spoke to them. They

wanted physical revenge. Sensing this in time, he changed his tone: 'I will do anything honourable you ask if you will spare the life of this man.'

There was silence, as though they were nonplussed, until someone shouted: 'Punch him in the face, Pagyi!' ('Big Father') Everyone cheered, and the thief eagerly turned his cheek to the Rector. He slapped the thief in the face. The crowd was not satisfied. 'Punch him, Pagyi, punch him hard like a boxer!' The Rector punched the thief in the face as hard as he could. They cheered enthusiastically. They had seen their Rector punch a criminal, and suddenly a mob who had been out for blood believed that justice had been done. The thief was handed over to the police, and the students dispersed happily and headed for the teashops.

By Courtesy of James Joyce

The Second Lightning Strike

To my relief I passed my second-year exams. It was not that I was clever – I had simply worked on and memorised all the fifteen essays that had been dictated to us throughout the year, and managed to guess which were the most likely to be set. Five of them came up in the exams. Some students had given money to certain favourites of our tutors who had been told what questions would come up, so they knew all the answers in advance. It seemed that the purpose of exams was simply to make people feel worried and yet important for a certain time.

Some of my female friends were failed in their science exams. They were all clever and hard-working, and had expected to pass. They were distressed, and I was angry. My anger came from my being sure, without being able to prove it, that they had been discriminated against because they were Christians. We believed that the authorities were unwilling to see Christians do well. (It was assumed that Christians would do well at English, and no one seemed to mind. But my girl friends were studying science, which was a different matter. The same thing happened to Christian students studying medicine and nursing.) They were thrown out of their hostel, and moved into 'Our Heaven'.

At the beginning of my third year I moved into a new hostel called 'Mandala' on the main campus. 'Mandala' consisted of three two-storey buildings with a dining hall nearby, all built on a swamp. Cows grazed between the buildings, which were ill-designed, badly thought out and jerry-built. Sometimes, when they ran out of grass, the cows ate clothes which had been left out to dry. Each room was fifteen feet by ten feet, and contained two small beds, with a small

table and chair between them. There was one lightbulb and, as usual, we studied on our beds inside a mosquito net. The wooden walls were so thin that one could hear all the movements of the students on each side, and indeed several rooms away. This was convenient for the government informers who were sandwiched among the rooms. They were excessively friendly – which helped us to recognise them as informers – but were unconvincing as students. They would listen to our conversations from their rooms and encourage us to discuss politics – which we were canny enough to avoid. We had to get up early to take a shower because the water supply always ran out after a few minutes. The hostel was run by a hall tutor who also taught us English literature.

The inhabitants of the all-male hostels would 'sound the alarm' by clattering with their spoons and wooden plates whenever a girl walked past their territory, and shouting obscene remarks. It was as if their visitors were aliens from outer space. The girls would do the same in their hostels if a boy walked past. Unlike the girls, we were not subject to curfew in our hostel, and we could move in and out freely. In the late evenings, when I had finished my work at the restaurant, I would go and see my friends in 'Our Heaven', visit teashops and serenade girls in their hostels.

Perhaps lightning does not strike in the same place twice, but in late 1987 the Burmese government did the unthinkable – they demonetised the currency for a second time, decreeing that all seventy-five-, fifty-, thirty-five- and twenty-five-kyat notes were to be demonetised without compensation. They were to be replaced by notes that could be divided by nine, which astrologers had long ago told General Ne Win was his lucky number. I lost nearly all my savings again.

I kept what I had left under my pillow as I slept. One night I awoke and found a pair of hands raising my head from my pillow. I seized hold of the thief's hands, but he punched me in the face and tried to run away with my money. As I chased after him he flung chairs at me. I recognised him as a schoolboy, desperate and starving, who hung around the Lafon church compound. I shouted at him to give me back my money, but he took no notice. I caught up with him at the top of the staircase but couldn't quite get hold of him. Frustrated, I kicked him in the back and he fell down the stairs, lying slumped at the bottom. I thought he was dead and felt a sudden horror. But no. He began running again, and I chased him. This time I caught

him and beat him unmercifully until he gave up the money. Only at that moment did I realise how physically violent I could be given the chance.

If surviving in Mandalay had been a struggle to keep afloat, after the second demonetisation it became like swimming in a burning sea. The chances of destruction seemed to have been doubled. The great majority of people had lost their savings, and many were reduced to near-destitution. Yet even as economic activity came to a standstill, some people prospered amid the misery of the majority. In the restaurant, merchants entertained their mistresses as usual; army officers made their profitable deals; the police still arrested people attempting to trade outside the official government-controlled economy. I did notice, though, that the Military Intelligence agents could now afford only about half the rum they used to consume.

You could feel in the air that sooner or later there would be a catastrophe. It really is true that before an earthquake the atmosphere can be absolutely still, and the air stiff with unendurable heat. The Burmese associate intense heat and stillness with earthquakes, and earthquakes are taken as omens of ensuing chaos and disaster for the nation. That was exactly the psychological atmosphere in Mandalay at that time.

I made some new friends from abroad at the restaurant. Sometimes they left me books to read, books that opened worlds for me and made me forget the harsh daily struggle for survival. One busy evening in late February 1988, two couples from England came to dine in the restaurant, and it happened to be my turn to serve them. They asked me where I learnt my English, and I told them of my background. We talked about literature, especially about James Joyce, two of whose books I had found by chance. I told them how much I liked *Dubliners*, especially the story called 'Eveline'. This is about a young woman befriended by a man who offers her the chance to leave a constricted and hopeless life in Dublin and start a new life in Argentina. She is too timid to take the chance, and refuses. I had been moved by this picture of tragic paralysis, set in a city that Joyce portrays as one of paralysis of the will. I was especially struck by Eveline's dilemma, because I felt I had already been presented with difficult choices myself. One of the men then said that as I was an admirer of one great English writer, here was my chance to meet the daughter of another. He

introduced one of the women as the daughter of Evelyn Waugh, a writer I had never heard of. In my confusion I thought there must be a connection with the Joyce story. She turned out to be Harriet Waugh.

I told my boss in the restaurant, and my friends, the other waiters. They were uninterested. I also told my friends in the university, and they were very excited. They urged me to introduce any such guests to them in future, so that they would have the chance to discuss literature with them.

A week or two later, another Englishman turned up at the restaurant. I was working in the kitchen when he arrived, but a fellow waiter shouted from the restaurant that a tourist wanted to see me. I was not expecting anyone from abroad, and wondered who it could be. I turned up at the man's table scratching my head. He looked unusual to me because he didn't seem like a tourist at all. I peered at him, puzzled, thinking he must be a priest or some sort of religious, with his Panama hat and white linen suit. At first he seemed pretty uncertain himself, but finally he introduced himself as John Casey. He said: 'My friends told me you like James Joyce.'

'Yes, sir.'

One of the couples I had met earlier worked at the British Embassy in Bangkok, and had spoken to Dr Casey at a dinner party the night before he left Bangkok for Burma. He was on his way to Australia and Japan, and he told them that he wanted to visit Burma because of Rudyard Kipling's poem 'Mandalay'. They told him that in Mandalay there were two good Chinese restaurants, and that in one of them worked a waiter who loved James Joyce. Dr Casey was being given a guided tour of Burma as a special guest of the regime. But he gave his hosts the slip when they were arranging a grand dinner for him, and decided to try the restaurant where the Joyce-lover worked. His look of puzzlement was (as I learned later) because he was expecting to meet 'a grizzled old Chinaman'.

To my astonishment it turned out that he was from Cambridge University, a famous and virtually mythical place in my eyes, and that Joyce was one of the authors he lectured on. He asked me about my studies and work. I listed all the plays and novels I had been reading, including *Macbeth*, *The Old Man and the Sea* and *Goodbye Mr Chips*, and some of the poems we had studied. I didn't have much time to talk to him because my boss was shouting at me to get on with my

work – even though there was hardly anything to be done, since the restaurant was almost empty.

Dr Casey ordered three or four dishes, and I advised him discreetly that he had ordered too much, as each of our dishes was practically a meal in itself. He said it didn't matter, since to a Western traveller the dishes were ridiculously cheap. But when he saw the enormous amount of food arrive, most of which he could not eat, he was convinced by what I had said. After he finished his meal I wasn't able to talk to him for long, but he said he would be coming back to the restaurant the next day. He returned as promised, and waited for me until I had finished work. I took him to the university campus so that he could meet my friends.

First, I took him to the Night Market, as it was on the way to the campus. This was near the railway station, and teemed with every sort of trader. It had a very different character from the Day Market – the Zaygyo Market – which sold rice, kerosene, dried fish, fruit and vegetables, snacks and quack medicines. The Night Market was full of temporary stalls, and had more of the feel or a *pwe* than a market. Families and other groups would walk around the Night Market inspecting goods, haggling, flirting and eating at every opportunity. There were second-hand bookshops and teashops, and intellectuals sat about in dark recesses having intense discussions. In the richer parts of the Night Market beautiful girls tempted customers to try Burmese sweet rice-cakes. There were also plenty of prostitutes.

As we walked through the crush of stalls and shops, some people called shyly from the crowd, 'Hey, Mr Bond!' And an Indian shopkeeper walked up to Dr Casey and said, 'Sir, my friend says you look like Sir James Bond.' It was his white suit and Panama hat that they admired. Someone even offered him a lot of money for the hat.

'Thank you,' he replied politely with a smile, lifted his hat and bowed to them.

I also took him to my favourite bookshop in a dark part of the market. Then I hired a bicycle trishaw for him, and I rode on my bike abreast towards the campus. He looked petrified on the trishaw. The streets were full of potholes, and there were no working street lamps. The rickety trishaw was driven by a skinny man who used a battery torch as headlight. After many swerves among flying horse-drawn carts, charging goats, dazed cows, scavenging pariah dogs, reckless

cyclists and motorists, I was proud to be able to show a Cambridge don the university built by his ancestors.

The main quadrangle of the old part of the campus dated from the British days, and had been built by the British in the early twentieth century. Of course we had always been taught by the government to despise the colonial past, but the quadrangle was more nobly built than the newer parts of the campus. I found myself pondering on the time when East met West in Burma – whether there might be something good in that, something that might still have value for us. For many years Burma had been shut off from the outside world, and here in the university I could see a reminder of a time when we were part of a larger world. I did not know how to judge how good or bad the old days were but, faced with these remains of an undeniable splendour from the past, I felt that our generation fared worse than our predecessors. We seemed to live in a time of paralysis, when nothing significant happened, or was allowed to happen, when all paths seemed shut off. I had the sense that the university – as these old buildings suggested – had been there to open minds and show new opportunities, but that now all this had been crushed. We were forced to swim in a small tank like goldfish. We were even told how to live and breathe. Our very wills seemed paralysed. We could hardly express our discontent even to ourselves.

The campus was unusually quiet that evening despite the turbulence in far-off Rangoon, nearly six hundred miles away. A student called Maung Phone Maw from Rangoon Institute of Technology had allegedly been killed by riot police after a 'town and gown' brawl involving the son of a high-ranking government official. The incident had begun trivially. A group of students in a Rangoon teashop (called by a strange chance the 'Sanda Win Teashop') wanted to play a tape of the songs of a popular Burmese singer. Some drunks prevented them, and one of the students was badly injured. The assailants were arrested, but the police soon released the prime suspect because – as everyone assumed – his father's connections with the regime made him invulnerable. A few hundred students demonstrated against this apparent injustice, and threw stones at the riot police. The *Lon Htein* fired into the crowd, and Maung Phone Maw was shot dead. At first we had taken little notice of what was happening in Rangoon, which to most of us was a different world. But gradually the indignation had spread to Mandalay.

Despite the quiet I could feel a tension in the air on that breezy night. Soldiers from the University Training Corps – a militia made up of the minority of students who supported the regime – were on alert just outside the campus.

I took Dr Casey to 'Our Heaven' to meet my Catholic friends, boys and girls crammed tightly into the one room. They had just finished their night prayer when we entered the hut and a candle or two was still burning on the shrine. I introduced my guest to them and they all shyly shook hands with him. I tried to persuade them to talk to him in English, but they were too shy to do so. In fact they were too shy to say anything at all. They just giggled like bashful children. A stench of sewage from the polluted stream outside struck the nose from time to time.

Then I took him to my hostel, 'Mandala'. I had to remind him not to tread on the fresh cow-dung on the ground-floor corridor as he walked to the bathroom. A cow was lying contentedly by the bathroom, chewing its cud. As we walked along the first-floor corridor towards my room, I could feel the building swaying gently.

I was relieved that no one behaved badly. To my surprise, my usually rowdy friends behaved themselves. They showed Dr Casey respect and interest, as the first foreign professor ever to visit their humble abode. No Burmese professor would ever visit our hostel, except to descend on us for disciplinary purposes, and the presence of this Cambridge don was as astounding to my friends as if he were a visitor from the moon. His informal and unpompous manner, and his readiness to treat them as equals, also astonished them, and instantly gave them a sense – hard to put into words – of liberation. They showed him their rooms and their treasures, including a dog-eared photocopy of Hemingway's *The Old Man and the Sea* wrapped in a silk cloth. We discussed literature as though this were the last day of our lives. We somehow felt he was our ideal teacher, who could understand our aspirations.

Everyone wanted to hear his opinion on Macbeth and his wife. *Macbeth* was the Shakespeare play we were studying and, frustrated as we were in any attempt to discuss or even think about Burmese politics, we were keen to find political allegory in it. Who was the evil usurper who kept a country captive through fear and keeping spies in every house? Who felt blood sticking to his hands? We were told in the essays that were dictated to us that Macbeth is a villain because

152

of his evil wife and his covenant with the three witches. We wanted to discuss the nature of power and corruption, but were discouraged by our tutors.

Although we sensed that Dr Casey was in sympathy with our feelings, we were surprised that he resisted a straightforward political interpretation. Yes, he said, *Macbeth* was a political play, but what it showed was perhaps universal temptations, abuse of power, the emptiness of ambition. Macbeth's ambition to be king was like a sudden falling in love – something that could happen to anyone. It did not prove he was already a bad man, only that anybody could develop a love for power. Dr Casey wanted to draw out our opinions as much as to tell us what to think about *Macbeth*. He said that this was how literature was taught in England, and at Cambridge. It was quite a new idea to us.

Someone asked him whether Dickens was a great writer. He said that most people thought so, but that he had some doubts – sometimes he thought Dickens was great; at other times he thought the flaws, such as sentimentality, outweighed the good things. We were used to dogmatism and authority in most of our professors, so it was strange to us that a don from a university as famous as Cambridge could seem unsure what he thought and not be afraid to say so to simple students.

It occurred to me that Dr Casey might like to meet our hall tutor and that the tutor would be very pleased to meet my guest, as he also taught us English literature. Our respect for our teachers is deeply rooted in our psyche, and I wanted to give my tutor a surprise. A surprise it certainly was – but as much to me as to him. He did not seem at all pleased to meet Dr Casey. He was not only surprised but also embarrassed, uncomfortable – even, I began to feel, frightened. The two teachers talked awkwardly for a while as we listened to their conversation respectfully from afar. When the meeting was over, I hired a horse-drawn cart for Dr Casey to return to his hotel, giving him a chance to recover from the fright he got from the long trishaw ride.

A day or two later, I was summoned by the tutor. Only then did I realise how embarrassed and afraid he had been. He warned me not to bring any more foreign friends of mine to the campus. I asked why. He was intensely uncomfortable and not very coherent, but he kept mentioning the authorities and 'security', as though we were working

at a nuclear weapons plant. I did not argue with him, for I knew that if I appeared rebellious I would only make matters worse.

After the browbeating I got from my tutor I was, strangely, not upset, although I felt bemused. I smiled to myself with satisfaction. I had never been a rebel, but I suddenly discovered what it was like to become rebellious. Because of that evening I surprisingly found cause for rebellion, and began to have a sense of who and what we might want to rebel against.

Three days later I got a letter from Dr Casey which was sent from Rangoon with the letterhead of the Strand Hotel. He said that he would keep in touch with me and my friends, and that he would send some books from Australia and from Japan where he was going to teach during his sabbatical.

I hoped that the political situation would improve enough for me to be able to finish my studies. But after the elation of our evening's discussion had worn off, everything about our situation – from the events in Rangoon to the pettiness of my tutor – induced a depression of spirits and a feeling of hopelessness.

The Whirlwind: Moe's Fate

A week or two later, in March 1988, the tensions in Rangoon culminated in a full-blown insurrection, a volcanic eruption of political rage. The government temporised, offering to set up a full inquiry into the death of Maung Phone Maw, and urging the students to remain calm. The inquiry was to issue its report within a month. Eyewitnesses insisted that Phone Maw had been beaten to death by the police, but the commission of inquiry – to the surprise of no one – came to a different conclusion: that the victim himself was to blame, and that he was a hooligan. It suggested that Phone Maw and another student had died of gunshot wounds after being fired on by civilians whom they were harassing. The worst sufferers of all, according to the report, were the paramilitary police, the *Lon Htein*, twenty-eight of whom had been hurt by 'rowdy students' who had thrown stones at them. (By a strange chance, the Burmese academic-politician who wrote the report had studied economics at Cambridge, and had been the pupil of a friend of Dr Casey's there. It was he who had organised Dr Casey's tour of Burma.) Rumours abounded that the Rangoon students were going to organise a full-scale boycott of all educational institutions, including schools, unless the authorities released full and true details of what had happened.

For me, using words like 'boycott', 'strike', 'demonstration', 'human rights', 'democracy', 'student union' and the like during this time was like learning a new language – or perhaps like rediscovering a long-forgotten one. It was astounding, unthinkable, that the students were actually going to defy the authorities. Even to think about the possibility felt like committing a crime. Yet as soon as you thought of it, it seemed to become possible, and then inevitable. The discourse of the regime was all of perfection, of a country so fully at ease with

its rulers that none of the ideas denoted by the words above could find a place in our consciousness. They were almost literally unthinkable. Yet here they were beginning to be thought, and as they were, you could sense the growth of huge rage.

Nevertheless, I remained non-political. My dearest wish was that there would be no closing of the universities as there had been during the U Thant riots of 1974, and that I would be able to complete my studies and graduate. We all drew back from the abyss that we could sense ahead of us, hoping both that the regime would prove tolerant and that the students would shrink from direct confrontation. Hardly any of us had what I later learned is called a 'revolutionary consciousness'. The authorities kept reiterating that the student activists were merely a small band of hooligans, and that good students should never get involved in politics. I was ready to believe them – in fact I almost did believe them.

Then I heard on the BBC World Service details of the killing of more students in Rangoon. Students had been trapped by the riot police by the side of Inya Lake. They were fired on, beaten and some were chased into the lake, where their heads were held underwater until they drowned. In another demonstration some students who had been wounded by the *Lon Htein* were taken in vans, along with dozens who had been killed, to Kyandaw crematorium and cremated alive along with the corpses. Later the BBC supplied details of the actual numbers killed, missing and arrested – up to a hundred. The state radio denied all of this, insisting that only a few students had been involved in disturbances, no more than a handful had been arrested, and none at all killed. In response – as it seemed – the BBC said that it had its information from good sources within Burma. Soon afterwards the state radio admitted that there had been killings, but gave a figure only a tenth of that suggested by the BBC. The more the regime denounced the hated BBC (the broadcasts of which it did not have the technical means to jam until 1989), the more it blamed it for fomenting the troubles in the country, and the more it reluctantly confirmed (at least in part) all the BBC claimed, the more people tuned into it to hear the truth. The BBC World Service audience soared.

State radio began to insist that the riot police had contained and stabilised the situation. At first the rest of the population kept their distance from the students, but gradually they were drawn in. What

started as a small student demonstration in the centre of Rangoon near the Sule Pagoda soon swelled to a crowd of fifteen thousand, cheered on by bystanders and by people watching even from the windows of government-owned offices.

Although the university – in common with Rangoon University and all the schools – had been closed a term and a half before the end of the academic year, I went on working in the restaurant so that I could remain in Mandalay and watch the great events unfold. It was rumoured that monks were going to lead the popular movement in Mandalay – which meant that an immensely respected and influential group would give order and coherence to what so far was a vast but uncoordinated uprising of public feeling. In the words of someone we had not yet heard of, but would soon come to love, a 'second Burmese struggle for independence' was being born in March 1988.

Meanwhile, Moe was nowhere to be seen. None of her friends could tell me of her whereabouts. I was anxious about her, even angry that she had gone away without talking to me. I suspected she had simply gone home to get away from the troubles. I rang her home, but her mother said she had not been there at all. Irritation began to give way to fear – but I dared not acknowledge to myself what I feared.

A week later she came to me. 'Where have you been?' I asked.

'In prison.' There was something new in her expression and tone of voice – something hard, indomitable and obstinate – that shocked me. As though a practical joke were being played on me, a secret side of her emerged. I had always thought of her as mysterious, but I had put that down to my own naivety compared with a sophisticated Burman. I had never thought of Moe as an underground freedom-fighter – the idea had never crossed my mind. Yet it was the truth. Her father was an army officer, and he had detailed insider's knowledge of the massacres of students by the army during the U Thant riots in 1974. He had been dispatched to one of the fronts against ethnic insurgents, and was eventually assassinated in an ambush set up by soldiers on his own side. The government claimed he had been killed by the insurgents, but Moe had been collecting evidence about the exact circumstances of his death – and this had drawn her to the attention of the secret police.

Moe had neither morbidity nor sentimentality in matters of life and

death, and her account of what had happened to her was starkly factual: 'They hit me about the head with sticks, and whipped me with canes. Before they let me go, three officers came into my cell and kicked me about like a football, from three sides. I was semi-conscious when they all raped me in turn. They laughed, and said: "Remember, this is what you will get if you ask for 'democracy' and fucking freedom."'

We wept together in impotent rage and shame – she hardly had the strength even to cry. It was then I found that determination had crept into me 'like a thief in the night'. It was late in the evening. The boughs of the trees outside the window were quivering in a pool of moonlight, moving left and right as they dropped their leaves.

I took her back to her hostel and tended her wounds and sores. Her skin seemed to me like that of a bruised pear. I put her to bed and stayed with her. The hostel was deserted. All Moe's friends had returned to their homes, and the landlady was away in a monastery for a retreat. 'It's good to be back in Burma again, with human beings,' Moe said. I understood what she meant: prison was part of the shadow world of our country, run, as it seemed to us, by pitiless robots. We talked and joked as though nothing had happened, listening to some music coming from outside not far away. I wondered whether things would ever return to normal, with students filling the air with their serenades. The music gradually died away and was swallowed into the usual deep silence of a Burmese night, occasionally interrupted by the distant barking of pariah dogs.

'Let's sleep. We have another day to fight.'

Outside someone chanted a night prayer: 'Impermanence. May the Lord Buddha protect us all. May all creatures live and prosper. Share my merit all you who hear my prayer.' Then the bronze temple prayer bell rang three times, the tremolo disappeared with the characteristic effect of ripples disappearing into the surface of water. I held Moe, and she seemed to be dead already.

Two weeks later she vanished. The prison authorities eventually informed her mother that Moe had died 'from natural causes' while in confinement. Her death, in circumstances I could not bring myself to imagine, seemed so unnatural, so impossible to accept, that even grieving was impossible. I believe that in the months to come, some part of her spirit of defiance entered into me. Beyond that, for this

loss I have no words. Moe's body was never returned or recovered. The strange thing is that for a long time I could not believe she really loved me, because I never dreamed of her in my sleep.

As the popular disturbances grew, a curfew was imposed district by district until it covered virtually the whole country. Tension was already high in Mandalay, and there was the feeling that the city was ready to join the uprising, when a novice monk was shot dead. It was believed that he had been shot by a police sniper through a window of his monastery as he sat and studied. His body was carried around the streets, and it was possible to see the bullet wounds. Monks and students now led the growing demonstrations in Mandalay. In the neighbouring town of Sagaing, many demonstrators were shot dead and their corpses dumped into the Irrawaddy and into sandpits. When rumours of this reached me I was unable to believe them. Even when I saw photographs of the decomposed corpses with obvious bullet wounds on various parts of their bodies I could not believe my eyes. I took my bicycle and rode down to Sagaing, and dismounted beneath the Sagaing bridge. As I stood there, I saw twenty or thirty corpses float past. I still do not understand why the regime made no attempt to hide the evidence of the atrocities – unless it was to sow terror or express contempt.

In Mandalay, ten to twenty thousand people marched daily through the city centre and around the Zaygyo Market. In their hundreds they took to surrounding the police stations in the area, silently holding up placards, banners and photographs of those who had been murdered in Mandalay. Then the troops were sent in, wearing their Second World War helmets, driving in their green Hino trucks. There was no longer any disguising the fact that Ne Win's was essentially a military regime. Some students were sticking posters carrying anti-military messages on trees and walls. One student was in the act of sticking a poster on the wall of a monastery when a truck loaded with troops, guns at the ready, drove past. Certain that he was about to be shot, or at least arrested, he turned and with reckless courage displayed the poster to the soldiers. It read: 'DOWN WITH THE ARMY! *LON HTEIN* GO TO HELL! DOWN WITH THE DICTATORSHIP!' The soldiers smiled and waved. They could not read English, and took him for a supporter. Giddy with confidence at the reprieve, the student went on to cover the entire wall.

Virtually every day rallies and conferences were held in monasteries

and public places. Artists, schoolteachers, office workers, doctors, nurses and civil servants joined the students and monks. It is hard to describe the thrill people felt in finding their voices for the first time, in being able to speak out about subjects that for more than twenty years had been unmentionable, and in finding that virtually the whole nation shared the same thoughts. It suddenly became obvious that the regime had no base at all in society. Despite all the – still existing – apparatus of repression, it had lost all political control and was isolated. Ancient traditions rose to the surface as the protests and demonstrations began to resemble Burmese *pwes*. Jesters – who had often been jailed for their jokes about the regime – found that they could appear before thousands without prison vans waiting for them behind the stage. All the way along the streets down which wound the immense processions of demonstrators people stood offering food and drink. And always the processions were led by hosts of russet-robed monks, so that from a distance the demonstrators seemed to be walking behind giant red ants.

Finally, Ne Win appeared on television. On 19 July 1988 the Burma Broadcasting Service had admitted for the first time what the authorities had always previously denied – that forty-one people (rather than only two) had indeed been suffocated in an overcrowded prison van in Rangoon in the March riots. On 23 July an emergency congress of the Burma Socialist Programme Party was convened at the Saya San Hall in Rangoon. That evening virtually the whole nation heard on the radio or watched on television the extraordinary speech made by Ne Win.

To general astonishment, Ne Win said that the 'bloody events' of March and June showed 'a lack of trust in the government and the party that guides it by the people who were either directly involved in or were lending their support to the events. But it is necessary to find out whether it is the majority or minority that support those people who are showing lack of trust. Since it is our belief that the answer to the question – a multi-party or a single-party system – can be provided by a referendum, the current congress is requested to approve a national referendum ... if the choice is for a multi-party system, we must hold elections for a new parliament.'

Then, even more astonishingly, one of his aides read out the next part of his speech, in which he announced that he felt some responsibility for 'the sad events that took place in March and June' and, because

of his advancing age, requested to be 'allowed to relinquish the duty as party chairman and also as party member'.

Our astonishment turned into excited delight. It seemed that the impossible was about to happen – after twenty-six years of military-socialist dictatorship there was the possibility of a return to the free Burma of which our grandparents had so often spoken. It was scarcely believable.

Our joy was tempered with anxiety only a few minutes later as Ne Win resumed reading the rest of his speech himself. He came back to the disturbances in the streets, and his words were ominous: 'In continuing to maintain control, I want the entire nation, the people, to know that if in the future there are mob disturbances, if the army shoots, it hits – there is no firing into the air to scatter.' This was an astonishing psychological mistake – compounded when Ne Win added that the riot police fired with live bullets because they could not afford rubber bullets and tear gas. This was instantly taken as a challenge to the entire nation.

At the end of the week it became clear that our anxieties were only too well founded, when the successor to Ne Win as President of Burma and Chairman of the Burma Socialist Programme Party was announced: it was Sein Lwin, the butcher of Rangoon. In 1962 Sein Lwin had been the commander of the soldiers who stormed the campus of Rangoon University, killing scores of students. During the uprising in Rangoon in mid-March 1988 the *Lon Htein* had beaten and shot students, raped female protesters, and chased others into Inya Lake, holding their heads under water until they drowned. The commander of the *Lon Htein* was Sein Lwin. Nothing could have been more brutally insulting to the people of Burma than that this man should now be elevated as head of state. Nothing could more clearly show that the 'retirement' of Ne Win was a trick and a subterfuge.

The almost immediate result was a resurgence of demonstrations fuelled by hatred of 'the Butcher'. They swept the country, and curfews were imposed in one town after another. Police again fired directly into crowds of demonstrators, but still the protests continued.

I rode continually around Mandalay on my bike trying to find out what was happening. I had to see for myself, because up to then I had taken no interest in Burman politics. The student leaders had not thought to discuss what was going on with us students from the minority hill peoples, and we in our turn had up until then thought

it was none of our business. I stopped near a monastery where I saw army trucks blocking a road down which some five thousand to seven thousand demonstrators were marching. There were monks, students and schoolchildren. The procession was on its way to link up with others in Mandalay. They were chanting their slogans but were entirely peaceful. Monks were holding aloft banners with slogans such as 'Stop the killing – we want peace and prosperity'. They were in the front as the leaders. Since monks are universally revered in Burma – although the regime's attitude to them was more of fear and suspicion – their presence seemed to protect and give validity to the whole march. It never crossed my mind, nor, I am sure, the minds of the hundreds of spectators who lined the road, that anyone would defy our ingrained and unquestioned reverence for the monastic order.

A single line of soldiers blocked the road in front of the demonstrators, who were still some distance away. I could see soldiers lying in wait behind trees and buildings with their machine-guns pointed in the direction of the unarmed marchers. I could not understand why, if they were going to order the demonstrators to stop, they were making themselves invisible.

I leaned my bike against a tree, went up to the first floor of a house and, watching from a window, waited to see what would happen that would explain these strange tactics. When the demonstrators came into full view I suddenly realised they were advancing into a trap. The palms of my hands froze. Without warning the soldiers opened fire indiscriminately, shooting directly into the crowd for about two minutes. The most vivid thing was seeing the crimson robes of the monks covered with blood as they dropped to the ground. That monks could be gunned down was unthinkable – I never thought I would see the day when such a thing could happen on the civilised streets of the holy city of Mandalay, allegedly founded on the instructions of the Lord Buddha himself.

The spectators fled in panic, while the screaming demonstrators tried to carry their wounded and dead away. It was a day in which (to use a Burmese expression) the sky had fallen down. What was as horrible as anything was the robotic way, their faces completely without expression, the soldiers carried out their orders to fire into the crowd. You felt that here were two worlds – one, the world of those begging the government to help and listen, the other of people who understood absolutely nothing.

Rage at the appointment of Sein Lwin continued to grow throughout the country. It became clear that there was unanimity among the people that such a man must not be their ruler. The idea was conceived and began to gain ground that there should be a day of nationwide demonstrations and a general strike. The day chosen was the auspicious one of 8 August – 8/8/88 – and the action would begin at eight minutes past eight. The attempt to organise for that day was assisted by a stroke of luck. Christopher Gunness arrived in Rangoon as the BBC correspondent, and immediately began broadcasting on the Burma section of the BBC World Service accurate and vivid accounts of what had been going on – including the fact that about two thousand demonstrators had already been killed in incidents throughout the country. He also revealed the plan for a nationwide day of action on 8 August, so the whole of Burma knew what was being prepared.

At eight minutes past eight on the auspicious day, the dock workers in the port of Rangoon walked out. Then the processions and demonstrations began, swelled by people who had come into the city from the countryside, until virtually the whole city seemed to be on the streets. The demonstrators carried portraits of Aung San, the hero of the independence struggle and founder of modern Burma, red flags for courage, and flags with the peacock emblem, the symbol of Burmese students since the nationalist, anti-British demonstrations of the 1920s. Simultaneous demonstrations broke out throughout the country – in Sagaing, Shwebo, Moulmein, Taunggyi and many other towns – and in Mandalay.

We heard horrifying accounts of what had happened in Rangoon. After a day of peaceful and cheerful demonstrations, trucks of soldiers and Bren-gun carriers rushed out towards thousands of people gathered near the Sule Pagoda and fired at point-blank range directly into the crowd. Corpses had been seized by the military and taken straight to the Kyandaw crematorium. There were credible reports that the wounded had been cremated along with the dead. Troops had also killed two to three hundred people in Sagaing, near Mandalay, and many of the injured had drowned while trying to escape by swimming across the Irrawaddy.

After eighteen days in office, on 12 August 1988, Sein Lwin resigned. It was generally believed that the decision to change the president was taken at a meeting over a game of cards in General Ne Win's house. Sein Lwin was replaced by a civilian (although an ex-army officer)

called Dr Maung Maung, the only intellectual ever known to be close to Ne Win. A few days later the Central Bar Council of Burma issued a statement condemning unequivocally all the killings in Burma over the weeks since 8 August, and declaring that the use of the security forces against the people was illegal and against the constitution.

Although Maung Maung was presented as a moderate, everyone knew that he was a puppet of Ne Win and his clique. He set out to appease the populace, and announced that the Burma Socialist Programme Party was being abolished. He was himself a Mandalayan – which did not stop a mob burning down his house in a suburb of the city within days of his appointment. It was enough that he was a continuation of the universally despised regime.

Meanwhile the regime had begun a 'dirty tricks' campaign designed to sow confusion among the populace. They began freeing criminals from prison and releasing them among the protesters, hoping that this would create suspicion and anarchy. Sometimes they were caught and lynched by the crowd. In Mandalay, the young monks' organisation, the *Yahanpyo* ('Young Monks Association') – which Sein Lwin had suppressed many years before – was revived, and helped to police the town. They escorted many of the released criminals to the safety of monasteries, and punished them if they reverted to their old habits.

The plan of the regime was obvious – to infiltrate the protest movements with criminals, and to so undermine the stability of the country that they would have an excuse for a military coup. The regime also tried to provoke riots between the majority Buddhist population and the Muslims. Sometimes this worked – as in Moulmein, where some Muslim shops were burned down. But usually the attempts failed. Then they created the fantasy of an elaborate anti-Burma conspiracy involving the Communists, the CIA, MI6 and the BBC which was out to incite instability in the country. The only effect of this was greatly to increase the audience for the BBC's Burma Service and for the reports of Christopher Gunness, because everyone felt that this was the best way of learning the truth about what was happening in Burma. It was through the BBC that we learned that around two thousand people including monks, women and children had been killed throughout the country.

At most of the big demonstrations, people had been carrying portraits of Aung San, the greatest Burmese hero. Aung San had had three

children: two boys, one of whom had been drowned in infancy, and a daughter, Aung San Suu Kyi. In April the mother of Aung San Suu Kyi, Khin Kyi, had become seriously ill following a stroke. Her daughter, who had for years lived abroad, in England and Japan, returned to Rangoon to care for her. Aung San Suu Kyi was married to a British citizen, Michael Aris, who was a Tibetan scholar at Oxford, but had brought both her sons up as Buddhists, even sending them to monasteries in Burma for their novitiate. She was a frequent visitor to Burma, and had written a children's book, *Let's Visit Burma.* The regime were already trying to discredit her, and used her foreign marriage to do so. They even claimed that Michael Aris was an Indian – which they thought would provoke the traditional Burmese antagonism to Indian *Chettias,* or money-lenders. But she had never been politically active, and the mass of the Burmese knew almost nothing about her.

It was announced that on 26 August Aung San Suu Kyi would address a public meeting outside the great Shwedagon Pagoda in Rangoon, the most venerated centre of Buddhism in Burma. The night before her speech thousands of people camped out to make sure of getting a sight of her. As the time of the meeting approached nearly half a million had assembled to hear her. They had come mostly out of curiosity to see and listen to the daughter of the national hero, but when she finally appeared she immediately won the hearts of the huge crowd.

First of all she spoke of democracy, the need for discipline among the demonstrators, and for national unity. But then she began to speak personally, addressing herself to the slurs and slanders directed against her by the regime: 'A number of people are saying that since I've spent most of my life abroad and am married to a foreigner, I could not be familiar with the ramifications of this country's politics. I wish to speak very frankly and openly. It's true I have lived abroad. It's also true that I'm married to a foreigner. But these facts have never, and will never, interfere with or lessen my love and devotion for my country by any measure or degree. People have been saying that I know nothing of Burmese politics. The trouble is that I know too much. My family knows better than any how devious Burmese politics can be and how much my father had to suffer on this account.'

These words created huge enthusiasm in the crowd, enthusiasm that came to a climax when she went on: 'The present crisis is the concern of the entire nation. I could not, as my father's daughter,

remain indifferent to all that was going on. This national crisis could, in fact, be called the second struggle for independence.'

It was these final words that gave a shape to all we were doing and had been attempting in the previous months. It was indeed a second struggle for independence – and more dangerous, confronted with much more ruthless opposition, than the first one. Above all, we saw someone expressing all our aspirations, confronting the regime and its gun barrels succinctly, eloquently and with not a hint of fear. At last we had found our leader, someone whom we trusted implicitly to restore the lost freedom of Burma and lead the country to peace and prosperity. Even the rebels who had been fighting for their independence from Burma for forty years began to see Aung San Suu Kyi as the only person who could fulfil her father's dream of Burma as a democratic country.

But by the time she spoke in Rangoon, I had already left Mandalay for home. The restaurant business had been badly affected by the curfews, because the Burmese like to eat late in the evening. I had lost my soulmate and lover, the university had been closed by the government, and I saw no point in hanging around Mandalay. It was time to go home and be with my family.

Before I went home, I visited the '*Nat Kadaw*', or spirit medium, our landlady who lived near 'Our Heaven'. She was preparing for her annual visit to a spirit festival. After we had talked a bit she said, 'Come to my spirit ceremony tomorrow. I will call the *Nats* for you.' To my surprise, she spoke with a sort of maternal wisdom, as though she already knew of my troubles by instinct. Then she added: 'Don't eat pork before you come – the *Nats* disdain it.'

When I arrived at the spirit centre near a large banyan tree the next day, she was already in ceremonial dress that made her look like a princess of old Burma. She was sitting among a crowd of musicians and worshippers in front of a shrine, its statues bedecked with offerings of coconuts, green bananas and lighted candles, and the whole area was suffused with the smell of burning incense. She indicated that I should sit with the other worshippers. I seated myself respectfully, but avoided arranging my palms in the form of a prayer. She kowtowed before the images and concentrated herself as if in a trance. Then she began slowly moving to the rhythms of the music, gradually seeming to become more and more involved, tapping her forehead with the tips of her bud-shaped fingers, inviting the *Nats* to possess her, rocking like a fat, female version of Michael Jackson.

When she seemed to have become completely possessed, she suddenly began demanding whisky and cigarettes. The devotees immediately supplied what she asked for. She gulped down the alcohol as if it were cold tea, and also began smoking cigarettes with great rapidity. This was puzzling to me, because I knew that normally she neither drank nor smoked – indeed could not bear the smell of liquor or tobacco. Her voice started to change. Then she came to me: 'Hold my hand.' I took it, and her palms were as cold as those of a corpse. A voice that was not hers said: 'It is I who will help you defeat the evil ones. The Great Guide will lead you. You will listen to him and you will not fail or be defeated. He it was who assisted your ancestors. He will do the same for you. Offer him food and drink.' Then she resumed dancing, going on for a very long time, tirelessly, until eventually she collapsed into a stupor. After about fifteen minutes she became herself again, as though nothing had happened.

Directly against the warnings of my tribe, I had made friends with a *Nat Kadaw*. In doing that and in taking part in the ceremony, I felt I no longer needed to be afraid of the *Nats* of the Burmans. Nor did I ever suffer any harm from them in the dangerous months that lay ahead. Already in Mandalay I had come to see that it was possible to be friends with Burmans, to appreciate and respect them. And the love of my life had been a Burman who met her end at the hands of Burmans. My tribal prejudices fell away. The ceremony was necessary to me, and through it I felt I had reconciled myself to Burmese culture, and the Burman spirit. I thanked the *Nat Kadaw* and went home.

So this was how my four years in Mandalay were ending – the closure of the university for political reasons, so that I had been able actually to attend for only two and a half years, in which I had experienced an inferior education with hardly any books, dishonest teachers (for the most part) and almost no opportunity for intellectual development. Yet I had rejected the seminary for the university. I now began to wonder whether, after all, I should have gone on to the Major Seminary in Rangoon. Even though I hoped to return when the universities were reopened, the future seemed blank. My secret, cherished ambition (which I had confided only to Moe and Dr Casey), to be a university teacher, seemed a mere dream. I felt I had wasted four years of my youth.

CHAPTER 15

SLORC

'It's a sober fool who doesn't drink bitter rain water,
which makes everyone mad.'
BURMESE SAYING

Retreat Home

In mid-August 1988 I had gone home with students who came from the Phekhon district. The monsoon was at its strongest, and the rain teemed down. The bus was laden with heavy boxes and baskets – our worldly possessions – especially on the metal awning. About three hours into the journey, one of the front tyres burst with a loud bang. The bus went into a long skid, ending near the bottom of the slope of the elevated motorway on which we were the only vehicle, poised over a deep ditch that was concealed by overhanging bushes. As we came to a halt our boxes and baskets cascaded down on us, momentarily trapping us. One of our number, in panic, jumped from the roof of the bus and vanished through a large bush that grew under the highway. Hearing his cries for help, we found him lying in a pit fifteen feet below the bush, two feet away from a sleeping Russell's viper – one of our most venomous snakes. The portents for our journey seemed less than favourable.

In the darkness, in the pouring rain, surrounded by the crashing of thunder and the noise of frogs, we waited for a lift. After an hour we were picked up by a truck with no awning that was carrying salt bags. We huddled together on the sacks, rain sweeping into our faces, some of the girls sobbing with misery.

Night fell and the rain eased off as we arrived at the town of Thazi.

From there the road wound constantly upwards into the mountains of Shan State. We dozed on the sacks and watched the stars go round and round as the lorry crept up the long, winding mountain road. When we reached Kalaw – dry but unbearably cold – the smell of pinewood, jasmine and other wild flowers carried on the cold, biting air greeted us. Our spirits immediately rose; we were now in Shan State, and in Kalaw, which always seemed to be free of political strife whatever was going on in the rest of the country.

We arrived at Pinlaung the next morning, freezing and soaked to the skin. Several of the girls were met by their parents and fell sobbing into their arms. Their families gave us the luxury of warmth and comfort in their houses that night. We went early to bed. I drifted off to sleep to the sounds of night prayers and prayer bells, and remembered Moe the night she had come out of prison.

Next day as we left we kowtowed to our hosts, and they gave us their blessings. We felt that on our home territory we were safe from being robbed by either dacoits or police. By noon we had arrived in the vicinity of Phekhon. From a hilltop on the west of the town I saw with immense relief, on the east side, the lake on which my eyes had opened every day of my childhood. There was no one to welcome me at the bus stop, but I saw one of my brothers, Christopher, playing with his friends at the roadside. He smiled at me in a confused, uncertain way and, without saying a word, ran off towards home. A few minutes later the whole family came hurrying out to meet me – mother, father, grandmothers, grandfather, aunts, uncles and their families, and all my nine brothers and sisters. Clearly they were puzzled that I had arrived without notice after three years away, but they strove to make everything normal with their welcoming remarks: 'You're looking more and more Chinese,' and 'His grandfather's moustache is starting to show.'

But the warmth of my homecoming seemed to me to have something false about it. I simply could not reconcile this return to my childhood security with what I had seen and what had happened to me in Mandalay. Perhaps I had simply become hooked on the excitement of the tragic national drama in which I had been caught up, so that normal life seemed flat to me. It may have been that for me, as for thousands of other Burmese students, the world had irrevocably changed.

My father sensed this, for he began, unprompted, to warn me against

getting involved in political movements. His own experiences had been no less traumatic than mine – as a student at Rangoon University in the 1960s he had seen the bloody consequences of rebellion when a couple of hundred of his fellow students had been killed. The immediate impact of his words was that I determined to forget the drama in which I had, in a small way, been involved. To relieve my grief I plunged into a round of visits to my relatives and friends.

From time to time I went hunting and fishing, and worked in the fields. I ate dinner with my family, and behaved as though nothing had happened. I had no plans and, unless the university reopened soon, no career prospects. To my surprise, my father began giving me pocket money to buy cheroots, for he had realised that I had begun to smoke. I gave my electric kettle to my grandfather's brother, Grandpa Nauk. As soon as he saw the water boil, he denounced it as witchcraft: 'There is no firewood, there is no fire. How could that water possibly have boiled?'

I reacquainted myself with my nine brothers and sisters – Peter and Patrick, Pia and Piarina, Sophia, Patricia, Remonda, Christopher and Henry. As the eldest I was the repository of their confidences, and they looked on me as someone who had seen the great world. Peter told me about his success as a footballer, and how he had given up drink. Patrick, a morose character, revealed his ambition to be a pop musician. Remonda made me sing to her whenever she became bored. I cherished Christopher, who at five years old seemed like a small version of me.

In every way I behaved as though all was as it had always been – except that I went on assiduously listening to the BBC Burma Service. Every night I took my grief to bed, and lay like a corpse. From my bed I could see the large cross on the Calvary Hill. One night I seemed to open my eyes and see a man hanging from it. I dared not look at his face, and closed my eyes. When I opened them again I could still see the face, which seemed to smile. I heard these words: 'Dear son, be watchful. I will be with you to the end.' When I awoke in the morning, I opened the window and looked up the hill. There was the wooden cross, but there was no figure on it. I felt haunted, reassured and yet at the same time warned, and could tell no one my dream, not even my family.

That day I had a serious talk with my father. I had the sense that he knew, and feared, what I was going to say – that it was impossible

for me to stay passive while other people were acting and sacrificing their lives.

'Son, I beg you, don't get involved in this mess. Leave it to the Burmans, it is their business and theirs only. Keep out of their politics – it only brings trouble and grief.'

'But this is not just something ordinary – it will decide the whole future of our country. Yes, I call it "our country", because we have to live here. We simply have to act, because we are all in the same boat – Burmans or Padaung.'

He was rigid with resistance to what I was saying, and more quietly determined and certain than I had ever seen him: 'Just don't get involved. It's too dangerous. You don't know how they treat political prisoners in this country.'

'I know.'

'No, you don't know.'

There was something I could not tell him, as my sorrow was too deep. In grief and frustration, my feelings simply rushed to the surface: 'Maybe I don't know, and you do, but I will have my say, and I will take my chance. I hate obedience, I hate authority, I hate being told what to think, and I hate living under this hopeless, stupid dictatorship.'

He was unprovoked, and when he spoke, his tone was sober: 'Don't do it. It's too dangerous.'

'I will do it if I have to. I am sick of being told what to do and what not to do. You are like them – telling me all my life what I may and may not do. You always preached obedience to them, always believed in their filthy lies about the New Burma. You are my father and you love me, but they are not my father and they don't in the least care what happens to me. No human being can live like this. I hate them, I hate all this talk of obedience, I hate all the shits who have been destroying this country.'

I was shaking with rage. All my suppressed emotion erupted like a landmine, surprising even me. I had never talked to my father like this before. I was being unjust, for I knew my father had abandoned his own faith in the regime. And he wanted to protect me and my future, to make sure that I would be allowed to go back and take a degree. He was visibly shocked. I suddenly realised that he recognised in me what he had wanted to be himself, but had never been or had the chance to be.

'Do what you think is right. I will not oppose you.'

* * *

Anti-government demonstrations and hunger strikes began to spread from the cities to the smaller towns around the country, and finally reached sleepy Phekhon. Because of my education and the name of my grandfather, I found myself regarded as a leader by students from Phekhon and other towns. I felt I had no option but to start what I thought of as a 'do it yourself' revolution. My father kept to his word and gave me his full support – but I saw that his face was full of anxiety and fear.

My entry into politics was by no means as dramatic as that of Aung San Suu Kyi with her speech at the Shwedagon, which it preceded by a few days. It started with my making a speech in Phekhon, standing on a bullock cart on market day in front of a group of peasants and people from the town. I found I could speak. Surrounded by a crowd of Padaung, Shan, Pao, Indha, Karens and Karenni – all there for the market day – and speaking in Burmese, I told them what had happened in Mandalay, described how I had seen a peaceful procession of monks and students ambushed by the soldiers, how between fifty and seventy people had been mown down – killed or wounded – how the whole of Mandalay refused, nevertheless, to be intimidated. I told them of the bodies I had seen in the Irrawaddy near Sagaing. Above all I tried to give them a sense that we need no longer fear. I had not forgotten the evening in Mandalay when I was berated by my tutor for daring to bring a foreigner to the campus, and my first sense that it was possible to rebel. I wanted to get them to feel the same. I spoke in the torrential monsoon rain and was exhilarated to find that the enthusiasm of the audience was not dampened.

In the evenings we students from Phekhon and the surrounding towns met people from other parts of Burma, trying to build up a nationwide sense of what we were doing. When Aung San Suu Kyi made her great speech a few days later, on 26 August, she instantly became our leader and inspiration. In the evenings we would listen to the BBC and hope for guidance from our goddess. We formed committees: committees for security, for the food supply, for information, for connecting the different ethnic and religious groups. We decided to form an executive committee. A certain Miss Pyo, a student from Taunggyi College, a famous athlete and her college's beauty queen, was elected president. Another student from Taunggyi, Edward Byan, was elected vice-president, and I was elected secretary.

Although I busied myself with all of this, I knew there was a pomp-

ous and officious aspect to it. It also had a dreamlike quality. Only weeks before, to speak in open opposition to the regime would have been unthinkable. Now the whole of Phekhon was talking about the future, about what sort of constitution Burma should have, about the place of the minority peoples. People who had been silent for twenty-six years now wanted to shout, or at least endlessly to debate. (In fact they had little idea how to debate, for they were learning the language of free discussion for the first time.) Police mingled with the crowds to observe us, having prudently abandoned their uniforms. We ought to have realised that they were playing their traditional game of letting the leaders surface so that they could be picked off later. But we no longer feared them. Who could oppose us?

The first immediate threat and sign of opposition came from that same distant relation of mine, Eugene, who years before had been built up by the government as the warlord of Phekhon and rival to my grandfather. As a young man he had been a promising footballer. He attended Rangoon University, but had to break off his education when the university was closed following the U Thant riots in 1974. He was a permanently embittered man, and sided with the regime that had provided him with his guns and his influence. My brother Peter and his friends saw that it was necessary to protect me, and volunteered as bodyguards. When Eugene and his friends publicly declared that they would use machine-guns against us, and he sent me a message saying 'I want your head,' the people of Phekhon organised security for me with their home-made guns and grenades, guarding our meetings and our office. I had hoped – even assumed – that we could introduce peaceful, non-confrontational politics using persuasion and rational discourse. Almost the first thing I learned was that there was no chance of that.

Before every speech I gave, I checked the stage and swept my glance across the audience to see if there was any sign of trouble or danger. I found that I was a natural orator, and that I could fit the length and content of my speeches to the mood of the crowd and the sense we had of possible dangers from the supporters of the regime. Whenever I mentioned the word 'massacre' I felt an inward dread, for I had a vivid sense that I might myself fall victim to sudden violence. Because of what I had seen in Mandalay, I knew what would happen if the crowd was attacked. I did not want to die young. It was not easy to preach peace and non-violence when we knew we could at any moment

be destroyed by their opposites. We did not destroy any property, or anything at all except photographs of the dictator and his associates. Meanwhile, in the big cities violence and anarchy were breaking out and many were still being killed. Sometimes MI agents or soldiers were captured by the crowds, which took a terrible revenge.

I could hardly sleep or eat, filled as I was with a mixture of fear and a desire to confront the regime's killers and see justice done. I slept in the homes of friends, never staying in the same house for two nights in succession, for I knew that there was an ever-present danger of surprise night-raids by police or army. To lift the anxiety from my mind, I would play with the children and watch them doze off at the sides of their parents each night. My sleep was fitful, punctuated with long bouts of insomnia. My chief hope as I went to bed each night was not to wake up with the barrel of a gun pointing at my face. I was lulled to sleep almost every night by the barking of dogs. When they were quiet I could not sleep at all.

Every morning I woke up confused, wondering what was happening to me. Only a month ago I had been an apolitical, bookish student working in a restaurant as a waiter. My dream had been to get a good degree and have a career as an academic. Never had I expected to be drawn into such an immense conflict, let alone to become, inexperienced as I was, a leader in a revolutionary struggle. Never had I thought of myself as a fighter. Although I felt satisfaction at finding myself able to lead rebellion against authority, I half felt at the same time that this was childish, half shared my father's outlook, and blamed myself for getting into trouble.

There was a time when in my intense anxiety I could not laugh or cry or breathe without an acute pain in the chest. I often asked myself whether it was worth it. I could not answer the question, but I felt that the dead, including my ancestors, might answer it for me. Fearful and hesitant as I was, I knew that there was no turning back.

18 September 1988 was a still, sunny day. I decided to go hunting with catapult and machete. Walking across the deeply green paddy fields with wet grass tickling my bare feet, I caught the fresh smell of the ripening rice grains – a fragrant scent that brought back my childhood days of roaming the paddy fields searching for wild nuts, fruits, vegetables and birds' nests and their eggs in secret places among the bushes. The fragrance made me hungry, and I felt drowned in the

pleasure of the fresh day. The dews on twigs and branches dropped on to me whenever I moved the plants aside, giving a tingling sensation. I didn't want to leave this imperfect paradise, yet the very pleasure I took in it somehow rekindled my childhood tendency to imagine what other paradisal places there might be in the world. What I did not know was that after this day my life would change for ever.

Scrutinising the misty mountains ahead, I concentrated on the sounds of the birds and animals. Wood-pigeons were cooing and courting on the tops of the bamboos, which meant they must be laying eggs, so they were not yet ready to be hunted. Tiny honeysuckers were hovering on the stems of wild pineapple plants, sucking nectar from the blossoms. The htutoos – that we call 'talking birds' because of the whistling noises they emit, which resemble conversation – were hopping from branch to branch in search of spiders and moths. Hturants – black minas, that ride buffaloes and eat their parasites, and that can be taught to talk like parrots – were brawling on top of a cotton tree as they built their nests. It was not the right time to hunt them either. Wild grouse and quail were making their frog-like croaking sounds from hidden places in the fields.

I picked a cucumber from the ground and began eating it while scanning the branches for targets. There were some banana blossoms ready to be picked, so I aimed my catapult at the stem between the blossom and the branch and released the pellet. Missed. Another shot. I hit the blossom. Another shot and I hit the stem. Another, and the blossom was on the ground. Still there was no sign of any moving target, so I kept on shooting down banana blossom.

Then I heard the htutoos uttering frenzied cries of warning. Something had disturbed them. I approached the bush over which they were hovering, and from behind a mango tree I caught a glimpse of snake scales in the bush. I waited until the target could be seen distinctly. At a clearing in the bush a forked tongue appeared, an inch or two from the htutoos' nest. I pulled the rubber of the catapult, steadied my hand despite the thumping of my heart, and released the pellet. Off it went, and hit a dry twig and the snake's head. Such was the impact that the snake fell to the ground, sinking into a heap like a silk ribbon, but in slow motion.

The creature didn't die at once. Its centre of life is not in the head, as it is with humans and animals – you can chop the head off and it will still wriggle and thrash and not die. You must break the spine to

render it lifeless. The big snake jerked round and tried to lunge at me. My hair stood up like a porcupine's quills. I launched another pellet at its head before it had the chance to attack. Crack, went the head bone, and a splash of blood mixed with venom was ejected from it. I walked close to the snake and shot at its head until it was quite flat. With a stick I dragged the still-wriggling, flat-headed monster out from the bush, grabbed it by the bloody head and swung it as though it were a whip against the trunk of the mango tree. There was a grinding crunch, and I just had something limp and lifeless in my hand. I held it up in triumph, thinking of St Michael the Archangel and the Serpent. Looking into the nest I found that it contained three baby birds, about two or three days old. Poor creatures, they almost ended up in the snake's belly, I thought, without ever having the experience of flying freely.

I took my trophy to the hut and rubbed it with ash. I cut off its head, skinned it and gutted it, then buried the inedible parts near the bush where it fell. 'I got you fair and square, now protect the nest,' I said as I stamped the mound. (In Burma we believe that a dead body – even of a sacrificed or murdered man – buried near a building will ensure that the spirit of the departed protects the place.) I collected the banana blossoms and wrapped the snake-meat up in leaves for smoking at home. I felt satisfied and had no wish for further hunting that day. I set off for home content with my success.

As I approached my house I met a friend, who gave me a meaningful look, as though there was something I ought already to know. There had been a military *coup d'état* at four o'clock that afternoon. It had been announced on state radio. The emergency statement said that there was to be a new form of government under General Saw Maung, to be called 'The State Law and Order Restoration Council' (which immediately became known as the SLORC). A curfew of indefinite duration had been imposed throughout Burma. The new government was made up purely of the people who had run the old one. They promised that elections would be held, and urged people to trust them when they said that these would be free, and that there would be an amnesty for all who had taken part in the pro-democracy movements. There was one uncanny reaction to the coup – dogs howled the whole night.

The first sign of the new regime's good intentions was not long in coming. That night, army tanks rolled into the cities and massacred

a thousand protesters. State radio broadcast military songs and slogans unceasingly: 'We are the mother and father of the country. We, the *Tatmadaw*, will protect our country from dangers without and within.'

Two friends of mine were seized from their houses in Phekhon and imprisoned that night. Other friends warned me that despite their promise not to touch students who had demonstrated, the government planned surprise arrests. I tried to stay calm. I did not believe in these rumours, nor yet in the promises of the regime. My policy would be that of Stephen Dedalus in James Joyce's *Portrait of the Artist as a Young Man*: 'silence and cunning'.

It was quite a long time later that I remembered Joyce had actually written 'silence, *exile* and cunning'.

The Reluctant Flight

Every night I would explore the radio channels when the government programmes had closed down. I discovered how to listen in to police communications. One evening, two or three days after the coup, I heard the noises of a cipher and someone shouting, interspersed with long pauses. I listened, turning up the volume: 'Calling . . . calling . . . We've got two sheep here.' This was odd, because there was not a single sheep within miles of our township. 'Two or three on the loose at the moment. Don't worry. We'll do the job.' Then came the names of my friends Edward Byan, La-O, Don Bosco – and my own name.

I switched the radio off and without delay took a bamboo bag and some clothes, my address book, a machete and an old pistol with two or three bullets that a friend had given me for self-protection during our speeches and demonstrations, and sneaked out of the house at the back. I did not want my parents involved. I was responsible for what would happen, and I had to face it like a man. I went to see my other grandparents, had supper with them in their sooty kitchen, asked their blessing and started on a journey to which I could not see the end.

I went to the village cemetery and talked to my ancestors, and lay all night by their graves under the shadow of a Lac tree to avoid detection. I felt safer with the dead than with the living, but I could not sleep. Next day, a friend took me to a hiding place. On the way we met a man whom we had long known to be a government spy. He asked us where we were going. We mentioned a farm nearby, and invited him to come along. We thought that if we lied he would sense it, and that if he came with us we would beat him up on the way. Luckily, he declined.

The sun was on the verge of a mountain slope, ready to sink out

of sight, when we arrived at the farm six miles west of the town. The colour of the sky changed rapidly from gold to red, to blood red, to dirty grey as darkness fell. At the same time the night revealed the unpolluted firmament littered with bright stars and silver-rimmed clouds.

Under the moonlight I found the hut I was looking for, where some food had been left for me. I ate a mature cucumber, fresh chillies and dried cooked rice for my supper, and scattered some scraps of food for the spirits of the farm. After supper I said my prayers and lay down on the bamboo floor, wrapping myself in a blanket to keep off the mosquitoes. I had not slept alone in the jungle before, and I listened to the sounds of the night animals: the growling of tigers, owl cries, mixed with the chorus of night insects. I composed myself to sleep by saying the rosary and counting the noises outside. Finally, I murmured my grandmother's charm: 'Do me no harm. I do you no harm. I go my way. You, yours.' I fell asleep.

No sooner had I begun to dream than a voice called out my name in the dark. I pointed the gun in the direction from where the voice came, my heart pounding and my hand shaking. 'It's us,' said someone quietly. I recognised the voice, and put my gun back in its holster. People emerged from the bushes. There was Lone Tone, my school-friend from Phekhon, and some other friends, including two Buddhist girls from well-off families in Loikhaw who were carrying their luggage on their backs. They warned me that an informer had told the army of my escape, and that soldiers were on our trail. They would escort me to a safer location. We decided to move on at once.

One of our group was from a nearby village. He went to a secret place near the farm and brought back a hand-grenade, which he handled pretty clumsily. It looked like a dried custard apple. It was, he said, in case of emergency, but I felt safer without it. We suggested that he walk some distance behind us, because we feared he might throw his new toy at innocent people we might encounter on our way. He put the toy in his trouser pocket. My tender feet, clad only in rubber flip-flops, were not used to the cutting roughness of the jungle, and I could hardly keep from crying out when they were pierced by sharp grasses and thorns. Bamboo branches were the worst – they cut your skin like blades.

Luckily, the moon was up that night. The stars were occasionally crossed by running clouds, an image, it seemed to me, of ourselves

and our desperate plight – refugees on the move. I forced myself to stay awake and alert, but I was counting every step on the muddy track, anxious to rest soon. We trekked on and on. Pain and tension started to move up my legs and gradually gripped my whole body. All I wanted was to go home and rest. It was hateful to travel with my body dominated by fatigue and sleepiness. Once we crossed a deserted cemetery to avoid having attention drawn to us by the barking dogs of a village, and I envied the dead. The villagers avoided their cemetery, visiting it only for funerals, because they were afraid of the ghosts of the dead. We were greeted by the stench of some corpses wrapped in shrouds that were sandwiched between the boughs of trees – a way of disposing of their dead that animists often prefer. Some scavenging birds and animals feeding on them fled before us. Just before dawn, we rested for an hour up in a wet tree just outside the cemetery.

In the morning we called from the top of a mountain to villagers on top of another mountain, telling them of our presence and asking them to prepare dinner for us. We used a simple code: 'Bears from other mountains will come to forage some honey.' As soon as they were convinced we were not enemies, they shouted back to us. It turned out that they were short-necked Padaung – our 'cousins'. The distance between the two mountaintops was only a mile or so, but it took us almost the whole day to get to the other side. Only the thought of nourishment and safety could have induced me to climb down one steep mountainside, only have to climb up the next one immediately.

The village was well-camouflaged on top of the mountain, and we had to climb for some hours to reach it. Being a warlike race, the short-necked Padaung sited their villages on the topmost peaks, to afford all-round defence. The tracks leading to the village were often disguised and covered by thick vegetation and thickets with traps beneath them, so that only our guide with the hand-grenade knew the way up. The village itself was surrounded by treacherous slopes and boulders. The thirty or so huts were identical in size and shape, with low thatched roofs almost touching the ground and no walls or windows.

We were greeted by packs of aggressive dogs that looked as though they were well cared for, and by wild pigs. It was quite a while before the villagers emerged from their huts with curious faces, grinning at us. With their tanned and weather-beaten complexions they looked like Red Indians. The women were fully clad, but the men were half-

naked. Both sexes heavily adorned themselves with jewels, mostly strings of amber bells, their ears pierced and studded with enormous corks or silver tubes. They were all tall and muscular because they had so often to cut their way through almost impassable jungle. Although they were our 'cousins' and could understand our speech, I could not make out their language, except for two sentences: 'I want to go to the loo,' and 'I am being bitten by red ants.' Both conveyed the agony of the speaker: '*Sa eedu*' and '*Tonsu eedu*.'

The villagers slaughtered a mountain goat for our supper. They cut the creature's throat and collected the blood in a huge wooden bowl, immediately drank the hot blood and then offered the bowl to us. I felt sickened, but dared not refuse. I asked for a cup of rice-wine, and mixed it with the warm blood, claiming that this was our tribal custom. The resulting mixture looked like red betel nut and smelled of castor oil. I gulped down a mugful, and nearly vomited. But within ten minutes all my aches and pains and fatigue had disappeared, and I felt like a new man.

They cooked the whole goat on the fire, cut it into pieces and sent the head and offal to the chief. They then cut up the meat and bones on the wooden floor of the hut and, to my disgust, threw all the pieces into a boiling pot to save water. Then the floating bits were scooped out of the pot before spices were added to what was left. It tasted delicious. After dinner they offered us hot rice-wine in pots. But when we stretched out our hands to accept them, they drew them away and themselves drank first. They explained that they never offered a stranger a drink without drinking it in front of him first, to show that the drink is not poisoned.

The female students were taken to one end of the village, and the men to the other. Female guests stayed in a 'girl-haven' and the men in a 'bachelor-harem' built in the same style. All night we could hear squealing, calls and ululating coming from each side of the village; a deep voice from one side, then a shriller, smaller voice from the other. It was the men courting their females with love poems, and the women responding to their calls if they loved them. The night was lively with the sounds of courtship and of the jungle animals.

Next morning we were awakened by the sound of a big gong. The chief was summoning the villagers to a meeting. He directed armed men to guide us to another village, having supplied us with dried meat, rice and rice-wine for the journey. On the way we met the

untiring lovers we had heard all night, working together on their farms, still smiling and ululating. As we left the village they covered over the tracks behind us. We were hoping to make contact with a troop of ethnic insurgents to get their protection, but we were unable to trace them because they kept constantly on the move themselves. I was almost glad that we didn't meet the rebels.

When we got to another village I realised that we were surrounded. The army had been following us from Phekhon, and had told the civilian militia, and also an army platoon which was in the Mobye-Loikhaw area, to block our way. The villagers were understandably afraid to shelter us in their homes, but they gave us food and told us about the movements and whereabouts of the army. We slept in their cultivated strips among the paddy fields and cornfields, which were infested with mosquitoes, leeches and ants. None of us could sleep. Throughout the whole night we were listening fearfully to the rustling of the leaves and the barking of the dogs in the village. I began to realise both the importance of companionship and the blessedness of silence. At midnight we heard a brief outbreak of firing. About six miles away, we would learn, two students had been killed by the army as they tried to break out. Three days later we decided to go separately, to reduce the risk of being detected. Over the next few days members of the group left one by one, and the number remaining grew ever smaller. I thought of giving myself up, for I had nowhere to go, but I decided to take the risk of trying to cross the army line – to somewhere, anywhere, that I could be a free man.

Flight Towards Thailand

After two days I decided to get advice from a friend who lived near a town called Demoso. There was a military post between the town and my hiding place, so I exchanged my clothes with a farmer and smeared mud and dirt over my face, hands, arms and legs. I hid all my important papers inside my trousers, coating them in mud that stank so much it made me feel sick. I wrapped my pistol in my lunch bag and put it in a basket. I covered my head with an old bamboo hat, and with a hoe on my shoulders I set off in the direction of the town, whistling military tunes with the (none too subtle) idea that that would give any soldiers I met the impression that I was a friend of the *Tatmadaw*.

After a couple of hours' walking along the quiet, almost deserted

country road I came, as I expected, to a sentry-post with two armed soldiers on guard. One stood in front of a barricaded bamboo hut with his German-made G2 automatic machine-gun at the ready. The other sat inside the hut smoking a cheroot, and looked suspiciously at me as I approached. I tried to stay and look calm, and kept on whistling army marching songs.

I smiled a greeting at them before they told me to halt. 'Hello, big brothers.' Then the usual Padaung greeting: 'Have you had your breakfast yet? Hot, isn't it?' I rambled on, starting with the perpetual countryman's grumble: 'It's a hard life being a farmer. But I suppose a soldier's life is even harder – I should count my blessings. I don't have to sacrifice my life for the country.'

It worked, for they were simple country boys. They responded with cautious grins, and became surprisingly friendly. They asked where my strips were. I told them that they were on the other side of the town and that I was going to do a bit of weeding, because I hadn't been able to get there since planting time. As soon as the words were out of my mouth I realised I had made my first mistake, for it was past weeding time. I hastily corrected myself, saying that I had planted my peanuts late.

Luckily the bored sentries did not notice, because they were already getting on to their next question. Did I have any sisters? I said yes. Teasingly, they then began calling me brother-in-law. Obviously they enjoyed badinage with one whom they regarded as a simple country boy. I said how good it would be to have big brothers like them who could protect my family. This certainly pleased them, for they gave me a cheroot. I went on chatting with them, all the time trying to work out a plan of escape should they find out I was not what I was pretending to be.

They obviously had no idea what was going on in Burma as a whole, only that they were doing their duty in protecting the country. Their generals had told them how the students – urban Communists to a man – were plotting to destroy Burma and to undermine the army from within. When they asked me if I had seen any of these students I said no, but mentioned that I had heard that some of them were fleeing to China. As I said that, I pointed in a direction the opposite of the route we were taking. I could not resist asking them what they would do to those students if they caught them. 'We will kill them, of course. They are all trouble-makers.'

I began praising their guns and telling them how smart they looked in their uniforms. In fact their uniforms were old and worn-out. They proudly explained the meaning of their badges. I took my leave of them, thanking them for their kindness.

I arrived at my friend's house as night fell. I found him helping his parents in preparation for 'Deeku', the harvest festival. I told him I was trapped between the army and the militia, and was desperate because I had no idea how I could get away. He made the suggestion – the first time it had been put to me – that I should try to get to the 'liberated zone' of the Karenni ethnic rebels, between the Salween river and the border of Thailand, and seek their protection.

I immediately saw that this was a good suggestion, but I was extremely reluctant. I shrank from being associated with an armed group. I clung to the idea which we had proclaimed, and in which we genuinely believed: that ours was a peaceful political struggle, one that had no connection with the armed insurgencies that had persisted in Burma ever since independence in 1948. I knew nothing about the rebels' territory, except that it was called 'the Karenni Liberated Zone', and that the Karenni, along with some Padaung, had held out there – sometimes being overrun, but always recapturing their territory – for a quarter of a century against the Burmese army. I was still influenced by the picture I had been given of them in childhood as sinister bandits who kidnapped young women and infested the jungles stretching from Phekhon to the Lawpita waterfall and to the great Salween.

My friend also told me that there were merchants who often crossed the border with goods and cattle, and that if I could manage to follow them I would be able to find my way to Thailand. But there was no guarantee that I would get there safely, because people were often attacked and killed by the army, by robbers or by wild animals. If I wanted to make the attempt he would help me with food and contacts. I remained there pondering his suggestions for three nights, constantly saying my rosary while I tried to make up my mind. But I simply could not decide. I had three or four days more in which to come to a decision.

One of the main reasons for my reluctance to flee into the further jungles was a bad one – or at least, it shows how influenced I still was, despite all that had happened, by the propaganda of the regime. I was afraid, quite simply, of being branded a 'jungle fugitive' by my fellow countrymen. The word 'jungle' still carried pejorative overtones

in the speech of urban Burmese. Anyone taking refuge with the ethnic insurgents was called a 'jungle child', which implied primitiveness, anarchy, violence and disease – as well as the unpleasant proximity of wild animals, which the Burmese detested. I had always been painfully sensitive about being regarded as part of a primitive tribe, and much of my ambition in Taunggyi and Mandalay had been to escape into civilisation. So it was old anxieties as well as present fears that stopped me from following the logic of my desperate situation.

I was still undecided when someone I had never met before – Dee Dee – and his friends arrived from Loikaw a few days later. Dee Dee had been a student at the government college in Taunggyi, and was a friend of Edward Byan. He and his friends told me they were planning to go to the border, but seemed disinclined to invite me to join them. I realised that they were suspicious of me, for they had never seen me before. We were all wary of the infiltrators whom the government were constantly trying to introduce – often with success – into the ranks of the students. To my relief, Dee Dee's mother came to say goodbye to him. It was great good luck that she turned out to have been my mother's best friend in their schooldays. She told Dee Dee and me to look after each other, and suspicion immediately turned into firm friendship. Now my mind was made up, and the group of us – seven in all – set off in the direction of the border.

Some hours later we arrived at a mean and poverty-stricken Kayah village of about seventy households. As soon as the villagers saw us approaching they abandoned their work in the fields and vanished into the jungle. They had mistaken us for Burmese soldiers – not surprisingly, since Dee Dee and another student, who had rucksacks on their backs, did look more or less like *Tatmadaw* men from a distance. We waited in front of the village chapel for the contact my friend had promised would turn up. No one appeared, so we befriended the village dogs, who had been preparing to attack us on sight. They were good, healthy dogs, and we told each other that they would be good to eat. We noticed that some children were watching us curiously from behind the trees. We heard giggles, and their smiling faces would appear from nowhere and disappear again. We tried speaking to them in Kayah, with our broken accents. At first this made them surly and suspicious, but at least they replied to us. This was the fifth language – the others being Padaung, short-necked Padaung, Shan and Burmese – I had had to use within a distance of twenty

miles. Burmese was a common language for all these tribes, but they were extremely reluctant to use it (and the Kayah absolutely refused, because of their resentment of the Burmans). So I had to communicate, brokenly, in their own tongues.

Eventually we convinced the inhabitants that we were neither soldiers nor government officials, and life in the village returned to normal. But the villagers were not yet prepared to invite us into their houses. A man in some authority interviewed us, sitting on a tree stump outside his house. The conversation lasted several hours. Although he did not show friendliness, his tone was unthreatening, and he spoke candidly. It was in talking to him that I learned a new set of words to describe both ourselves and the people to whose protection we were fleeing. In the jungle you did not use the regime words 'rebels', 'insurgents' and the like. You spoke of 'revolutionaries' – which I realised included ourselves – 'freedom fighters' and 'liberated zones'.

I realised how much I needed to learn this new language. For although I had been of necessity, and from no choice of my own, turned into a fugitive fleeing for my life, it was only now that I consciously became a 'freedom fighter'. I now embraced my fate and became active, rather than simply a victim. I knew I had to give up my lingering hopes that somehow I might escape this fate, not drink this cup. Only as darkness fell were we taken to a house in a corner of the village.

The Kayah houses were radically different from those of the short-necked Padaung. Like ours, they accommodated both people and animals; animals on the ground floor and the family above them. The smell of cow-dung was overpowering, because the Kayah, unlike the Padaung, seem to have little idea how to construct efficient drainage for their houses. We climbed big wooden ladders up to the first floor of the house, followed by dogs. There were only two rooms, and there was a big fire in the middle of the first, in a foot-deep sunken area in the floor, half filled with clay. Some people were cooking and talking over the fire. The rest of the room was in almost pitch darkness and choked with soot and smoke. As in my house, there were no chimneys, but neither were there any windows or holes under the eaves to let out the smoke. An old man invited us to the fireside, then we were given supper. Only after a while did our eyes get accustomed to the gloom, and we could see the contents of the house, including some machetes and hunting guns hanging on the walls.

Once the villagers had fully accepted that we were not government agents and could be trusted, they became very talkative and friendly. Indeed, they wanted to pour into our ears stories of what they had endured from the Burmese army. It was in that room that for the first time, and at first hand, I learned of the atrocities the army had for long been perpetrating against the villagers.

They told me of women – including pregnant women – raped and disfigured, often bayoneted whether they had resisted or not, how some had been crippled, mutilated or killed. Men had been beaten up and tortured for no reason other than the fact that they lived on 'brown' territory – that is, territory of those thought to sympathise with the rebels. One of the young men of the village had joined the rebels, and had risen to become a famous commander, because his father had regularly been arrested and used as a human shield and mine-clearer against the Karenni soldiers. The village elders had often been interrogated and beaten – they showed me their scars, which were evidence of beatings of extreme severity. The villagers were frequently seized and compelled to be porters of ammunition and clearers of minefields. The soldiers had taken it for granted that they had the right to take and eat the villagers' cattle as and when the fancy took them.

The village chapel had often been desecrated, covered with abusive graffiti and used as a barracks. Parts of it had been broken up for firewood. The crucifix outside the chapel had been smashed. Nor was the destruction confined to Christian symbols. The spirit houses were also burned. The grain silos and houses were burned after each irruption into the village of the *Tatmadaw*.

I was shocked at my own ignorance. We know that in the Second World War many Germans were – or claimed to be – unaware of the genocide that was being perpetrated by thousands of their fellow countrymen. I had lived not more than twenty miles from this village (even admitting that it was isolated in the jungle and hard to get to), and I had heard stories of atrocities like these in Phekhon – but I had simply refused to believe them. I thought them invented, so passively had I absorbed government propaganda. I had even suspected that those who relayed the stories were propaganda agents for the rebels. It was only now, expelled from the comfort of my home, and seeing their wounds and scars with my own eyes, hearing in detail what had been going on for at least two decades, that I was convinced. Only

now did I hear the desperate urgency with which they told their stories. What above all was borne in upon me was the sense that the army assumed that it was untouchable, that it could never be called to account. Indeed, many of the atrocities were simply a direct expression of arrogance, a demonstration of supremacy.

As long as these villagers were left in peace to trade, harvest their crops and live their lives, they did not care who ruled Burma. But the *Tatmadaw* had been treating them with a brutality that was astonishing in its recklessness, and that had made passionate enemies out of those who had been neutral and docile. This had been going on for twenty years – and all that time people like me, people who lived in the towns, had unthinkingly accepted the government line that these people were criminals, 'destructive elements', savages. I had now met the 'destructive elements' face to face, and seen the human reality. I started to get a deeper, much more sombre sense of the Burmese reality. It was like a conversion as I shed the last tatters of my hopeless wish to remain non-political. My fears and indecision had gone, and I was resolved not to go home – even if that had been possible – until the outside world, and the Burmese, knew what was happening. I was ashamed and angry at what I had been unconsciously complicit in as I listened to these harrowing life-stories – stories that I resolved to keep in my mind (in Hamlet's words) 'whiles memory holds a seat/In this distracted globe'.

CHAPTER 17

The Great River at Last

Meanwhile, government radio was uttering urgent pleas to the students to return home: 'Come back, children, we still welcome you with open arms. You are forgiven.' Only weeks – even days – before, I would not have been totally immune to these siren voices. Now I realised – and events were soon to prove this right – that to go back would be to step into the abattoir.

Because of my own previous indifference, I now understood that the outside world might be equally indifferent to what was happening to us, that our story might never be heard. I consoled myself with the thought that at least a few might hear and care. I put myself into the hands of luck, the protection of my ancestors, my guardian angel (whom I still pictured as leading the boy over the broken bridge) and the Holy Spirit. With this powerful combination, surely I could not fail. Yet everything I had previously relied on was now called into question in the light of what I had experienced. The props of my childhood all seemed to have been cast away.

The locals proudly told us the name of the famous guerrilla fighter, one of the best in the area, that their village had produced. He was called General U Reh, and was only twenty years old. They regaled us with stories of his astonishing fighting exploits. He was in the vicinity ready to welcome and escort students to the border. This was extremely welcome news. The border was only thirty miles away, but the route we would have to take, over mountains and through thick jungle, was at least fifty miles, and we had no maps or compasses. They told us we should wait for more students to turn up, so we stayed a further three days, though I was reluctant to wait when I knew I was being hunted down. More students did arrive, but some also returned home. Those who returned were immediately arrested by the authorities,

tortured and compelled to reveal where we were. We had to move to another Kayah village. General U Reh never turned up, as he was busy fighting elsewhere.

The Kayah were celebrating the harvest festival, and they invited us to join in the festivity. They slaughtered cows and pigs, offering the heads of the animals to the spirits. We danced around the totems to the rhythms of frog-drums and two monotonous gongs accompanied with bizarre singing. We also helped them get in the harvest. But we knew we had to move on.

We trekked past several small lakes and a waterfall with seven cascades, leading to the famous Lawpita waterfall – the very one of which I had dreamed in my childhood. Every morning we woke up to see the green of the forest trees reflected far, far below in the cascading waters. Fresh morning dews, sweet cool morning air, crisp bright morning sunlight and the songs of birds heralded for me something deeper and spiritual here. I felt the presence of the *Nats* and other spirits in this sacred place, and in the jungle. I wanted to stay longer to communicate with the spirits of the land and therefore the soul of the tribe. I knew I was in a paradise, imperfect though it was, and I was bewitched by something out of my control. My feeling for the beauty of the place was also my sense of the real presence here of dryads and naiads, that the beguiling charm of the scene also revealed actual magic. To be enchanted by the magic was truly to communicate with the soul of the tribe whose sacred place it was. Day, and especially morning, was the realm of good spirits, as night was that of ghosts and demons, who came in many forms. It was the jungle as the jungle should be, filled with presences and mysteries. There were absences as well – the more common plants and animals were not to be found, nor the ordinary jungle birds.

The worst problem on our journey was defecating. We had to use bushes, which caused great problems. The villagers, out of their over-zealous hospitality, kept giving us chilli curries, which caused us many anxious nights. I hated having to answer the call of nature at night with the wet grass touching my bottom. Torches were forbidden for security reasons. One of us once sat on a log, which would not stay still. In the morning it turned out to have been a sluggish python. The grass was always wet, and we wore *longyis* which were wet through. After a week, going to the loo was like taking a shower with your clothes on, except that it wet only part of your body. An alternative

was going to the loo in a tree to avoid the wild pigs, which had a liking for human excrement, and for charging suddenly and ferociously.

It was impossible to assess distances and locate places without maps and compass. The tribesmen said that a stranger could get out of the area only with the guidance of a local villager. A village guide was assigned to lead us out of this paradise – he had the name of the archangel who led Adam and Eve out of theirs. He led us as far as the river Poon and, like the Archangel in Milton's *Paradise Lost*, 'then disappeared' back into the jungle. We were on our own.

We had to work out our way from the position of the sun and the shadows on tree trunks. The Kayah have no idea of contours, and always make their tracks straight up and down mountainsides. Without a guide we always became lost, because we had to make detours whenever we feared something ahead. It was a maddening experience almost to be able to see our destination, the Thai border, but never to get any nearer.

There were eight of us, including Dee Dee, Edward Byan's brother Johan, Phadee Saw Jackson (a Karen – the Karens have a great liking for the name Jackson), also known as Hajee Razat, and myself, when we started our journey towards the east. Phadee had studied economics at Rangoon University, but had been press-ganged into acting as a military porter for the army. Two or three times he had been forced to be a landmine sweeper for them while carrying ammunition. The result was that his nerves were wrecked. In the middle of the night, whenever dogs began to bark – which they did almost every night – he would jump out of the first-floor window of the Kayah house and disappear into the bushes.

Not surprisingly, two of our number were utterly unsuited to the journey. They would smoke and talk while we were nervously on the look-out for the army at night. To get rid of mosquitoes they would make fires, which simply pinpointed our position to the pursuing enemy. We tried to avoid giving them any tasks at all, simply regarding them as burdens we had to carry. They had filled their rucksacks with unnecessary bits and pieces, and would complain of the weight. They would not carry the food supplied by the villagers, but would throw it away during the day's march, as though at any moment we would come on a noodle stall in the middle of the jungle that would supply our wants. When they were hungry, they helped themselves to other people's rations.

Dee Dee proved to be expert in distinguishing the footprints of enemies from those of friends. One area we crossed was known to be patrolled both by Burmese soldiers from a town called Shadaw, and by the rebels from the Thai–Burma border, so Dee Dee's skills were invaluable. This no-man's land was once a large village, now destroyed, and was the most dangerous part of our journey. Only small thickets and bamboo groves dotted the landscape, giving no solid cover if we were ambushed and attacked. Landmines were our blind enemy, and they were planted by both sides. Once we had crossed no-man's land we all sighed and smiled. From the top of a mountain I could see ranges of pale blue mountains plunging into the eastern horizon, which seemed a lifetime away.

Death in No-Man's Land

The monsoon was gradually retreating. The Karenni countryside was at its best, and the deep mud of the tracks was beginning to dry out. Often as we trekked through this glorious countryside I could not but feel that we were out on a walk for pleasure that would end with a picnic. But it would have been a dangerous one, and the picnickers would have been exhausted. The mountainsides were splashed with cool-season flowers, ranging from many varieties of orchid to small white and purple bush-flowers. They thrived on the dews and mild weather. But the landscape was disfigured by burnt-out villages and farms. It was a countryside that the hand of war had several times touched.

Everywhere there was the stench of decomposing corpses and animal carcasses. In one deserted village we found ourselves walking past a big pile of cow-dung mixed with rotting and burnt leaves. But there was an unusual foulness in the stench, which suggested something more sinister than cow-dung. We poked the pile with sticks, and found at the bottom the decomposed corpses of Kayah villagers, all with bullet-holes in the head and body.

I discovered a special horror – that the corpses of the murdered made me feel sick, and vomit more violently, than did ordinary corpses. Anger seemed to emanate from them, and it affected me physically. I had a stone in the pit of my stomach. We buried each one we found, and placed stones on the graves. Only then did my physical horror lift. Some of the corpses were of civilian porters, seized by the army

for carrying ammunition, forced to clear fields of landmines by walking through them, and used as human shields when the soldiers were under fire from the ethnic insurgents. They had been abandoned by the army when they were no longer able to walk.

One man was still alive when we came across him. He was starving and suffering from malaria, and the lower part of his body was rotting with wounds from beatings and from the iron chains on his hands and legs. He was between life and death when we found him. We tried to find out who he was so that we might eventually contact his family. All he could do was blink and open his mouth. We gave him water, and he died. We didn't even manage to get his name. We called him 'Nowhere Man', and buried him among the rotting leaves, placing a stone on his grave. After he died we communicated with his spirit with the help of a local shaman. We learned that he was married and had four children, and had been snatched from a cinema by soldiers at night.

The place we buried him in was known to travelling merchants as the Valley of Death. It is on one of the oldest routes from Cambodia and south China to central Burma – a notorious road along which slaves were imported to Chiangmai and Maeseriang in old Siam. You could feel a chill and dampness as soon as you set foot in it. I hummed the gospel song 'There will be peace in the valley' over and over again. We tried to escape the valley as quickly as possible, yet we seemed to be lured back into it by unknown powers. The more determinedly we set off to walk out of it, the more certain we were to end up in the same place. I would resolve to move at speed and then find I could not. Again and again we found we had been walking in a circle. Finally I led my companions in the wake of an owl's call, and we escaped. Later I remembered my grandmother's story about the 'khimakha' yeti and its power to confuse and lead astray, and also the owl I had released at her urgings.

We picked up pebbles from the bottoms of the mountains and carried them to the tops, where we piled them up to appease the spirits and prayed for our safety. The sensation of climbing up and down the mountains determined our state of mind. The deeper we disappeared into the jungles beneath the tree-canopy, the more depressed and apprehensive we felt; and the higher we climbed, so our hopes of survival rushed to the surface. We knew that good spirits inhabited the mountaintops and evil spirits the depths. The joy of climbing those

unfrequented mountains was almost indescribable. When we knew we were far from the pursuing soldiers we sang our way up and laughed our way down the mountains. In the jungle you simply had to be determined to keep going, to take one step after another – for you could see no goal. But once we got to the top of each mountain, we could sit down and look at the neighbouring mountains, planning our next climb and getting a sense of where we were heading. That view was as precious as an oasis seen by a traveller in the desert. But each moment like that was short-lived. We started to our feet again, and hurried on. It took an age to reach each destination, and when we reached it it simply pointed us to the next one:

> 'Th'increasing Prospect tires our wandering Eyes,
> Hills peep o'er hills, and Alps on Alps arise!'

We were so stiff from the long marches of each day that every step was an effort. I was always soaked to the skin either by rain or sweat. I discovered that it was impossible to be motivated to force one's body to climb the mountains, day after day, from fear of death. If I let my mind dwell on the dangers, I found that I lost all physical energy. It was only if I thought about freedom and love of life that the physical burden was supportable. I was determined not to talk about danger, and to avoid those who did so.

The slopes of the mountains became steeper, and the jungles became thicker and darker, each day. As we penetrated the deepest jungles we encountered more wild animals, including bears, barking deer, snakes and monkeys. Hungry as we were, we could not hunt them because we knew that if we fired our guns we would give away our whereabouts to the enemy. Our consolation was that in this thick jungle we could hide among the trees if we were searched for by planes or helicopters – which we were most days. But we constantly lost our way, often travelling in a circle and ending up, after hours of trekking, at our starting point.

There were a lot of hazel trees growing on the slopes of the mountains, so we picked the nuts and ate them along the way. When we reached the bottoms of mountains we would drink water from the streams and fill up our bamboo containers. When we got to the top we found that as it cooled it had become deliciously sweet with the fresh fragrance of mature bamboo.

Hysteria was never far away. Fears swarmed in our minds 'like hornets armed' when we got stuck in a difficult climb. I found myself expecting an army ambush over the next ridge, feeling sure that my strength was about to give out. Would my corpse be eaten by wild animals? Would I be given proper burial after I died? The sounds of gunfire and landmine explosions followed our trail, never far away.

To the Salween

Travelling by night turned out to be the best way of keeping terror at bay, because then we could not see the possible dangers such as land-mines, booby traps, cliffs and awaiting guns. It behoved us all the more to watch our steps. My mental condition bordered on madness. I suffered hallucinations about warm beds with Moe, hot chicken curries and rice, a strong massage by my mother. An insatiable desire for food and drink possessed all of us.

We held each other's hands and moved slowly in the dark, smiling. We desired, above all, a good night's sleep, but that was not possible as we pressed on to the Liberated Zone beyond the river Salween. Salween became the symbol both of a great barrier and of the way to safety. The river was already reverting, in our minds, to what it had always been for our ancestors – a spirit, even a god, to be worshipped and propitiated. We talked about it all the time. We tried to see each other's smiles in the darkness. We travelled together at night, but stayed apart during the day. There was a time when my whole existence was wrapped in oblivion, which made me feel the joy of a creation with a body and a soul.

We met a group of merchants with cattle and travelled and rested with them, camping at an abandoned, mosquito-infested farm in the middle of the jungle. The area had once been the site of a prosperous village that was a halting-place for caravans bound for Siam and inner Burma from ancient times. Caravans laden with goods from as far away as southern China, Cambodia and southern Siam stopped here to refresh their animals, letting them graze in the green valleys for a few days before they resumed their journey to central Burma to the west, and the seaport town of Moulmein to the south. Slave traders, merchants and invading Burmese armies had all stopped here on their way to Maeseriang and the further parts of old Siam. Now with the civil wars of the past forty years the place had been abandoned, and

the jungle had returned, allowing occasional fugitives to rest on its verge.

In the intense humidity and soaking wet we tried to keep warm and to protect ourselves from mosquitoes with an open fire beneath the floor of the hut. We stayed up in turn to look after the fire. Quite often it licked our backs and burnt our blankets. The damp wood gave out dense smoke and we choked and coughed, with tears in our eyes.

We woke up at about six o'clock the next morning. The first thing I could think of was Salween. Salween kept me awake. Salween washed away all my fears. I could feel the pulse of Salween beating as I slept on the ground. The enemy did not bother me any more. I was going to fulfil my long-awaited dream on that day. Salween was going to transport me to the other side, to the Karenni State, to the Liberated Zone. In all my friends' faces I could see the same thought.

After an hour of travel, we could hear the sounds of the troubled waters of Salween. We first heard it as of a rush of wind through a pine forest. My face lit up as though I were about to meet an old friend or a lover I had not seen for many years. Salween was singing like a river Janis Joplin, full of rage and beauty. We looked each other in the face, but no one spoke. Then we shouted gleefully, forgetting the danger around us. Enclosed by high cliffs and mountains, Salween was rolling furiously, raging to escape its confinement. An auspicious sun at last arose above the mountains, slowly parting the mists to reveal the beauty of Salween. We ran down along the stone slabs leading to the bank of the river, where some wild animals were drinking. We washed our faces in purification, and ritually drank the dirty brown water.

The army had been gaining on us all the time. Across the river we could see some powerboats tied to trees along the bank. Nearby, some barricaded huts perched on the slopes of a valley, looking uncannily like a Burmese army camp. Some armed men in uniform were on guard. We were 60 per cent sure they were the Karenni rebels, but we knew there was a chance they were the Burmese army. We were desperate – pursued by the Burmese, and with the possibility that we were about to fall into their hands. We reasoned that if it was a Burmese camp we could always run back. It was the reasoning of desperation, but there was no other hope. We shouted to the men for help. A boat appeared, crossing the river diagonally to the place where

we stood. It seemed an eternity of fear before we were able to decide, as they got closer, whether we would have to run.

Two men in military uniform pointed their guns at us and asked us to identify ourselves. We said, 'Students,' and they smiled: 'We have been expecting you.' They let us into their boat. The merchants tied their cattle to both sides of the boat, with their heads above the water. In the middle of the river the animals would struggle from time to time, and the boat seesawed precariously. The roaring of the waters, the black and white whirlpools and the ferocious currents seemed likely to swallow the whole boat and its passengers, but the skilful pilot avoided every whirlpool by a foot or two. It was absurd and terrifying at the same time. It took the boat, which had a twenty-horsepower engine, fifteen minutes to cross a river about a hundred metres wide. As we landed I gave thanks to St Christopher.

I turned my head upstream, and waves of homesickness hit my heart, like a wind from the valley. Now I realised that the great river had parted me from home; a concentration of forces full of destructive power within and without. What I didn't realise at the time was that the fulfilment of my dream was also the beginning of my nightmares, which would shatter my life and change my personality. A dream so true that my sense could not cope with the reality. From that day on, from the east of Salween, I could see the affairs of my country from a different viewpoint, shadowed by the mountains and blurred by the mists.

With the Rebels

'Welcome to the Karenni Liberated Zone: you will possess our land only over our corpses.'

These words were written with charcoal in Burmese on brown cardboard and nailed to a tree. We were led into the barricaded compound in the shady vale between three high mountains. The camp was called Ple-le. I was amazed at its orderly layout, which contradicted my ideas of what a rebel camp would be. There were five huts in the small compound, built in the same style as those of the Burmese army. On the left-hand side were two huts for radio communications, and a kitchen. On the right were three others camouflaged by tall chilli plants. Beneath the plants were trenches for emergency escapes that led to the slopes of the mountains. A flagpole had been erected in the middle of the compound.

Most of the Karenni fighters were out of sight, stationed around the camp on the tops of the mountains, well hidden by trees. At first glance the rebels we met, with their malaria-ravaged faces, did not look like formidable fighters. I doubted that they could even protect us with their meagre resources. Their weaponry amounted to no more than a few second-hand guns dating from the Second World War, mostly German, which they had captured from their enemies. The Burmese disdainfully called them 'jungle fowls' because of their ability to disappear swiftly into the jungle as soon as they had finished a battle. My first impressions were wrong, as was proved when I saw them in action later on.

Then, a novelty. A woman fighter – nervous but tough-looking – took down our names and addresses with a ballpoint pen on a scrappy notepad. She looked fetching in her uniform, as she sat on a bamboo bench resting her M16 on the table. Her pistol dangled by her right

hip. She wrote with her right hand, all the while stroking the loaded M16 with the slim fingers of her left – amorously, it seemed to me. Dee Dee could hardly contain himself, and grinned like a horse. 'What do you think of that, brother-in-law?' he whispered. I did not answer him, because the barrel of the gun was pointed in my direction. When she finished her task, she neatly folded the papers and stuffed them into her trousers, along with the ballpoint pen, leaving Dee Dee speechless. She then disappeared into the jungle, as did all but three of the rebel fighters.

In the evening we went down to the river to bathe. After our days of trekking over the mountains, this was a deliciously refreshing experience. I was a bit bothered, though, when I reflected on the colour of the water – brown – and realised that we had to use it for everything, including cooking. Then came dinner. The rebels slaughtered a cow to celebrate our escape. The special menu that night went under the name 'Salween Delight'. Sure enough, the soup was brown. There was brown rice with a brown beef curry, and kidney-bean soup served on a brown plastic sheet. 'You know, we can't afford to eat like this all the time in the jungle,' said one fighter. That turned out to be true. Most of the time we would have to depend on the vegetables of the jungle, especially tender wild banana plants. After dinner, brown tea was served with brown jaggeries.

Later in the evening we were invited to the hut of the Commander. He was severe-looking, intimidatingly authoritative, as we first saw him in the pale flood of a paraffin lamp. He put down the bible he had been reading, switched off the radio, puffed his cheroot and scanned us with red, intent eyes. He was a thin, brown man in his early fifties, although he looked older. Having looked us over, he gave us a faint smile and invited us inside the hut. To my surprise, his voice was gentle and soft. We sat down, and he offered us his betel-nut box. He fidgeted with his gun belt, then put it away. ('I treat it better than my wife – it is my most reliable comrade,' he said with a tense smile.) It turned out that he had been a friend of my father at Rangoon University, and we soon came to see that he was a thoughtful, civilised man, and much more open-minded than I had expected.

He asked us why we had fled and what we intended to do. He advised us, young as we were, to think ahead, to look to the future, and to avoid the mistakes that the Karenni had themselves made. His frankness encouraged a similar frankness in us, and the conversation

that followed was an important moment in the growth of my own ideas about a possible future for our country.

'We have been fighting this loathsome regime, and its predecessor, ever since Independence,' he said. 'We killed a lot of them and they killed a lot of our people. We destroyed their electricity pylons and blew up their railways and the like, but we never attained our object. The minority peoples never came together in a united front. And we got no support from the outside world. They couldn't defeat us, and we couldn't drive them out for good. Our nationalism had something blind about it – even if Burman arrogance was still more blind. But something important has happened. The Burmese people have at last come to understand why we are fighting the regime, and we have begun to understand that we can find common cause with them. And we need the help of the outside world. Now it is your chance to help your people. Be intelligent, and don't throw it away.'

I asked him whether he still fought for the dream of an independent Karenni state.

'I have to say yes and no. Yes, because I love my people and would dearly wish to see a Karenni state in which the Karenni can run their own affairs without the bullying and corruption from Rangoon. No, because I can see that what we have been waging all these years is not just an ethnic struggle – although we thought it was. It is now the struggle of everyone who lives in Burma proper and the minority states. We admire what the Burmans have done in the past few months. It has begun to show us that a federal system might be possible after all. We are tired of killing each other.'

Next day I did not move until the sun was up. I just groaned, turned over and went to sleep again, with the delicious feeling of one who has no responsibilities and no reason for rising. Politics and struggle were far away. But when we were finally awake and up, joining other students among the three hundred altogether who had fled to the Karenni, and the rebels began introducing us to guns and explosives – for the training was to begin immediately – we were instantly fascinated and alert, forgetting all our recent anxieties and terrors in the new excitement. We disassembled and reassembled the weapons, following the instructions of the rebels. Many of us felt that we were being instantly transformed into fighters for the future of our country, hardened veterans of the jungle, ready to face the enemy whom only a day before we were fleeing in terror for our lives. The rebels smiled

grimly and told us to tame our enthusiasm, for the other side had better weapons and far more soldiers than we had. Furthermore the enemy was already approaching our positions, and we would have to move to headquarters.

Towards the end of the monsoon the massive downpour ceases and the rains fall with a peaceful, lazy regularity. On a wet night during that 'retreating monsoon' we were lying in our bamboo huts, smoking and listening to the rhythms of the falling rain, when the hut shook violently as a massive thunderbolt struck the ground just outside. Within seconds another bolt struck. We sat stunned for a few moments, astonished at a double lightning strike. Then a rebel soldier shouted, 'Get out! Take cover! Your fathers-in-law are attacking us.' It was not lightning – it was mortar shells, the first ever experience of any of us of coming under fire.

There were more blasts, followed by anti-aircraft fire. The latter, when directed along the ground, is a particularly effective terror weapon. Big bullets from guns positioned on slopes sweep the forest floor, shredding the largest trees, giving hardly any chance to run for cover. We rushed out of the huts in abject panic, screaming and weeping. Another rebel shouted at us, 'Don't go mad like pigs! Take cover behind something solid! It's not even the fighting yet.' But I felt that the ground was disintegrating beneath me. So frozen were we with terror that the rebels had to manhandle us to safety, unable to fire a single shot themselves until they had dealt with us. We were still cowering behind trees, shivering and sobbing in the rain, in the thick of the mortars, when another barrage from the enemy blew away the huts we had been sitting in.

At last the rebels began replying with weaker but more accurate shots from the mountaintops. Then a full-scale clash began. The whole forest was lit up with gunfire, while at the same time, as it continued to pour with rain, there was also natural thunder and lightning. It seemed like a small clash between mortals, presided over and instigated by the gods. Branches of immense forest trees fell to the ground like twigs after each barrage of jagged metal. The blasts came in regular patterns, sweeping up the valley. Some of our huts and bunkers were destroyed. The rebels moved methodically, changing their places each time they fired, taking advantage of the craters gouged out by the blasts and using them as bomb-shelters. I began to see how they had

perfected the art of survival against a much more powerful enemy, and were even able to turn his strength to their own advantage. All I wanted to do was run far away from all this, but I understood that I had nowhere to run to, that there was no safety except under the protection of these battle-hardened rebels. The enemy bombardment lasted for an hour before they retreated to a safer position. When it was over we noticed that our bodies were infested with leeches. We pulled them out from all the intimate places of our bodies, rubbing them with salt and tobacco. No one on our side had been killed.

We slept no more that night, for fear of another attack. The rebel soldiers tended their wounds quietly, while we bemoaned our mosquito and leech bites. We sheltered under the trees, wrapping ourselves in plastic sheets, waiting impatiently for daylight. With the distant roar of the Salween in my ears, I managed to doze off just before dawn, and awoke tired and lonely. All the optimism of the day before had gone. I took in fully for the first time that I was entirely cut off from family, friends, everything I had known, surrounded only by mountains, trees and wild animals. This was uncanny and demoralising.

The enemy were good psychologists. These were terror tactics, and they worked. Some students – including some who only the day before had made fiery revolutionary speeches vowing a fight to the death – were so terrified that they were ready to surrender immediately. The oratory had been drowned out by gunfire, although not yet quenched in blood.

The Commander came down from his position in the lines. 'Calm down, that was just the starter. There is more to come.'

It was decided to send us away from the immediate fighting zone to the Karenni headquarters as soon as possible. After our baptism by fire, we were not unwilling to go. Even though the twenty-five-mile journey from the Salween was arduous and the tracks treacherous, our knowledge that we were in no danger of attack by the enemy kept us in high spirits, and we shouted and sang all the way. The area was heavily wooded with teak and other hardwoods. Lying glimmeringly ahead of us we could see the mountains that separate Burma and Thailand. The mountains on the eastern side of the Salween are between 3000 and 3500 feet, with many sheer cliffs rising from narrow valleys. The tops are covered with pine trees, and the slopes with teak,

elephant grass, hazel woods and an abundance of trees and shrubs too various to recount. The valleys are filled with bamboo groves, fruit-bearing trees, wild banana plants and assorted vines and grass. The narrow tracks wound along steep slopes, at times shooting straight up an eighty-degree gradient, which made climbing them like scaling slippery walls. Often the tracks and paths suddenly disappeared in a way that seemed senseless. Eventually it dawned on me that in fact there were no fixed paths, because travellers, both merchants and rebels, carved out a new one every time they travelled to avoid ambush by dacoits, soldiers and wild animals. The lush, fast-growing jungle smothered every track within a few months.

We knew that this area was the domain of the 'wild' Kayah, who are regarded as among the shyest and quietest of hill tribes in Burma. They are another cousin tribe of ours. I was not on a journey for pleasure or exploration, but I found myself fascinated by the variety of peoples – so close to myself and yet so distinct – and customs within such a short distance. I saw how absurd it was for a blinkered regime in Rangoon to try to impose uniformity on a country so rich in human differences, and how this absurdity might lead to the unforgivable barbarities I had both been told about and had witnessed myself.

Our first contact with the 'wild' Kayah came when we were received into a house on a hilltop owned by a shaman. He squatted by the fireplace smoking a pipe as if he were a guardian ghost of the place. He made me think of an unwrapped mummy, and he neither smiled nor spoke to us. We felt like intruders who had wandered into an ancient tomb, and soon set off to the village spring for a shower.

At the spring we waited for the villagers to finish their own shower. They included some stark-naked young women, who were unembarrassed and unashamed. As we watched them they talked to us with the familiarity of old friends. We felt ashamed at our curiosity about this (for us) novelty. When dressed, these women wore a black tunic which revealed one of their breasts. We were told later that they would not cover the naked breast until they were betrothed.

A traditional 'wild' Kayah woman is like an uninhibitedly colourful work of art. Her clothes are made of home-woven material in which red and black predominate. She wears black-lacquered cotton-thread rings beneath her knees in large lumps that look like twin beehives. Bunches of silver coins dangle from her neck along with a few strings

of semi-precious stones. The younger women wear cone-shaped silver earrings that look like bunches of miniature carrots, while the married ones stuff their big earholes with silver cylinders. A married woman also wears a red turban on her head and a white sash around her waist, but no shoes or slippers. Her lips are red from chewing betel nuts. She walks like an elephant, slow and with jingling sounds at every step, reminiscent of the tinkling bells on a Burmese pagoda top. These gorgeously caparisoned females scratched their bodies liberally and spat copiously. And all the Kayah, children included, continually smoked pipes.

Darkness fell and we went back to the shaman's house and cooked our supper. Our host offered us some of his long-preserved meat, which we had seen hanging on hooks in his smoky kitchen as we arrived. It was like chewing dried jute, but quite delicious. After dinner we went to bed by the fireside. It was a draughty and cold night. The split-bamboo floor of the house creaked at the slightest movement, and I could not sleep. A wild dog came through a hole in the bamboo door and licked my feet, taking them for food. I kicked at it and it ran outside with a yelp. Again I tried to sleep. Then someone came in and lay down to sleep by my side. He was breathing heavily and seemed to be mumbling to himself in his sleep, but his words were unintelligible. I lit a candle to see who it was. One of his eyes was missing, and he had no nose. Then I saw that his right ear was also missing – in fact half his face seemed not to be there. My hair palpably stood on end. He was awake, and smiled at me grimly while uttering words – or sounds – that I could not understand. Then the shaman pointed out to me that I had usurped the place where he always slept.

We talked to him, and he went on muttering. He also had no tongue! He gestured with his hands. Our host explained to us that while walking back from cultivating his strips in the jungle, the man had been attacked by a black bear – creatures notorious for their ferocity, which inflict terrible injuries on their victims, leaving them mutilated and in agony without killing them. The best way to escape a bear is to hit it on its nose – the weakest point – and run away. I could not help thinking that this was an apt symbol of our own attempts to confront the Burmese regime.

Guns and Ghosts

Arrival at the Headquarters

By lunchtime the next day we sensed the presence of rebels hidden in the jungle. The vegetation had become thicker – perfect for defence and concealment – and in places was so dark that we could scarcely see our way even in the middle of the day. This area had rarely been penetrated by the Burmese army in the more than two decades of civil war.

It was chilly, for winter had arrived early in the Karenni hills. We followed a stream downhill and reached our destination in the late afternoon. The headquarters of the Karenni was situated on the river Pai, which has its source in Thailand and flows from the east of Burma into the Salween. It was simply a bamboo hut perched on the top of a hill amid dense trees. Nearby was the 'Karenni Central School', a long bamboo hut thatched with leaves. There were a few other huts and, in front of the school, a volleyball ground in the middle of the clearing surrounded by elephant grass. So this was the centre of the web of those sinister 'destructive elements' who had haunted my childhood imagination and had kept at bay the might of Rangoon for the past twenty-six years! It looked not much more than a clearing in the jungle.

And there, to my surprise and joy, I found that all my friends who had fled at the same time as I did were alive and well. Of the three hundred students, most were from the minority, hill peoples, with twenty Burmans, including six or seven girls. The great majority of the many thousands of Burman student refugees were down at Maesod, west of Chiangmai.

We were to be housed in the school, and were given mosquito nets

and blankets by the Karenni rebels. They also fed us at the beginning, but told us that from then on we would have to forage and hunt for our food in the jungle. There was no question yet of our being given guns, for the Karenni did not have enough money even to arm all their own fighters. Many had arrived at the headquarters in a euphoric mood. They believed that with the exodus of students an army could be formed that would unite the ethnic Burmans with the rebels and bring down the regime. If there was a strategy that inspired the exiles, this was it.

For my own part, I was sceptical. I did not see how a military victory might be possible, and I did not take seriously the heady promises that it could. I clung to the hope that the regime would be forced to hold free elections, and that I could go home and carry on with my life when the National League for Democracy – Aung San Suu Kyi's newly-founded party – won.

In fact, we were all unrealistic. We were to see before long that our strength could never match the growing might of the *Tatmadaw*. And the news from within Burma – by word of mouth and on the BBC – continued to be bad. More and more people were incarcerated as the regime cracked down with increasing brutality and confidence. The morale of the students plunged as all this sank in on them, and as large numbers of them succumbed to malaria.

The students were from all parts of Burma. This was encouraging, for it reinforced our hopes that the opposition to the regime could become a united force, bringing together the Burmans from Upper and Lower Burma, Buddhists, Muslims, Christians, Indians and all the ethnic minorities. But it soon became apparent that they were deeply divided amongst themselves. Some wanted to get admitted to Thailand, and remain there under the protection of the United Nations – even though no camps existed there at the time. Others wanted to get military training to go back and fight the Burmese army. They were more divided than the Israelites in the desert. I was particularly puzzled and disheartened by a clique of students, unknown to me and to most of us, who already honoured themselves with military titles such as captain, colonel and general. Each of them carried two guns and ate excellent food which they seemed able to buy every day from Thailand, while the rest of us contented ourselves with rice and beans. When they spoke of the 'locals' they invested the word with an astonishing depth of scorn. They seemed very ready to give the rest of us orders,

although no one knew whence their authority came. It was an uncanny replication of the structures of power we were fighting against – and bore an equally uncanny resemblance to the revolution gone wrong that Orwell described in *Nineteen Eighty-Four*. Luckily that was a book I had not yet heard of, otherwise my depression would have turned into alarm.

The Karenni leaders did their best to help us and to teach us how to survive in the jungle, and to build and organise our camp, called 'Hwe Zedi', which was situated further inside rebel territory. But it soon became sadly clear that our urban student 'leaders' regarded them with a disdain that they hardly bothered to hide. Every day there was an assembly where they made promises in which the element of wishful thinking increased as the plausible options diminished. There were to be powerful brand-new guns, artillery and helicopters from the Americans. We had, alas, imbibed the habit of fantasy from the regime that had manipulated us all our lives. They had little interest in learning to survive in the jungle, for most days they went up to Thailand – to which they seemed to have privileged access – to stay in hotels. Slowly we learned that most of them were former members of the Burma Socialist Programme Party who had opportunistically abandoned the regime as its power slipped away.

It was inevitable that paranoia grew amongst us. The Karenni leaders warned us that at least one Burmese army officer was posing as a student leader with the task of dividing the students. We were unwilling to believe them. We were newly out of our cage, confused and not knowing how to use our freedom. We felt that the babble of discordant voices was natural, and we hated to distrust each other. One thing I was certain of – having tasted a morsel of freedom, I could never go back.

Meanwhile we set ourselves to forage for food. We searched for vegetables in the old battlegrounds in a jungle littered with landmines from decades of fighting. The rebels were fairly lax in keeping records about where they had planted their mines. On one occasion they assured us that an area where we intended to forage was mine-free, and we set off confidently to search for food. A quarter of an hour later, we glimpsed a wild boar charging towards us headlong from the top of a slope. As one, we took cover behind trees. Before the monster reached us, it was blown up by a hidden landmine. We collected the scattered meat of the animal, and returned to the camp

for an unexpected and welcome feast. The blindness of landmines could sometimes be lucky.

A Jungle Conference

In December 1988 five students from our camp, including myself, were invited to the Karen National Union headquarters in Kawmura, near the Thai border-town of Maesod, about five hundred miles to the south, to attend a secret student conference. We travelled in a pick-up truck under the cover of night, on a dirt track just inside the Thai border. Occasionally we could hear the sounds of clashes between the Karen rebels and the advancing Burmese army from the other side of the border. The road was so bumpy and full of sudden curves and descents that we vomited all night. We eventually arrived at Maesod at the crack of dawn, exhausted. We headed west towards the border and re-entered Burma by boat across the river Moi. We were to be put up in a Karen Buddhist monastery.

Seventy student representatives were there, representing all parts of Burma. We were guarded by local Baptist and Buddhist Karen girls, each with a gun. Their men were away fighting the Burmese army: this model of sacrifice was not followed by the participants in our conference. The conference was presided over by the Vice President of the Karen National Union, but even he was unable to persuade the delegates to show the maturity their perilous situation demanded. The student leaders were inexplicably unwilling to agree even on small matters, let alone seriously discuss a strategy for the grave decisions with which we were faced. The only example we had known of political meetings was the gatherings of the Burma Socialist Programme Party, which took place purely for the purpose of applauding the wisdom of Ne Win and unanimously approving the policies of the government. The idea of people on different sides of a question properly arguing for their point of view was still novel. The paranoid style of the BSPP dominated the discussions, and therefore there was little serious debate about the problems facing the country – rather a mixture of facile utopianism and vainglorious boasting.

I realised how hard it was to escape the psychology, the pathology, of the regime we detested. As I had witnessed at the Karenni head-quarters, so here people seemed more interested in claiming leadership than in actually giving a lead. The BSPP mentality which concentrated

A family portrait taken in front of the old teak house built by my grandfather in Phekhon and sent to me when I was at university in Mandalay. In the background, top right, at the end of the veranda is Grandfather's room, where he came back to say goodbye to his wife after his death. On the back of the photograph my father wrote, in English: 'We wish you a very merry Christmas and an excellent New Year. Be Patient – Humble – Brave, and keep on your best trying for the studies.' Back row: Priscilla, Piarina, Peter, Patrick, Pia, Sophia. Middle row: Father, parish priest Father Augustine Tan, Mother. Front row: Henry, Christopher, Remonda.

Padaung belles in the early 1920s.

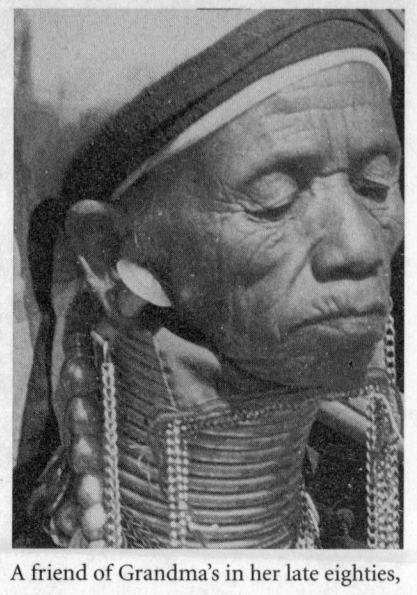

A friend of Grandma's in her late eighties, 1990s.

A Padaung in traditional attire and a Burmanised Padaung woman, 1920s.

A student fighter on her way to stalk Burmese soldiers, 1992.

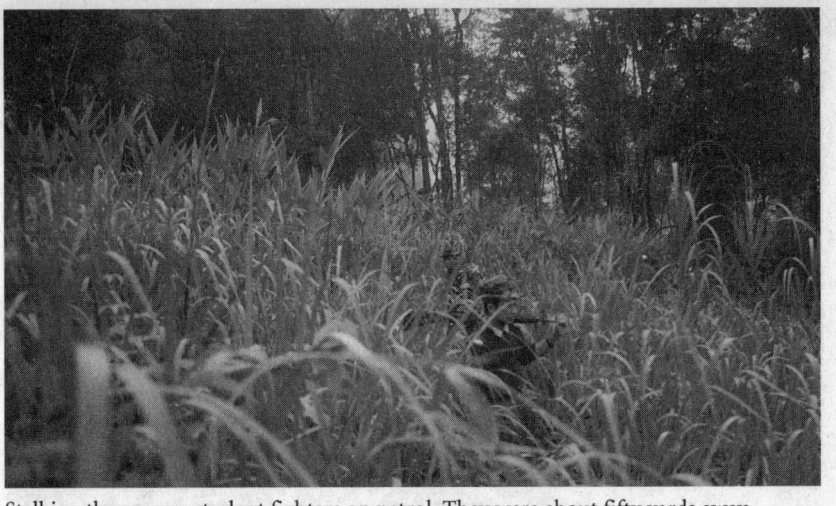

Stalking the enemy: student fighters on patrol. They were about fifty yards away from the Burmese soldiers' camp. Only fog and landmines deterred them from carrying out attacks.

A student fighter eyeing a Burmese army camp, 1993.

A student relaxing on a motorbike after a battle in 1993. He was to die of malaria later.

Dee Dee inside his command control, 1992. On the wall are the Virgin Mary, an AK-47 and a pin-up of Madonna.

Monday-morning meeting of ABSDF executive members, 1993.

Aung Than's back: he believed that the tattoos protected him from hand-grenades.

Fresh bamboo shoots: they are to be peeled, sliced, washed and cooked, or preserved underground for emergency use.

The soul of Maehongson; a Thai town with Burmese characteristics.

Pupils in a refugee camp, in front of their makeshift school.

Carrying on the traditions: a Padaung woman weaving in a refugee camp, 1992.

My first letter to Dr Casey from the jungle in 1989. The courier, a journalist, is still unknown.

PLEASE GIVE THIS LETTER TO MY GOOD FRIEND
MR. JOHN CASEY WHOM I MET LAST YEAR.
(THANKS)

Dated: 11 April, 1989.

Dear Sir,

You would be very surprised to read my letter and see me here at the Thai-Burma border. I'm so sorry to fled from home for nearly 6 months. I ran for safety but I didn't commit any crime. I may tell you in detailed later. I'm so glad I have a chance to write to you again. I was hospitalized to Maehongson, Thailand, a border town, in northern Thailand. Write to me as soon as you receive this letter. I'm in trouble of health, food and others. I'll appreciate for any help and suggestions from you. I can't forget the day I met you in Mandalay. I'm still eager in my English studies in future.

You may write to: PASCHAL K.T
C/O MR. ABEL TWEED
P.O. BOX 19
MAEHONGSON 58000
THAILAND.

Yours Sincerely,

Paschal K.T

displaced 3rd English Major
student of Mandalay University
Burma.

With John in Thailand after my escape, September 1989.

Identity card, passport and visa in one: the paper with which I was allowed to enter Britain.

A nervous portrait taken with John in the college library after my exam results, summer 1995.

With Aung San Suu Kyi's husband Michael Aris on the day of my graduation, summer 1995.

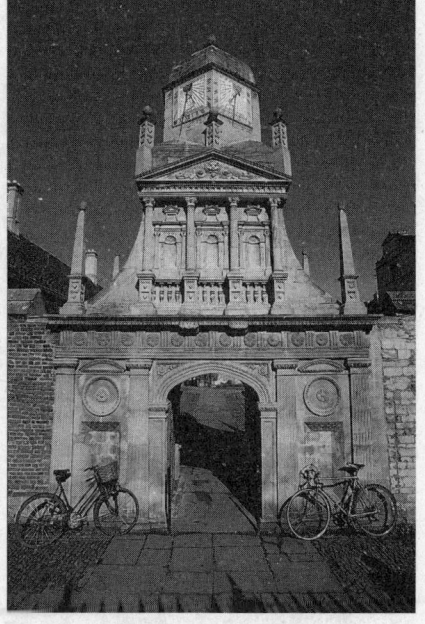

The Gate of Honour, Caius College, Cambridge.

The ghost of an ancestor: the bust of Grandma Mu Tha which I came across in Suffolk in November 1989.

With the bust of Mu Tha.

My father in Thailand, summer 1994. It was the last time I saw him. He died in January 1996.

on appointing people to important-sounding offices still possessed us. Some of the students were pleading for unity with tears in their eyes – at the very moment when shells were landing on the camp. The Karen leaders had to intervene to prevent the conference disintegrating completely. Then, on the second day, we received reliable information that some of the most obstructive delegates were actually troublemakers who had been infiltrated into our ranks by the SLORC. The infiltrators got wind of our having discovered them, and vanished. The conference had lasted three days, with no useful outcome. We came back to our camp dejected at a wasted journey and a lost opportunity.

Further cause for anxiety met us when we returned, for confusion and doubt now reigned in our own camp. The administration was in disarray, the students were divided and confused by the wildest rumours, and it seemed impossible to provide leadership. The son of a famous retired Burmese politician had been touring the camps at the border. It was believed that he had acquired quite large funds from abroad and was offering financial inducements to the students to transfer to camps inside Thailand, where they would be recruited to a political party he was organising. He suggested that if they could get to Thailand they would find much better living conditions than if they stayed with the Karenni rebels. He was in effect offering bribes to the student leaders to give up the struggle and look after their own interests. Some students did want to leave the camp, others were undecided. The leaders began putting pressure on the undecided to leave. This immediately led to a crisis with the rebels, for they were extremely anxious lest those who left might reveal what they knew about their activities, positions and plans to the enemy.

Meanwhile Burmese military planes were making constant passes over the camp, and helicopters were hovering above it. They were dropping leaflets which sometimes promised safety if we returned home, and at other times threatened bombardment. Some students began to panic. It was reported on the BBC that many students who did return to Burma, beguiled by the promises of the government, had disappeared from their homes and not been seen again. All this, despite the disappointments and disillusions in the face of our own divisions, confirmed me in the determination that had now become fixed in me: I would never return home, whatever happened, until there was a change of regime. My resolution for 1989 would be to remind myself of this every day.

* * *

At the beginning of January 1989 the government radio announced that new camps were to be set up in Thailand to welcome students who wanted to return to Burma. These camps were, in reality, nothing more than repatriation centres. A place called Tak in particular, in north-west Thailand, was well-documented as a reception centre for refugees who were to be returned to Burma compulsorily. There was a barely concealed understanding between the commander-in-chief of the Thai army, General Chavalit Yonchaiyut, and the Burmese army. The general wanted teak concessions from Burma – from which he was likely to profit personally – and realised that for the Thais to offer refuge to the students would jeopardise his relations with the Burmese. In repatriating them to Burma he would gain the favour of the regime. Burma's economic under-development had had the lucky consequence that her rich teak and other hardwood forests had been left largely unexploited and undisturbed. By contrast the forests of Thailand had been almost denuded by loggers a decade before, and the Thais had improvidently ignored the need to replant in the wake of the logging. Having destroyed their own once-rich resource, they were looking to the virgin forests of Burma to supply their industrial needs. Therefore the Thais and Burmese planned to squeeze out the rebels from both sides so that they could do business. General Chavalit later became Prime Minister of Thailand, and continued to keep his links with the SLORC in good repair.

Meanwhile, back in Hwe Zedi camp, the problems that arose from having to keep three hundred students together in a malaria-infested patch of jungle were getting worse. More and more of us suffered from malaria and skin infections.

One morning, without warning, 150 students began preparing to leave the camp and to take with them the equipment that had been supplied to them by the Karenni rebels. The Karenni were, understandably, enraged that they had been told nothing of this plan. More dangerously – for they have a high sense of their own honour – they were insulted by what they rightly saw as the contemptuous ingratitude of their guests. As one of them put it, they felt they were being treated like public lavatories 'for emergency use only'. Even those of us who had no part in the plan to abandon the rebels felt nervous. Then the Karenni surrounded the camp and placed their machine-guns in strategic positions commanding all approaches and exits. They made it plain that they would fire at anyone who dared to disobey their

orders. Our unease turned to cold terror. We understood that the Karenni had every reason to dispose of people who were not only treacherously ungrateful but who would be in a position to betray them to their enemies.

I was one of those who had to negotiate with both sides. After a whole day of talks the Karenni agreed to let the deserters leave, but not before they had been searched. Even then in their folly those leaving tried to trick our protectors, and the rebels confiscated from them tools, weapons and other equipment which they had purloined not only from the Karenni but also from their fellow students.

They got to the Thai border at a village called Hway Hai, where they were all arrested and detained by the Thai police, and left stranded in no-man's land. They were in the village for a week, and stole vegetables and livestock to survive. No representative of the United Nations came to see them, as had been rumoured. None of the people who had tempted them out of the camp in the first place came to give them food. Their leaders vanished, reportedly taking with them funds that had been supplied by foreign benefactors. The deluded students were left like a motherless coop of chickens, helpless and confused. At the end of the week they were all rounded up, sent with armed escorts to Tak repatriation camp, and repatriated back to Burma, where many were arrested and disappeared.

The government kept dropping leaflets on us from the air saying that the rebels intended to slaughter all of us. As these events unfolded, and the propaganda war intensified, I occupied myself with teaching children in the Karenni school.

By now, only 150 students were left (including the two girls from Loikaw, who resisted the temptation to return to their affluent homes). I was in charge of the sick and of supplies for the camp. Having managed to get on good terms with some border guards, I was regularly able to make the eight-hour walk to Maehongson, just inside Thailand, to buy supplies. Some benefactors also brought us staple food and medicines, and some fishing nets and vegetable seeds, so that we were able to grow our own vegetables. We caught fish in the river Pai and bred some chickens and pigs, and some dogs to guard them. The dogs were also supposed to act as guards for the camp itself, but they were often stolen by thieves to be eaten.

Five months of mosquito bites in the jungle and bouts of malaria were beginning to seriously weaken me. After training I had been

given a pistol and an M16. A few days later I suffered an unusually heavy malaria attack after a drinking session. I took anti-malaria tablets and hoped to sweat it off. But it got worse, I became delirious, took my M16 and fired a full round of bullets at the trees, sobbing and cursing. When the magazine was empty I threw the gun away and collapsed onto my bed. I escaped the usual punishment of three nights in the stocks because of my condition, but the M16 was confiscated for the time being.

Guns and Ghosts

By February 1989 the whole of the west bank of the Salween, which had been disputed territory for years, had fallen to the troops of the Burmese government. We felt that the rebels were preparing for a decisive battle. A platoon of student fighters was sent to Salween to aid the Karenni. They were equipped with rifles, hand-grenades, forty-millimetre hand-launched mortars, RPGs (bazookas), torches, rice bags, medicines, cheroots and betel nuts. At last they felt like proper soldiers. Only fifty students, including myself, were now left in the camp.

One night we went to bed as usual in our hut, which did not have walls. At about three o'clock I woke up with a start, because someone was trying to pull the blanket off me. I thought it was a prank by one of my friends, and went back to sleep. Then I felt a kind of fanning sensation around my head. I tried to dismiss it from my mind, but after another jerk I woke up again. My friends were all asleep. I awoke them and told them what had happened. After that we slept with our guns on our chests.

Holding my pistol in my right hand, I covered my body with my blanket. This time I didn't go to sleep, but listened carefully for any unusual noise or movement. Nothing happened for five minutes, so I began to make deliberate snoring noises. Another pull on my blanket, and some groans. My blanket was slipping away from me. We all leapt up and cocked our guns. Then, guns in hands, we began a search, scanning the whole area with torchlight.

There they were, squatting with their faces turned away from us, shivering and groaning. Some of them seemed to be in uniform, and some in ragged civilian clothes, soaking wet and grey in colour. We approached them cautiously, our guns pointed at them. There was a rush of wind and they disappeared like smoke.

In the morning we told the Karenni commanding officer what had happened. He said: 'Oh! You built your camp just where we buried the enemy.' Some years earlier, a battalion of Burmese soldiers were surrounded by the rebels, and almost all were killed. Their corpses had not been given proper burial, just dumped in ditches and covered with earth and vegetation.

We performed Buddhist rites and said Christian prayers over the grave to give rest to the spirits and drive them away. We never saw them again. Sometimes, though, we heard noises from the tops of the hills.

'Like Alcestis from the Grave'

'But O as to embrace me she inclined,
I waked, she fled, and day brought back my night.'
MILTON, SONNET XIX

There was nothing much to do in the camp, so I often explored the jungle with a pistol and a bottle of water. My only companion was a pariah dog that looked a bit like a chow, and that had appeared from nowhere. I called him 'Zhivago', because he would turn up every time I whistled the theme tune from the film – a favourite of the Phekhon brass band. I fed him well and he followed me with slavish devotion. He was not a trained dog, but he was constantly alert, a brave little cocker but wanting in sense. He was not good at sniffing landmines but he was an expert in sensing danger. I asked the Karenni fighters not to eat him.

One evening we walked back together to our camp after a tiring day of exploration. Zhivago leapt from tussock to tussock, occasionally sniffing and marking his territory with urine. He ran on ahead and was barking at something in the bushes when I felt all was not right. Suddenly, some sort of enormous cat jumped onto him. I aimed my pistol at the creature. It was a hungry, pregnant tigress. Dumbfounded, all I could think of doing as the tigress grappled with Zhivago was to fire my gun into the air. It worked. The tigress ran off. I was relieved that my dog had escaped and that the tigress was unharmed. Zhivago was astonishing – he just shook himself and carried on exploring as though nothing had happened.

As more and more students went to the front, Hwe Zedi became almost deserted, and a depressing place to live in. Malaria and news

of deaths in the fighting became our daily experience. One day an English journalist visited the camp and, before he left, asked if any of us wanted to write to someone we knew abroad. He said that he would happily post any letters from Thailand for us. We were suspicious of him at first, and he obviously realised that we were. Some students believed that the regime was recruiting white men who would gain our confidence and then pass on information. It was always possible that letters from us might be passed to the Burmese authorities, so I was very doubtful about taking up his offer.

But at the last moment I asked him whether he could deliver a letter by hand to an English professor I had met in Mandalay, because I had forgotten his address. He said he would. I wrote a short letter to Dr Casey, giving as my return address a secret post office box used by the rebels in Thailand. On the envelope I wrote, 'Dr John Casey, c/o English Department, Cambridge University, London, UK'. I expected no reply, but I felt better. This was the letter:

> Dear Sir,
>
> You would be very surprised to read my letter and see me here at the Thai–Burma border. I'm so sorry to have fled from home for nearly 6 months. I ran for safety but I didn't commit any crime . . . I'm in trouble of health, food and others. I'll appreciate for any help and suggestions from you. I can't forget the day I met you in Mandalay. I am still eager in my English studies in future . . .
>
> Yours sincerely,
>
> Paschal K. T
>
> displaced English Major student of Mandalay University Burma.

Meanwhile the enforced inactivity and solitude of the camp gave me a chance to revive my hunting and fishing skills in the jungle. We fished in the river Pai, and my speciality was diving among the rocks and catching fish with my bare hands. The rebels forbade fishing with dynamite and other explosives. In the evenings we would go shooting wood-pigeon among wild marijuana fields. The birds were high on the marijuana seeds and barely able to fly, but fluttered helplessly in the bushes. Their spasmodic, interrupted flights, together with their strange little cries, made me think of drunken people trying to waltz. We stuffed the barrels of our home-made guns with pebbles and shot the pigeons down. Just the sound of gunshots seemed to stun them

and they dropped from the trees at our feet. We killed them by seizing them by the legs and dashing their heads against trees. They made an excellent dish. We cooked them with marijuana sauce according to the local recipe. Here it is – Smoked Pigeons with Marijuana Sauce: 'Smoke the birds with the twigs of marijuana for a day. Stuff them with lemon grass, kaffir lime leaves, garlic, ginger with a pinch of salt and wrap them in banana leaves. Boil or bake according to taste.'

Although we used marijuana for cooking, smoking it was strictly forbidden by the rebels. You could end up condemned to the stocks, plagued by mosquitoes, for three nights if you did that.

When the rainy season began we caught frogs. There was some danger in this, for we were not the only party who preyed on them. We usually made sure of first killing the frog-eating snakes, and then caught the frogs afterwards. Pythons, like frogs, are quite delicious to eat. They taste like smoked salmon. We also hunted moles, guinea-pigs and rats. We hung and smoked the rodents for three days before cooking them. Rat soup, minced moles and roast guinea pigs were our common recipes. The local people liked to hang the meat of porcupines until it stank like that of a corpse before they cooked it with herbs. It tasted delicious, but we had to eat it holding our noses.

At the end of 1988 we were invited by the Karen villagers to share a Christmas meal with them. The main dish had a strange flavour – the meat in it tasted like dog meat with a strong whiff of garlic and lemon grass. After the meal, our hosts didn't wash their fingers, but sniffed at them for some time. Before we went home they told us that we had been eating monkey. Suddenly, I wanted to throw up. For the Karen, the meat of monkey was a typical Christmas dish, like turkey or goose in the West. They believed it was a gift from God, and that even the smell should not be wasted.

Tender wild banana trunks were available throughout the year, and we used them in soups along with lentils and vegetables. Truffles and wild mushrooms were in season at the beginning of the monsoon. Fresh bamboo shoots could be had throughout the monsoon. During the cold season, when the bamboo shoots had matured, bamboo mushrooms became available.

We had more than one way of cooking rice without pots and pans, depending on the situation we were in. It could be cooked in bamboo stems: you soak the rice in green bamboo stalks for half an hour, and stuff the open end of the bamboo with grass. Roast the bamboo

slowly over the fire until the rice is cooked, then peel off the bamboo skin. In this method, the rice comes in cartridges. Another method we called 'rebel style'. The rice is soaked in a towel, linen or sarong for more than an hour. Dig a hole in the ground, one foot deep, bury the rice bag, then make a fire on top. Steamed rice will be ready within fifteen minutes. We used this method often when the rebels were on the run.

Our morale continued to decline. At the end of March, the parents of the two girls – under pressure from the regime – came to our camp to persuade their daughters to give up the struggle. Their arguments were familiar, and it was impossible to deny that they had force – that the cause was a hopeless one, and their idealism was being abused by opportunists who simply took advantage of their bravery. There was no chance of success. And who would look after them if they were wounded or fell seriously ill? There was no proper medicine, let alone a proper clinic in our camp. As girls they were more vulnerable to dangers than the rest of us. They should go back home with their parents and try to live unobtrusively, hoping that the regime would forget about them and their transgressions. Then they might be able to get jobs and – who knew? – a new government might emerge and all would be well.

These were the arguments any good parents might use who cared more for their children than for the madnesses of Burmese politics. Yet it was, in a certain sense, a dialogue of the deaf. The parents were anxious to respect their daughters' beliefs, and not to force them to do anything against their will, yet there was a fundamental gulf between the generations. To these parents – like my own – rebellion was almost unthinkable. Respect for authority of all sorts was ingrained in them; added to which, the penalty for rebelling against the regime was terrible. In the end, perhaps unconsciously, they assumed that to express any individual political opinion was so shocking as to be virtually criminal. Our rebellion was against much more than the SLORC.

The girls were in a dilemma. They loved their parents, and in refusing to obey them they, too, had to go against most of their instincts. Yet they would not return home. Their parents left shocked and sorrowful at the rejection, but with their loyalty to their daughters somehow reinforced by an uncomprehending admiration.

More students were hospitalised in Maehongson as the fighting

raged. There were cases of cerebral malaria, which brought on temporary insanity. We also suffered our first direct casualties in the fighting when three of our number were killed in battle near the Salween. Most of my friends were ill. I myself suffered bouts of both malaria and dysentery, accompanied by skin infections caused by the lack of pure water. For a week at a time I would become so weak that I had to sleep right next to the stinking latrines which I was compelled to use more than twenty times a night. I often passed out in the latrines with blood coming out of my mouth and anus. Yet I gradually learned to live with malaria.

On one of those nights I fell into a heavy sleep of exhaustion. I found myself in a place that looked like Mandalay, but was at the same time unfamiliar. The wide streets and narrow alleys of the city had become a veritable maze. I felt an urgent need to see and talk to old friends and acquaintances. There was one who, in particular, I had a terrible desire to see, but I could not remember who this was. The streets of Mandalay were covered in a luminous haze, so that it was impossible to get my bearings.

Suddenly I felt sure that Moe was alive. I ran towards her women's hostel at the university. My hope was that nothing would have changed her beauty. Then I thought I had a glimpse of her. The haze began forming itself into Moe, as though she was being born out of the mists. At last the image formed completely, and Moe stepped out of the haze fully herself. I dared not speak, because I feared it would frighten her away, whether she was real or a ghost. I wanted to hold her, but I felt she would slip through my embrace like a shadow. I waited until her face had emerged completely from the haze, and called her name. She smiled in the way she used to. I was confused and did not know what to say. She walked towards me, and when she was right in front of me my confusion was complete. I wanted to question her, but dared not, for I felt that any questions would hurt her feelings or offend her.

She gave me her hands. I touched them, and she was not a shade, for her hands were as warm as my own. I knew she really did exist; we were locked in each other's arms, touching and kissing.

'Darling – you are thinner.'

'Yes,' I said, my eyes closed as my hands travelled over her body, checking that everything was the same – her birthmark, her breasts. All were as they had been, except that her face was somehow fuller

than when she had just come out of prison. 'Are you the same girl?' I asked, with suggestive intent, as my hands continued their explorations. 'Are you angry with me? Can you understand my despair since you left me?'

She gave me a sidelong glance: 'I have changed – your grief can no longer touch me. But stop fretting. No one can disturb us now. They couldn't kill me.' Her voice had begun to turn into a moan. Then she giggled strangely: 'By the way, do you like my new room? We will spend the whole day in this bed and watch the raindrops through the little window falling on the green grass. Then we can put on our favourite music and make love. Don't fret. All will be well.'

I closed my eyes and kept on caressing her. Her soft skin gradually turned leathery. I feared something was wrong. The walls of her room began to resemble the concrete sides of a grave. I locked her in my arms, trying to preserve this moment of sensuality. By and by, I realised where I was, and deliberately didn't open my eyes for some time. I woke up with my M16 in my arms. But she had, at last, come to me in my sleep.

I had learned how to deal with the Thai police. Occasionally I was arrested when I crossed the border to buy medicines and food, but they released me as soon as I gave them money (the total cash I had to meet the food and medical expenses of the camp came to about 500 bahts – $16–20). Between the border police, with whom I had made friends, and the tourist police in Maehongson, the Thai intelligence reigned supreme.

I had begun to stay regularly in the house of an ex-Burmese soldier, Mr Somsak, when I had to go into Thailand. His house was situated on the outskirts of Maehongson, not far from the territory controlled by the chief opium warlord of the Golden Triangle, Khunsa. Khunsa was half Chinese, and claimed to be an ally of the Shan in their struggle for independence. The general opinion was that he was on good terms with the Burmese regime, that he helped fund them, and that they were quite content with his warlord status. Two border guards had decided that I strikingly resembled Khunsa, and they always addressed me by that name as I crossed the border. It stuck, and Mr Somsak would not call me by any other name. Indeed, quite soon he forgot my real one.

Mr Somsak had been a truck driver in the *Tatmadaw* before he deserted and fled to Thailand. He told me that his reason for deserting

was that one evening he found that no dinner had been left for him. He was a devout Shan Buddhist, and now made his living by telling fortunes and giving his clients home-made medicines. Every day he meditated for an hour in front of the shrine inside his house. After that his Burmese army training took over, and he would spend the evenings telling obscene jokes. He believed that the Lord Buddha would forgive him his obscenities as long as they were not uttered near the shrine.

I had to get a permit from the immigration office each time I visited Maehongson. I normally went to the market and bought food and medicines, visited the hospital and returned to the jungle within a day. The town was full of shady characters, and I never felt safe there. It was said that there were professional assassins in the town who would kill for $50. The whole area was known as the Siberia of Thailand, because Thai army and police officers who had committed some offence against discipline were sent there as a punishment.

One evening while I was staying in Mr Somsak's hut, a friend of his, a member of the Thai intelligence in plain clothes, with a revolver strapped to his waist beneath his shirt, came to visit. I was sleeping in front of the shrine under a mosquito net. The intelligence man asked who I was. 'Oh – that is Khunsa,' said Mr Somsak in all simplicity. Like a cowboy in a Western, the man whipped out his pistol and pointed it at me, shouting loudly in Thai. I dared not move a muscle. His face had lit up like a traffic lamp with joy that he had captured such an incredibly valuable prize. My host explained that I was not the real Khunsa, and that it was only my nickname. With a great sigh of disappointment, his friend returned his gun to its holster, while I sighed even more with relief.

So the days passed, with occasional diversions, but with a sense that even though we still expected to fight the Burmese army, we were coming to a dead end. Lethargy began to settle on me. Boredom became worse than fear of the enemy.

One day, when boredom had reached new heights, a package turned up at the camp via our secret post office box, addressed to me. I opened it and found that it contained two books. There was also a letter, a short note from Dr Casey. In it he said he did not yet know how he could help me, but would do his best. I was surprised and delighted to have any reply at all to my letter, although my friends did not see that books were of much use to us. I took the package to

my hut, and took out the books. One was a dictionary, the other *The New Oxford Book of English Verse*. I opened it, and among the pages I found green banknotes – $US140. The largest-denomination note was inserted at Kipling's poem 'Mandalay'. I gave some of the money to the rebels, and with the rest bought food and medicine for my sick friends. I read the poems on the tops of mountains (I thought the mountain heights and the poetry would together blow away my troubles), and tried to imagine what daffodils looked like. Reading English poetry in the Burmese jungle seemed as incongruous to me as reading the New Testament in a brothel might have done. Out of boredom, I also noted down in my diary the news of the death of Ayatollah Khomeini in Iran and of an English actor called Laurence Olivier. I felt a desire to see his films, even though I knew nothing about him. The BBC was also reporting protests by Chinese students against the Communist regime in Tiananmen Square in Beijing.

To relieve boredom, the two girls ate and drank as much as they could, sang sentimental songs and wept by the fire in the evenings. Maung Win, an Indian student, accompanied them on the guitar while they sang 'Every Time You Go Away', 'Devil Woman', 'I Have a Dream', 'Fernando', 'Bridge Over Troubled Water', 'The Sound of Silence' and other Western songs popular in Burma. The extraordinary thing about the girls was that they never got a malaria attack, while the boys were constantly lying in bed with high fevers.

As the Burmese army started to advance towards the Karenni head-quarters at the end of the hot season, we prepared to evacuate all the refugees. I went to the areas west of the Salween with the Karenni fighters for a week. By chance we found and rescued a starving porter abandoned by the Burmese in the depths of the jungle. He had been used to carry ammunition and to walk ahead of the troops in order to set off any landmines that had been laid in their path. He was still able to talk, and we carried him to the camp. First we gave him water and a drip, intending to take him to Maehongson hospital later, but while we were tending to other sick people, a villager gave him a hearty dinner out of compassion. The porter sat up contentedly against a tree after his meal and fell asleep. When we tried to wake him up, he was already dead. His digestive system could not absorb the food after he had starved for so many days. He had been allowed to eat himself to death. I was furious, but how could I blame the villager for his act of charity?

Staying Alive

The longer I stayed in the jungle, the more determined I became not to die of malaria or boredom. I began to think that hell must be an eternity of repetition. But my position as procurer of food and medicine gave me a perfect excuse to slip quietly away into the battle zones without telling anyone, both to explore and to find out for myself how dangerously near the fighting might be. I studied the terrain, and also the plants and animals of the jungle. The Karenni leaders understood my curiosity and gave me permission to roam freely without having to ask permission at every point. In fact this was dangerous, and it was only luck that prevented my being picked up, accused of being a spy and executed on the spot. There were at least four rebel groups operating within the Karenni-controlled area: the Shan Democratic rebels, the Kachin Independence Army (KIA), the Muslim fighters and the Wa. Centuries ago the Wa were a highly cultured people with a kingdom in northern Thailand. They are now a tribal people who in living memory were notorious headhunters, and are still suspected of a taste for human flesh. All four groups were under the general, sometimes nominal, command of the National Democratic Front (NDF).

There were good reasons for all the insurgents to be on the alert for spies. While we awaited the coming offensive from the Burmese army, the Karenni rebels captured two infiltrators near Salween who tried to pass themselves off as civilian porters escaping from the army. But they had not taken the precautions they should have done to make their story credible. There was no sign of wounds to show that they had been porters. Genuine porters usually had wounds and deep bruises on their shoulders and other parts of their bodies from being chained and repeatedly beaten and forced to carry heavy loads. In fact the

signs of the chains, the chafing and the sores were an almost infallible sign of what had happened to them.

At first the rebels questioned their captives in a correct and reasonable way. But they were determined to confess to nothing, and stood up well to the questioning techniques even as these became harsher, to the point of severe beatings. Other porters who had escaped testified that the two were indeed Burmese soldiers – but their resistance did not crack. Finally the rebels used their secret weapon to get the truth out of them. They invited their allies, the Wa fighters, to come and inspect the meal that was waiting for them.

Several Was turned up and came forward eagerly to examine the two men. They were actually carrying their cooking pots and pans. One Karenni leader said, 'Choose the one you would like to eat tonight.' The captured men began, for the first time, to show signs of fear.

The Was began pinching and pulling the men's skins in a professional way to decide how edible they were. One said to his companion, 'This one is too flabby – too fat – not good to eat. Which do you think is the better? The other one might be better for a lean dinner, I think.'

The Was began conferring, discussing the finer points of human flesh with ever-increasing excitement. After all, they were being offered a real feast. Eventually they agreed to take the one with less fat on him. The targeted man began to protest and to plead with the Karenni not to let the Was eat him. His pleas for mercy were ignored, and finally he pointed to his companion: 'He is my captain. I am only his soldier. Eat him if you must, I will tell you everything.' (It stood to reason, of course, that the fatter one would prove to be an officer.) The rebels had what they wanted. They told the Was that this had all been a charade, that they had no intention of encouraging cannibalism, and that they had only been trying to discover whether the two really were spies.

The Was were gravely disappointed. They complained bitterly how unfair it was to raise their hopes – and appetites – only to deny them their dinner. I was extremely relieved, for I had not been sure that it had really been a charade. I had been witnessing a necessary cruelty, but I was glad that the Karenni still knew where to draw the limits. The two infiltrators gave us useful information about the dispositions of the approaching Burmese army, and soon decided to join the rebels themselves.

The frightening reputation of the Was was well earned. A few years earlier, the Karen rebels had sent two captured civilians to assist the Was in carrying their food supplies. The Was misunderstood what was being offered to them, and ate the two men.

I wrote a long reply to Dr Casey's letter, giving an account of what had happened to me since I went into the jungle. I was very conscious of my imperfect command of English to say all I wanted to tell him:

> . . . I was hospitalised in Maehongson for several times due to a malaria attack. I'm not as fat as before. I arrived in this area since October 1988. My relatives hid me in the jungle near my home for two weeks before that. That time I was wandering in the forest, eating vegetables and sleeping under heavy rain and leeches. Though I didn't commit any crime the rulers of my country town wanted to kill me because of their narrow minds, seeing me as a 'black sheep'. I'm the only one who could attend university because of my hard earned money. I'm sorry for them, because their eyes and ears are closed by the tyrant dominators. On the way to the border, I saw many villages destroyed by military regime and villagers killed desperately . . . I still have a strong desire to learn abroad for further studies. My parents also do not want me to be back home for now. They would be in trouble if I returned home where no foreign reporters could arrive . . . The weather here is terribly hot now. It is difficult to go to Maehongson, for the river becomes shallow. In the raining season the river flows too rapidly . . . The people here are suffering from cholera, malaria, typhoid and diarrhoea etc . . . If you have any chance to come to Thailand please let me know before you do. I'll tell you the best way where we can meet in safety . . .

I enclosed a map I had drawn, showing him the route (or 'root', as I called it) by which I had escaped.

Clashes by the Salween

Meanwhile on the other side of the Salween the government troops were advancing from two directions: one force from the north and another from the west – four columns altogether equipped with the most advanced weapons, newly acquired from China. The rebels were outnumbered at least twenty to one. The army brought the usual

complement of half-starved civilian porters to carry ammunition and clear minefields by being forced to walk through them ahead of the soldiers. All the outnumbered rebels could do was cut the enemy's lines of supply and reduce their capacity to use all their lethal weapons.

Although I was hopeless at fighting, the rebels had come to respect me as a speaker and student leader, and I also helped teach their children. Now, finally, I met the famous guerrilla fighter General U Reh, on top of a mountain near the Salween. He was determined to mount a counter-attack, or at least an ambush. Some of the Karennis' scouts had sent us information about the movements of the government troops, who had been sighted in the south, near the Karen State on the west bank of the Salween. It was clear that they intended to attack first from the north, so that they could distract the rebels' attention from the south and carry their supplies eastward up the river Pai. Their strategy was to provoke the rebels in the south to go up north to oppose their attack, after which government troops would enter the Karenni area from the south, where the Pai meets the Salween. This would put them in an excellent position to drive up to the Karenni headquarters.

On the far side of the Salween in the south, the Burmese soldiers had paused to relax and were behaving like men out on a picnic. Many had gone for a swim in the river, blissfully ignoring the dangers. Some were cooking and singing as evening came on, and they seemed to have set no guards. As it was the end of summer the river was quite shallow and narrow. The rebels had been watching them all the time since they arrived at the river, and were planning their ambush. U Reh was constantly on the move, assessing the vigilance (such as it was) of the enemy, whether they had posted lookouts, scouting out the terrain and the means of communication.

According to U Reh, the government troops were being very careless. His tactic was to provoke them to enter the rebels' territory prematurely, before they could join up with the forces from the north in a two-pronged attack on the rebel headquarters, so that he could demoralise them with a first blow. He briefed a platoon of fighters before sunset.

The rebels approached the river stealthily, taking cover behind the trees and boulders that line the sandy banks of the Salween. With professional calm U Reh chewed betel nuts and gave precise orders to his men over a walkie-talkie as he surveyed the scene. For a non-

professional observer like me, the minutes passed with unbearable slowness. I counted time by watching the crimson sun sink over a mountain in the west.

When everything was ready, just before the sun set, U Reh ordered his men to attack. Suddenly, all the rebels sprang forward to the edge of the river from their hiding places like so many jacks in the box, and opened fire on their reckless enemy. The chaos on the other side of the river was complete: screams, mixed with the sound of gunfire, flooded the whole valley and shattered what seconds before had been the deep peace of the jungle. We watched the pandemonium develop as we surveyed the whole scene with binoculars from our mountaintop. For a precious three minutes the rebels fired without a shot being returned. The counter-attack came only after some soldiers managed to scramble up the riverbank to their weapons. It was too late for many, and the casualties were high.

The rebels, their mission completed, retreated as quickly as they had attacked, without suffering any casualties. Belatedly the Burmese army turned its massive firepower upon them. Showers of bullets and anti-aircraft shells followed in their wake, and mortar shells rained down. The fighters came back to our meeting-point with broad smiles on their faces. The exercise had lasted only ten minutes, after a long day's hard work and still longer preparation. We retreated to a safer place for the night, knowing that otherwise we would be bombarded all night. We needed a good night's sleep before the next attack.

U Reh's stratagems were resourceful, yet we understood that this was only a brief reprieve.

On the Receiving End

Meanwhile, on the upper part of the Salween, in the north-west, the inexperienced All Burma Students Democratic Front (ABSDF) and National Democratic Front (NDF) forces were being overpowered by the enemy. They were trapped between the pursuing Burmese troops and the Salween, and were slowly retreating to the liberated zone. I rushed upstream with the rebels, but Zhivago refused to come with us. He just ran back to the HQ. That worried me – he was a canny dog who knew how to avoid dangers.

The sound of continuous gunfire could be heard as we approached the area where the clashes were taking place. The Karenni rebels were

trying to help the students, but to no avail. The government troops were closing in on them from several sides. Some boats were sent across the river to rescue the remaining fighters, including the wounded. As they returned across the torrential river, Burmese bullets followed them, holing them, wounding the passengers, sinking some of them in whirlpools. The rebels tried to give the boats protective fire, but their bullets could not reach the other side of the Salween. When the advancing Burmese troops reached the river, they caught two wounded students who hadn't managed to get across. One of them was my friend from Phekhon, Aung Than Lay, a sixteen-year-old schoolboy and ex-seminarian. The soldiers first beat them with their rifle-butts, then poured petrol over them and burned them alive on the bank of the river, before dumping what was left of them in the water.

In the face of this I could not even pray. All I could grasp was that the torrents and whirlpools of the Salween were less terrifying than the mystery of human cruelty that I could see being enacted on the opposite bank. It had the unreality of a silent film – silent because any cries were drowned by the noise of the waters. All the animals and birds that regularly drank from the river had fled, leaving only human beings caught in a fit of madness.

As expected, the enemy returned to the Salween next day at the crack of dawn. This time they came to cross the river, seize the rebels' positions and stay as long as they could. They brought all the equipment needed for crossing, along with a mass of ammunition, food and medical supplies. The rebels, with a small number of fighters and antiquated Second World War guns, evacuated their camps and prepared to face the attack. They took up positions on the tops of the mountains where they could see their enemy crossing the river.

I was sleeping in a hut that morning, wrapped up in my blanket, when I was rudely awakened by the sounds of exploding mortar shells. Such is the power of habit that my first reaction was one of irritation. I had already learned to hate being woken up by gunfire, and felt simply angry that someone had roused me so unceremoniously. The sounds of gunfire had lost their power to stupefy me. I was afraid I might be hit by the bullets, but no longer was I cowed. The compression of air caused by the exploding shells had the effect of someone headbutting you in the face, which helped explain my reaction of anger. As if in a trance, I got out of bed and walked with lazy anger towards a safer place in the midst of the explosions.

Although the shells kept coming, the Karenni didn't return fire, but waited patiently. The shelling lasted for at least half an hour before the enemy commandos crossed the Salween in motorised inflatable boats. The rebels shot at the boats; some sank, but most kept on towards the shore. Then the real battle commenced. As shells and bullets flew around us, the sounds of swearing and screaming seemed almost as loud as the artillery explosions. I could see some of my friends lying wounded, but it was impossible to get near them. The bullets were coming in low, and the shells exploding high so that the fragments ricocheted in all directions. Boulders were blown off the mountains and branches of trees torn down and shredded.

The enemy eventually took hold of the camps at the foot of the mountains. The rebels were desperate to escape, but were intimidated by the intense hail of bullets and shrapnel. I wished I had had the good sense to stay behind at the headquarters, like Zhivago. The bullets really were as thick as a hailstorm, but fortunately they were coming horizontally rather than vertically. Everywhere I could hear the screams both of the killers and of dying men.

We had managed to escape halfway up a mountain when the government soldiers came crawling up the slopes for another attack. In desperation, a rebel fired an anti-tank rocket launcher, or bazooka, without warning his comrades. Suddenly the fighting stopped completely and there was silence all along both lines, because all the guns were jammed by the magnetic shock caused by the explosion. It was customary to switch off automatic guns before launching a bazooka. But luckily the rocket hit one of the enemy's anti-aircraft guns that had been pinning the rebels down. One of the enemy below shouted, 'Fuck off, you slugs-to-be! You are only allowed to use bazookas against tanks, not against human beings with machine-guns. You are breaking international law. It is not fair!' His indignation was genuine, if comic. I suppose he did not think that dousing a student with petrol and burning him alive was against international law.

The rebels and students did not return the abuse but quietly and quickly occupied themselves with disassembling and reassembling their guns. To save their bullets they retreated to the top of a cliff and began throwing stones down onto the enemy positions before they could shoot back. The enemy soldier's angry protests started again: 'You sons of my fucking! This is not a stoning festival or a water-festival.

It's a fight. If you go on doing that I am going to kill you.' Then he opened fire again. Still the rebels said nothing.

One of the strange things was this semi-intimacy with our enemies, even when we had seen their atrocities against our friends with our own eyes. Perhaps this is typical of civil war. And to swear effectively at the enemy as a way of keeping up one's own morale and damaging theirs was a skill actually taught to Burmese soldiers (it virtually proved that they assumed their enemies would always be their fellow-countrymen). When they called us 'slugs-to-be' they were employing the Buddhist idea that we would be low creatures in the next reincarnation. 'Sons of my fucking' meant that they were superior to us – almost stern fathers and elders.

We retreated to the lower slope on the other side of the mountain when the government troops captured our positions at the top. One particular Burmese soldier kept throwing hand-grenades from his vantage point down to the bottom of the hill where we were taking cover. He shouted a comment before he threw each grenade: 'Here comes a present for you, brothers-in-law!' The grenades were exploding on our only escape route, while we were running out of grenades. The chief recipient of the 'presents' was a student called Aung Than, who was marooned in a trench with his rucksack sticking out of it. As the grenades exploded close behind his back, destroying his equipment, he became enraged with the man who was throwing them. Shrapnel kept hitting him on the back, but luckily his rucksack protected him. All he could do was duck and hope for the best. Another grenade landed just in front of him, and he could hear it rolling leisurely towards his face, right down into the trench. He could only wait for the explosion. None came. He closed his eyes and waited another moment for the bang. No. He opened his eyes and looked at the toy under his feet. By an incredible piece of good fortune his tormentor had forgotten to pull out the pin before he threw the grenade. Aung Than picked it up, drew the pin, and threw it back to the sender: 'Thank you brother-in-law. But take it back. I don't need it.' It landed in the foxhole from which it had been thrown. There was an explosion followed by a muffled shriek. Then silence. Aung Than retreated.

I crawled away and tried to find a way out beneath the flying bullets and shrapnel. It was quite impossible. I thought this must be the end of me. Then a Karenni fighter appeared. He was walking in an unhurried way, carrying his medical kit and whistling the Bee Gees number

'Staying Alive' amid the bullets. He was obviously high on marijuana, and quite without fear. He went on whistling as he picked up and tended wounded fighters. Coming to me, he patted me on the shoulder. 'Are you all right, mate? Still in one piece? That guy doesn't look very well. I am going to look after him.' And he walked off in the same unconcerned way among the bullets and shrapnel to a fighter who had been hit in the leg. I stayed crouching on the ground, thinking how to escape in one piece. At last everyone managed to retreat and escape, although with many wounded and some killed. One rebel even managed to record the fighting on his Walkman.

The battle at the front was lost. The attacking troops were aiming at the headquarters of the Karenni near the Thai border. But for the moment they were content with their victory at the Salween and didn't pursue us any further.

I helped evacuate our wounded fighters to the hospital in Maehongson. This magnificent hospital was partly funded by the royal family of Thailand, and its philosophy was to treat everyone with equal care, wherever they had come from. People made donations according to their means, and the poor could be cared for for free. As a result of the hospital's philosophy, rebels, Burmese soldiers and soldiers of the army of the opium warlord were all being treated there, in the same rooms. It was an uncanny experience to be in one of those wards. It was also sobering to see people who had been killing each other only a few hours before lying quietly next to each other. They even became friends. Then when they recovered you knew that they would return to their respective camps and start the killing all over again. Poor Burma!

An Impossible Hope

A new rainy season had arrived, and the monsoon was at its height. Clouds gathered from the western horizon and the rain over the mountains and in the jungle became incessant. The jungle tracks again became treacherous and impassable. My depression set in as firmly as the weather and became a despair that I half acknowledged to myself, even as I kept it from my friends. I saw only defeat, but I knew that despair is contagious, and I did not want to pass it on to them. Yet when we had held a brief meeting to reflect on our situation, the disappointment and disillusion we all felt was hard to conceal. The two girls had been crying, and the boys looked weak and dejected. When I could stir my imagination out of the paralysis of the present, all I could see was the shabby buildings of Mandalay.

Since I had to stifle my inner imaginings, I transferred all my feelings onto what was around me. I still explored the jungle in the midst of the rain. There was no greater pleasure than watching flowers, including orchid blossoms, on the verge of cliffs and on trees after each warm downpour. They swayed in the breeze, now and then shedding their petals. I imagined them as a host of young women on swings. The black and yellow spiders were building their webs, occasionally shaking down droplets of pearl-like rainwater.

Here in the jungles my frustration began to be directed at the destruction of the forests, that had already begun but had been suspended because of the civil war. The ugly scars from the chainsaws of the loggers could still be seen in parts of the jungle, and the closer we got to Thailand the more the thick teak forests had been transformed to scrub. I watched the pounding rain gouging out the topsoil of the rainforest where there were no longer tree roots to keep it in place. Saplings were swept downstream. Animals which could no longer find

a habitat were fleeing a disaster. Disoriented, their cries continued throughout each night in the rain, when normally they would have been asleep in shelter. The sound drove me crazy. Before the destruction of the forests you would never have heard these sounds of woe mingled with the rain and wind. In the Shan State I had assumed that there would always be the sounds of birds and animals to soothe the soul, and everywhere an abundance of water to quench the thirst. Here, when the rain stopped, there was neither, only the monotony of insect sounds and the maddening hum of cicadas.

I directed all my feelings at this vision of destruction because I was unable to possess or face what I felt for myself, for my dead friends, or for the mutual destruction that was going on in Burma. I felt I was living a posthumous existence, a ghost in a dreary landscape of the dead.

What had happened in Burma in the past twelve months seemed unreal. The government had done what was unthinkable – promised free elections. The students and then the whole population had gone onto the streets in a massive festival of demonstrations. Under the butcher Sein Lwin many hundreds, perhaps thousands, had been killed. The butcher had abdicated, and victory had been in sight. Then the *coup d'état* and the SLORC had erased all our gains, killing thousands more. By October thousands of students had fled into the jungle, hoping to bring down the regime in a grand coalition of urban Burmese and their old enemies, the ethnic rebels. The army had counter-attacked; disillusion had set in, there had been betrayals and surrenders. By March 1989 the blossoms of wild red cherry simply made me think of blood.

Some accidents in the camps brought the tragedy of the absurd. One evening a man was brought as a patient to the rebels' clinic near the border. He was burnt from top to toe, and hardly resembled a human being. He had gone hunting with his friends that morning in the hope of catching wild pigs. They were townsmen who had no real idea of how to bring the animals out of their cover, so his friends simply torched the dry jungle vegetation at the foot of a mountain while he waited for his prey in a tree at the top. This was extremely dangerous, for in the early monsoon although the top layers of leaves are drenched, they quickly dry off between showers, and the vegetation beneath remains dry, becoming saturated only after two or three weeks of the rains. The pigs escaped, but the bushfire rapidly reached the

man's tree. He had no chance of escaping as the flames licked him down from the branches.

A young rebel fighter in his early teens, bored like all of us, experimented to find out how slowly the bullet would come out of the barrel of a gun if you pulled the trigger very slowly. He carried out the experiment while gazing into the barrel with one eye. The bullet came out faster than he expected, and blew his head off.

In spite of my depression, I was determined to keep fit in readiness for all emergencies. I often practised running up and down the river and on the brink of the cliffs at night, in preparation for escape in case we were surprised by the enemy. Sometimes it was too dark to walk safely without stumbling into concealed traps, and I had to crawl on the ground to find my way back to our camp. I tried to memorise every part of the jungle, but often ended up in the wrong place. I also started to hear the hootings of an owl – the bird that I believed was destined to warn me of danger ever since at the behest of my grandmother I had released the one I had captured as a child – and the barking of a stag at night. My friends said these were bad omens, and tried to hunt the stag down. I had the presentiment that things could only get worse.

One humid evening, during a break in the rain, I was walking through the jungle to visit my sick friends in the clinic at the rebel headquarters. Just before I arrived I felt a sharp pain on my calf and saw a small, deadly poisonous green snake gliding away into the bushes. The elephant grass was quite high along this stretch of track, and I thought I had simply been scratched by a thorn. I did not even examine my leg, and carried on walking.

As I arrived at the hospital I felt dizzy, and told a nurse what had happened. She examined my leg and found two small holes, the sign of snake fangs. Immediately she borrowed a clean double-edged razor from the adjoining house and tied a rope around my calf above the wound. She heated the blade with a candle-flame, cut the wound crosswise and squeezed out blood. It was a dark, claret colour. As I grimaced in agony she held my foot with both of her hands, as though it were a giant chicken drumstick ready to be eaten. She deftly sucked the wound, drew the poisoned blood into her mouth and spat it out until the colour of the blood changed to normal red. She doused the wound with iodised cotton wool and dressed it with a not-so-clean puttee or bandage. I reflected on the fact that I had been bitten as I

neared the hospital, and that the venom was taking effect just as I arrived. I remembered Hamlet's words that there is 'a special providence in the fall of a sparrow'. I had to value my extraordinary luck, and felt rebuked for my despair.

Another letter from Dr Casey arrived from England. It began in a way that puzzled me. He asked me to send him a complete account of my school education and of all my examination results at Mandalay University. He said he knew I had no papers, but that my word of honour would be accepted. It seemed that the letter was leading up to something important, and when I reached that point I was astonished: his Cambridge college, Caius, was prepared to offer me a place to study ('read' was the word he used) English literature. He cautioned me that he was still lobbying his friends to raise the necessary funds to support my studies, that I would have to spend a preliminary year or two in England improving my English, and that I would somehow have to be got out of Burma and admitted to England.

I was unable to take in this sudden possible change in my fortunes. I still had no idea where Cambridge University and its colleges were. I thought Cambridge was somewhere in London. I could not be sure how serious the offer was, or how I could possibly be transported from the jungle to a country that I knew about only from a few works of literature and the curious anecdotes of my grandmother. But suddenly there was a glimmer of hope. For a delirious hour I danced alone in the Burmese jungle with my M16.

Immediately, though, I felt plunged into a dilemma. Even if I were allowed to study in England, would it be right to go? What would my friends feel, whom I would be abandoning, and who would never have such a chance or such luck? How would I survive in a foreign country without my friends? Our comradeship had been so close and intense that to leave them seemed a dreadful prospect, a sort of death. But did I really want to turn down the chance, and stay and rot – or be killed – in the jungle? Again, what was special about me? Did what was going to happen to my life depend simply upon a chance encounter in a Chinese restaurant in Mandalay?

I asked myself these questions over and over again, and determined to subdue my excitement so as not to cause offence to my friends, an offence which would come from letting them down in a way that was tantamount to betrayal. After much thought, however, I did tell my

closest comrades, and discussed the possible future with them. I was moved by their generosity of spirit, by their unselfish enthusiasm. Dee Dee and two or three other friends from Loikaw were understanding. They told me I must seize the opportunity, but urged me never to forget them and their struggle in the place I would be going to.

Edward Byan, though, was troubled. 'You will forget us Padaung, you will forget our language when you are with foreigners. You will forget us altogether.'

'Why should I?'

'When you have become educated, and are living among foreigners, you will think your people are primitive. You will try to forget them. And we need people like you to be with us here, to help us here.'

I insisted that I was not going away for ever, that I would return and help my people. He was not persuaded: 'You say that now. But once you settle down in the soft Western world, you might not even want to visit us. You will just think about your own career. You will forget us altogether.'

I was silent for a long time, pondering the undoubted truth in what he was saying. There was a terrible egoism in my leaving them. We had gone into the jungle together, faced disease and death, and intended to stay together until the end, whatever that might be. Yet now I was thinking of leaving them, perhaps to be killed, while I took an opportunity that had come about purely through luck. Surely, though, I had a right to do what I wanted to do and what I thought right for me. That was one of the things we were fighting for. If I did not take the chance, it would be gone for ever. I might be killed, which would be useless. From afar I might be able to do more to help my people and friends than I could by staying with them hopelessly in the jungle. I knew I would be back. I knew also that I was making a sacrifice by leaving my beloved friends.

I found it hard to say all these things, because I was not sure what the truth was. Finally I said to Edward: 'I will be able to let people outside know what is happening to us. If I get an education I will be able to write about it in a way that will move people.'

But I felt guilty and confused, and unable to decide. He only said: 'Do whatever you like as long as you know who you are.' We did not mention the subject again. I do not know whether I swayed him. I never shall.

Talking to the Enemy

The Attacks on the Headquarters

As the enemy advanced ever closer to the rebel headquarters, the villagers began evacuating their houses. The patients, along with medicines and supplies from Hwe Zedi camp, were evacuated across the border into Thailand. It was late June of 1989. The monsoon was at its height, the rain falling with such intensity that it seemed to be searching for something precious in the earth. I scouted around the houses of the villagers, built so as to be hardly detectable from a distance, and now apparently deserted.

In one hut, a woman was still sitting in the kitchen comforting her three crying children, one of whom was feeding at her breast. She could speak Burmese, so we were able to communicate. I asked her why she remained. It turned out that she was unable to move her children or her possessions because her husband was absent. He had gone to fight on the front line some months earlier, and had not returned. She had scarcely the means to feed her children, and the youngest two had dysentery and malaria. I hired a power boat and sent the whole family to the hospital at Maehongson, across the border in Thailand, using $50 that Dr Casey had sent from England. After two weeks they moved into a refugee camp at a place called Hwepuke in Thailand. Shortly afterwards the father returned from the front. Only then did I realise that I had helped a whole family survive.

The rebels were eagerly anticipating the attack on their headquarters by the Burmese army, as though it were a festival or an extremely important football match on home ground. Even the children of the refugees were playing war games among the trees and along the bank of the river Pai. The whole area of the HQ was in a state of agitated

expectancy, with people scurrying about just as they would on a market day. They chose their strategic points carefully, laying artillery, heavy guns and landmines on every path by which the enemy might enter. The progress of their expected guests was regularly reported. Some civilian porters who had escaped the Burmese military were debriefed. They provided information about the enemy's strength, morale and movements that, although sketchy, was crucial. Some of these porters were so emaciated that they seemed hardly to be covered by their skin – they looked like walking skeletons with leather veils on. The wounds on their bodies, caused by repeated beatings and by their skin being lacerated by the metal fetters, were infested with flies and maggots, so that they smelled like corpses. Even old men and pregnant women were forced to be military porters.

The orgy of killing started on a blazing evening.

The distant sound of artillery, which caused small waves in puddles on the monsoon-soaked ground – as the tread of the Tyrannosaurus Rex in *Jurassic Park* causes ripples in a tumbler of water – announced the approach of the Burmese forces. Regular rounds from anti-aircraft guns followed the thunderous explosions of mines and shells, the effect making me think of bass-drums and kettle-drums in a brass band. As usual, in the face of the terrific barrage there was for a while no return of fire from the rebels. Encouraged by this lack of response from their enemy, the Burmese charged precipitately towards the rebel head-quarters, shouting their usual battle-challenges and firing all the while in a frenzy of excitement. 'Come out of your hiding-holes, you slugs-to-be.' The rebels waited for the enemy to be close enough to be picked off individually.

The incessant sounds of Burmese army assault rifles drew ever nearer. (The carbines made a popping sound, whereas the sound of the G3s and G4s was like a rapid drumbeat that seemed to strike your heart more heavily.) But before we saw the soldiers themselves, something horrible occurred. People who were obviously civilians began emerging from the jungle into the clearing in which the head-quarters stood. They came out in pairs, chained together and clearly in a state of abject terror. They were civilian porters, kidnapped like the others we had seen and forced to carry munitions and walk ahead of the troops through minefields. Behind them was the uproar of the Burmese soldiers, barking orders at them to advance quickly. There

were puffs of dust as the bullets of the soldiers followed close at the porters' heels. They were forced to move quickly across the no-man's land, sown with mines, towards the rebel headquarters. The first pair stumbled onto a landmine. There was a huge explosion, the dull boom of which echoed through the jungle, some shrieks, instantly cut short, and the severed body parts – hands, eyes, legs – of the sacrificial victims flew instantly into the air mingled with a cloud of dust. But the chain that bound them was unbroken, so their trunks collapsed onto the ground with a hollow thud, while arms, feet and fingers were scattered among the bushes.

The remaining porters shrank back instinctively. More bullets followed at their heels, but they now refused to budge. A barrage of abuse was aimed at them from behind, along with bursts of gunfire. The porters collapsed onto the ground screaming with pain, and within seconds they were all dead. Anger and violence are very swift-footed. I trembled uncontrollably, my legs knocking together like a pair of bamboo clappers.

One young Burmese rushed forward shouting, 'I am Rambo!' A rebel took aim and fired a single shot. 'Rambo's' head burst open, and he collapsed among the brambles with a cry of pain. Then the bullets of the enemy reached our position. We ducked and ran.

At a position further back from the front line, the man who commanded the rebels' guns – Browning semi-automatics – had settled to his task with apparent enjoyment. He took aim with calm deliberation, as though he were playing golf or shooting clay-pigeons. After each round had been fired off he would fall to chewing betel nuts in a leisurely way and muttering to himself incessantly, 'Aye, aye, aye!' to the dragging sound of his weapon. He kept up a running commentary on his own performance: 'Missed that one' (as a Burmese soldier escaped with his life), 'Try again. Here's another. See what we can do.' A soldier would charge directly at his position, the Browning would fire its two or three bullets, there would be a pause, then the next three were fired. 'Well, I got that one fair and square,' the gunner would say as the man dropped dead almost at his feet. Then he would coolly search for his next victim. He soon became a target for intense and sustained enemy fire. His response was to ask one of the rebels to 'solve' the problem for him: 'Could you be so kind as to take out that position for me? They are being pretty irritating.' The fighter 'solved the problem' by blasting the enemy's position with an anti-tank

launcher. Silence ensued. Honour preserved, the rebels retreated to a safer position.

I do not think that these exceptional fighters, these men who coolly and scientifically searched out their enemy targets, were addicted to war exactly, or possessed by bloodlust or machismo. It was more like a pride in craftsmanship, along with a refusal to appear intimidated by a much stronger enemy.

At one point in the fighting a mortar shell landed about ten feet behind our position, but luckily failed to explode. No sooner had we sighed with relief at our escape from such excellent targeting than one of our own side ran up. 'Sorry, boys. The fuse didn't seem to work. I'll try and launch it again.' It turned out that the mortar that came closest to killing us had been launched from our own side, but only managed to make it to near our front line. It dated back to the Second World War, so we should not have been surprised. At the second attempt it landed on target. But we got back at least twenty mortars in reply from the enemy. Again we retreated to a safer position. Because our aim was better than that of the Burmese, their casualties were very heavy. But still they came on. Hardly any of our own casualties were from enemy fire, but from explosions and misfires of our weaponry.

During a lull in the fighting we inspected several enemy bodies. The sight of one of them shocked me. In 1987 a friend had invited me and some fellow students to visit him in Maymyo, a quiet and beautiful town situated three and a half thousand feet above sea level, and about forty miles east of Mandalay. It had been a hill station for British officers during the colonial period, a place to which the commander-in-chief and his staff would retreat to escape the searing heat of Central Burma during the hot season. The town looked like an English south coast town during the cold season, but a bit more Mediterranean during the hot season with its avenues of eucalyptus trees and bougainvillaea-covered walls and arbours. It enjoyed regular rainfall and cool weather throughout the year.

We visited the botanical gardens and their waterfalls, the Kandycraig Hotel, which boasted a cricket pitch – very rare in Burma – and the Chinese temple where there was a zoo full of obscene monkeys in small cages (someone had taught them to masturbate when they were being watched by women). The town is nothing much in itself, but with the Purcell clock tower at its centre it has the strange character

of a perfectly preserved relic of colonial times, a virtually British town in the middle of Burma.

Maymyo was the British garrison town from the 1880s up until the Second World War. It was occupied by the Japanese when they invaded in 1942, after the fall of Singapore, and is now a large military cantonment of the Burmese army. One of our friends, a classmate of mine in Phekhon, had gone to the Maymyo Military Academy to be trained as an army officer. He was a naive, idealistic young man for whom service in the army was a fulfilment of chivalrous, patriotic and unrealistic dreams. He it was who had invited us to Maymyo. At the time we were proud of him and of his achievement in getting into the military academy. We admired his smart uniform, his upright bearing. We looked up to him as an officer more than we would have done had he been a doctor. That was the normal attitude then. It never occurred to us or to him that his army life would not consist of a series of smooth promotions, parades and desultory engagements against ethnic insurgents, that most of his class would soon be fighting their fellow countrymen – including their relatives and friends – on the Burmese borders, and that half of them would be casualties. Nor did he know that it was only the sons of high-ranking officers who would get serious promotion, away from danger. None of that crossed our minds.

When he joined the army he had asked us to pray for him, which we did, for he was a good friend and a good man. Our prayers availed him nothing, for here he was now, stretched before me, with one clean bullet-wound in his head.

An Interlude

We moved to another mountaintop as the enemy continued gradually to seize our positions. We bugged their communications line and eavesdropped on their conversations. They were exchanging angry words and insults, mixed with ritual banter, regiment to regiment.

'Come in, Nagah (dragon). Galon's [Garuda, a creature of Burmese mythology, half man and half bird] speaking. Come in, Nagah. Where the hell are you? Still raping the women and burning the villages? Could you leave that off for a bit and come in? Are you there, rapists? Over.'

'Nagah speaking. We're doing our fucking best, motherfuckers!'

'You cripples! You can't even hobble up to attack their positions. Stop malingering! Stop playing truant! We're under heavy attack by the red ants!' Come and help us. Over.'

'How can we help? We're under attack as well! Over.'

'What do you mean "under attack"? There are no red ants in your area. You're lying. You're just lounging in the jungle wanking yourselves.'

More accusations and denials followed. Then we heard a loud explosion in 'Nagah's' area.

'Bloody hell! Did you do that? Did you bombard us, Galon?'

'Yes, we did. Move your arse.'

'I'll kill you for that, you food for maggots. When this is over, I'll get you. You're dead!'

Then 'Galon's' radio was switched off. It was time for us to join in the conversation. I began: 'Hello, rapists. Over.'

'What the hell? Who is that?'

'It's us – the red ants, the enemy.'

'You slugs-to-be – go to hell. How the hell did you get our line?'

'Calm down, father-in-law. Your machine's pretty ancient, isn't it?'

'Certainly is – we never get new ones.'

'I've an idea. Why not ask your father, Ne Win, for a new one? He could surely afford it, what with all the rubies he's smuggled into his account in Switzerland.'

'Sod off! He's not my father.'

'That's pretty disloyal of you. He'd be upset to hear you talking like that. He's always saying he's your father.'

'Fuck off! He is not. How many times do I have to tell you he's not my father?'

'So you don't love the old man any more? I'm really shocked. By the way, how many men have you got?'

'Do you think I'm going to tell you that? Morons!'

'And how many civilian porters?'

'They're all volunteers, all volunteers. It's a lie to say we kidnap them.'

'Well, you said it. Pretty impressive that they volunteer to wear chains, volunteer to walk through the minefields, volunteer to be blown to bits. The Burmese like getting killed, then?'

'Shut up. What does it matter?'

'Are you really going to seize our headquarters?'

'We certainly are. You too. Dead or alive. But I expect you're all already half-dead with fright.'

'Try if you can.'

'How old are you?'

'Only twenty.'

'You are still young, my son.'

'I know. And you?'

'Old enough to be your father.'

'Daddy! Ah! If only you were my father. How happy I would be to have a rapist daddy – the son of Ne Win, too!'

'Bastard!'

'Why are you trying to kill us?'

'Orders. And it's my duty.'

'I bet you enjoy your duty – you know, all that mowing down monks, women, unarmed students. You must feel pretty good after that, I suppose? After all, what could be more satisfying than murdering your own children?'

'My soldiers were not involved in that.'

'It's the same army, you are all in it together, all you are doing is protecting the murderers.'

'I'm not going to talk politics. I have a job. I have to feed my wife and family. Don't try to teach an old crocodile how to swim.'

'Talking of old crocodiles, how is your boss, your father? Still the benevolent ruler? Still ending the exploitation of man by man? Who is his new mistress?'

'Shut your mouth. I'm off to lunch.'

'What is your curry?'

'Bloody beans and beef. What's yours, you jungle bunnies?'

'Lentils with leaves and banana trunks.'

'A good meal for bunnies. Ha, ha, ha!'

'By the way, when are you going to start shooting at us again?'

'Afraid to die then, are you? Two o'clock. Watch out!'

He switched off his machine, and we took a leisurely lunch by rebel standards, in the sense that we were confident enough actually to sit down to eat it. Afterwards we lay down behind our covers and smoked cheroots. Then the plopping and whistling sounds of flying shells, followed by explosions, started up again. Shells began landing all around our positions. I looked at my watch. It was two o'clock exactly.

That evening the enemy seized the Karenni headquarters, and we

retreated in good order. We took some casualties. One was a Muslim fighter who trod on his own landmine and was mortally wounded. He lost one leg and was hideously wounded in the other, lost an arm and an eye, and was bleeding heavily, but he could still crawl. He knew that his friends would not be able to carry him to safety because the enemy were too close behind. So he asked them to give him some water – wounded fighters always craved water before they died. He packed himself with grenades, lay feigning death, and waited until the Burmese came in his direction. Then he sat up and began lobbing the grenades. He killed five or six of the enemy before they could finish him off.

Our retreat continued. At one position we left some pariah dogs behind as we withdrew. The unfortunate creatures were tied to wooden posts hard by the fortified trenches and rice-bunkers. Over several nights we evacuated all our heavy guns, supplies and other equipment, because we knew it would be impossible to defend the hill for much longer. The dogs kept up their barking throughout each night. This deceived the enemy into thinking that we were digging in, so they waited three nights before storming the position. They even sent in some fighter planes to bombard it from the air. Then, yelling and firing, they charged up the hill, only to be greeted by the defenceless dogs. They killed them and ate them. We renamed the position 'Fighting Dogs Hill' in honour of the creatures that had provided us with a respite.

We settled for a while in a village called Hwayhai, just inside the borders of Thailand. We students were homeless again – a depressing thought. I tried to imagine what it must be like for the local people, whose houses were ransacked by Burmese incursions and their lands occupied. There were only a few villagers left – most of them had fled deeper into Thailand. Heavy downpours were turning the jungle paths into long mud-ponds, and the river Pai began to swell, making it more difficult for us to escape across it should there be an emergency. As the rains increased to an unending downpour, I began to feel very tired and unwell – the malaria was active again in my body. Then I suffered a full-blown malaria attack, as did some of my friends. Some of them couldn't even walk. My condition got worse, and I started to cough and vomit blood with dysentery. I had a bloody stool when I went to the loo.

Then something very astonishing happened. It seems that Dr Casey

had written an article in an English magazine, the *Spectator*, about his visit to Burma. It was called 'A Burmese Evening'. In the last part of it he described how he met me, and the time he spent with me and my friends at the University of Mandalay. It ended by quoting in full the letter I had sent him from the jungle. The article was broadcast on the BBC World Service.

I didn't hear about any of this, for I was lying in bed delirious with malaria. My friends, however, had listened to the broadcast, and were thrilled. They felt that the outside world knew about them, and this gave them hope. They did not realise that the broadcast could put us in danger because we would attract the special interest of a vengeful regime. In my delirium I wondered whether I would pull through this bout of malaria, go to England and study at Cambridge University. But in the state I was in, England and Cambridge were just phantasmagoric images.

3
RESCUE

CHAPTER 24

Defeat: Escape into Thailand

Defeat and Escape

'No guns allowed in Thailand,' the Thai border police told us when we arrived at the Burma–Thai border. We had been regularly crossing the border in ones and twos to buy medicine and food, but now the whole band of almost a hundred of us, our camp in Burma lost, was begging admittance. We knew we would be disarmed. We had become so used to our guns that we knew we would feel – and be – defenceless without them. It was no use protesting, however, and the border police anyway assured us that we would be safe in Thailand. Strangely enough, we felt relieved – as though the giving up of our weapons really did mean that the bitter fighting of the past ten months had come to an end. At the same time we felt uncomfortable, because of the resemblances we knew there were between the role of the army in Thailand and in Burma.

It turned out that we should have been more apprehensive, because before darkness fell the Thais withdrew silently and without letting us know from the border posts they were guarding, further back into Thailand. They did this because the Burmese had warned them not to defend the border. Furthermore the Thais and Burmese were accustomed to the border shifting back and forth, and the Thais were quite prepared to sacrifice a few refugees rather than defend this relatively uncertain line. I heard an owl hooting that night in a rather unusual way, but took no notice of it. As always, it was only later that I recalled the owl I had released at the urging of my grandmother and that I had adjured to help me in my day of trouble.

The fighting at the former rebel headquarters went on sporadically for the whole day, with the sounds of Burmese gunfire gradually

247

becoming more dominant as the afternoon wore on. In the evening the dogs began barking frantically from the Burmese border as we cooked supper in a house we had been allowed to occupy. Perhaps because we had been lulled into a feeling of safety by the Thais we took little notice of the dogs, and assumed that they were barking at wild animals, or at refugees like us. (We had noticed that Thai dogs quickly got a sense when people were armed; they never chased them, whereas they were in the habit of harassing unarmed people as though they knew there would be no comeback.)

Minutes later we saw uniformed soldiers emerging from the bushes and approaching our house. At first I assumed they were some of our friends the Karenni rebels, and paid them little attention. But then I remembered with a start that no rebels or refugees were allowed to carry weapons in Thailand. We were – stupidly – puzzled and slow to react. No sooner had we the time to think, let alone call out the word 'Enemy!', than they were upon us and aiming their guns at us. We could see their badges and the whites of eyes that stared hard at us in the gloom. They were unmistakably Burmese soldiers with the same type of uniforms and guns as the rebels. They shouted at us to 'freeze', but by then the feeling for self-preservation had finally asserted itself, and we knew that if we offered to surrender we would all be massacred. As soon as it was plain that we would not be killed without a struggle, the thudding sound of gunfire began. It rapidly intensified – they were certainly intending to kill us all. The bullets were flying around and penetrating the walls of the house.

We all jumped from the first-floor windows to the ground. The sick amongst us flew like frightened birds from their nests. As soon as we hit the ground, bullets flew above and around us. The German-made G2, G3 and G4 guns spat out bullets as large as those from anti-aircraft guns, and split house-posts in two. Without thinking I rolled myself round and round along the ground. My ghost seemed to abandon my body, which felt no pain as it struggled through the brambles and thorns. The more I rolled the more acutely aware I became of the whistling, buzzing sounds of the bullets flying around me as if in slow motion. They came first from one side and then, puzzlingly, from the opposite side. They were accompanied by more explosions from hand-held mortars and bazookas and from Burmese eight-millimetre field-guns. What was going on? Then I understood – we were caught in the crossfire of a fight between the Burmese army

and the Thai police. The bullets followed me like a swarm of hornets. I was certain this was my last day on earth, and cursed myself for trusting the assurances of the border police.

I closed my eyes and pretended to be rolling in a dream. Suddenly I plunged into the river Pai, which was in torrential spate. I held my breath and let myself be swept along, giving thanks that this was the monsoon season. Luckily, the river was murky and filled with debris. I found myself caught in the reeds along the riverbank, and lifted my head above the surface. A decomposing corpse swept past me, its stink mingling with that of other rotting things in the river. I was not far from the shooting, shouting and cursing. My body and soul came back together again. Soaking wet and shivering uncontrollably, I crawled ashore. I began to feel a pain in my body. Sitting on my haunches behind some trees I saw the Burmese soldiers retreat back into Burma.

I was so frightened that I didn't realise what had happened to me. As I sat on a log I saw blood trickling slowly between my thighs. I hoped no vital part of my body had been hit. There were grazes on my skin, and two small bullet wounds – one on my right foot, the other on the left thigh. I found some antiseptic leaves in a bush, crushed them and pressed them onto my wounds. I was not bleeding badly, and crept off to dry myself in the sun, longing for a cheroot. Whether it was my guardian angel or my ancestors who protected me, I do not know.

As the Burmese retreated, one of their officers covered for some of his men. When they had reached safety he stopped firing and followed them. As he turned around, Thai bullets hit him in the back and he collapsed onto the ground. The bullets kept raining on his dead body. When there were no more bullets coming from the opposing side the Thai soldiers broke cover and surrounded the corpse, for all the world like a pack of wild dogs approaching a carcass. They pointed their guns at it and poked it with a long bamboo pole, all the while crouching cautiously on the ground. When they had convinced themselves that there was no danger in the corpse, they all jumped up and cheered as though they had just won a war.

I stayed in the jungle for a couple of days on my own before I was reunited with my friends. Astonishingly, none of them had been killed. It turned out later that a Burmese officer, having heard the BBC broadcast of Dr Casey's *Spectator* article, had infiltrated the students and informed his superiors where we were hiding. He had then slipped

back into Burma to rejoin his regiment. The broadcast had made me a special target.

More Thai reinforcements – we were told they were commandos – arrived at the border, because they were expecting some act of retaliation from the Burmese. They had been air-lifted from their bases, and turned up at the front line with duvets, gas-cookers, portable showers, tents, hammocks – all of which were, to the Burmese army as well as us, unimagined luxuries. As they moved among the civilians they looked and acted the part of impressively tough soldiers. They rode to the area of the fighting on mopeds. At the border it was necessary for them to climb a steep and slippery hill, called locally 'the Hill of Hell', in order to see the positions of the enemy on the other side of the border. They began the scramble up the slope with the enthusiasm of Boy Scouts on an Outward Bound test, full of high spirits. The euphoria kept up until they reached the halfway point, by which time they were breathless. It normally took half an hour for a local villager to reach that point, but it took the commandos about an hour. They came rapidly to the decision to turn back, get drunk and never face their enemy. I found myself in the very strange – even shocking – position of admiring the fighting spirit of the Burmese army.

More Thai soldiers arrived at the border. They all lined up on a mountaintop and pointed their guns towards Burma. Sure enough, explosions of mortar shells announced the return of the Burmese to Thailand. Suddenly, three Burmese soldiers emerged and charged up the slope with maniacal determination. The Thai soldiers, astonished, sprayed them with rounds of bullets and showered them with mortar shells. Still the 'dauntless three' came on, although it was clear that they were doomed. They were simply cut to pieces under the hail of bullets and shells. Then both sides retreated.

When it was all over I walked up to the field of battle. One of the Burmese soldiers was lying on his face. Curious, and with a feeling of presentiment, I turned him over. It was the very same army officer who had told me in the restaurant in Mandalay that I was worth only one bullet. 'Surely,' I thought, with a cruel and exultant sense that justice had been done, 'he was worth a lot of bullets.' Then I looked down at his puckered face, and all I could feel was pity at the waste of it. After all, he had been courageous. I could not sum up his worth by the number of bullets needed to kill him.

* * *

My wounds healed completely in a few weeks. After the attack I had descended into depression and listlessness, largely because we now had no clear aim, and were beset with uncertainty. We set ourselves to rebuild the homes that had been destroyed in the fighting on both sides of the border. This seemed depressingly to symbolise the futility of our whole struggle – something we had not felt before even in the most dangerous of times.

An unaccustomed gloom settled on all of us. Immediately after my escape, in the few days I had spent in the jungle before being reunited with my friends, I had started to learn how to survive on my own, and without the hope that had sustained me up to now. There seemed little to hope for. Students were scattered everywhere in the jungle, most of them ill and dejected, chain-smoking cheroots, sitting and lying in their huts as if they were awaiting something astounding and miraculous – like (say) an unexpected visit by the Pope. Motivating them seemed an impossible task.

Life went on. One student, Valentino, got cerebral malaria, the sign of which was that he foamed at the mouth like a dog with rabies. We took him to the hospital organised by the Thai royal family in Maehongson. He had to be tied to the bed to prevent him injuring himself in his delirium. When he recovered he wanted to return home to Burma. We persuaded him that it would not yet be safe to go back.

Another student was also taken to hospital with cerebral malaria. We went to visit him one day, only to find he had vanished. He had simply walked out of the hospital, unnoticed by anyone. We suspected that he had secretly returned to Burma, but were afraid he might have been kidnapped by agents of the regime. We had given up hope of finding him when, three or four weeks later, he walked into the camp fit and well.

It turned out that he had been discharged from hospital, probably still hallucinating from the anti-malarial drugs he had been given, and was arrested by the Thai police for having no papers and being unable to speak Thai. They put him in jail, hoping that someone would come and bail him. But no one turned up. His jailer was a sympathetic man, and the student happened to have a skill much prized in Thailand – he was an excellent masseur. So every evening he gave his jailer a thorough and expert massage, and the jailer in return brought him clothes, fed him, taught him Thai, and even gave him pocket money.

When he was due to be released he was reluctant to leave his cell for the uncertainties of life in the jungle.

Everything that was happening to us now seemed the result of random chance. The monsoon gradually retreated. To keep mentally steady I read as much as possible. Most of my books and papers had been destroyed by the Burmese soldiers when they raided and destroyed our camp, but Dr Casey sent me some more books, including *The Imitation of Christ* by Thomas à Kempis, *Heart of Darkness*, *Youth* and *The End of the Tether* by Joseph Conrad. He also sent me letters. In one of them he asked me some questions the point of which I could not understand – such as whether I had committed any crimes in Burma. I simply replied I had not. I also described in detail the situation in the camp.

During these listless days we just listened to the radio, vaguely hoping to hear good news – but the good news never came. Rather, things grew worse. On the day before Martyrs' Day, 18 July – which commemorates the massacre of Aung San and his cabinet in 1947 – we heard the announcement that the SLORC had placed his daughter, Aung San Suu Kyi, under house arrest. We knew then that it would be a long, long time before we could safely see our country and our families again. Perhaps we already knew this, but for it to become starkly obvious lowered our morale in a way we could not have predicted.

By now, only the most mentally and physically tough of the students remained capable of surviving the trial by ordeal of life in the jungle. But physical toughness was no defence against malaria, and our mental strength was severely tested as objective grounds for optimism suddenly evaporated. Pressure was mounting on us to give up the struggle. Our parents were being persuaded to entice us back to Burma; the regime promised that we errant, or misled, students would be welcomed back to the motherland with no fear of reprisals; and the army meanwhile kept up a campaign of sudden, brutally violent attacks. In one of them the soldiers got hold of my diary, *The Imitation of Christ* and *The New Oxford Book of English Verse*. I cannot imagine what they made of the books. I began reading one of the few books I had left – *Portrait of a Lady* by Henry James. It did not seem at all strange to me to be reading that in our mosquito-infested jungle camp, steaming in the post-monsoon heat. I did find it difficult, and the world it describes was supremely exotic to me – but I was captivated by it. At

the very least, it expanded my English vocabulary. The pocket diction-ary Dr Casey had sent me had been lost during an earlier attack. Learning new words was as good as saving new bullets, or making new friends.

Valentino came out of hospital. He had been a small man before his illness, and now he was even smaller. The malaria had ravaged him, and his health and humour had gone. He sat for long hours playing the guitar and singing sad songs about home. Eventually he could hold out no longer and went back to Burma, only to be murdered by soldiers two years later, along with several friends of his. They were shot in their beds while asleep. Somehow Valentino escaped, with a gaping wound in his stomach and his guts hanging out. He managed to get home to his mother, and told her that it had been a mistake to return to Burma. He then disappeared into the jungle, and was never seen again.

The two girls cried most evenings, and talked about home, their lovers, their marriages and their blighted prospects in life. Yet they were determined not to return before the struggle was won. The vil-lagers' patience seemed infinite. They rebuilt their destroyed school and houses, and asked us to volunteer to teach. It was almost impossible to persuade the children to study, for they were obsessed with the fighting that had erupted into their lives. We never forgot how close the Bur-mese forces were, and that a brutal incursion might happen at any time. Occasionally they attacked villages in Thailand, to put pressure on the Thai government to push the refugees back over the border into Burma.

Almost every day there were skirmishes along the border. We con-tinued to find corpses. One was of a young girl, in a wood near a Thai village. She had been separated from her family in the chaos of the flight from the Burmese soldiers during one of their incursions. There was evidence enough on her body to show she had been raped before she was murdered. The Thai police refused to make any enquiries about her death, on the grounds that she was not a Thai citizen.

Around that time – August 1989 – I had a disturbing dream. I was being pursued by a pack of ravenous wild animals in the jungle. As I ran with the speed of desperation, they were at my heels slavering and growling. I ran for a time that seemed endless, until I came to the river Pai, the waters of which were flowing torrentially, seething and

boiling with the monsoon rains. Two strangers appeared on the opposite bank. They beckoned to me to jump into the river and swim across. As I hesitated, the pursuing creatures were about to leap on me. I jumped into the river, and swam with all my strength while the waters threatened to rise above my head. But I was unable to get across, and the current swept me downstream and beached me right near the Burmese army camp. I awoke in great anxiety.

That very same day I received some letters from Dr Casey. I had written to him describing the situation in the camp, but had had no reply for some time. In fact, because of the chaos as our camps were overrun, several of his letters had been lying at our secret address in Thailand, undelivered. In the letter with the latest date, he wrote that he was coming to see me in Thailand. Because the letter had been delayed, he would be arriving only a day or two after I had received it.

In his letter Dr Casey gave me the address and telephone number of a friend of his in Bangkok, and asked me where we could safely meet in Thailand. All I could think of was the house of Mr Somsak, which was situated in some paddy fields outside Maehongson. I wrote to Dr Casey at the Bangkok address, enclosing a map I had drawn of Mr Somsak's hut, indicating that it was in some paddy fields and near a temple. To pinpoint it more precisely, I wrote that it could not be missed since it had 'a bench in front under a tamarind and a plum tree'. This was not very useful advice, for there are hundreds, if not thousands, of tamarind and plum trees around Maehongson.

A few days later, towards the end of August, I walked through the jungle for eight hours to Maehongson to telephone Dr Casey at his friend's Bangkok number. By chance he had arrived in Bangkok that very day, and when my call came he was just about to go out. I didn't understand all he said, although he spoke slowly. He asked if I would call him again next day, because he was not sure what his plans were. 'Yes,' I said, without hesitation. I then walked back through the jungle to the camp. The next day I walked up to town again, and talked to Dr Casey. It was arranged that we would meet either at Mr Somsak's house outside Maehongson, or at the Bayoke Chalet Hotel, a sleazy place right in the middle of town.

I was not sure whether I would be able to meet him before being arrested, for the Thai police had begun forcibly returning refugees back over the Burmese border. And I couldn't remember exactly what

he looked like. I was full of anxiety that we might miss each other, and that all his efforts to come and meet me would have been in vain. I realised I felt guilty that he had made this effort to come, convinced by the letters I had sent him of the danger I had been in. I had no idea what I would say to him, and felt both confused and excited. I told Mr Somsak and a few other close friends that a white friend of mine was coming to visit me, but I didn't tell them who he was or why he was coming, for reasons of security.

That same day, in the marketplace, I chanced to meet a merchant from my home town. If I was surprised, he was amazed – even, for a moment, frightened. He had believed I was dead. He said: 'The soldiers told everyone that they shot you dead near the border. We all believed them. The parish priest even said a Requiem Mass for you and for all the other dead students.'

I wrote a short letter to my parents, and asked him to deliver it into their hands. In it I told them not to worry, that I was alive, not suffering from malaria, and that they should try not to grieve even though we could not know when we would meet again.

I also asked them to call back my *Yaula* butterfly from the world of the dead.

CHAPTER 25

The Rescue

Waiting for the Rescue

Saying goodbye to my friends was the most difficult thing for me. So I never said goodbye, nor did I tell them what I was about to do. When it was time for me to leave, I just packed up my few possessions and left the camp without letting them know of my departure. Just before I left, I threw some coins into the river. It was about three o'clock. The sun was still hanging in the sky over Burma, blurred by the monsoon vapours. The blue ranges of the mountains were massive walls separating me from my family. As I reached the top of the hill I looked back at the shabby camp in the valley. I was tempted to go back to say goodbye to my friends, but I knew that if I saw them again I would not be able to leave. I was not sure what exactly I was going to do, but just followed my instinct. I left my faithful Zhivago with a Karenni family. He looked miserable – as if he knew he would become a meal sooner or later after I left. 'We will only eat him when he gets old,' said the father.

I walked up to Thailand along the river Pai which flows back into Burma, giving my back to the setting sun. Everything seemed to be against me. The sun, the river, the wind were all travelling against my journey – everything except the impending darkness of the night. On the way, near a leper colony, I was chased by a pack of dogs. I found myself thinking that the dogs of lepers looked like their owners, with blunted paws and noses. I picked up a couple of stones, and they left off chasing me. After walking for five hours through the jungle, I was able to hire a bicycle. An hour later I could see the lights of Maehongson. I glanced back: the jungle and the mountains had disappeared completely under the blanket of darkness topped with a blue-black

256

sky strewn with stars. My imagination was running wild, and I felt myself suspended as in a trance between the grim past and a future that had no features I could discern.

I was thinking what I would say to Dr Casey when I met him. Would I tell him about all that had happened in the jungle, about my state of body and mind, about the friends I was leaving and those who had been lost to the enemy? I could not imagine what real connection he or I could make between that world and the world he came from. So consumed with uncertainty was I that the only idea I could dimly grasp was that there might still be some hope. My body and legs were aching from lack of sleep and too much walking, and my stomach rumbled thunderously with hunger. I hadn't eaten for days from excitement and anxiety. As I approached Maehongson I could see its lights projecting upward, blurring the lights of the stars. As usual, the town welcomed me with apathy and suspicion, but now I didn't care.

First, I returned my bicycle to the organisation from which I had hired it – the Pa-o rebels – and went to see Mr Somsak. He offered me supper, but I was too excited to eat. I told him that a friend, a white man, might be coming to his house, that I had told him he could find it by looking for a hut with a bench under a plum and a tamarind tree. He seemed embarrassed, and I realised that he felt ashamed of receiving a foreigner in his shabby house. I borrowed his bike and went to the Bayoke Chalet Hotel in search of my guest. The girl at the counter adamantly told me that there was no 'farang' guest in her hotel. When I asked if I might look for him in the bar she sharply refused. I suppose a half-starved Burmese from the jungle intruding into the bar would have seemed like Banquo's ghost. It was no use arguing, because if I got into trouble with the Thai police it would have been a disaster.

I rode off to another friend's house, but he said that no one had been to see me there either. My hopes began to slip away. I didn't give up, but kept on riding round the town visiting the night market and guest houses in case I might recognise someone who looked like Dr Casey. Most of the tourists I saw were backpackers, scruffy and in shorts. None of them could be him. I circled the town two or three more times. It was about nine o'clock. The police were watching me, puzzled, perhaps suspicious: no one went bike riding round and round town at that time of night. They began following me on their motor-bikes, but didn't stop me.

I went back to Mr Somsak's house in despair. I had just about given up any hope of meeting Dr Casey as I approached the house when, in the dark, I saw the silhouettes of some people standing by the roadside near a jeep against the blue starry sky. I had a moment of panic – were these the Thai police coming to arrest me after my suspicious behaviour? I was about to flee when I saw that one of them was Mr Somsak, who turned his head to me and smiled. Relieved, but still nervous, I approached him.

'Ah, here is Mr Khunsa,' he said to his companions, who turned and smiled at me. One of them was a tall, stocky white man. For some reason it struck me that he might be an American marine. He said, 'Hello, Khunsa.' Then, just as I was dismounting from my bike, he took the handlebars with a firm grip: 'Pascal Khoo Thwe, I presume. I'm Jim – I am here to take you to Dr Casey.'

It turned out that when Dr Casey was in Chiangmai on his way up to Maehongson, trying to work out how to contact me, he spoke to an Anglo-Shan woman who used to bring food and medicines to our camp. She told him of my nickname, 'Khunsa', and he mentioned it to Jim, who was working on community projects in a Karen village in the hills above Chiangmai. Mr Somsak had never known me by my real name, or else had long forgotten it, and when Jim and his assistant Chompoon had arrived at his house, he insisted that he had never met a 'Pascal Khoo Thwe'. They were on the point of deciding they had come to the wrong place when Chompoon remembered, and asked after 'Khunsa'.

Jim went on to tell me that Dr Casey was waiting for me at the hotel, and that we would probably have to travel tonight. He said it was not safe for us here, so I was to go to the hotel lobby and wait for them. (In fact Dr Casey had been in the hotel dining room when I asked for him there, drinking many cups of coffee and reading St Augustine's *City of God*.) They would join me in half an hour. My reaction was one of incredulous joy, mixed with disappointment that I was not going to see Dr Casey straight away. Only then did it dawn on me that they were on a rescue mission.

Jim introduced me to Chompoon, who was a Thai Karen and a fluent English-speaker. I felt strangely disturbed by the fact that Chompoon could not speak Burmese, nor I Karen. All my life I had mixed with Karens, many of them my relatives, who could converse in Burmese, and the fact that Chompoon could not gave me a sudden sense of leaving behind the world I knew.

I thanked Mr Somsak, returned his bicycle to him, embraced him and bade him farewell. I began walking to the hotel through the dimly lit streets, once again gripped with overwhelming anxiety. I had no idea what I would do if the police arrested me. Equally I had no idea whether what I was now doing was right – in fact I had no clear sense *what* I was doing, what had been planned, where we were going.

The hotel lobby was full of men reading newspapers. They were wearing dark glasses and a lot of gold jewellery. They made me uneasy as they kept peeping out from behind their newspapers like nervously alert porcupines. They were spies and informants – men belonging to the private army of Khunsa, the opium warlord, to the Burmese Military Intelligence, the Chinese Communist army, the Thai intelligence or the Kuomintang. I suddenly felt that trying to sit inconspicuously among such people was the sheerest folly, and after a few minutes I had almost forgotten what I had come for and was simply trying to calculate how I could get out of the hotel without betraying myself, and in one piece.

Before long Chompoon appeared, and quietly ushered me out of the room like a nurse taking charge of a patient. He took me to a dark corner of the street where he had parked the jeep, and asked me to stay put until the others joined us, so as to avoid the suspicions of the police. As I sat in the dark in frozen anxiety, the sound of the police motorcycles in the sultry monsoon air grated on my ears like chainsaws. In my frenzy of impatience and excitement my heartbeat raced up and down, and I was sweating as profusely as I had ever done under fire in the jungle. I kept control of myself by thinking of one thing only – escape. At the first sign of trouble I would take to my heels.

Dr Casey and Jim joined us at about eleven o'clock. I recognised Dr Casey immediately, because 'Sir James Bond' never seemed to change his outfit wherever he was. His white summer suit was impeccably untouched by dust, and his panama hat was in his hand. I struggled to express what I felt, but without success – my poor command of English, my sense of incredulity at what was happening, a mixture of fear and anticipation, rendered me speechless. So we just shook hands.

Dr Casey was as nervous as I was. He spent a few minutes asking me some curiously indirect questions about what had become of my friends whom he had met in Mandalay, about that evening in the

university, about what had happened to me in the jungle. I was puzzled. The truth was that he had to make sure I really was the Pascal he had met a year ago in Mandalay, since he couldn't actually remember (as he told me later in some embarrassment) what I looked like. Then he seemed to relax, and we set off. They told me we were going to stay the night in a small town. This turned out to be Maesariang, a border town on the ancient route from Cambodia to Central Burma and to Chiangmai. The journey to Maesariang was hazardous, along a winding, mountainous dirt track, with much erosion and a danger of slipping off in a number of places, but it was a starry night as we travelled along the Burmese border to the south-west.

We arrived at Maesariang well after midnight. All the restaurants had closed, and I had eaten nothing at all that day. Jim decided we should all have a drink before going to bed. We drank whisky in my room. Jim became expansive and delivered me a long, fatherly lecture on how I should survive at Cambridge University. I was very hungry and tired, but I managed to nod politely at all he said, although I found his accent difficult to understand, and anyway hadn't the faintest idea what he was talking about.

Jim helped himself to more whisky, and got into his subject: 'Cambridge is not like any other town in England, not to say the world. It is more or less a medieval town. Do you know what "medieval" means? You are not to spend all your time studying. You have got to make friends – that is the most important thing. You have to learn to be an educated English gentleman. Don't be shy and overawed. Just enjoy the life there.' So he went on, with growing eloquence.

Dr Casey had hired Jim to come and rescue me. Jim was from Northern Ireland, and was a former member of the SAS. He had served with the British army in Northern Ireland, and on our journey had told a thrilling story about a gun battle with the IRA amongst the tombstones of a cemetery. That established a bond between us. Jim was an Oxford man, and he and Dr Casey soon launched into an animated discussion of the merits of Oxford versus Cambridge. I tried to listen to what they were saying in order to keep myself awake. I could understand hardly any of it, but at the same time, even in my exhaustion, I felt pleased that they were already talking perfectly naturally in front of me as though I were an old friend and an equal. I was also fascinated by the way they seemed to forget where we were in the pleasure of their talk. There was a huge moth on the wall of my room,

and after a while Dr Casey seemed more fascinated by that than by the conversation. Finally, the bottle of whisky having been finished, we all went to bed about three o'clock in the morning.

Next morning I ate an enormous breakfast – three bowls of rice soup, hot vegetables, scrambled egg, toast and coffee. Just as we were about to begin the meal, I crossed myself as usual and said grace. I realised that Dr Casey, Jim and Chompoon were waiting with polite impatience, because they were nearly as hungry as I was.

As I finished breakfast I noticed a man staring at me above his reading glasses as he pretended to scan a newspaper. I thought I had seen him before, and then I realised that he was one of the men in dark glasses who had been sitting opposite me in the lobby of the hotel the previous night. Before I had time to panic, Chompoon ushered me quickly to the car. A few minutes later we all set off to the village where Chompoon lived with his Karen wife, and where Jim also had a house. Jim was a Protestant who had converted to Catholicism, was married to a Thai Buddhist, and was bringing up his two children as Catholics.

It was Jim's idea that I should spend these last few days among Karen Catholics so that I could get some spiritual consolation and take a peaceful leave of people who, if not Padaung, were our closest cousins. So I stayed with Chompoon and his beautiful wife, while Dr Casey stayed with Jim in his house, where they were looked after by Karen nuns from the church in the village.

After all my experiences in the jungle I urgently wanted to talk to a priest. Such were the horrors I had seen and been part of that what I most wanted was to have the intolerable burden of experience lifted from me. I asked the French parish priest to hear my confession, but he could understand neither my Burmese nor English, and I could understand neither his French nor Karen. So we gave up the idea. But he gave me permission to take communion, provided I made the best inward confession of which I was capable. I suppose that what I felt was that I had seen things that no one should see, and even if this was not the same thing as a sense of sin, it was barely supportable. The next morning, for the first time in nearly a year, I attended Mass and received the sacrament.

In the evening I suffered another malaria attack, and stayed in bed all the next day. Jim and Dr Casey came to see me, and showed their concern in their characteristically different ways. Dr Casey looked

anxious, because he had never come across malaria before. Jim took my skinny hand in his own huge palm, and felt my pulse: 'You have no pulse at all. You must be bloody dead.' The next day I recovered.

The day after that they asked me if I would like to go to Bangkok. I thought, 'Why not?' I had little idea what I was supposed to do there, or where I would stay, but three days later we drove down to Chiangmai to catch a flight to the capital. At the airport Dr Casey lent me his panama hat, camera and sunglasses so that I could disguise myself as a Taiwanese tourist. Jim and Chompoon bought the plane ticket for me under the name 'Michael Tan'. Neither of them was to accompany us.

Dr Casey and I had coffee in the lounge before departure. My anxiety grew as I watched people stepping on and off what looked to me like moving stairs, and realised we would have to do the same. As far as I knew there was only one escalator in the whole of Burma, in Rangoon. It was quite a tourist attraction, and I had once gone to look at it, but discovered that it had not been in working order for years.

When the the announcement came that it was time to board our plane I felt as though I had just been sentenced to be hanged. I forced myself to step on to the moving stairs, felt I was about to fall and grabbed the belt to steady myself. I managed to compose my features, but noticed that Dr Casey was finding it difficult to contain his amusement. So I made even more effort to hide my terror at flying for the first time. I had seen planes high in the distance, but as we walked across the tarmac to this one I felt pure incredulity that this enormous metal ship could take off from the ground and fly.

As it did take off, Dr Casey was anxious to see that I was not frightened. I felt nervous, almost irritated by his concern. I told him that it reminded me of looking down at a Christmas crib from the arms of my father when I was an infant. To show that I was not excited, I pretended to read a newspaper – but then I realised I was holding it upside down. I also noticed that the Thai intelligence man from the hotel was on the same plane.

Only when we were airborne did Dr Casey tell me that I was to stay in Bangkok with a friend of his while I awaited permission to enter the United Kingdom. He didn't tell me who this friend was or where he lived, but he did reassure me that he was a good man. I had the feeling that he did not want to raise my hopes too high for fear

of disappointing me. He told me not to worry, but the more he told me not to worry the more worried I became. I needed to ask him how to behave with his friend, for I had never been out of my country before. I never managed to ask him. I was too shy to confess to the host of things I did not understand – I thought it would be rude and ungrateful to ask such questions.

An hour later we landed safely at Bangkok airport. Dr Casey had also noticed the intelligence man on the plane, and he was very quick to order an airport limousine and to get us inside it. Once in the car, he told me where we were going to stay and whose house it was.

'I must tell you something about the place we are going to stay. It's quite out of the ordinary – not a hotel, but not a private house either. You will be safe there, because it is a place that no Thai police can enter to arrest you. You will be staying with civilised people. I have to tell you that it is a very grand place – incredibly grand after the jungle. But don't be nervous; there is absolutely no need to be.'

My nervousness was growing by the second. 'We are going to stay in an embassy. Don't worry, the Ambassador is a good man. He will like you.'

I had no chance to ask any more questions before the car stopped in front of a gate in a secluded part of the city. A uniformed Thai guard opened the gate, and as we drove past him he saluted. The gate closed behind us. Dr Casey said quietly: 'Now you are on a free territory, Pascal.'

On a Free Territory

A tall, elegant man with a pipe in his hand came to greet us, wearing a short-sleeved shirt and a pair of shorts. Dr Casey introduced us. 'This is Mr K – he knows all about you.'

'Welcome,' he said. 'Did you have a good journey? Come, I'll show you your room. Let me take your bags.' He grabbed my luggage and led us into the building. It was only at that moment that it dawned on me that this was the Ambassador himself. I felt so humbled by his hospitality and lack of pretension that I was struck dumb. I had never come across anything like this before. I simply followed him.

Dr Casey gave me a little nudge and murmured, 'Life in Bangkok isn't always like this, you know.'

Mr K took us to the first floor of the central building, and showed

us to our rooms. I had expected to be in the servants' quarters, so what followed was pleasantly shocking. The room I was shown into was far too good for me. It was furnished with simplicity and luxury. There was a writing table with a radio on it, a bed with a bell button to call servants, and the room was air-conditioned. Later I learned that it had been used by the queen of Mr K's country when she came to Thailand on a state visit. I entered the room, but felt so awe-struck that I could not imagine that I would dare to stay in it for long. Mr K explained to me how to use the European bathroom and toilet, then let me alone.

I just sat in my room wondering how I could make myself useful. Then I stood in the bathroom for some time, and felt I simply must see what it would be like to take a bath there. I took my bath, the first one I had ever had in European style. This was the biggest culture shock of that extraordinary day. The warm water reminded me of my mother. She used to have hot baths with soothing herbs when she gave birth to babies. I had had hot baths only when I was ill – in fact until that day I imagined that a hot bath was only for women in childbirth and the sick. But I was so overcome by the luxury of the bath that I soaked in it for a very long time.

After the bath I dressed myself in the new clothes and shoes we had bought on the road from the border. This was the first time I had worn proper shoes, so I took great care not to slip on the polished floor of the staircase. I walked (in my own mind) half dancingly, like Michael Jackson in a fit – after all, everything I was experiencing seemed a fantasy. I went down to the drawing room, which opened onto the lawn and gardens through french windows. Dr Casey and the Ambassador were listening to a Beethoven symphony on an old record-player. 'It's time to celebrate your escape,' Dr Casey said. While I was bathing he had gone out and bought some champagne. A handsome butler brought a chilled bottle on a silver tray. They drank to my health, and I to all those who had helped me in the worst of times.

My first drink of champagne was memorable. I took a mouthful, and immediately the gas was too strong for me. My eyes filled with tears, which were also ones of happiness. From the first sip I knew I liked champagne. I began to say that it reminded me of our home-made rice-wine. 'No – it's not like home-made anything,' said Dr Casey. Now that we had reached safety, he was determined not to be sentimental.

When we had finished the champagne the butler offered us gin and tonic. I finished mine quite quickly – much faster than the others. As soon as my glass was empty, the butler asked me if I wanted another. Nor did I refuse a third. I assumed you took whatever you were offered. I dimly realised that all the while the others had been nursing their single glasses, waiting to go in to dinner.

The three of us sat down to dinner at the end of an enormous dining table. I was seated on the Ambassador's right, Dr Casey on his left. The butler served Mr K first, then Dr Casey, and then me. This was delicately arranged so that I could watch how they did things and then follow suit. I watched them cut their beefsteaks with ease, feeling that my own knife was too blunt. The truth was that this was the first time I had used a knife and fork, and I felt angry with myself that I had never learned to eat European-style before. I decided that the only thing to do was to cut my steak into four large cubes, chew them as hard as I could, and then swallow. I washed it down with a glass of red Bordeaux. The rare steak, though, was no problem for me since I was used to eating raw-meat salad in the jungle.

After dinner, brandy and coffee were served in the drawing room. The Ambassador lit his pipe and offered me cigarettes. I also had three brandies. I learned later that the others were awed at the amount I drank without ill-effects. By now I felt quite at home and at my ease. Mr K was annoyed at some glaringly bright lights that penetrated his garden from the East German Embassy opposite. He half-heartedly threatened to 'create a diplomatic incident' by shooting out the bulbs. Dr Casey pointed to me: 'Give the job to him – he'll do it expertly.'

Two days later we saw a young man doing sprints and exercises on the lawn. Dr Casey thought he might be the Ambassador's son, but he looked Anglo-Burmese to me. It was Alexander Aris, the son of Aung San Suu Kyi and Michael Aris. Michael Aris and his two sons were on their way back from the last visit they were to be able to pay to Aung San Suu Kyi for several years, and were spending two or three nights at the Embassy. I need hardly say how astonished I was at this coincidence, and find it hard to describe what I felt on this unexpected meeting with the family of the adored leader of Burmese democracy, on whose every word we had hung during our months in the jungle. Alexander undoubtedly resembled his illustrious grandfather, Aung San, founder of modern Burma. However, our rapid friendship was not based on politics or history. He lent me some books, including

Are You Lonesome Tonight? by Priscilla Presley and a biography of Mike Tyson.

Dr Casey left for England, to prepare for my arrival there. In the weeks that followed I lived alone with the Ambassador and his staff. On Sundays, when his chauffeur had the day off, Mr K would drive me to Mass himself. Often he would take us on a tour of Bangkok. He had a low opinion of Thai drivers, especially of their ability to park. He would roll down his window and call out to them: 'Bloody Thais! Has no one ever given you driving lessons?' I would shrink into my seat, waiting for a confrontation, but the Thais, noticing the ambassadorial standard fluttering on the car's bonnet, would draw back and slink away. I had never come across such uninhibited behaviour before in a high official, and gradually realised that Mr K did not regard himself as (to use a term Burmese officials apply to themselves) 'heaven born.'

Mr K had a sort of pass issued for me confirming that I was his guest, which I was to use if the police stopped me on the streets of Bangkok. The Burmese Embassy was not far away. I had heard on the radio that Burmese troops, in pursuit of dissidents, had burned down a Thai village, and relations between the two countries were tense. The Burmese had sent a delegation to Bangkok to negotiate a settlement, and once, in the course of my explorations, I stumbled across two of the delegation near the Burmese Embassy. They were on the way from their hotel to a restaurant, and were talking loudly in Burmese, naturally assuming that no one would understand them. I followed close behind them. 'We only destroyed one village – the Thais are demanding far too much,' one of them said. 'We should have finished off their villagers as well.'

After six weeks under the paternal guidance and hospitality of Mr K my papers and visa for the United Kingdom had come through. The Ambassador himself came with me to the airport. He was a little anxious about whether I would have trouble with Thai immigration. I checked in, and we walked towards immigration. I was asked to wait outside an office while Mr K acted on my behalf. While my fate was being decided, I saw the immigration officer occasionally glancing towards me from behind the glass window. Then, finally, I saw him lift a stamp and bring it down on my papers. I drew a sigh of relief. It occurred to me that this would be the first time I had crossed an international boundary legally and with papers. We walked towards

the boarding gate, and Mr K said goodbye to me. Apart from thanking him for his kindness, I was unable to say anything of what I felt. He watched me walk towards the plane through the chute – and I felt like an animal being released into a new habitat.

As the plane prepared to take off, I was reminded of a Burmese tale of two baby parrots in a nest on the top of a tree. One day, a storm blew them away. One parrot was caught by a dacoit and the other by a hermit. The one in the hands of the dacoit learned how to swear and curse. The other learned words of civility and religion. I thought of my friends who had been blown away in the storm of the Burmese uprising. We had thought it a wind that would sweep away a hated regime, but it hadn't. I was the only lucky one.

About forty minutes after the plane took off, I looked down onto some small, yellow lights that stood out amid a territory of pitch-darkness. It was Rangoon.

I awoke in the early morning as we approached our destination. My instinct was to share my breakfast with the unseen gods above England, but I had soon realised that it was not possible to open the plane's windows. On landing I was subjected to half an hour's polite but searching questions at passport control, so that I sweated with the fear of rejection. By another piece of luck I had found myself sitting during the flight with an official working for the United Nations High Commissioner for Refugees in Thailand, and he stuck steadfastly by my side during the ordeal. Finally I was released, and walked out into the airport, wondering how I would cope if no one had come to meet me. Someone waved from the crowd, and then someone else, and a woman lifted her hand elegantly in the manner of my grandmother. The relief was so great I nearly screamed. Instead, I smiled. My burning cheek was cooled by the relief of the cool air. Here were Dr Casey, Michael Aris and Mr K's wife.

CHAPTER 26

Learning Words of Civility

Outside it was cold and misty. I had been given a sweater so that the change of climate would not be too shocking, yet I immediately discovered that I took pleasure in the smell of fogs. I thought I caught a forlorn look on Michael's face – the Burmese junta had already made it plain that he and his sons would not be allowed to visit Aung San Suu Kyi again in the foreseeable future.

After the welcome we separated, and John Casey took me downstairs into the Underground. A machine that looked like a giant metal caterpillar, making a frightful grinding and clanking noise, crawled in and drew to a halt. The metal doors of the underground machine opened automatically. We took our seats in the train and the doors closed behind us with a bang. Inside were people dressed mostly in grey or black coats, some reading, some just sitting looking ahead. They were uncannily silent. I remembered my grandmother's remark about the world of the dead: 'A dead soul has to travel to a land where there is no sunlight and cross an underground river where you have to pay for the crossing.' We took the Underground as far as a large railway station, and then caught a train to Cambridge.

My first impression of Cambridge was of a place of orange lights and darkness. John took me first to his college, where we had supper in his rooms, brought by a college servant. The order and formality of the place made me feel as if I was entering a monastery. Then John took me to his friend Dr Graeme Mitchison's house at a place called Maids' Causeway. Graeme was a mathematician and scientist, a friend of the famous scientist Francis Crick, who in 1953 had discovered the structure of DNA along with James Watson. He was a bachelor who lived an austerely intellectual life. I had never met an intellectual like this before, and I pictured him to myself as a sort of Buddhist monk

268

of a superior type – or of the hermit I had thought about as the plane left Bangkok. Here I was to live until I entered the university. We drank whisky before I retired to my bedroom in the flat at the top of the house. It was a long way from the jungle, but I retained my innate fear of being bitten by malaria-carrying mosquitoes.

Next morning I was wakened by an alarm clock. It was worse than the sound of gunfire. I was confused. Out of the window I could see Midsummer Common – a large green area abutting the river Cam (after which Cambridge takes its name) and one of the colleges – dotted with cyclists and pedestrians. The house vibrated every time a truck drove past it. It was the first time in my life that I had lived near a road with quite heavy traffic. In my old life the sound of a motor engine had promised something exciting, a sign of civilisation, but here in the West the constant droning of traffic brought back to me, by contrast, the quietness of the jungle. Some blackbirds had made a nest in a hole in the roof, and I could hear their singing. There were numbers of books on the shelves by the bed. I dozed off for a while before getting up, brushing my teeth and washing my face. I went down to where Graeme was having his morning coffee. Had I slept well? Yes indeed.

Eating muesli with cold milk for breakfast for the first time was a shocking experience. I chatted as best I could with my host, who by our standards was remarkably quiet. We exchanged perhaps twenty sentences a day. He lit the gas stove to keep the kitchen warm, but the other rooms were deliberately kept cold. There were eight rooms and one conservatory in this eighteenth-century house, and only my room was heated – to a tropical temperature. Graeme slept in an austere room on the first floor. He was from a famous political and scientific family, and on the mantelpiece in the drawing room downstairs was a photograph of one of his forebears talking to Einstein. There was a garden in the front of the house and another at the back. There was no television.

I realised that John wanted to introduce me to civilised, cultured English people as a way of my getting a sense of the best of the country. I could not have done better than stay at this house, full of books and a sense of the English intellectual aristocracy. In the drawing room were three pianos, two of them Bechstein uprights and one a Steinway grand (not that these names meant anything to me). On many evenings Graeme had friends in to play chamber music, and I was always welcome to sit and listen.

John had arranged for some of his friends and ex-pupils to coach me in preparation for the university. One of them, a Fellow of Trinity, introduced me to medieval literature. Another young colleague (who later became the headmaster of a famous school in Australia) tried to revive my Latin, but I seemed to have lost my old flair for it. An ex-pupil – now prominent in the newspaper world – gave me lessons in English criticism at his flat in London. Meeting John Casey's intellectual friends was daunting, as my English was certainly not good enough yet for me to have serious discussions with them. In their kindness they would not fail to ask me about the jungle, which was the only subject on which I could talk with fluency.

I read Macaulay's *History of England*, and sometimes tackled John about English history. We visited Ely, and John showed me the house near the cathedral where Oliver Cromwell had lived, and the Lady Chapel where stained-glass windows and sculptures had been destroyed by his soldiers. I went on to read about Cromwell in Macaulay, who admired him. But his destruction of places of worship enraged me, and I thought it unbecoming in the ruler of a civilised country. I asked John if anyone had tried to topple Cromwell. He said they had, but had not been successful. Then what happened to him? He died in his bed. At least they dug his body up later and threw it into a pit. Since then, no soldiers have been allowed to intrude into British politics. I was reassured, for I was seeing the history of England through Burmese eyes, and I thought of Cromwell on the model of our junta.

When I was bored in Graeme's house I would go into the garden to do some weeding. As a tribesman, I always feel in my element working with plants and the earth, and the smell energises my body. But I was not good at understanding what counted as weeds in English gardens. One day, I climbed one of the walls and began hacking at a noble old clematis. The neighbour from next door looked at me over the wall. He mentioned that the clematis was growing strongly and was coming into full flower. Yes, I said, it was a pity I had to cut it down.

'Where on earth do you come from?' he asked.

'Burma,' I innocently replied, unconscious of his enraged sarcasm, and returned to my act of vandalism.

There were several birds' nests in the garden bushes. I tried to protect them, but a cat managed to eat all the eggs. I was upset, and

wanted to kill the cat and eat it. John Casey asked me how I would kill a cat. I said that you banged its head on a wall or tree. 'Ah yes. In English we have a saying, "not enough room to swing a cat".' His sense of humour was still too dry for me. I was astounded when I learned that to kill a cat in that way might be a criminal offence in England.

I regularly cooked pungent dishes in my flat. One day, Graeme suggested that it would be a good idea if I told him when I intended to cook, so that he could then take a walk. I was puzzled at this apparent English habit of walking when cooking was going on.

Out of the blue, Graeme asked me whether I was bored in his house. I said, 'Yes – a bit.' I was thinking that I would like to watch television. Next day, he bought me a cassette player and tapes of all of Beethoven's symphonies. A week later he bought me a racing bicycle so that I could go on expeditions around the Cambridgeshire countryside.

So my time of preparation passed. It was a leisurely time, and also a period in which my anxieties and memories of my eleven months in the jungle were partially suspended. Once I had another attack of malaria, but then the disease, miraculously, seemed to have been eradicated from my body. I spent some uneventful months at a sixth-form college in Cambridge to improve my English.

John went back to Burma, this time to write a long article for a newspaper, the *Independent*. While he was there, he slipped away from his compulsory guide and revisited the restaurant in Mandalay to tell the owner what had happened to me. He also interviewed an important cabinet minister of the SLORC. This man began the interview by accusing him of imperialism because he resolutely used the old place names while talking to him – Burma instead of 'Myanmar', Rangoon instead of 'Yangon', and so on – but within fifteen minutes the minister had lapsed into all the old names himself. I was relieved when John came back safely. He had a little news of my family from a retired bishop in Taunggyi. And he brought back Burmese national dress – a shirt and *longyi* – for me to wear, he said, at my graduation.

Gate of Humility: Cambridge

In the autumn of 1991 I entered Caius College and the University of Cambridge, intensely anxious, afraid that I would not fit in, that I would be unable to measure up even to a small part of the knowledge and ability of the other students. Cambridge students have every right to feel superior, for they have won places in the most famous university in the world. In the face of their confidence I felt overwhelmed with shyness. It was not only shyness. There was an acute pain in my heart that was both emotional and physical. I could not get away from the feeling not only that I had no right to be here, but also that I had no right to have left the jungle, my friends and what had seemed my destiny. My sensitivity fed off both my own culture of shame and the Western culture of guilt. In the months of my preparation I had read Dickens's *Great Expectations*, and like Pip, the hero of that novel, I felt ashamed about everything from my accent to my mere presence in this venerable place filled with super-intelligent people. Meeting new faces and wondering whether I would ever make friends was intensely painful.

I bought my college gown and set off for my matriculation photograph before the Gate of Honour of Caius. Our venerable Second Founder, John Keys (who Latinised his name to Caius), seemed to have done his best to make people like me feel inadequate. He had built a court, named after him, in which the progress of a student was symbolised by a series of Renaissance gates: the Gates of Humility, Virtue, and finally Honour. The last was the gate you would ceremonially process through to take your degree. The only gate I could identify with was the first, the one which received the ignorant newcomer. I scarcely dared to wonder whether I might one day proceed to the Senate House through the last gate to take my degree. While

the other students joked and got to know each other as the photograph was taken, I was seized with the certainty that I was a man in the wrong place.

The matriculation dinner in Hall soon afterwards, with the Latin grace, the Fellows sitting at the candle-lit High Table, and all of us dressed in gowns, added to my terror. I forced myself to make conversation and find something out about my fellow students. The first thing I discovered was that, apart from a formidable German, I was the only foreigner reading English Literature. People asked me what school I had been to and where I came from. 'Burma.' There was a pause. They asked me where Burma was. They mentioned that they were reading law or medicine. What was I reading? 'English.' They looked at me with suppressed amusement. For a moment it seemed they had noticed my tribal Burmese, and were going to ask me what I had been asked in my first days at Mandalay – whether I was a cannibal. They asked me what I would be reading in my first term. I told them. 'Oh, I read that for A-level.' They turned away, comfortable in their own groups, and I was on my own again. The plates vanished from the table, and so did I. I went, as usual, to see John and get cheered up.

Yet through my paranoia and self-doubt, I could see there was something in this place that, with more confidence, I might love. Caius is one of the smaller colleges in Cambridge in terms of the space it occupies, and although it has quite a large number of undergraduates and Fellows, it is still an intimate community where everyone knows everyone else. It was founded by Edmund Gonville, a priest, and refounded by John Caius, a doctor, in 1348 and 1565 respectively. William Harvey, who discovered the circulation of the blood, was a Caian, and two Masters in a row had been Nobel Prize-winners in Physics. Stephen Hawking was also a Fellow, and from time to time I saw him trundling through the courts in his wheelchair.

There are more than thirty colleges at Cambridge, and each has its own atmosphere and retains its independence within the university, and has its own endowments. This independence struck me as a sort of emblem of political freedom. Caius had been free to offer me a place, taking a chance with me, even though I hardly fitted the criteria by which they usually selected people to read English Literature. John had urged my case on the college and had simply said that he would take the blame if I failed.

My fellow undergraduates reading English seemed to assume that they could get away with doing very little work. They concentrated on extra-curricular activities such as singing and playing in the college orchestra, acting, athletics, joining the countless university societies, drinking and socialising. Since I wanted to be normal and to seem busily occupied, I joined some societies. One was the Cambridge University Ballroom Dancing club. I had been good at my tribal dances, so I thought I might as well master those of the Europeans. I asked a girl to dance with me at one of our evenings, but she told me I was too short to be a suitable partner for her. I consoled myself with the thought – quite true, in fact – that she was too tall and ungainly to dance gracefully. I joined the Heraldic and Genealogy Society; after all, we Padaung have a consuming interest in our own genealogy. They were much more friendly, and we drank port at our meetings.

My real source of shame and embarrassment was that I felt I had nothing to talk about. The others thought I was mature and experienced, whereas I felt I had wasted my youth in the jungle. I wanted to catch up on the modern world. I felt that mine was a lopsided maturity, and tried feverishly to lengthen the shorter leg, by reading as much as I could, listening to the radio and reading newspapers. But while the other students would talk about their schools, their work, lovers, family, I could only talk of my past experiences in the jungle, which would kill the conversation. I felt guilty and a bore. Unconsciously, they found me disturbing, uncanny, in fact, weird. I felt like the Ancient Mariner, cursed to tell my story all the time to strangers. It hung round my neck like the albatross, for I was a sinner, and a pathetic one at that. To make me feel at home, a medical student gave me a box of locusts he had stolen from his laboratory (as a result of which my bedder dared not enter my room any more). When the creatures were mature, I roasted them and gave them to some students to eat. They said the meat tasted like shrimp.

My room was on the Market Square, and there was a bar nearby that stayed open until well after midnight. On Friday and Saturday evenings the students habitually became drunk and boisterous, and mingled with the rowdy crowds in the square. As I sat alone in my room listening to the noise, I was transported back to the jungle. The males would urinate against the walls of the college buildings, as if marking their territory like the wild animals of the jungle. As the voices of the drunken female undergraduates rose, I was reminded of

the cries of hyenas and excited monkeys. I knew that my stand-offish attitude had something in it of misanthropy and paranoia, and I feared that this was becoming a habitual state of mind.

Yet in the mornings – between six and seven o'clock, before the students, traders and tourists began filling the centre of Cambridge – the astonishing and beguiling beauty of the place took possession of me and consoled me. The college buildings then revealed their nobility and delicacy. The colours changed subtly as the sunshine touched their surfaces, as if they were in a constant flux of blushing. This was a Cambridge of the imagination, a place of impossible beauty in which I could feel solitarily at home. I imagined that the buildings glanced at each other in a silently conscious way. Meanwhile, Great St Mary's, the university church, crouched uncompromisingly in front of them like the Sphinx, with its head facing the Senate House and its back to the Market Square.

There was one pleasurable surprise during these early days. I wandered into Queen's College, and there found Newton's Mathematical Bridge, the idea of which had fascinated me in childhood. I learned that it had been taken to pieces in the nineteenth century, but that nobody had been able to put it together again without using metal screws, which Newton had done without.

But I was at Cambridge to resume my interrupted education. Here at least, the mountain I had to climb showed itself clearly in front of me. It took me at least twice the effort of a normal student to write an essay. I had to read every book twice to understand its argument, and I had to think twice, first in Burmese and then in English, before I found it possible to start forming an opinion. Sometimes I had to think three times, in my own tribal language as well.

The hardest thing, though, was the very idea of forming my own opinion. In my first term I was reading Renaissance English literature, including Spenser, Milton and Donne. Not only was I expected to master these texts – difficult for me both in their language and in their historical and religious background – but I had also to come to a personal point of view on them. Nothing could have been more opposed to the whole pattern of my previous education, and the thought of writing essays on my own was as frightening to me as the experience of defusing a landmine. The excitement of that evening in Mandalay when we had been thrilled to learn that a professor might draw us out on an author, instead of dictating to us what to think,

now turned into the nightmare of having to cope intelligently with that very freedom. I hardly knew where to begin.

I learned that some famous literary critics – including some here in Cambridge – had not greatly admired either Milton or Spenser, arguing that the language they used was not sufficiently precise, that it lacked 'sensuous vividness'. I tried to get my mind around the idea that I could take up a position on such arguments, and form personal opinions about these giants from the past. This was a freedom, I began to feel, even more radical than political freedom. Perhaps it was even a basis for other sorts of freedom. In Burma, while we called for democracy, we had not yet developed any serious idea of freedom of thought. I felt that in reading these texts and trying to see how I could personally 'criticise' them I was in a sort of engine room, and saw how much bigger things were moved.

There was also a Cambridge discipline in English called 'practical criticism'. Here you were presented with short passages of prose and verse and were expected to study them and form judgements about their qualities. As you did not necessarily know who the author was, it was impossible to rely on authority and reputation. These authors had to stand up to the gaze of first-year students like me. We had to think and write not about the doctrines of the writers, but the actual textures of their writing, the tone, rhythms, emotional feel. I discovered that at least I was not tone deaf, and although I found it hard to find words for my responses, I did find that these writers often spoke to me in the way they were expected to.

Nevertheless, the sheer bulk of what I was expected to cover overwhelmed me when I dared to think about it. When I had met John Casey in Mandalay, I had told him of the fifteen poems, the two novels and the one Shakespeare play we had to master at Mandalay University. But here, in my first two years leading to the first of the two main examinations ('Part 1 of the Tripos'), I would have to study Chaucer in the original, other medieval writers, and English literature in general over the sixteenth, seventeenth, eighteenth, nineteenth and twentieth centuries. Cambridge English has the principle of 'no hither limit' – meaning that one can study authors right up to the present day. There was also a whole paper on Shakespeare, and one on practical criticism, where the student would probably never have seen before the passages on which he was expected to comment.

I found this central requirement that I express my own opinion

almost insuperably difficult – and not just because I lacked confidence. I somehow managed to feel ashamed of giving my own opinion, which felt like being ungrateful to my supervisors (the Cambridge word for those who give tutorials). My supervisors and fellow students were patient with me. One of my teachers, Colin Burrow, was especially good at picking up obscure arguments in my essays. 'Leave the jungle out of it,' was one of his comments on an essay of mine. (He became a little exasperated by my lack of a Western sense of time, which led me often to turn up late for his supervisions. He wrote on one report: 'Pascal seems to operate on Burmese time.' The odd thing was that I had deliberately kept my watch on Rangoon time – until one day a fellow student seized the watch and changed it to British time.)

I attended far more lectures than most students in my subject, who seemed to take a pride in going to as few as possible. I frequently found the arguments of the lecturers too abstract for me to take in, their language too complicated for me to make head or tail of. But I was attending the lectures just to take in words and to absorb the subject slowly. Although I laboured to expand my English vocabulary, it was a labour of love, and I delighted to look up all the (many) words I did not know in dictionaries. I look back now on the books I owned and read at the time and in which I had underlined all the words I had to look up. In that first year it would be up to ten on every page. But I had an appetite for words. One word I learned was 'osmosis', and I suppose I felt that by attending the lectures I would absorb the subject by a process of osmosis.

I was not an intellectual or a reasoner in the Western sense. I realised that Cambridge ways of thinking were deeply foreign to me. But I did have what in Cambridge English they called 'sensibility', and my love of words was the best sign of it, and made it possible for me to learn. I consumed words like food, became acquainted with them like new friends, and hoarded them like jewels. Considering the base from which I started, I suppose I learned quickly.

In Cambridge the methods of teaching were liberal – films and videos of live theatre featured in the courses of some lecturers. The more I became acquainted with the vast possibilities of Western education, the more angry I became at the grotesque restrictions imposed on mental development by the Burmese regime. Yet at the same time, Cambridge taught me to see that you could not blame all that simply on a regime – for our conformity and readiness to learn parrot-fashion

was deep in our culture. I was determined to absorb this new world of ideas and feeling. Above all, though I feared failure in a way I could never admit to others, I was determined to get a degree.

I had now become used to physical safety after nearly a year in which the fear of death was with me most of the time. Yet the notion of being safe became different and subtler as physical struggle receded into the past. It was as though I had to replace physical fear with other sorts of anxiety, as though fear had become a habit, even a drug. I needed fear to give a flavour to my life. The more I thought about gaining a Cambridge degree for my own glory and that of the Padaung, the more I felt the strain of responsibility – and the less I studied literature for love. The universities in Burma were still closed, and I told myself again and again that I was astonishingly lucky to be here. Yet that is not what I felt. It was a shocking paradox. In Mandalay, where there were hardly any books, I devoured literature with a passion. In the jungle, where there were still fewer, I read in secret lest my friends might think I was not revolutionary enough. But now, although my love of words grew, reading became a duty – here in a paradise where all the works of English literature ever written were easily available. I forgot how to enjoy the present. A mixture of fear and pride drove me to try and try, but there was something missing. Like any machine that depends on a huge intake of fuel, I had to feed my ego repeatedly with the hope of success. But I knew that if and when success came, I would be too exhausted to enjoy its fruits. I became almost addicted to worries and anxieties.

My eyesight, once keen, had deteriorated in the jungle with illness and poor diet, and now deteriorated further. The pain in my eyes got worse and I acquired a pair of glasses. I thought of them as the sort of Western gadget I probably ought to own. They made the English winter landscape look less bleak, and I could now distinguish Marilyn Monroe from Madonna in films. Before that, I knew that one of them was dead, but could not tell them apart unless they were wearing their most famous outfits.

My perverse (as I saw it) reaction to my newfound physical safety also came out in my dreams. Ghosts and nightmares returned to haunt my nocturnal world. Sometimes my ancestors visited me to offer their blessing, while at other times evil *Nats* haunted me and bullied me into giving up the struggle. The ghosts of dead friends came often to my assistance, and the goodwill of living ones was a balm to my

horrors. Yet much of the time I felt that I was under the spell of evil powers. I could not talk about any of this to my friends. They had no conception of our 'ghost culture', of how we took for granted things that to them would have seemed quaintly superstitious or mad. My chief way of dealing with the outside world was to smile. Of course, they did not understand the 'oriental smile' with its tradition of masking hurt and embarrassment.

The space between being awake and asleep, the gap between the physical and metaphysical or subliminal worlds, between East and West, were eerily interlocked in my mind. All I needed was to go to sleep and I was in another world – whether of nightmares or visions of my friends and my home in Shan State. When I woke up I was thrown back to the lonely reality of exile. I was worried about my friends and family in the wrong way, because my feelings for them were mixed up with guilt and frustration.

My religious faith was still strong, and has never diminished. But as I began to see a wider world, I became confused. I came to feel a conflict between the authority of the Church and my own experience. Nearly all the people I met in England were moral relativists, and I began to feel that the rigid structure of the Church as I had known it in Burma was not something that had ever engaged me at the deepest level. Sometimes I felt that my Padaung, missionary Catholicism did not travel well, for it had never needed to encounter modernity and scepticism as I was now encountering them. The figure of Christ and the idea of suffering and compassion fully answered to my own life, yet I sometimes found it more practical to follow my ancestors' nature worship and add it on to the new religion to make that bearable, even humane.

One source of comfort that was always available in the midst of turmoil was talking to John and drinking wine with him, listening to music and reading. It was now that I remembered some wise words he had spoken to me just before I came to England. We were sitting on a bench in the Karen village before travelling to Chiangmai and Bangkok, and he seemed anxious to prepare me for a world very unlike that of my religious upbringing. He urged me to realise how immensely different my traditions were from those of the West, so different that I might find it almost impossible to adjust to the new world I was about to enter: 'Don't forget that being an exile is one of the hardest things there is. The ancient Greeks thought that exile was a sort of

death. At least hold on to your traditions and your faith. Remember what your faith means to the Padaung and your family. Find out about modern Catholicism while you are in England, and see how it has tried to come to terms with the modern world, because you were brought up in an authoritarian, missionary Catholicism, a very literal faith, and as you become dissatisfied with that – as you inevitably will – you may give up your faith. You are bound to be disorientated. In a way you are luckier than many undergraduates you will be mixing with in that you know exactly what your traditions are. Most of them don't. You are a Catholic, you are a tribesman, you will have had hugely more experiences than your peers. I think you should write down your life experiences and all that you can remember about your tribe.'

He was right – but I was unable to understand fully what he meant at the time. I almost felt that I needed someone to tell me what to feel.

I began to write, from time to time, about the jungle, about Mandalay, about my childhood. Gradually more and more of it came back to me, demanding to be written down. I wrote in English, but to make the language express what I wanted to set down took years – and I am still learning.

My Part 1 exams, which were to be taken at the end of the second year, were approaching. I had grave fears about my prospects of passing them, despite my efforts to work harder than my contemporaries. I had no confidence that I had made the transition from a type of education in which you simply have to master a few set texts, as well as being told exactly what to say about them by your teachers, to the Cambridge system in which the Part 1 exams demand from the candidate 'coverage' of all periods of English literature. I was not sure whether to be encouraged or depressed when I realised that other undergraduates, despite their backgrounds in good British schools, felt exactly the same nervousness. I had no hope of taking a paper that required knowledge of one or more European languages, and instead chose the option of the History of the English Language.

In Part 1 you were allowed to substitute for one 'period' paper a five-thousand-word essay on an author from that period. I chose to write on Evelyn Waugh. The fact that he was a favourite author of John Casey, and that I had met his daughter in Mandalay and had

got to know her a little in England, may have had something to do with my choice. The subject I chose was 'civilisation and barbarism'. This was because it seemed to me that Waugh was fascinated both by semi-civilised countries in the Third World and by a barbarism under the surface of English society. As a result he brought to his own social world the same sense of incongruity and false standards that made him such a comically destructive observer (in his fiction) of the empire of Azania in *Black Mischief*, of the realm of the Jacksons in *Scoop*, and in his travel writings of Haile Selassie's Abyssinia. But my central text was *A Handful of Dust*, where a parallel is obviously drawn between a spiritually dead marriage and dehumanised people in England, and a semi-civilised man in Central America who rules over a primitive tribe and loves Dickens. I found that the cruel humour of Waugh was an accurate evocation of my own past experience.

I spent a term of this year studying Shakespeare, and found some glimmers of hope in discovering that I loved surmounting the difficulties of understanding his language in the late plays. I even began to form the ambition that one day I might translate some of Shakespeare's plays into good Burmese. Most of my Shakespeare supervisions were with John – we even had one on *Macbeth*.

My depressions and nightmares continued. The sense of being oppressed and bullied crept back, even though Cambridge offered more personal and spiritual freedom than I could have imagined existed two years before. In *Black Mischief*, an old man who has been unexpectedly released from prison and made Emperor of Azania constantly feels, throughout the coronation ceremony, for the ball and chain that he had worn on his leg in gaol. Sometimes I locked myself up in my room for three or four days, just to have a sense what it was like to be imprisoned, and as a sort of penance for all my luckless friends who were locked up in noxious prisons in Burma. A friend had told me that when he was in a Burmese prison, to keep his sanity intact while cold water dripped on his head day and night, he used to recite the alphabet backwards. I drew strength from his example of sheer perseverance.

I began to get to the root of my problem when I realised that I could not understand the Western enthusiasm for physical exercise. When I discovered that my tutor, Mark Bailey, had played rugby for England, I thought I should take an interest in the game. I patriotically supported Cambridge in the Boat Race. I took up squash and found

that it both released anger and reduced anxiety. But after each game I would smoke excessively, which made me feel guilty.

Traditionally, my people engage in physical exertion only out of necessity – ploughing, sowing, cutting the jungle. They never do it for health alone. I would have been perfectly happy doing nothing. The cult of exercise and athletics struck me as an extension of the competitiveness that I found all around me. It seemed that in the West – and especially in a super-competitive place like Cambridge – you had constantly to be making and remaking yourself; you could not simply be. Individualism was forced upon you. As a tribesman I had been surrounded by the unquestioned customs of the Padaung, and the no less unquestioned teachings and discipline of the Church. In Mandalay the students – especially those of us who were from the minority peoples – created a comradeship that supported us amid hardships few of my Cambridge friends could guess at. In the jungle this comradeship was the most important value, both a moral imperative and essential to survival. So my mentality was at loggerheads with the modern world I now encountered. I could not cope with the pressure to be ahead of everyone else – or, at least, not to fall behind. Equally hard was the necessity always to have something new – including new knowledge, new ideas. The root of my depression was modernity. I told myself that I was lost, definitely lost in the modern world.

My friendship with John remained the sheet-anchor. I kept most of my anxieties from him, out of my old fear of appearing ungrateful. Our friendship was no substitute for the family I dearly wished I had around me, but it contained a loyalty that was unconditional. He wanted me to pass my exams and get a degree, but he did not encourage this competitive sense. His main idea seemed to be that I should develop a real, inward love of English literature and that one day I should be able to go back to Burma as one of the very few Burmese (and, of course, the only Padaung) with that.

Our friendship was in some ways quite impersonal. John could be bossy in a way that sometimes reminded me of my grandmother. At the same time he was determined not to have too much influence over me, and so he never tried very hard to persuade me to do something he thought was right. He wanted to keep a distance between us. His fear was that because he was so overwhelmingly my benefactor, this would lead me to defer to him in a way that he described as

'Confucianist'. So he did whatever might counteract that temptation – even leaving me to my own devices and not enquiring too closely into my state of mind. He thought that was something I should talk about to my friends and tutors rather than to him. Nearly everything between us was unspoken. In fact, when we did speak about the past, he liked to dwell on the incongruities, the occasions there had been for humour in the jungle even in desperate situations, and my outsider's impressions of England and Cambridge. He felt that we did share a sense of humour.

But I never had any doubt that the bond that had been created between us was unshakeable, and that in all circumstances I could rely on his support. That never needed to be spoken of.

John sometimes got me invited to a society that he ran – it was called the Oakeshott Society after Michael Oakeshott, a philosopher who had been a Fellow of Caius and had been one of John's friends. The members were both undergraduates and dons. I had never read Oakeshott, but I did absorb some sense of what he stood for. One of his ideas was that a university was not a place where you simply competed, nor was it merely a means to an end. It was a place where you were given the gift of an 'interval', a time of leisure, where you did not have to make up your mind about your beliefs, and learned as much from conversation as from lectures and books. The Oakeshott Society held a dinner once a term which always ended in a general conversation on a topic. We met journalists from London, old members of the college and the occasional politician. As we sat for our 'conversation' amid the candles, drinking claret, I realised that all this was incredibly privileged, and perhaps as remote as anything I encountered in Cambridge from my own background. But it did give me a chance to realise that there was a world of leisure as well as of anxiety, and that I was not necessarily excluded from it.

Some undergraduates thought of John Casey as a 'reactionary' and even a 'racist' because he indulged in nostalgia for the imperial past, and believed in patriotism. In fact he had frankly told me when I met him in Mandalay that one of his reasons for coming to Burma was his fascination for the (now) three countries of the Raj. I hardly even attempted to explain to other students that most of the minority peoples of Burma – especially the Karens and Karenni – had favourable memories of the British years, and that even many Burmans, after their experience of Japanese occupation and the Ne Win regime, had

softened towards the old empire. I remembered my grandmother's talk of the 'golden age'.

The examinations in May 1993 approached like the Day of Judgement. I had been taught in Caius College by people I came to know, but these examinations were university-wide, marked by a Board of Examiners consisting of about twenty lecturers. On the day of the first exams, some students were so anxious that they were unable to bring themselves to enter the examination hall. One just walked around the streets, while another deliberately overslept. I walked into the hall like a zombie or lost soul. When I looked around I saw that I was the only oriental reading English literature in the whole university. Despairing, I seated myself at the desk, took a deep breath, exhaled, put all my pens on the corner of the desk, slowly and deliberately turned the question paper over, read through all the questions, and equally deliberately made a short list of the ones I decided to answer. These little ceremonies kept terror at bay. Then I started to write. There was no turning back. After three hours, and four essays, I was still physically tense with anxiety.

Afterwards I went to the nearest pub with some friends, downed a pint of lager, and felt better. I drank half a bottle of red wine in my room before the second paper in the afternoon, and felt more in control of myself. I repeated the same procedure for all the remaining papers.

After the exams came the weeks of waiting for the results. When I knew the examination list was out and published in front of the Senate House, I dared not go and see it. I went to John and asked him my results. He already knew them, but told me that I should go and see for myself, like the others. Off I went, consumed with anxiety. I went through the list from the bottom up. I had passed my exams with Third Class Honours. I went to a pub with my friends again to get drunk.

CHAPTER 28

Reunions with Old Ghosts – and a Farewell

Return to Thailand

During the long vacation in the summer of 1994, before my final examinations, I took the opportunity to go to Thailand. I would return to the refugee camp. Then, through some priests, I hoped to meet members of my family on the Burma–Thai border. I flew to Bangkok, and took an internal flight to Maehongson. The monsoon season was at its height, and visibility at Maehongson airport, which is flanked by high mountains, was very poor. The plane, severely buffeted by the winds, hovered over the border, where I could see – too close for comfort – Burmese army camps, before it could successfully land on the runway inside Thailand.

As I stepped off the plane the hot, sticky monsoon wind swept my face and brought a wave of nostalgia. I caught a boat down the river Pai, and all my old feelings came back, the wind caressing my neck and face as I travelled along the river swollen with the monsoon rain. As before, an oozy, festering miasma predominated, and I even caught the fresh fragrance of Shan maize with a touch of burnt grass. I walked into the camp, took off my dark glasses, and was immediately recognised. 'Son of a bitch! You came back! You look fat – English food must agree with you.'

I had brought whisky, champagne and Earl Grey tea from England. We celebrated our reunion with a bottle of champagne – which my friends insisted tasted like rice-wine. They gave me chilli curry for dinner to test whether I still had my tribal resilience. We played

Scrabble, and I tried to explain the game of cricket to them with the aid of a rifle and a grenade.

But the good cheer was somewhat forced. Malaria and other illnesses had taken their toll of them. They looked gaunt and ghostly, shadows of their former selves, cadaverous faces peering out of their worn-out shirts. Enthusiasm had vanished from their faces. They kept themselves entertained by watching *Mr Bean* and *Monty Python* videos to which they had been introduced by a British ex-soldier.

From Dee Dee I learned that some of their leaders had left for foreign countries that had let them in. Edward Byan had gone back home to Burma. General U Reh had died a few months before, accidentally blown up by his own grenade while on a fishing trip. Occasionally, as we talked, the sounds of landmine explosions and spurts of gunfire could be heard across the border. Inside Burma, the army had intensified their campaign against the rebels. The line between the insurgent Karenni and the Burmese army was almost impossible to pinpoint, and was revealed only by fields of landmines planted by both sides in the conflict. Occasionally, wild animals would set them off. Sometimes one side would lure the other by deliberately blowing up their own mines. Whenever a mine exploded, the rebels would feel they had to go and investigate. The enemy would frequently be lying in wait to ambush them.

Down south, on the border near Maesariang, the students were getting ready for a major battle. The Burmese army was about thirty miles away inside Burma, preparing for a sortie across the border to destroy them. The dry season would be starting before very long, and that would be a good time for the army to try to wipe out the few remaining bases of the rebels. Burmese government finances had sharply deteriorated in the past two or three years, and the army's determination to break the rebels' grip on the teak forests and sell logging concessions to the Thais was stronger than ever.

I left to visit another camp. As I was going inside, a Thai guard asked me for 300 bahts as an entry fee. To his surprise I swore at him, pushed past and continued on my way. I had heard about this camp, and was determined to see it. I met some children, and spoke to them first in Burmese, then in Padaung. They were astonished. It was obvious to them that I was not Burman or Thai, but I was no longer tanned as a Padaung or other hill tribesman would usually be. They ran to their parents, and I heard them saying that here was a strange

Japanese tourist who spoke Padaung. Some Padaung men, and women wearing neck rings, advanced uncertainly towards me.

This was the 'human zoo' I had heard about, run by Thai businessmen and guarded by armed men, in which half a dozen families – fifty or more people – of my tribe, who had fled across the border at the same time I did, were being detained to be displayed for money to tourists. Eventually some of the older folk recognised 'Khun Sa'. Where had I been? Could you get rice-wine in England? Did the English have buffaloes to plough their fields? In keeping with Padaung – and Burmese – tradition, they talked about food rather than politics or the future, all the while plying me with the Padaung rice-wine they were shocked to hear I could not get in England. Here too, as we spoke, we could from time to time hear firing and landmine explosions across the border. I stayed with them a few days.

When I returned to the students' camp I was greeted with the news that one of my close friends, Aung Soe Lwin, had been shot dead by Burmese infiltrators while I was away. I could not bear to see his body, or to help bury him, a task that I left to the other students. Before I left the camp I offered sacrifice to the *Nats* of the jungle, and performed the ceremonies to lure my *Yaula* to come back with me to England. I invited the spirits of the dead to travel with me, if it so pleased them.

I took an internal flight to Chiangmai, where I met a friend. We took a bus to the north-east of Thailand, to a small town called Maesai, near the notorious Golden Triangle. There I hoped to meet my father. On the way we stopped overnight in a Catholic mission run by some old Italian nuns. They had been expelled from Burma in 1962, but instead of returning to Italy they stayed on in Thailand near the border, in the hope that one day they would be allowed back into Burma. Their old convent had been not far from Phekhon, and my arrival plunged them into reminiscences and nostalgia for 'Birmania' (the Italian word for Burma): 'Pasquale, we think always about Birmania and your people. And always we cry when we think of them. We love your people. Will we ever see them again?' We talked about Birmania the whole evening. Only a few years later their prayers were granted, and they were allowed to return.

We proceeded to Maesai, where we managed to make contact with one of my sisters who was working as a volunteer in an orphanage on the Thai side of the border. She told me that my father was being

brought by friends on the three-day journey by car to the border, and would be waiting for me inside Burma. I asked her to go back into Burma, find our father and bring him to Thailand. This was the one place on this part of the border where Burmese were allowed to come over for a day's shopping. Secrecy was necessary, for if the authorities knew my father was coming to meet me, they would certainly not allow him out. We arranged to meet in a restaurant the next day.

When the next day came, I waited anxiously in the restaurant as we ate our lunch. Then came a moment of panic when I saw a Burmese army truck stop right outside. About ten officers in civilian clothes but wearing army hats jumped from the truck and entered the restaurant. They were talking excitedly to each other. My heart stopped. 'We are betrayed,' was my only thought. What had happened to my sister and my father? Had they been arrested? And was I about to be seized? I prayed that they would not turn up while the soldiers were in the restaurant, and urged my friend to stay calm and not to speak in Burmese in any circumstances.

The soldiers took their seats at the table next to us, and ordered whisky and sodas to drink with their lunch. I knew that they tended to become convivially 'friendly' when they were drunk, and prayed that they would not come over and talk to us. I caught the words of one of them to another: 'What is that Japanese tourist doing here?' It was certainly not a place that Japanese tourists normally frequented. This gave us a cue, and we mumbled some meaningless words to each other that we hoped sounded Japanese. We intended to get through our lunch quickly and leave, but then I heard them talking about the fighting on the border, and decided to stay and listen.

'They just give us orders when they know nothing about conditions at the front. All they know is giving orders. Apart from that, they are completely useless,' said one officer.

'I couldn't agree more. They have no idea. Those rebels and students are cunning bastards – hard nuts to crack. Their landmines are diabolical, and their snipers are lethal. All this talk that they are defeated – it's pure rubbish. We're going to get them, and that means we will have to come into Thailand whenever we need to – and sod the consequences.'

They drank some more, and another spoke: 'I'm sick of all this killing and fighting. I have lost too many good soldiers. And plenty of my men tell me they've got friends and relatives with the rebels.

You know what I want? I want to quit the army and get abroad. I'm sick of the whole thing.'

'Oh, come off it! What do you have to worry about? The pay is good, we can feed our families. If you go, there will be others to take your place. You're a ruthless bastard, but they will be ten times worse. Anyway, don't talk about that any more, because if those swine at the top hear they'll "dilute" you.'

After thirty minutes they finished their lunch and drove back into Burma. As soon as they were gone, we left also. Almost at once I saw my father on the other side of the road walking briskly towards us with my sister and some friends. Our meeting lasted only two hours. I suggested he stay the night in Thailand, but he was too afraid. I changed a couple of hundred dollars into Thai currency, telling him it was a present from Dr Casey.

'He is your father now, according to our traditions,' said my father. 'Listen to what he says. Make sure you stay a good Christian – and remember your people. By the way, you can fall in love and marry anyone you like, but make sure she is a woman. And give my regards to your adoptive father.'

I walked with them to the checkpoint at the border and watched them until they disappeared into Burma with the crowd of shoppers. They did not even wave goodbye, for fear of being discovered. The two countries were separated by a river and connected by a bridge several hundred feet across, manned by Thai soldiers on one side and the Burmese army on the other. They were only fifty feet apart. Standing on the Thai side, I stared at my country. There I saw my father for the last time. He died from tuberculosis two years later. The only consolation was that he heard my voice on the BBC Burma Service on his deathbed. Before he died he wrote a letter to John Casey inviting him to come and visit him in Burma, but he didn't mention the fact that he was dying. Nevertheless, there was an undertone of desperation in his letter. John Casey was refused a visa by the Burmese Embassy in London, so my father never met the man who looked after his son on the other side of the world.

Gate of Honour: Graduation

My Third Class Honours in Part I of the English Tripos had been a shaky one. I had in fact come close to failing, but I was told that the external examiner had taken the unprecedented step of writing to my tutor about me after the results were published. In his letter he spoke of the perceptiveness he found in my work, my evident enthusiasm for English literature, and moments of genuine originality. He particularly commended my work on Evelyn Waugh. He called me a 'gifted but disadvantaged student', and thought I had the potential to get a better class. But he went on to say that unless I improved my command of English, I would face great difficulties in my final exams in May 1995, and might even fail altogether. The final exam was much more difficult and involved completely new and (to me) daunting material. He recommended that the college allow me to take two years over Part II. This would mean that I would have to take an extra paper, but at least I might be able to avoid ruining my chances through clumsiness of expression. The college had agreed to this, and I settled down to prepare for these final exams heartened by the promise that this disinterested judge found in my work, but also warned and worried by the chance of failure.

The most difficult new work was on the Tragedy paper. Here I had to study (in translation) the work of the ancient Greek tragedians Aeschylus, Sophocles and Euripides, then Shakespeare and other Renaissance tragedy, Ibsen, Strindberg, Chekhov, and any other literature that could be deemed 'tragic' right up to the present day. Many of the questions invited you to write about the theory of tragedy – something for which I felt particularly ill-equipped. It was impossible to ignore the fact that I had only a fifty-fifty chance of passing my final exams, that my command of English was not up to Cambridge

standards, that my disadvantages compared with other students increased rather than diminished as I approached the final goal.

I simply set myself to ignore the possibility of failure. The thought that I might leave Cambridge empty-handed, that I would let down those who had supported me and paid for me, was too hideous to dwell on. I willed myself to remain in a state of permanent intoxication at the thought that I was certain to pass my exams.

This time I wrote two dissertations, each of seven thousand words. One was on George Orwell, the other on A.E. Housman. As well as the Criticism and Tragedy papers, I took papers on the novel and on American literature. I prepared for the exams as for a battle. At least I was determined to be efficient, and I delivered my dissertations in good time. The English Faculty at Cambridge also allows you to write an 'original composition' – an optional further extra paper – which is really a test of whether you can write creatively in English. Given the problems everyone knew I still had with the language, I knew this would be a long shot. But I decided to submit about five thousand words describing my Padaung childhood, bringing in as much as I could about the customs of the tribe.

I kept up my tradition of drinking half a bottle of wine before each examination, and went to the hall on the first day (it was the dreaded Tragedy paper) full of willed confidence, sure that nothing could come between my degree and me. After the paper I went to the pub with my friends, knowing I had done my best, answering questions on Greek, Shakespearian and modern tragedy. There was no exam in the afternoon, so after lunch I went to the Junior Combination Room to smoke. I picked up a newspaper, flicked absently through the pages, and saw the headline 'Burmese Opposition Leaders Killed'. My eye ran on to see the details. Edward Byan and his brother Gabriel were dead, gunned down in Burma by the pro-government militia. All my false optimism fled immediately. I went back to my room and phoned Thailand to confirm the news.

I went to see John, and told him I wanted to give up the struggle. The guilt I had felt in leaving my friends, so many of whom were now dead, flooded back. I knew that Edward had never been reconciled to my decision, that I had left him with a difference between us unresolved, and that it could not now ever be resolved. The fact that I had learned the news in the middle of my exams seemed a sort of punishment.

Of course John urged me not to give up, tried to argue that the only thing to do in the face of these horrors was to achieve at least a personal victory in gaining a degree. The one thing he did not mention was that in giving up I would also be letting him down – but that was an unspoken thought in my mind. I was not convinced, but fortunately there were three days before my next exam, during which I could grieve and hope to achieve temporary insensibility. I went back to my room, and wept until dawn. At the end of the three days I was resigned to going on.

The results came out on a sunny, hot day. I searched the list from the bottom, the Third Class. I could not find my name. I despaired. I searched the list again and could not find my name anywhere. I hunched up. I knew that I had failed. I felt faint, and gripped my knees with my hands to prevent the other people who were milling around the lists from seeing how my limbs were trembling. My heart stopped and my body broke into a cold sweat under the hot sun. Then I scanned the list of Second Class, up, up, S, R, P, O, N, M, L, K – and there was my name! Suddenly I was unable to contain my joy, as so many memories – the drum of desire, the goddess of creation, Mandalay, the sounds of gunfire, Moe, Edward – coalesced in my mind in an instant. The whole past existed, for a moment, in the present, in my sense that I had got revenge for my people.

John Casey wrote to my father to tell him of my success. He also gave me the list of my benefactors, whose names were previously unknown to me, so that I could write and thank each one. I learned that my original composition had been awarded First Class marks by both examiners who read it, the only one to do so in the whole university.

For my graduation John persuaded me to wear the Burmese national dress that he had brought over from his second visit to Burma. At first I was reluctant to do so, because I did not want to be the odd one out among the other graduands. In the end, I was persuaded by John's argument that I should publicly show loyalty to my background, and pride as the very first Padaung to graduate from a Western university, and the first Burmese to gain an honours degree in English literature at Cambridge. I decided to wear the national dress, and to combine Burmese and Padaung traditions. I wore threads of good luck around my neck and wrists, and ordered a gold leopard brooch – my own

emblem, given to me by my grandmother – and a gold peacock brooch, the symbol of Burmese students.

On graduation day, dressed in my Burmese clothes with the Padaung additions, I went to meet Dr Michael Aris and other guests, including a grandson of U Thant, for lunch in John Casey's rooms, which are under Caius's Gate of Virtue that had so intimidated me on my arrival in Cambridge. I was moved that we had among us representatives of the two families that are most respected in modern Burma. We drank to my family, to my friends in the jungle, to the memory of the dead, to Michael's wife, Aung San Suu Kyi, to the future of the country. The words that came into my mind were those that would have been used by the Italian priest – captive, friend and mentor of my grandfather – *Viva Birmania*! Then I went to join the procession through the Gate of Honour to the Senate House.

Epilogue

In the early eighties the bamboos had started to flower in unusually massive numbers. Throughout the Shan State and elsewhere the floors of the forests were covered in tiny yellow flowers. From ancient times the Burmese have taken the flowering of bamboos as a sign of future disaster, especially of famine. It was a bad omen for the country, said my grandmother: 'They flowered like that before the Japanese came. During the war people had to eat bamboo blossoms because they couldn't grow rice. I think something terrible is going to happen. It could be drought, or dearth, or death from civil war. I am too old to face that. I shall pray to God to let me die as soon as possible. I want to be a man in my next life. I am praying to the Holy Virgin.'

My curiosity was aroused. 'What do you need to do to become a man in your next life?' I asked her.

'When I die, I have to climb that mountain and collect seven flowers on the slope before I cross the river. Only virtuous women can collect all seven.'

As the country slid into chaos and bloodshed only a few years later, I remembered my grandmother's predictions. She died while I was in the jungle with the rebel students.

Within two or three weeks of my arriving in England, John Casey had taken me to stay in a house, part of which he rented from some friends of his, in Aldeburgh, on the Suffolk coast. It had a small art gallery attached.

I had never seen the sea before, so he left me standing on the beach gazing out to sea under autumnal skies. That evening I read Keats's 'Ode to Autumn', and noticed how in East Anglia the sun touches 'the stubble plains with rosy hue'. Meanwhile John went to have a

drink with his friends. He had written to them warning them that he was bringing a Burmese refugee with him, telling them how he had met me, and a bit about my background.

That evening he prepared dinner – local partridges. He seemed preoccupied, as if he had something important to tell me. After dinner, he told me what it was: 'I suppose you think that your coming to England is a result of divine providence?' I said that indeed that was what I thought. He seemed troubled: 'Perhaps I have to think about that as well.' I was puzzled, and he explained.

When he had met his friends, they told him how interested they had been in my story, and the wife, Jean Cowan, added, 'Especially the bit about the grandmother, the giraffe woman. You see, we think we have seen her.' He could not grasp what she was driving at. She went on: 'We had a friend, Hazel Armour, who died a few years ago in her nineties. The great thing about Hazel was that she loved circuses and circus folk. Not long before the war she spent six weeks with Bertram Mills's Circus doing paintings and sculptures. She showed some of them at an exhibition in our gallery. One of the busts was of a giraffe woman.'

With that, John unrolled a poster from the exhibition. There were four black-and-white reproductions of Hazel Armour's work. In the lower right-hand corner was a photograph, taken before the war, of a handsome middle-aged woman – the artist – polishing the brass head of a woman with an extraordinarily long neck and wearing a full complement of neck rings. 'Does that remind you of anyone?' I immediately recognised her. It was my grandmother. Mrs Cowan had assumed that this was the bust of a member of an African tribe, until she read in John's letter about the Padaung.

I felt that the circle was complete. What were the odds against my meeting a couple in a Chinese restaurant in Mandalay, talking to them about James Joyce, so that I provoked the interest of a Cambridge don who met them the day before he came to Burma, and who on the spur of the moment decided to visit the restaurant; and then that as a result of my writing to him from the jungle he brought me to England and, a few weeks later, to a house in Aldeburgh with a small private art gallery; and that there I would come face to face with a bust of my grandmother taken on her visit to England with a circus in the 1930s? I cannot calculate them. Do we only talk of luck?

* * *

EPILOGUE

Nearly every night I dream of Shan State, of Phekhon, of Mandalay, of the jungle. The landscapes of my dreams resemble real ones, yet they shift like images on silver screens. Now that I have travelled so far beyond the 'unimaginable places' that haunted me in childhood – beyond the Lawpita falls and the great Salween – the dream-images have all become mixed up, the elements transposed. Snow may fall on the Shan State jungles, or palm trees may grow in the Alps. But something never changes. The pictures are always blurred by mists.

Index

INDEX